SHOP DESIGN

daab

Commercial architecture allows many people to enjoy a type of architecture that is reserved for a select few in its residential version. Fashionable companies are aware of the appeal of this phenomenon and are increasing their investment in the location and design of their stores to give their brands an added attraction. Furthermore, carefully planned commercial architecture also offers the opportunity to embody abstract concepts like brand values by using design to evoke specific sensations, in the same way as advertising and marketing. In addition, shop design must respond to functional needs, such as comfort, an efficient layout and a suitable, effective display of products. The configuration of consumer goods acquires great importance, while the supports on which they are exhibited tend to either pass unnoticed or be very large, to bestow personality on merchandise and prevent it from being a passive presence, allowing it instead to interact with the architecture to create a specific "ecosystem". The esthetics of stores have evolved so that they are now more similar to private homes, giving rise to more intimate settings in which a customer does not feel like one among many but rather the leading player. Elements that lend continuity to spaces and invite passersby to come inside are used to capture attention and create a sense of dynamism. Elements such as corridors and walkways serve this purpose. Commercial architecture also plays no small part in the advertising process. Some stores now form part of the tourist routes of great cities, and the stores that are most highly recommended and discussed are sometimes those that break new ground and make a greater visual impression on visitors than the merchandise they stock. An increasingly specialized, distinctive and sophisticated architecture for commercial spaces has emerged to bring the abovementioned concepts to life. In this book, we wanted to present architecture involving major brands and architects, but also to throw light on the work of less well-known architects unafraid of innovation and risk.

Während die Ästhetik des Wohnungsbaus oft nur einer gewissen Elite vorbehalten bleibt, erlaubt die Architektur in gewerblicher Form einem breiteren Publikum ihre verschiedenen Ausprägungen zu genießen. Der Attraktivität dieses Phänomens bewusst, investieren viele Modeunternehmen immer mehr in den Standort und das Design ihrer Boutiquen um dem Markenimage einen neuen Reiz zu verschaffen. Wie PR und Marketing bietet eine sorgfältig ausgewählte Ladenarchitektur die Möglichkeit abstrakte Konzepte zu materialisieren und den Wert der Marke durch das Hervorrufen von konkreten Gefühlen zur Geltung zu bringen. Auf der anderen Seite muss das Design auch einer Reihe funktioneller Ansprüche, wie der Verkaufsflächenoptimierung oder der praktischen, perfekten, und effektiven Produktpräsentation gerecht werden. Die Präsentation von Konsumgütern gewinnt an Bedeutung und es reicht nicht mehr die Ware nur auszuhängen. Um ihr einen Charakter zu verleihen, muss die Ware, unauffällig oder imposant präsentiert, mit der Architektur in Interaktion und Einklang verbleiben, um so ein separates „Ökosystem" zu schaffen. Die Ästhetik dieser Art Raum entwickelt sich immer mehr in Richtung Privathaus und schafft somit intimere, weniger öffentliche Atmosphären, die dem Kunden das Gefühl vermitteln sollen, nicht Einer von Vielen, sondern Hauptdarsteller zu sein. Um die Aufmerksamkeit des Kunden zu erlangen und ein dynamisches Umfeld zu kreieren, greift man zurück auf Elemente wie Passagen und Laufstege, die den Kunden einladen einzutreten und die Kontinuität des Raumes akzentuieren. Auch die Werbefunktion der gewerblichen Architektur ist in keiner Weise zu vernachlässigen. Einige Geschäfte sind fester Bestandteil touristischer Routen berühmter Großstädte. Nicht selten sind es vielmehr die Gebäude und Innenräume, als die eigentliche Ware, die Grenzen überschreiten und in der Erinnerung derer bleiben, die sie besuchen, darüber reden und empfehlen. Um die erwähnten Faktoren umsetzen zu können, entsteht eine immer spezialisiertere, differenziertere und progressivere Architektur. In diesem Buch wollen wir der Architektur großer Marken und Architekten Ausdruck verleihen, aber auch der Werke weniger berühmter Agenturen gerecht werden, die die Fähigkeit besitzen, eine gewisse Portion Innovation und Risiko mit ins Spiel zu bringen.

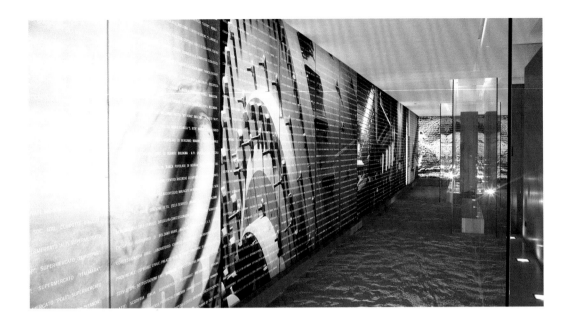

L'architecture commerciale met l'architecture à la portée d'un grand nombre de personnes, alors qu'elle n'est, dans sa version résidentielle, que l'apanage d'une certaine élite. Conscientes de l'attrait de ce phénomène, les entreprises de mode investissent de plus en plus dans l'emplacement et le design de leurs boutiques pour stimuler l'image de marque de leur enseigne. En outre, une architecture commerciale bien étudiée offre la possibilité de matérialiser les concepts abstraits et de mettre en valeur l'enseigne par la mise en scène de sensations concrètes, grâce au design, comme le font déjà la publicité et du marketing. Par ailleurs, le design des boutiques doit répondre à certains besoins fonctionnels : optimisation de l'espace, exposition du produit pratique, parfaite et la plus efficace possible. Car la présentation des biens de consommation est d'une extrême importance. En effet, les présentoirs exposant les produits doivent, soit passer inaperçus, soit être imposants, pour mettre en valeur une marchandise qu'il ne suffit pas d'accrocher mais qui doit entrer en interaction avec l'architecture créant ainsi un « écosystème » particulier. L'esthétique de ce genre d'établissement a évolué pour s'assimiler à des espaces proches des maisons individuelles, créant des ambiances plus privées et intimes, moins publiques, qui permettent à l'acheteur de ne pas être simplement un numéro parmi d'autres, mais d'en être le protagoniste. Pour capter l'attention du client et créer un univers dynamique, on a recours à certains éléments, à l'instar de passages et de passerelles qui accentuent la fluidité de l'espace et incitent à entrer dans la boutique. Quant à l'aspect publicitaire, le rôle exercé par l'architecture commerciale n'est en rien négligeable : en effet, certaines boutiques font partie du parcours touristique des grandes villes. Ce sont ces magasins qui, parfois, plus que les produits offerts, transcendent les frontières et marquent le souvenir des touristes qui en parlent et les recommandent. Pour concrétiser tous ces facteurs, une nouvelle architecture des espaces commerciaux est née, encore plus spécialisée, différenciée et progressive. Dans ce livre, nous avons mis l'accent sur une architecture de grandes marques, réalisée par des architectes de renom, mais également sur l'œuvre d'architectes moins connus, aux idées tout aussi innovatrices et audacieuses.

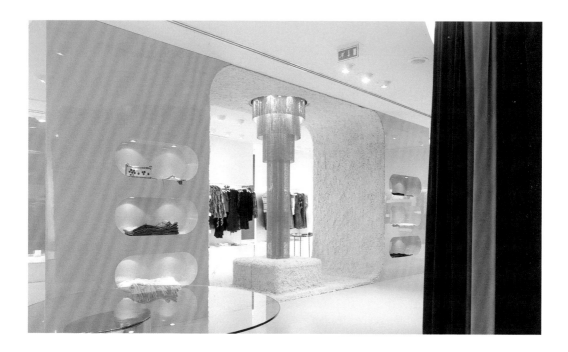

La arquitectura comercial permite que muchos disfruten de una arquitectura que, en su versión residencial, se reserva a unos pocos. Conscientes del atractivo de este fenómeno, las empresas de moda apuestan por invertir cada vez más en la localización y en el diseño de sus tiendas, y así proporcionar un nuevo aliciente a sus marcas. Pero una cuidada arquitectura comercial ofrece, además, la oportunidad de encarnar conceptos abstractos como los valores de la marca, evocando sensaciones concretas a través del diseño, como hacen la publicidad y el marketing. Por otro lado, el diseño de las tiendas ha de dar respuesta a unas necesidades funcionales, como el aprovechamiento del espacio, la comodidad y la correcta y efectista exposición del producto. La disposición de los bienes de consumo cobra gran importancia y los soportes en los que se exponen tienden bien a pasar desapercibidos, bien a ser de grandes dimensiones, para que confieran carácter a una mercancía que ya no cuelga simplemente, sino que interactúa con la arquitectura y crea un "ecosistema" único. La estética de este tipo de establecimientos ha evolucionado hacia espacios más parecidos a casas particulares y ha dado lugar a atmósferas más privadas e íntimas, menos públicas, en las que el comprador no se siente uno más, sino el protagonista. Para captar la atención y crear una sensación de dinamismo, se emplean elementos que dan continuidad a los espacios e invitan a adentrarse en la tienda. Elementos como pasillos y pasarelas contribuyen a crear esta sensación. En cuanto a la función publicitaria, la que ejerce la arquitectura comercial no es nada desdeñable; hay tiendas que ya forman parte de las rutas turísticas de las grandes ciudades y, a veces, son ellas las que traspasan fronteras e impregnan las retinas de los que las visitan incluso más que la propia mercancía, y son ellas las que son comentadas y recomendadas. Para materializar los factores mencionados, ha surgido una arquitectura de espacios comerciales cada vez más especializada, diferenciada y desarrollada. En este libro hemos querido apostar por una arquitectura de grandes marcas y arquitectos, pero también por otra creada por arquitectos menos conocidos, capaces de aportar grandes dosis de innovación y riesgo.

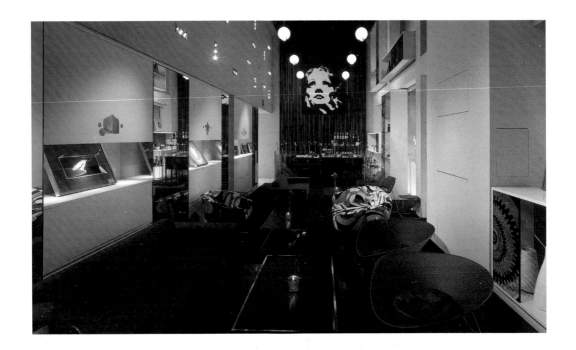

L'architettura commerciale consente a molti di fruire di un tipo di architettura che nella sua versione residenziale viene riservata solo a una cerchia ristretta di utenti. Consapevoli della forte attrazione suscitata da questo fenomeno, le grandi imprese della moda puntano, per i loro punti vendita, sempre di più su location mirate e design innovativi, per dare così uno stimolo in più ai loro marchi. Ma un'accurata architettura commerciale offre, inoltre, l'opportunità di incarnare concetti astratti quali i valori aziendali evocando sensazioni concrete attraverso il design e l'arredamento, così come avviene nel campo della pubblicità e del marketing. D'altro canto, il design e l'arredamento dei negozi deve rispondere a delle esigenze funzionali, come lo sfruttamento dello spazio, la comodità o l'adeguata ed efficace esposizione dei prodotti. Sotto questo aspetto riveste quindi una grande importanza la disposizione dei vari beni di consumo; i supporti, invece, sui quali questi vengono esposti tendono a passare inosservati oppure a essere di grandi dimensioni, per dare maggior carattere a delle merci che ormai non sono meramente appese a tali supporti ma interagiscono con l'architettura del locale creando un'atmosfera e ambiente del tutto peculiari. L'estetica di questi tipi di negozi si è evoluta adottando forme sempre più simili a case private, ed ha dato vita ad atmosfere più intime e private, meno pubbliche, dove il cliente non si sente come uno dei tanti acquirenti bensì come il protagonista. Per colpire l'attenzione e creare una sensazione di dinamismo, si utilizzano elementi che danno continuità agli spazi e invogliano a entrare nel negozio e darci un'occhiata. In quanto alla funzione pubblicitaria, quella esercitata dall'architettura commerciale non è per niente da sottovalutare; vi sono negozi che ormai fanno parte degli itinerari turistici delle grandi città, e a volte, sono gli stessi negozi, più che le merci in essi esposte, ad essere commentati e raccomandati. Per materializzare i citati fattori è nata un'apposita architettura per spazi commerciali sempre più specializzata, differenziata e sviluppata. In questo libro abbiamo voluto illustrarvi esempi di architettura di grandi griffe e di rinomati architetti ma anche progetti realizzati da architetti meno conosciuti, ma altrettanto validi e in grado di apportare soluzioni innovative ed audaci.

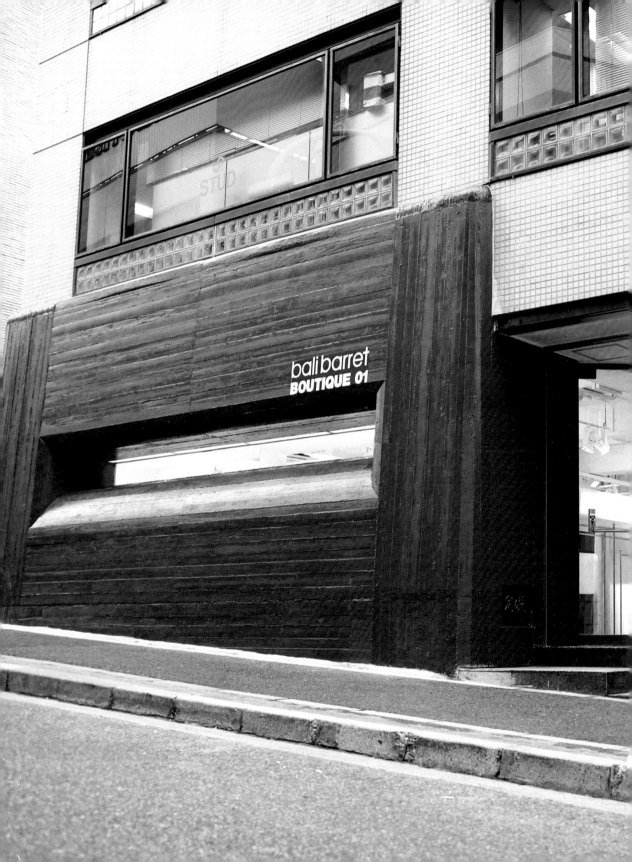

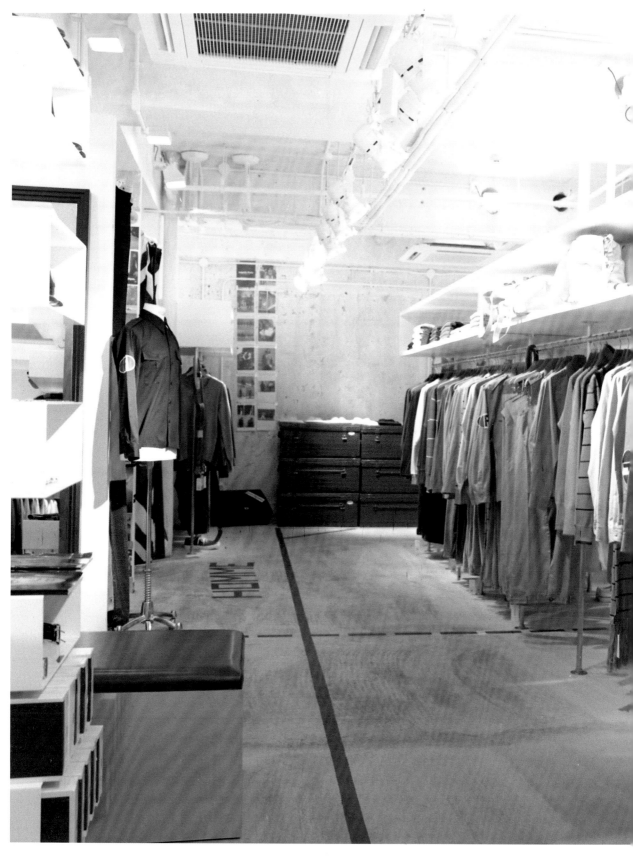

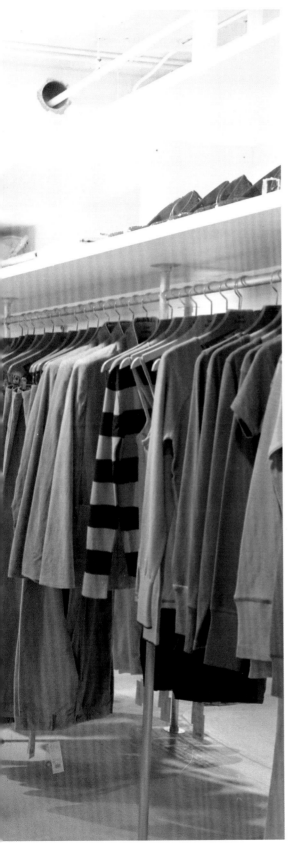

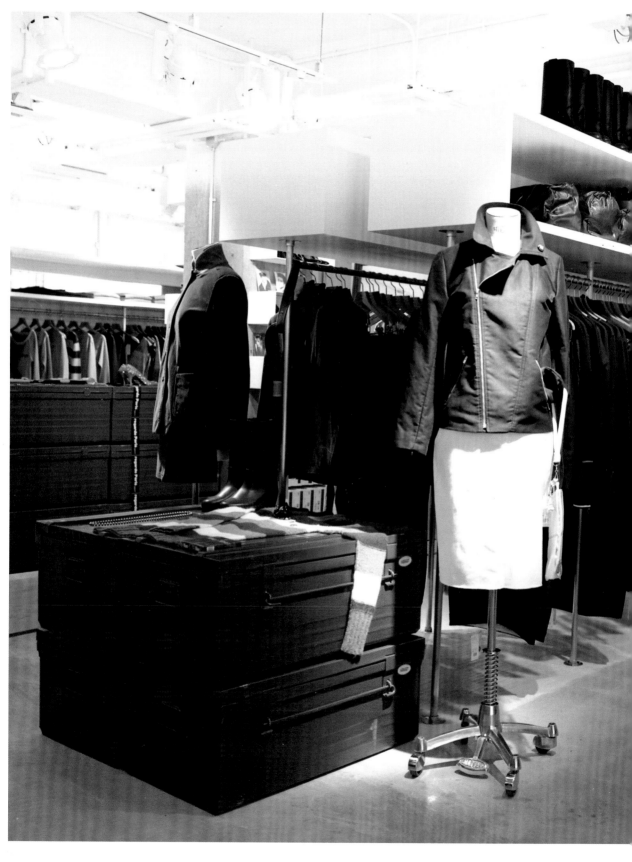

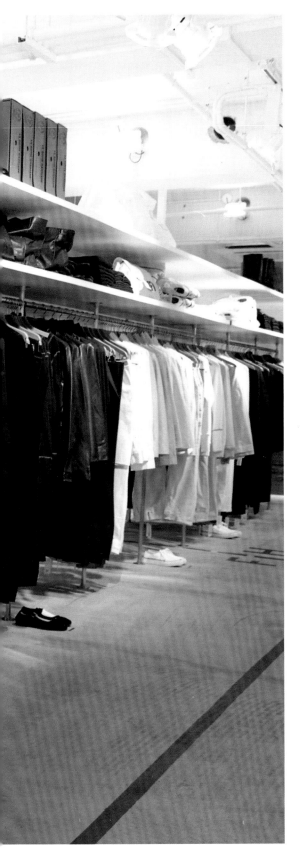

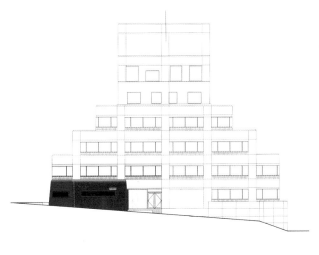

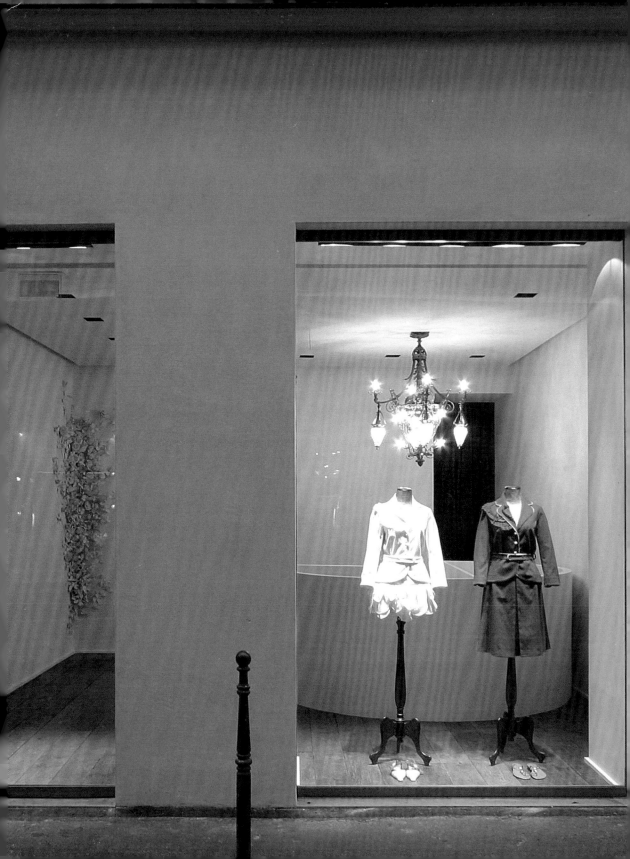

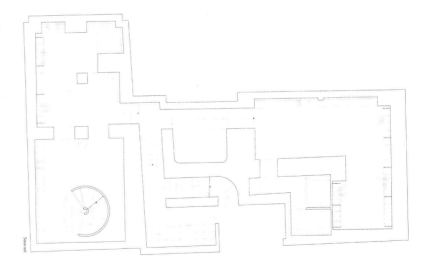

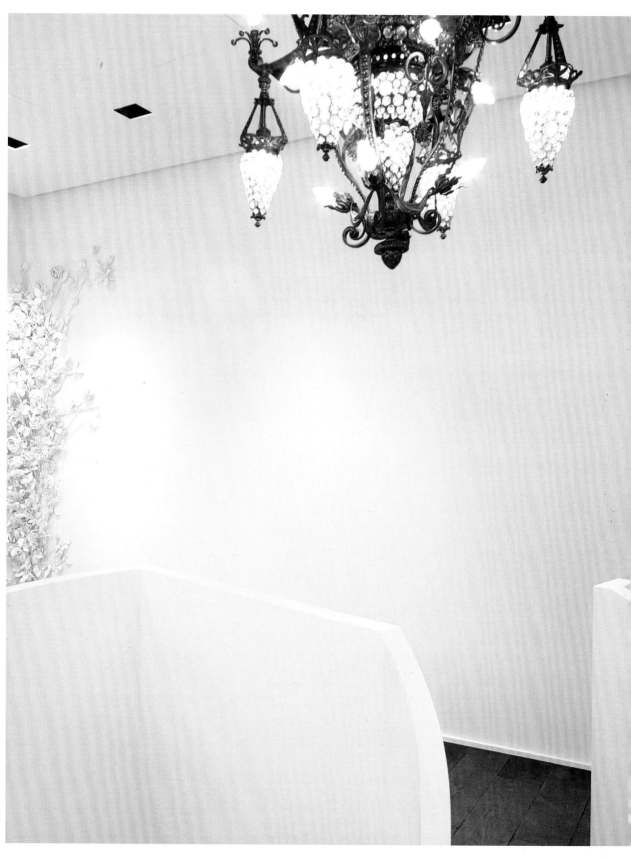

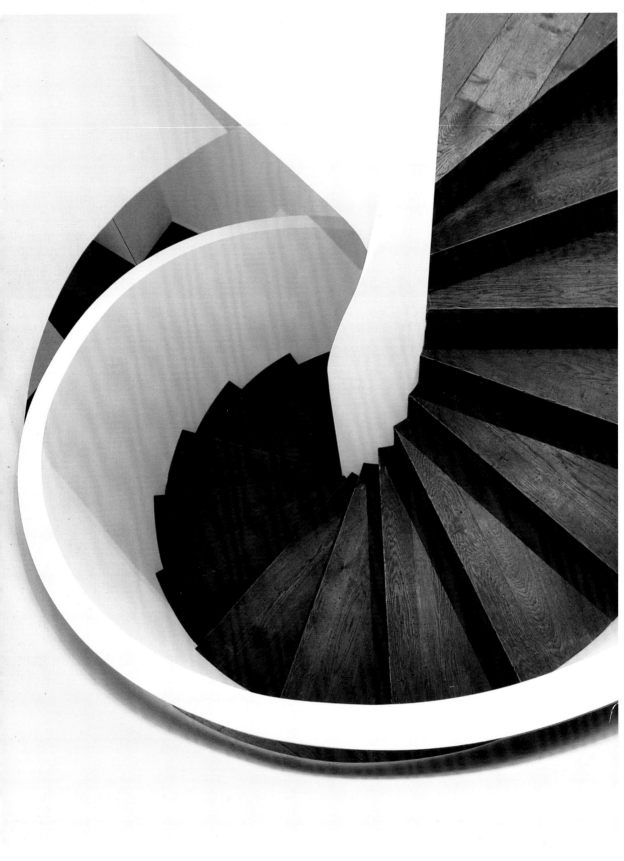

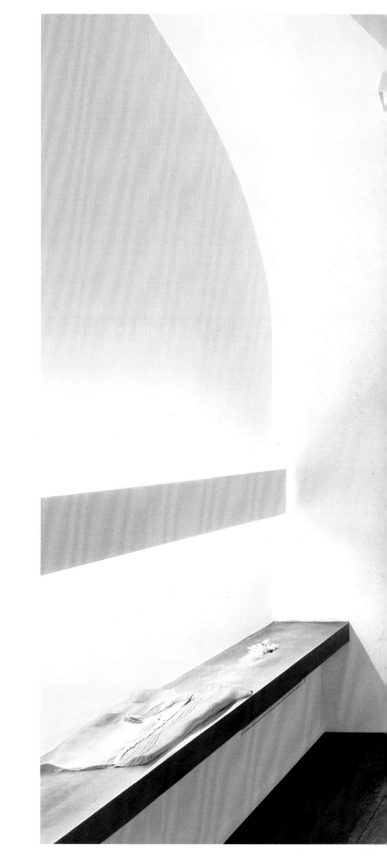

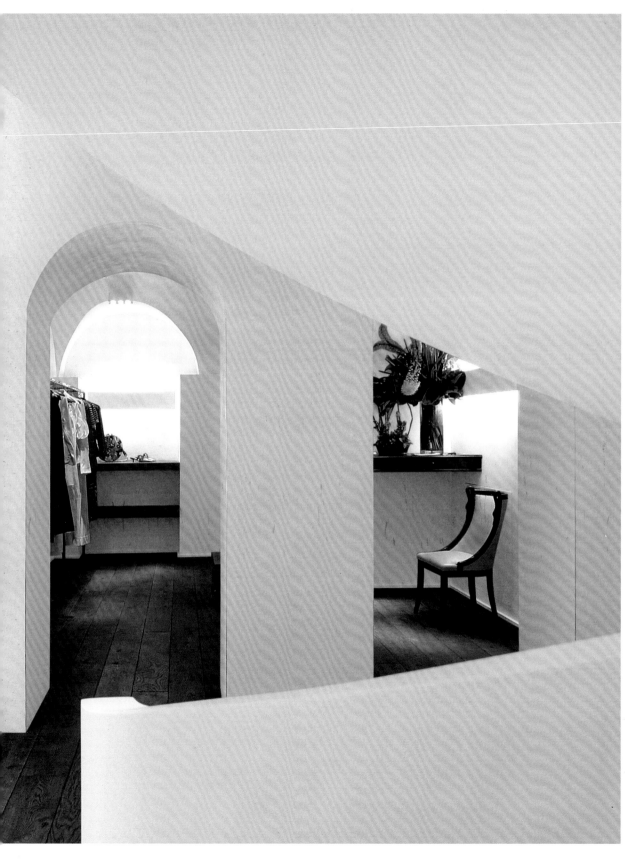

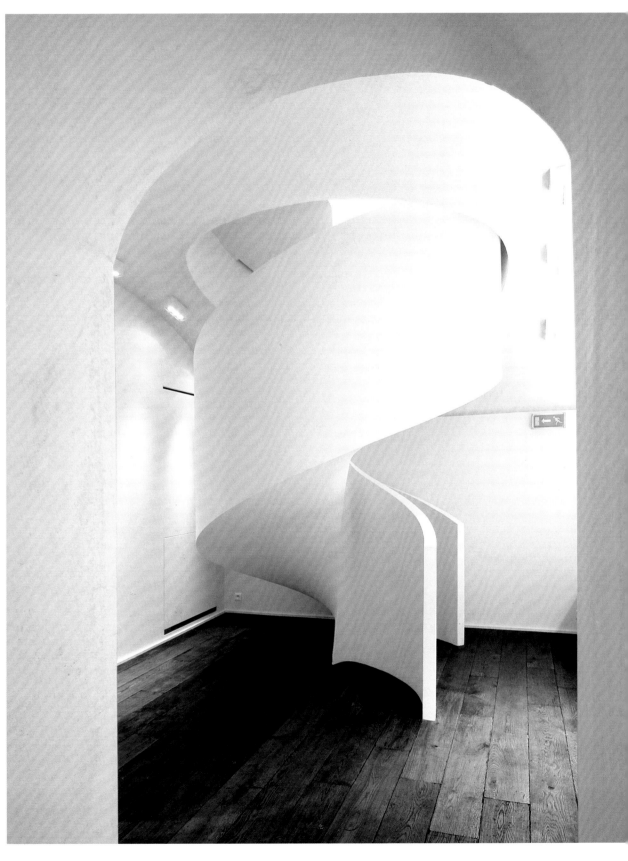

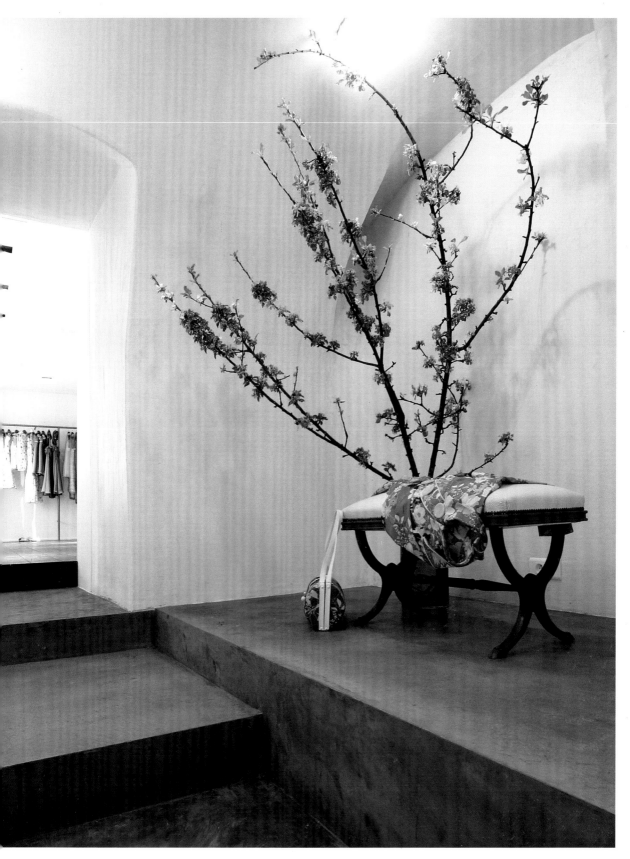

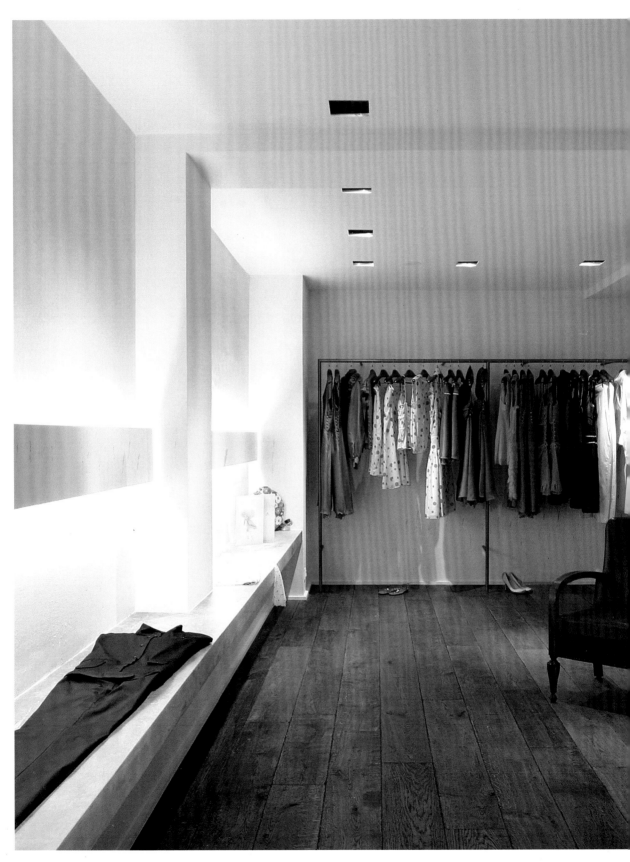

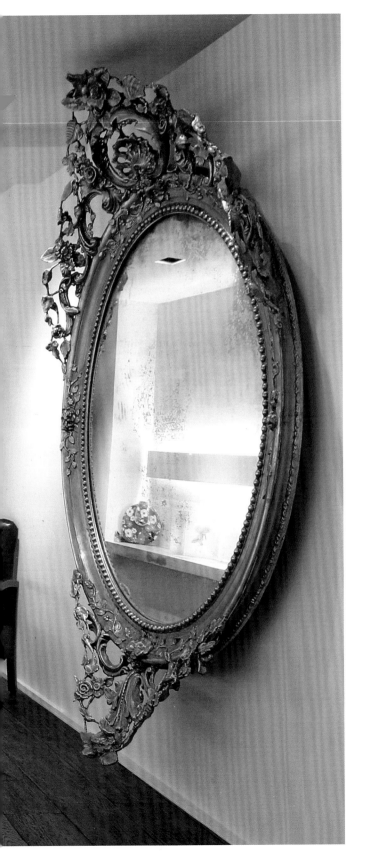

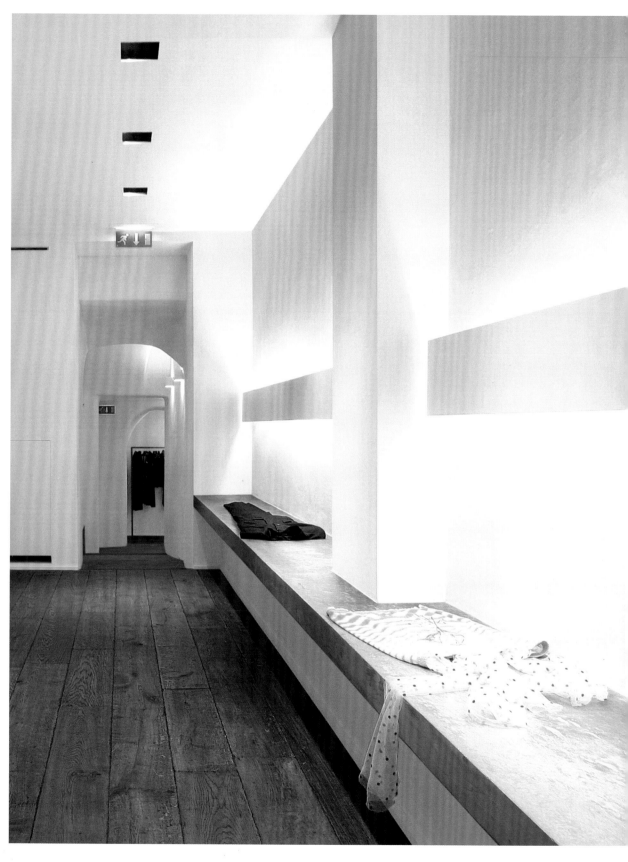

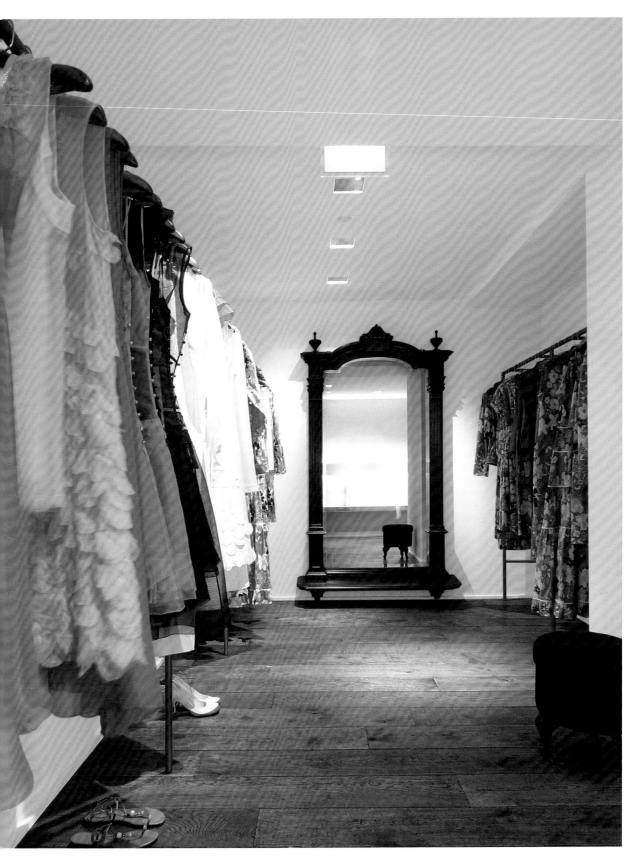

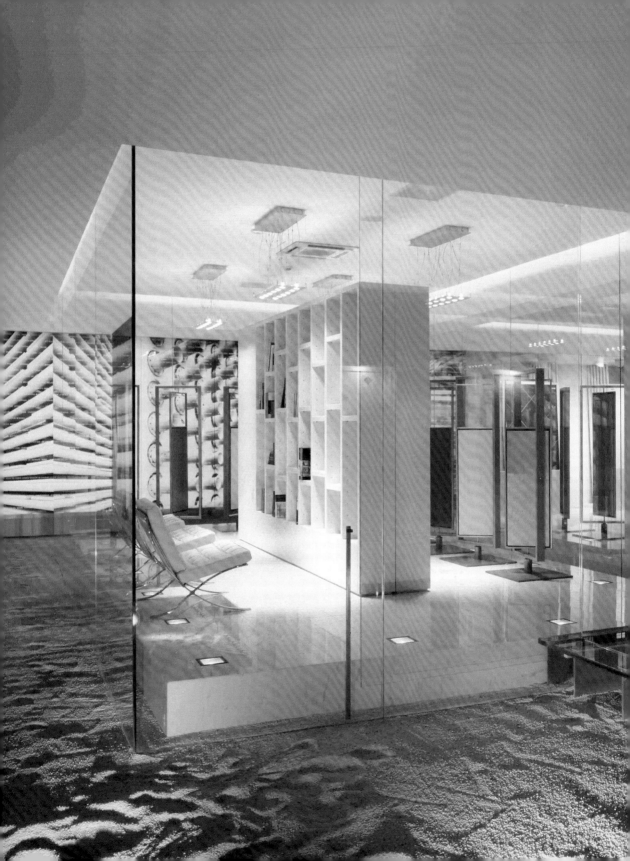

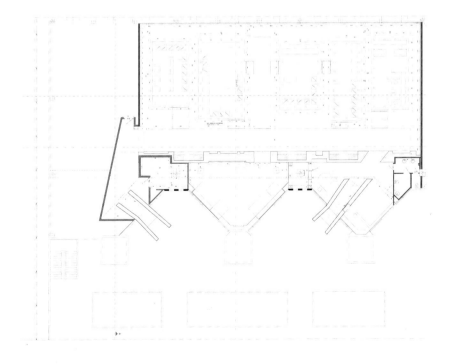

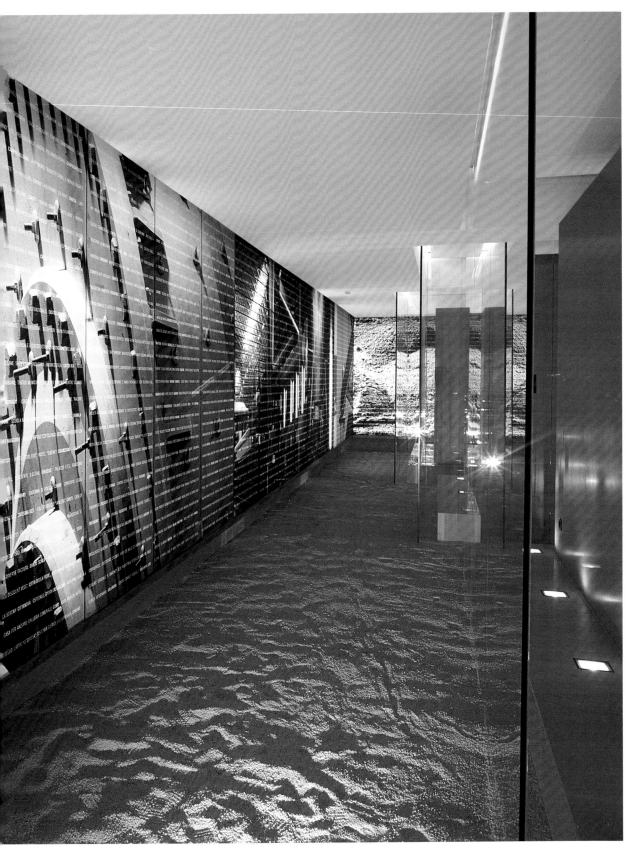

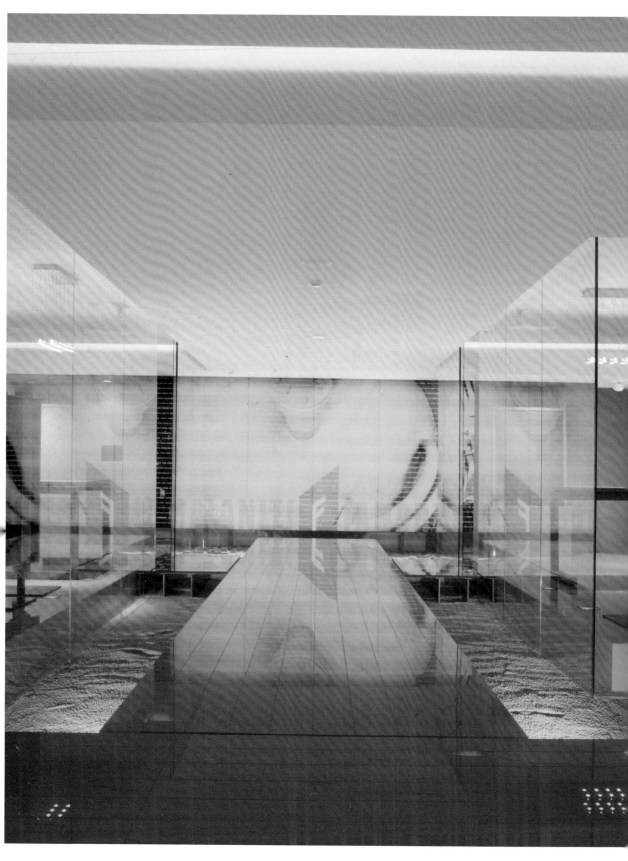

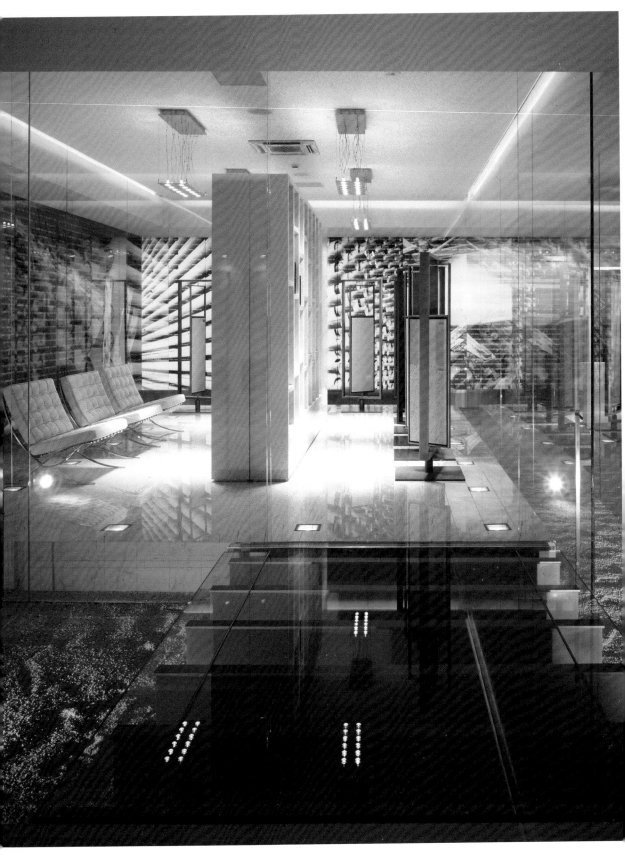

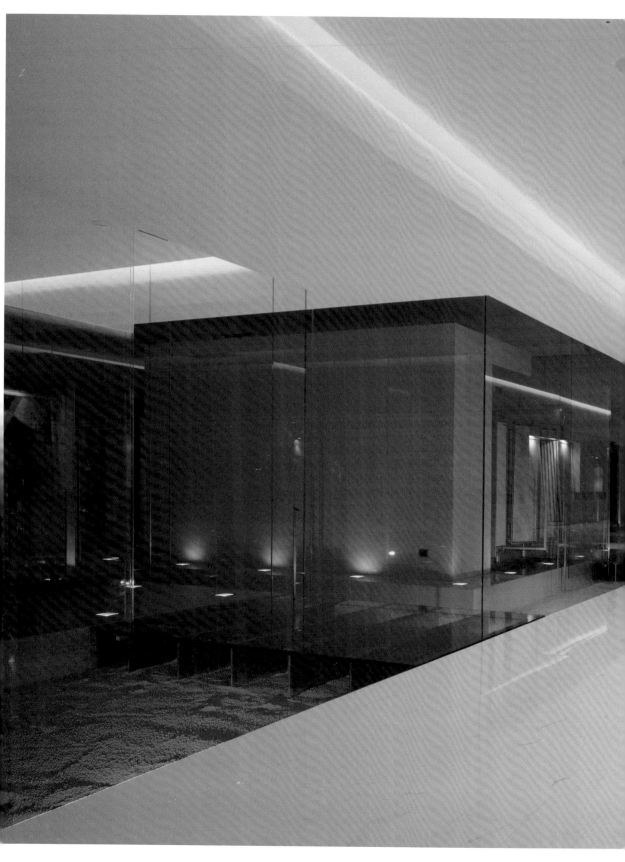

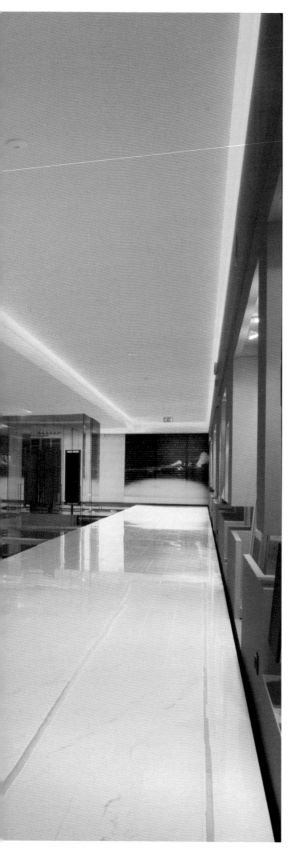

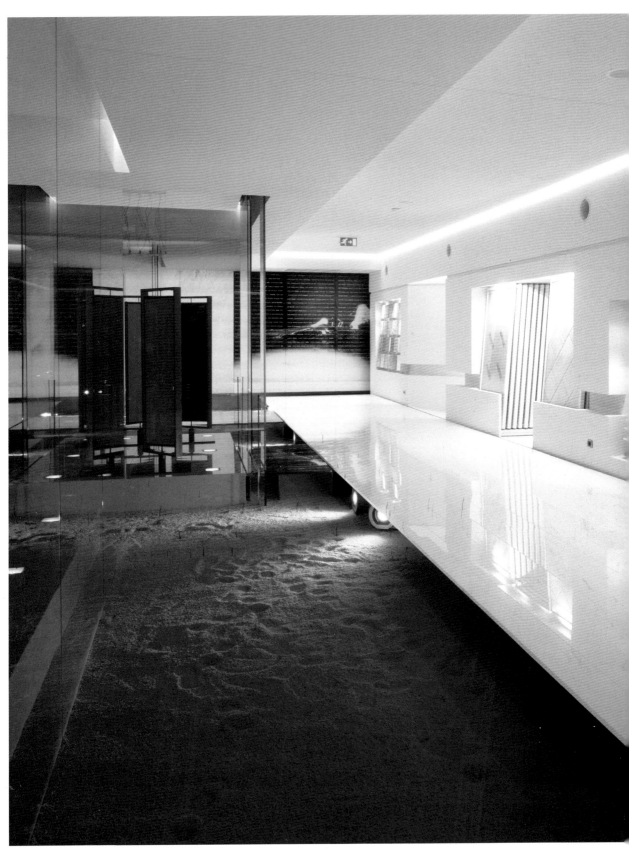

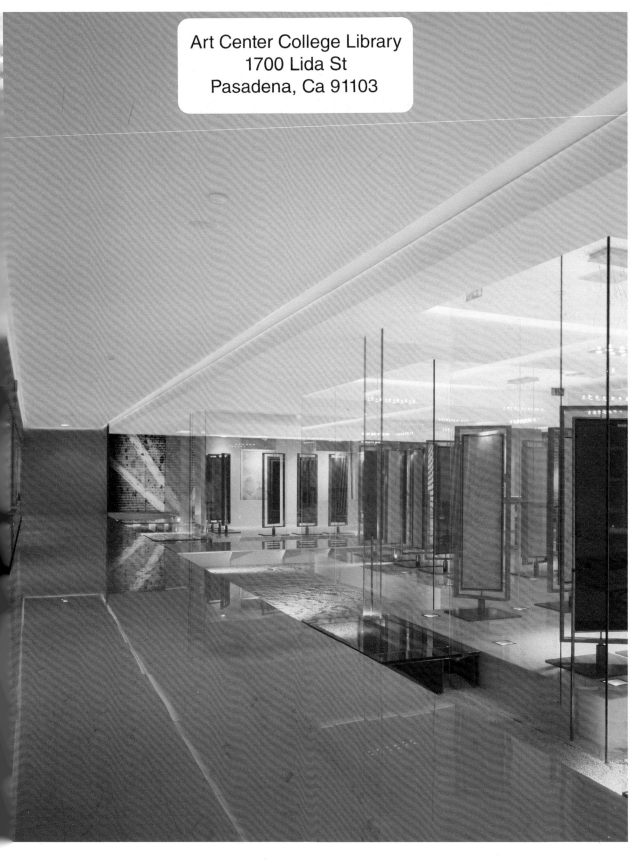

STELLA McCARTNEY

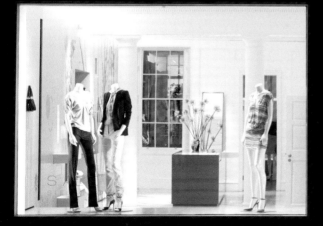

A. UNIVERSAL DESIGN STUDIO | LONDON
STELLA McCARTNEY
London, UK | 2004

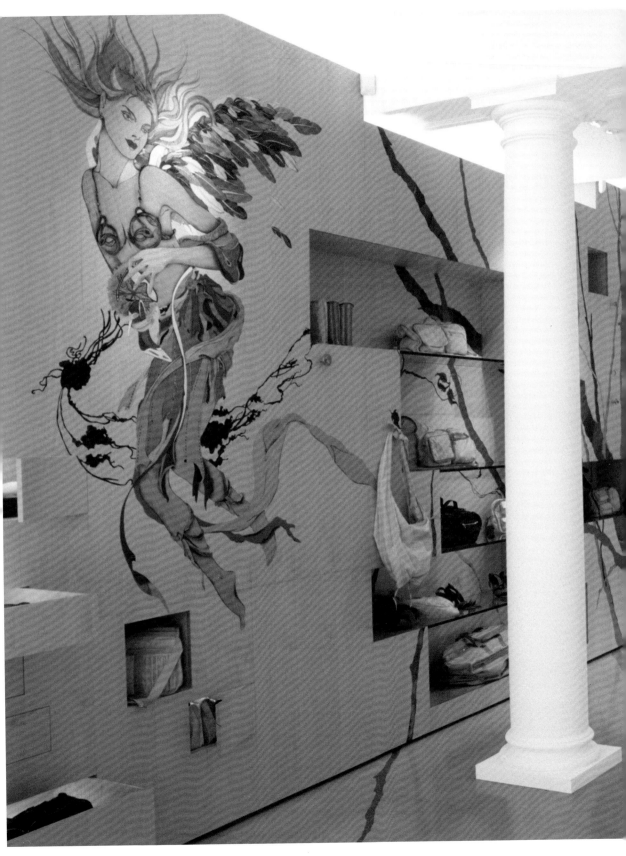

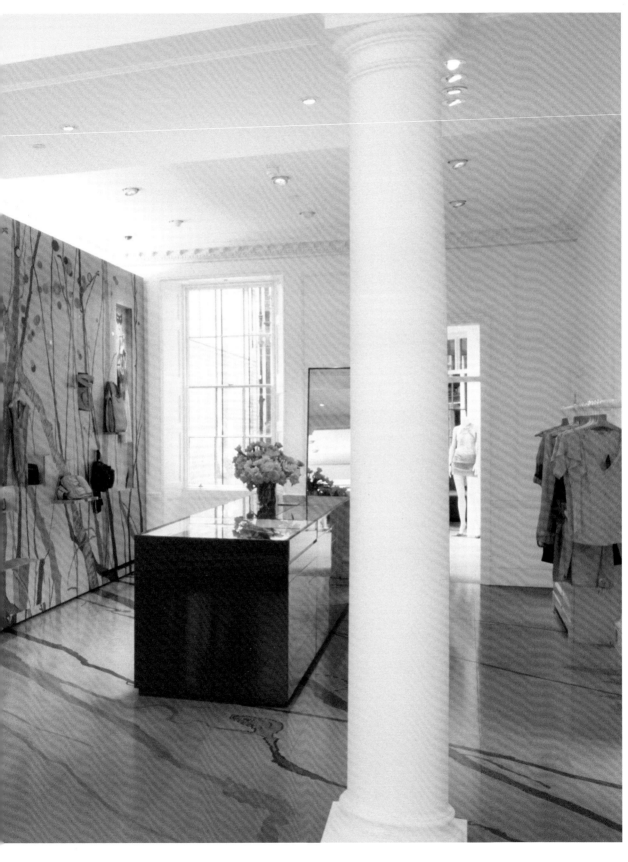

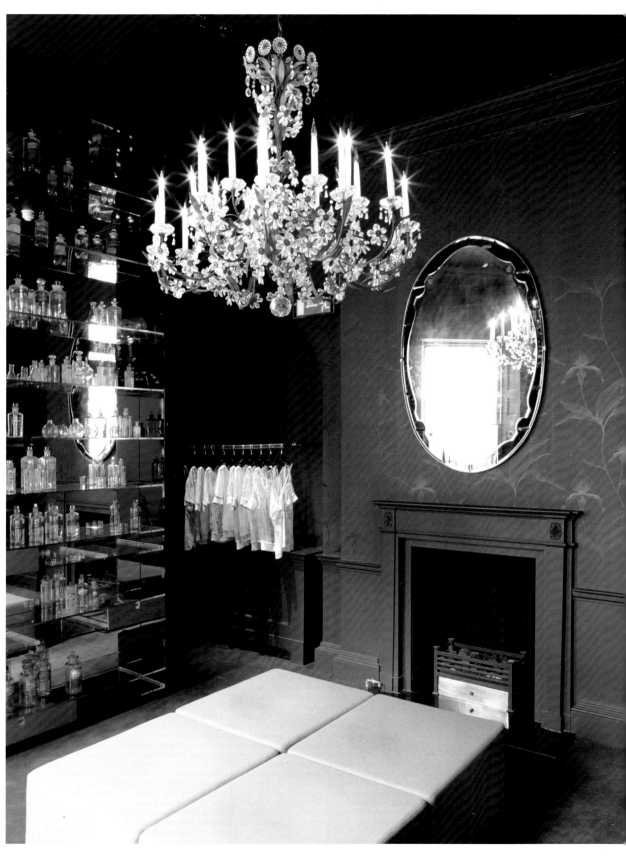

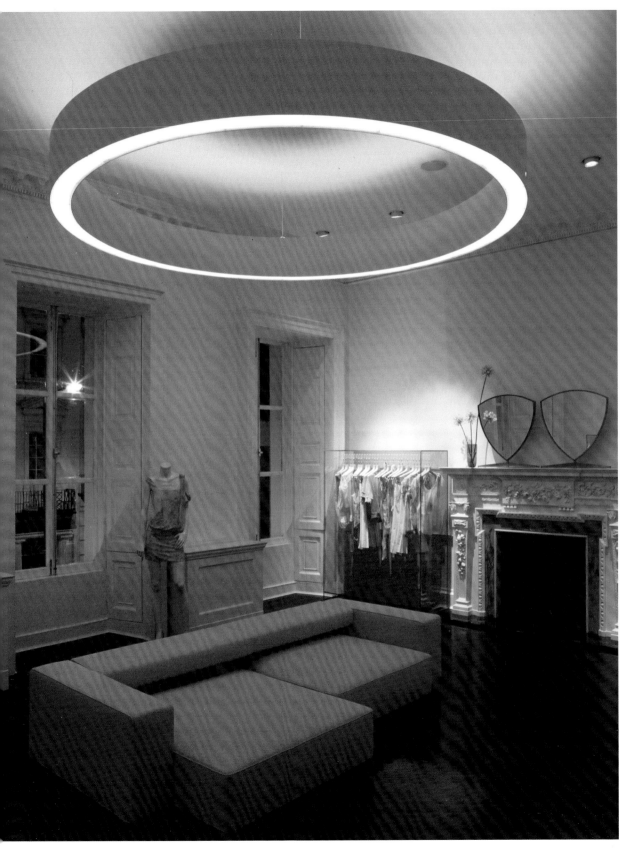

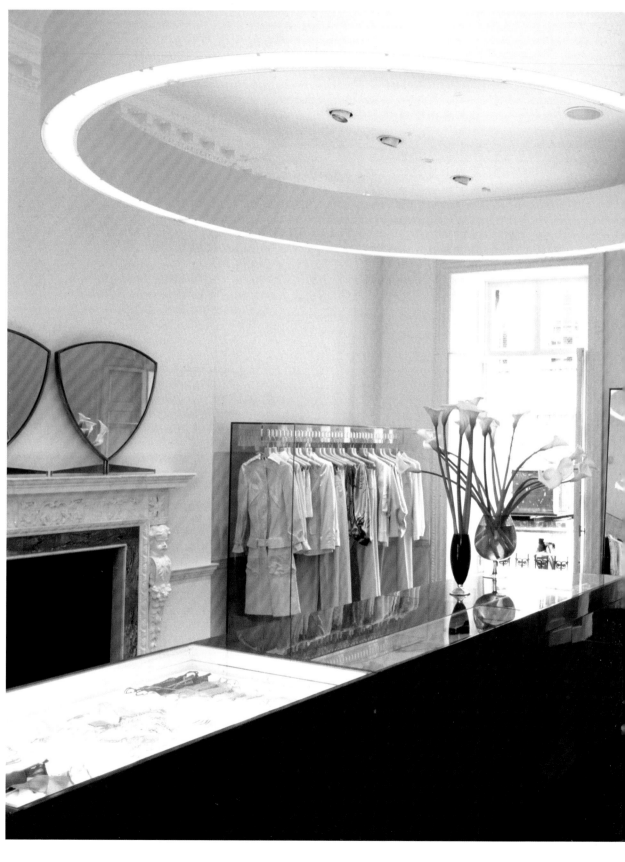

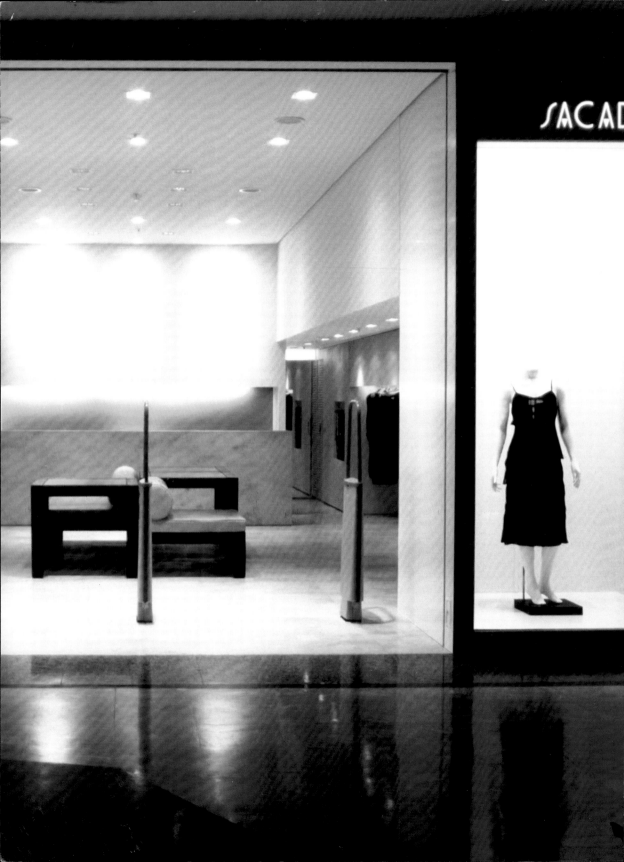

ARTHUR CASAS | SAO PAOLO
SACADA BARRA
Rio de Janeiro, Brasil | 2003

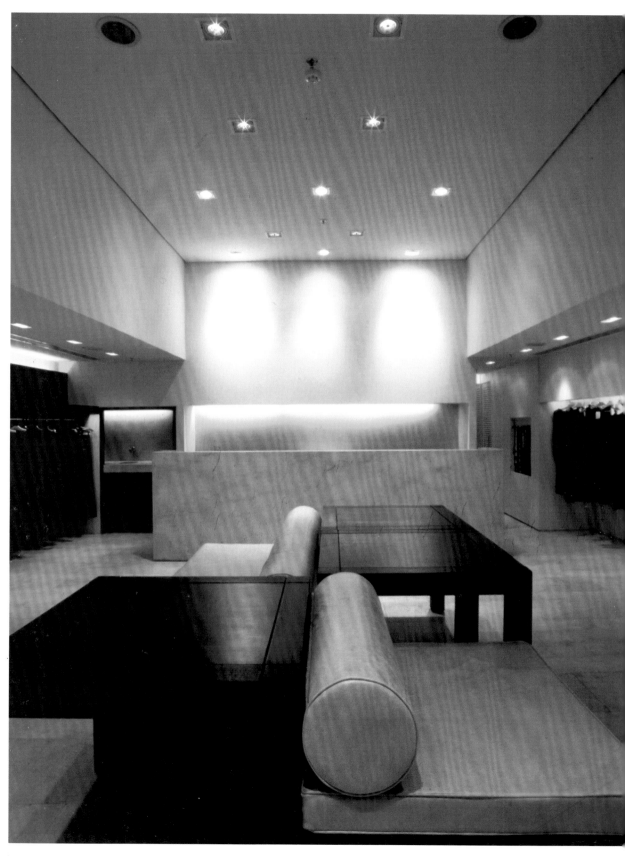

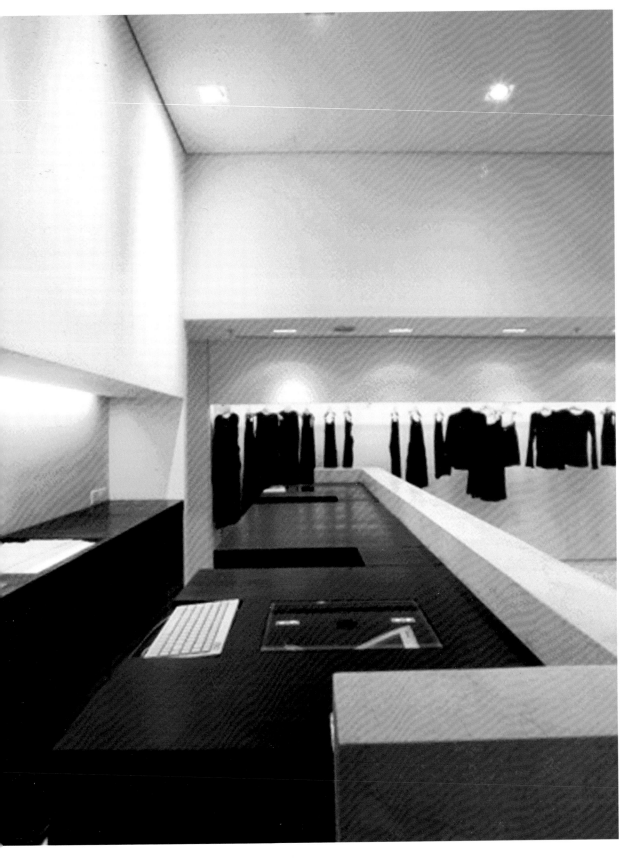

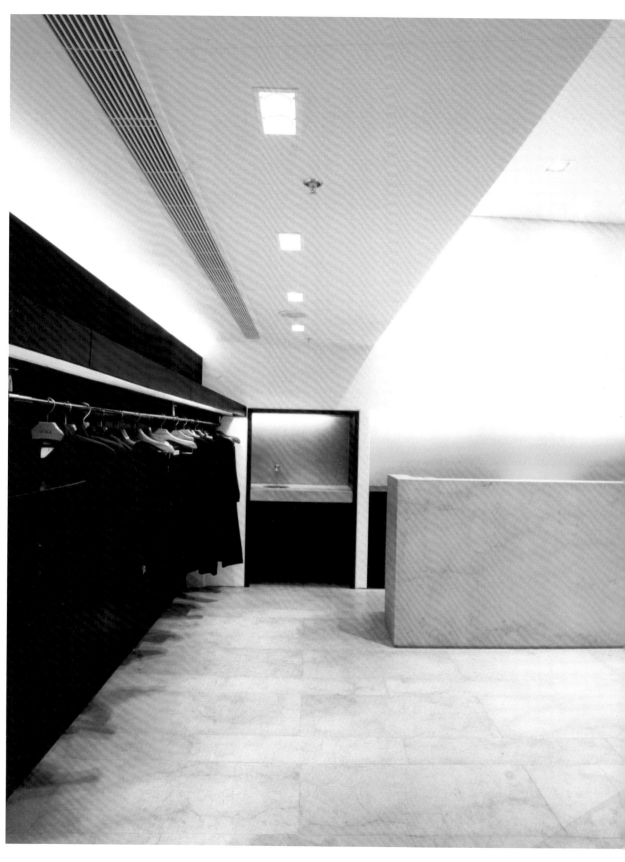

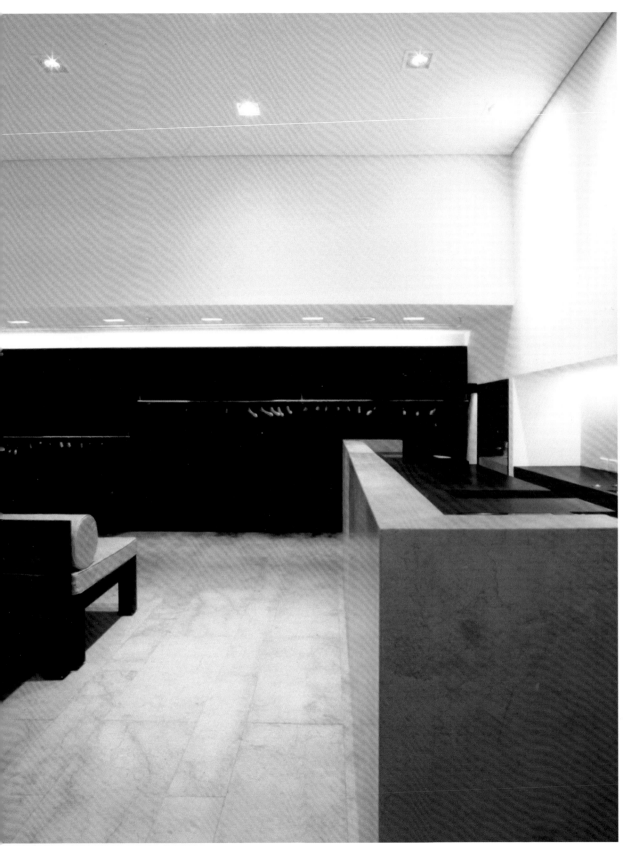

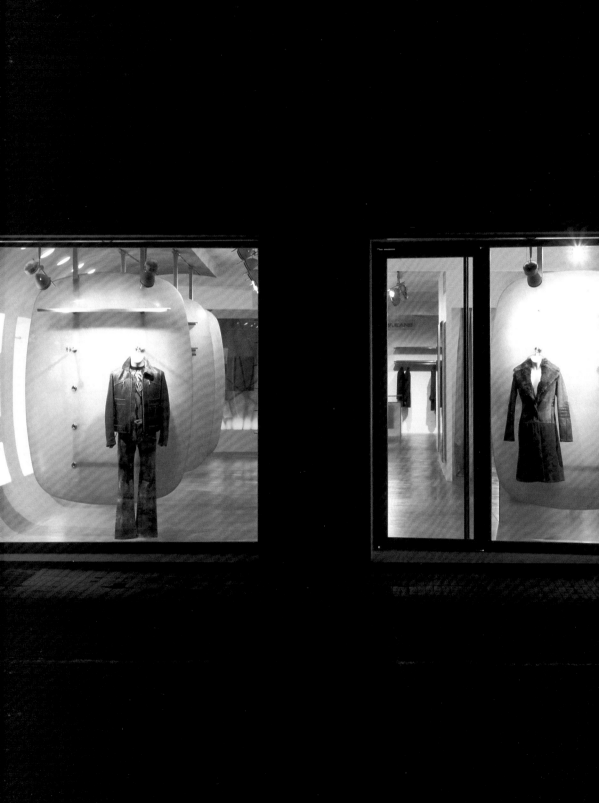

BASELLI VANNUCCI ARCHITETTI | FLORENCE
BARGHINI FASHION
Pistoia, Italy | 2001

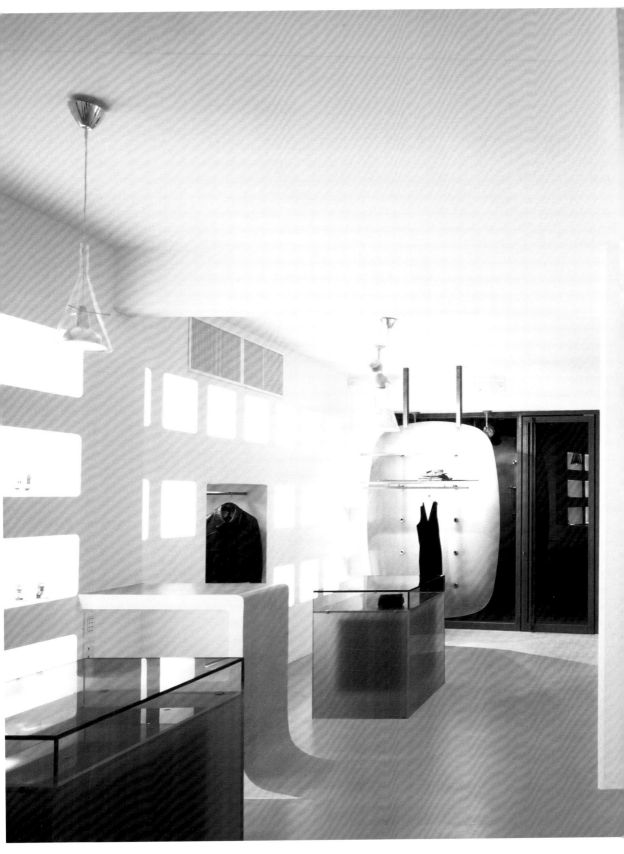

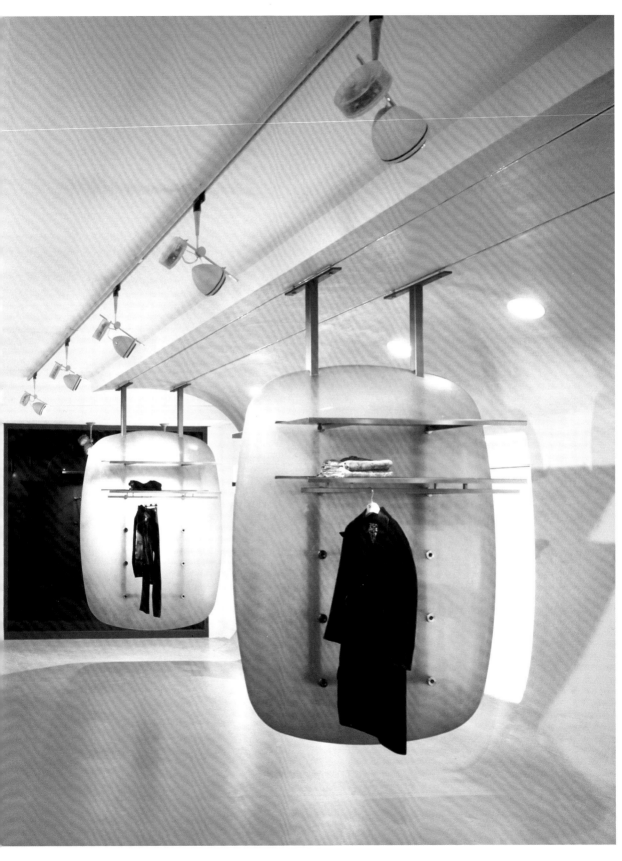

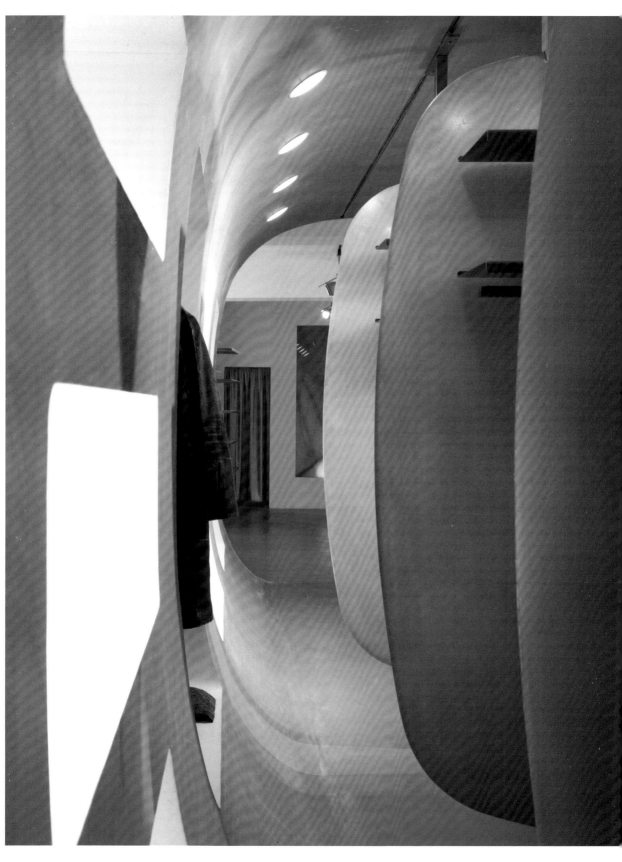

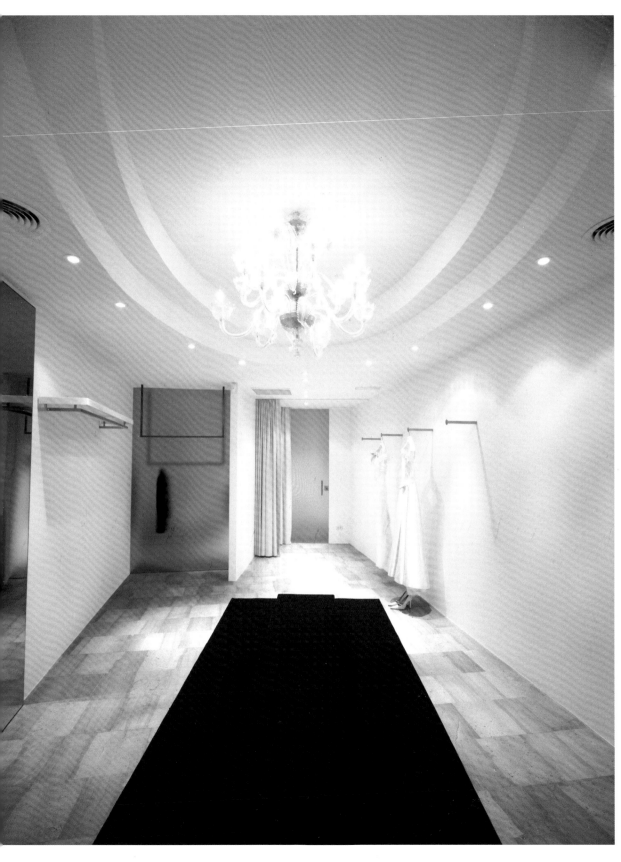

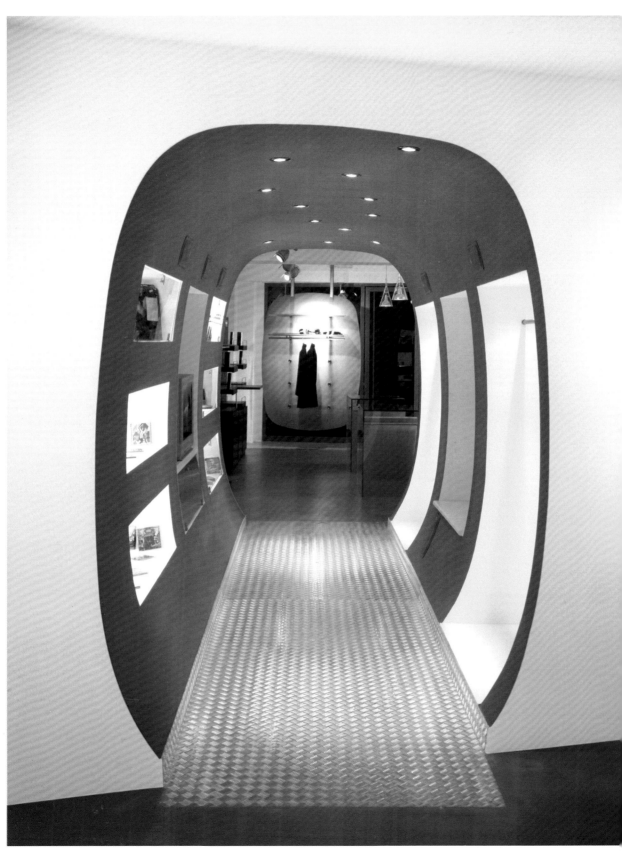

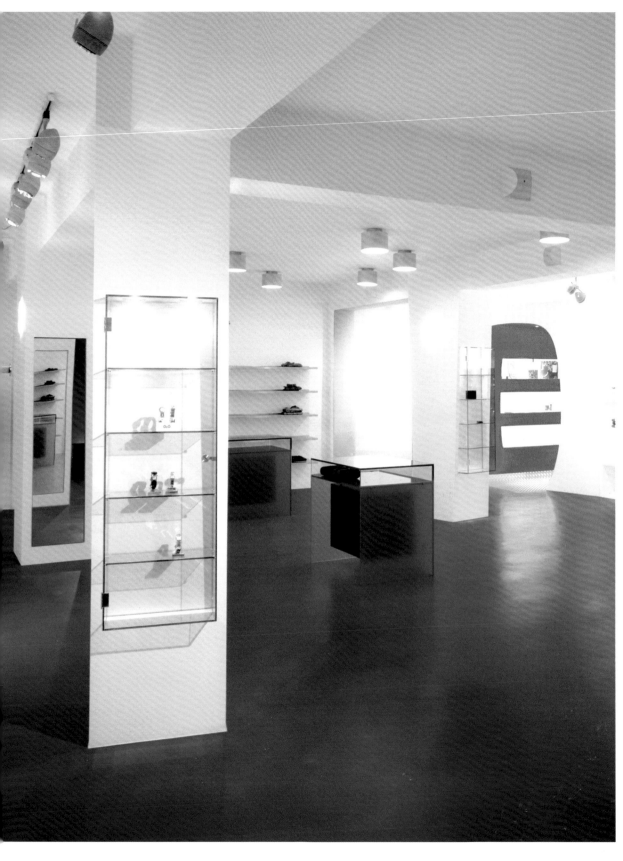

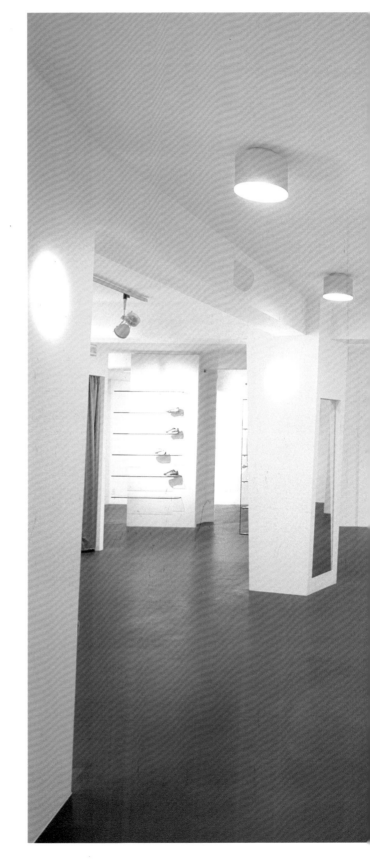

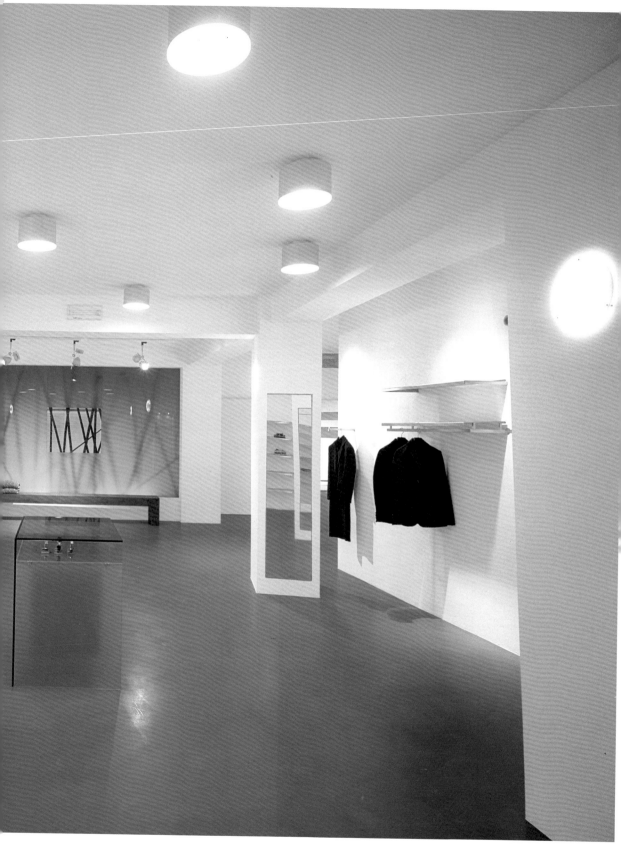

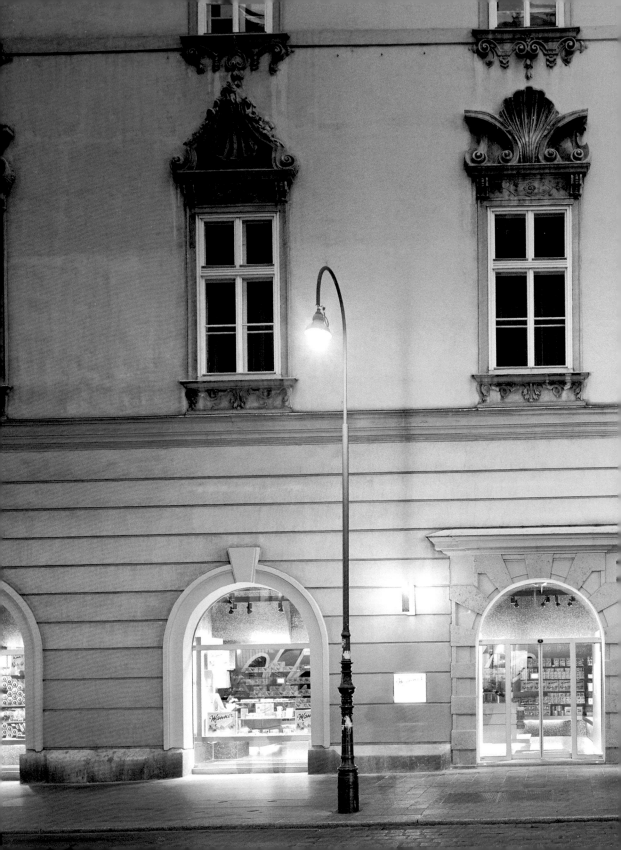

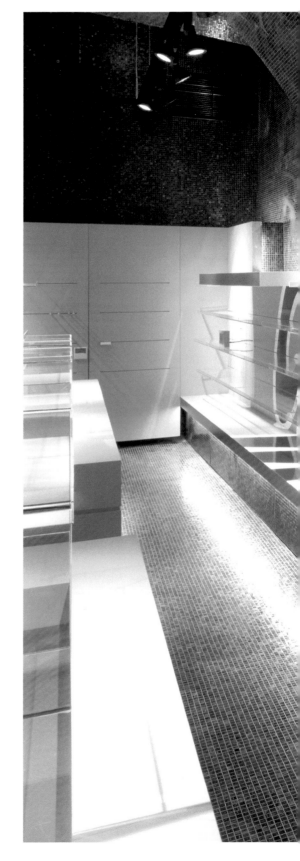

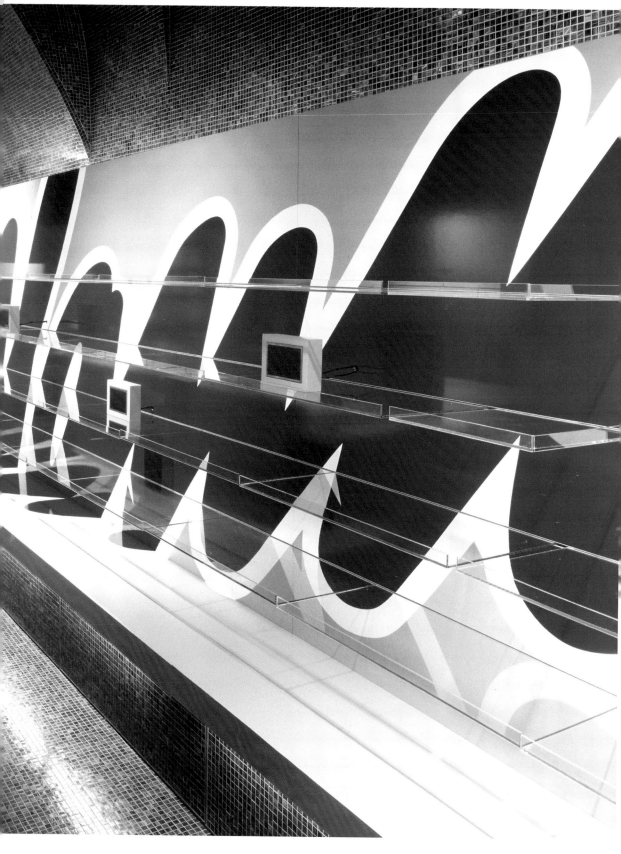

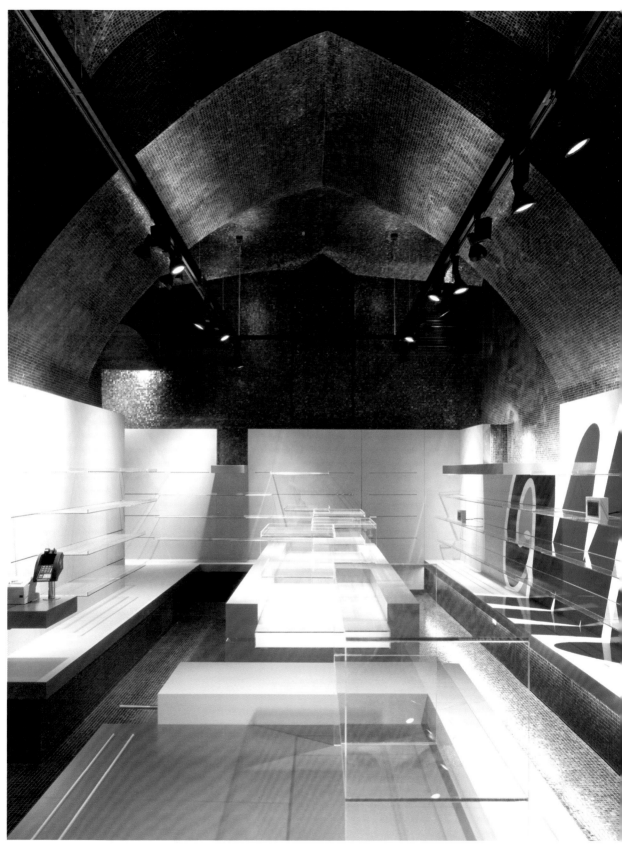

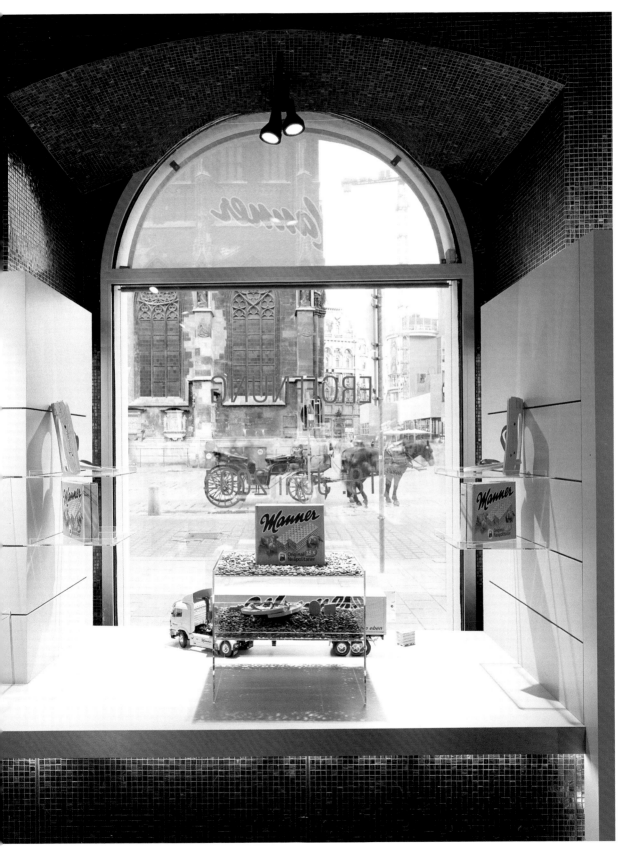

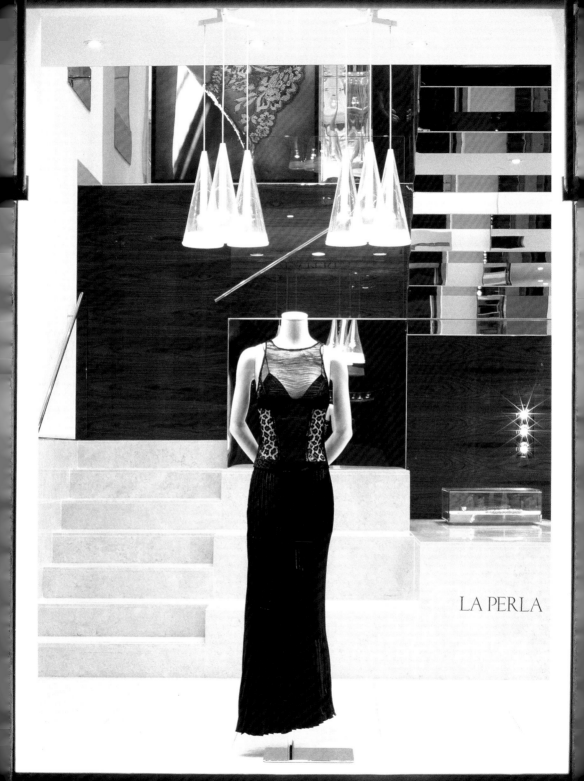

LA PERLA

BURATTI & BATTISTON ARCHITECTS | **MILAN**
LA PERLA
Rome, Italy | 2003

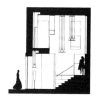

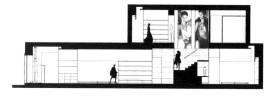

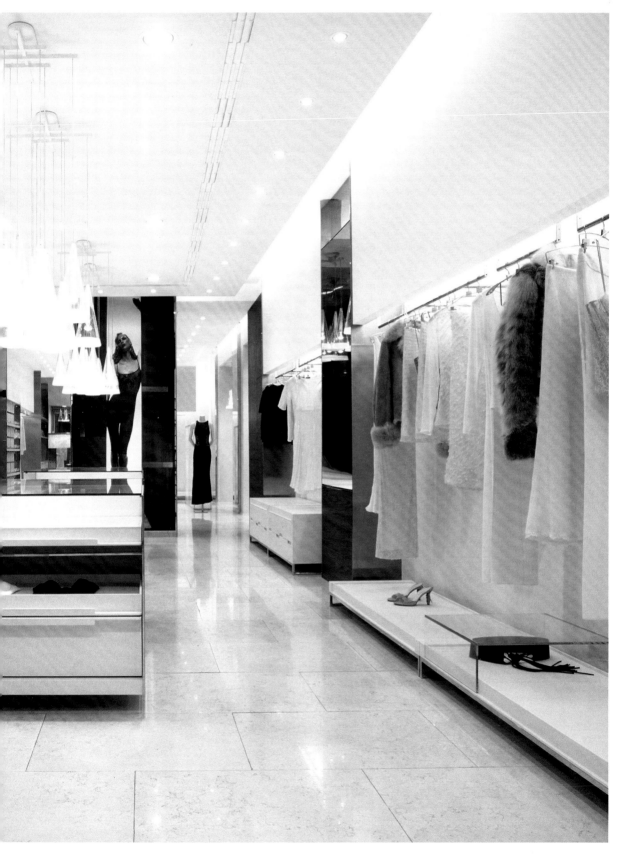

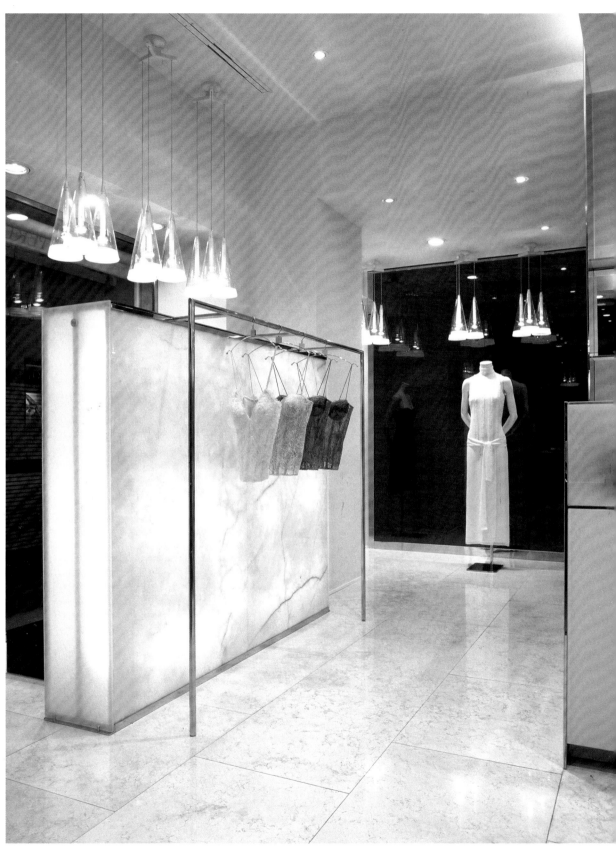

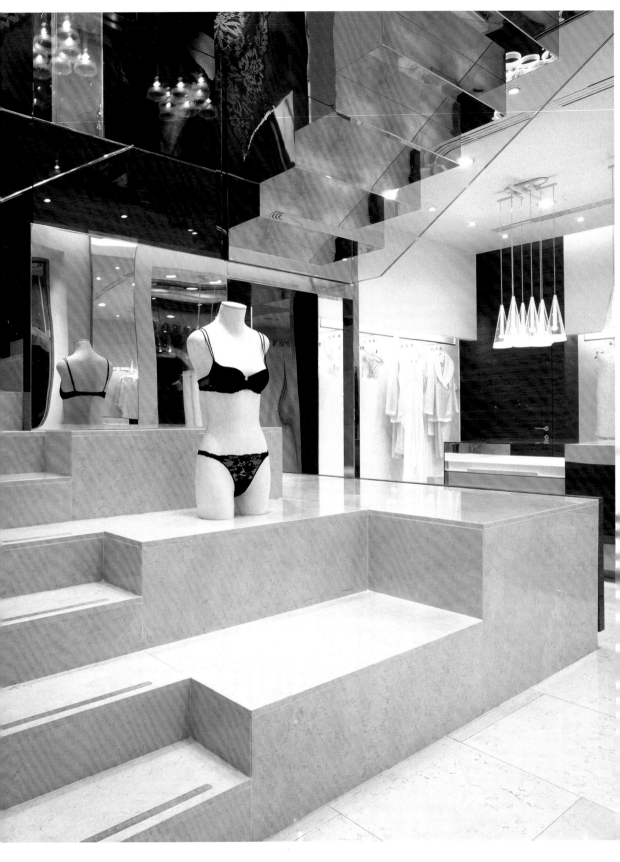

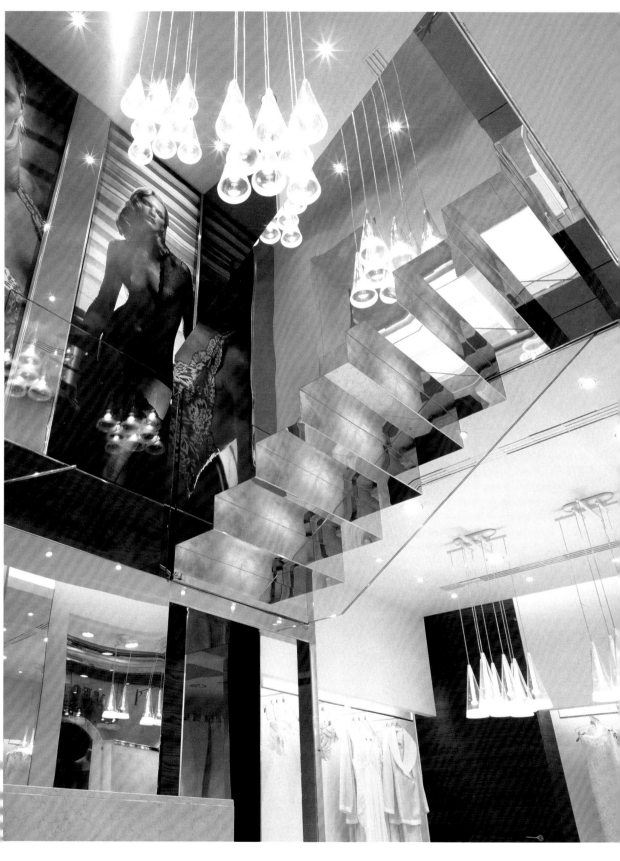

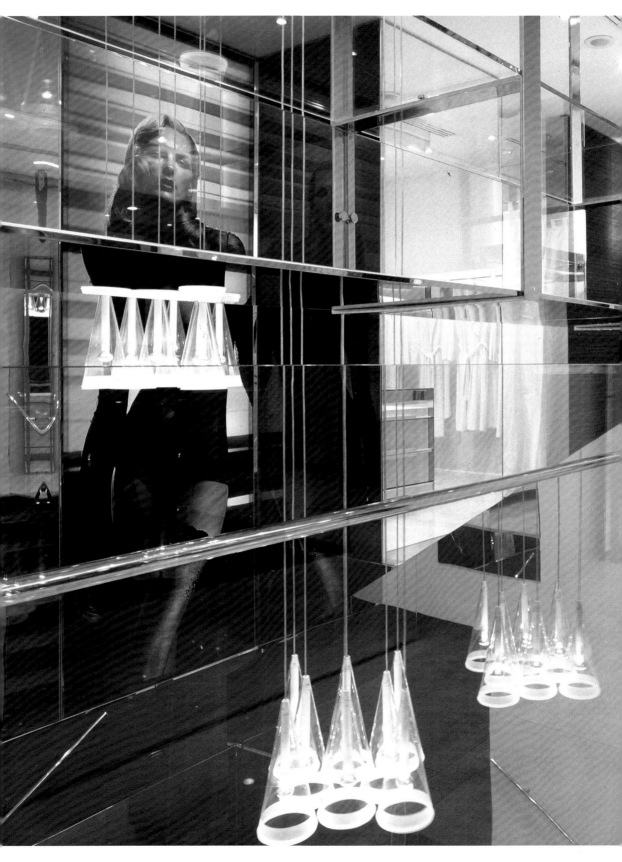

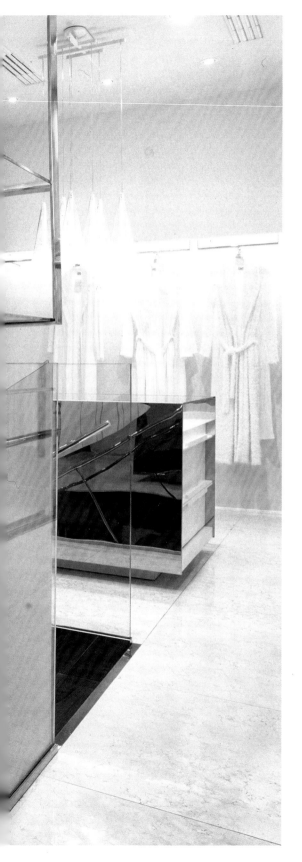

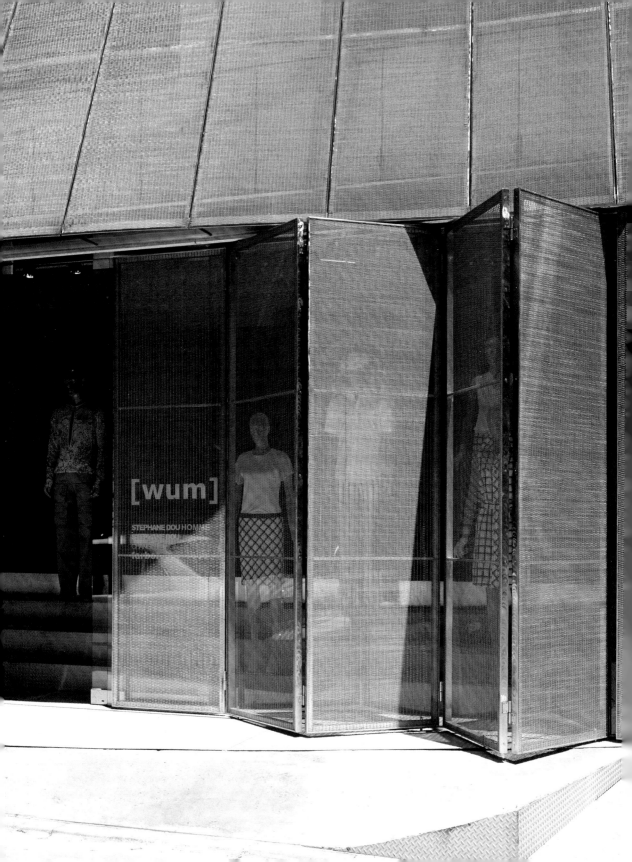

CJ STUDIO| **TAIPEI**
WUM-SHOWROOM
Taipei, Taiwan | 2003

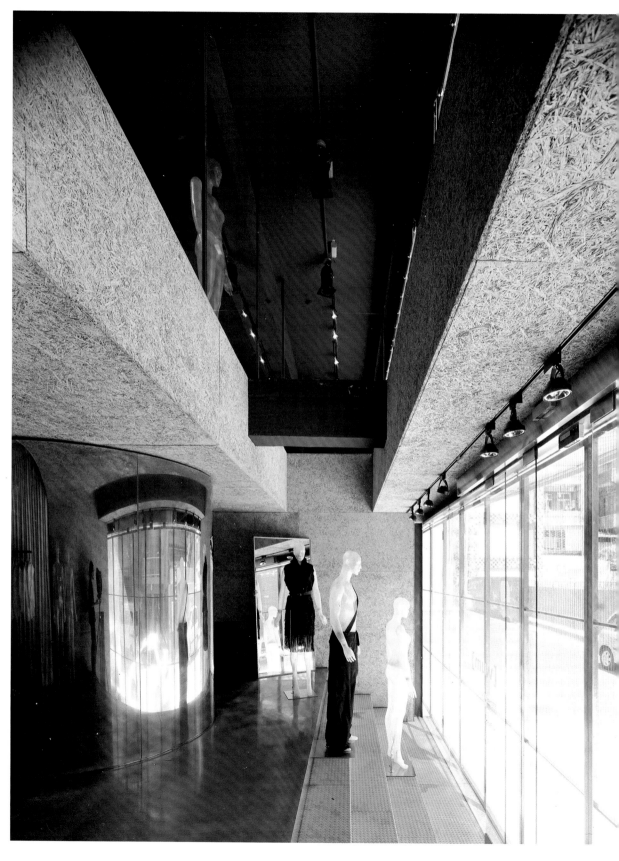

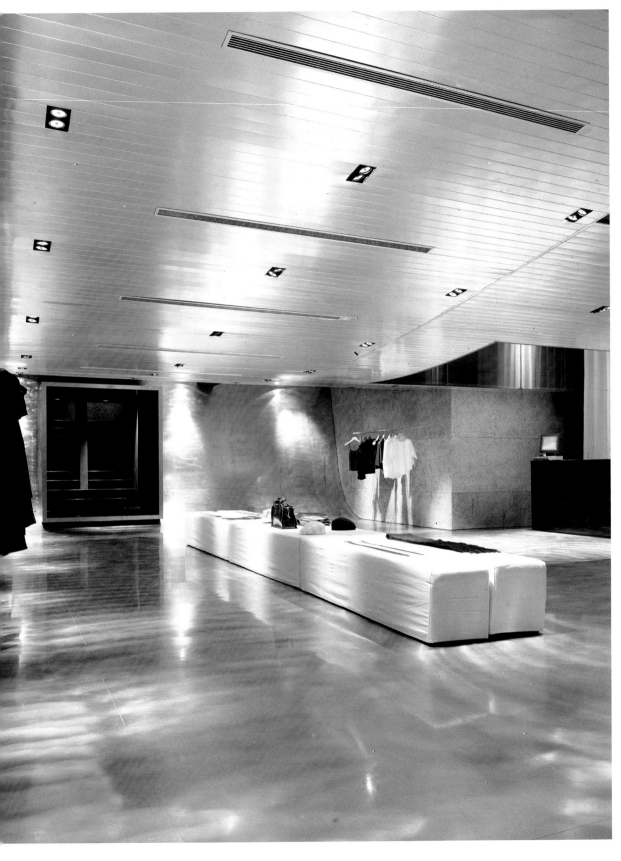

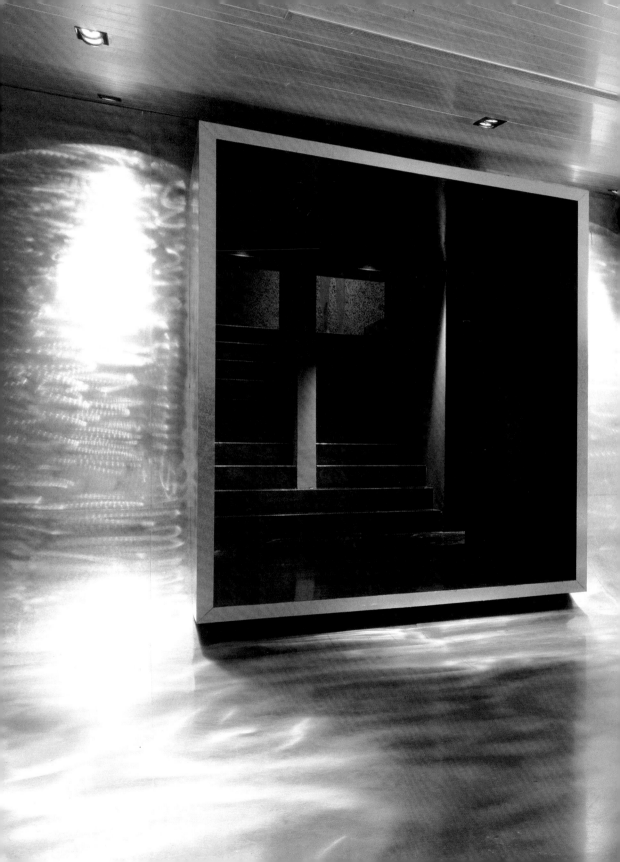

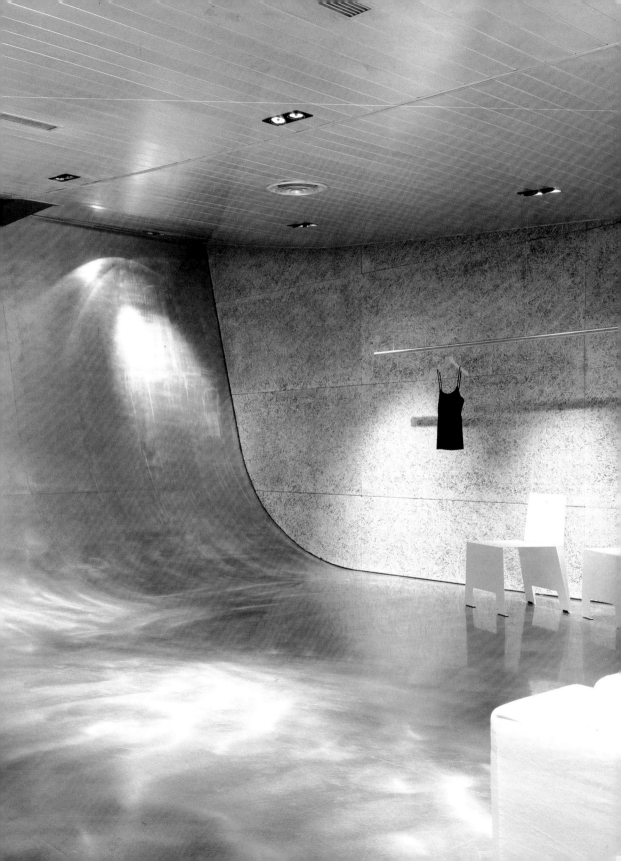

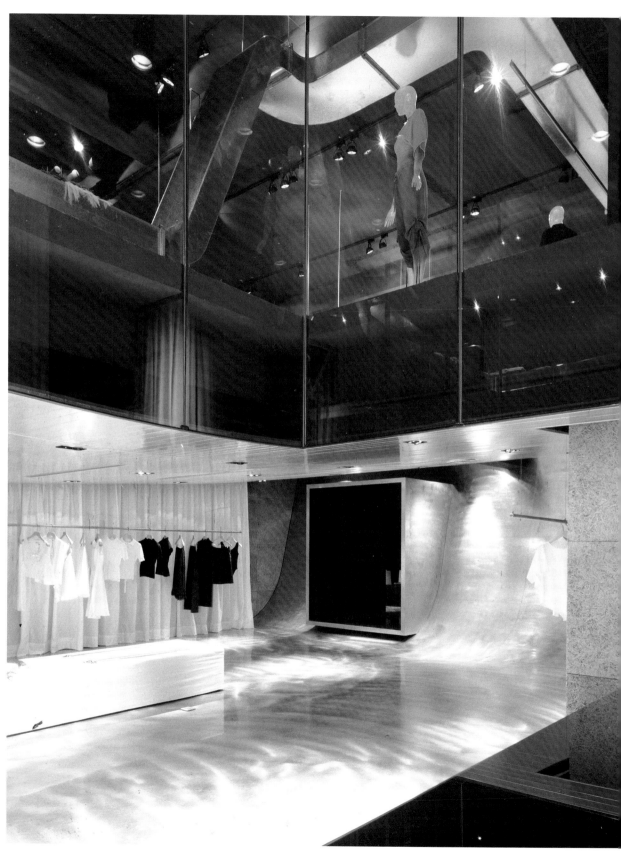

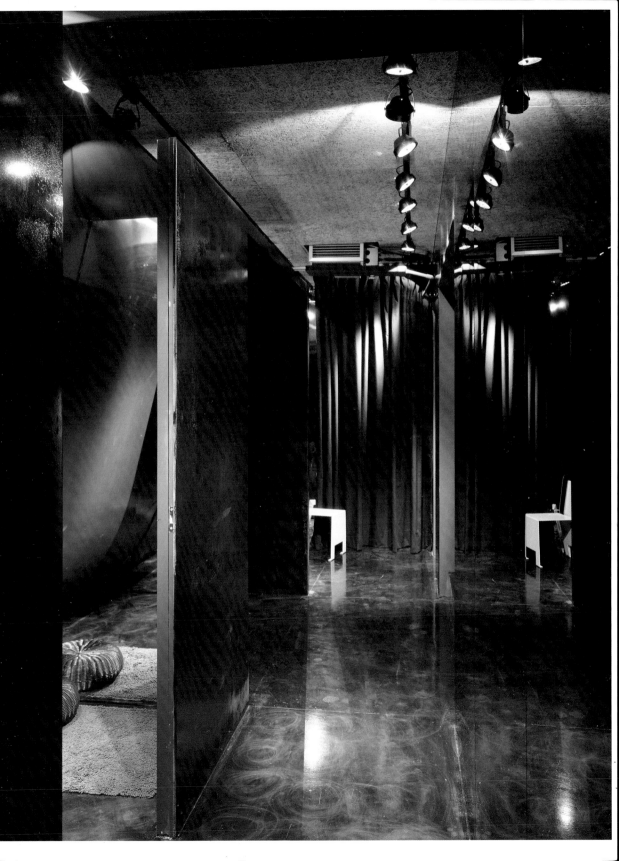

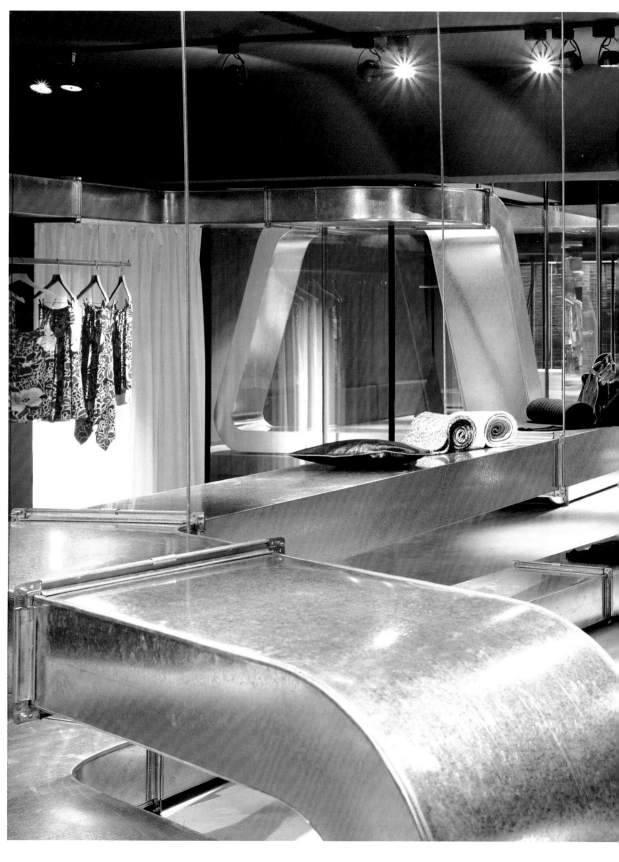

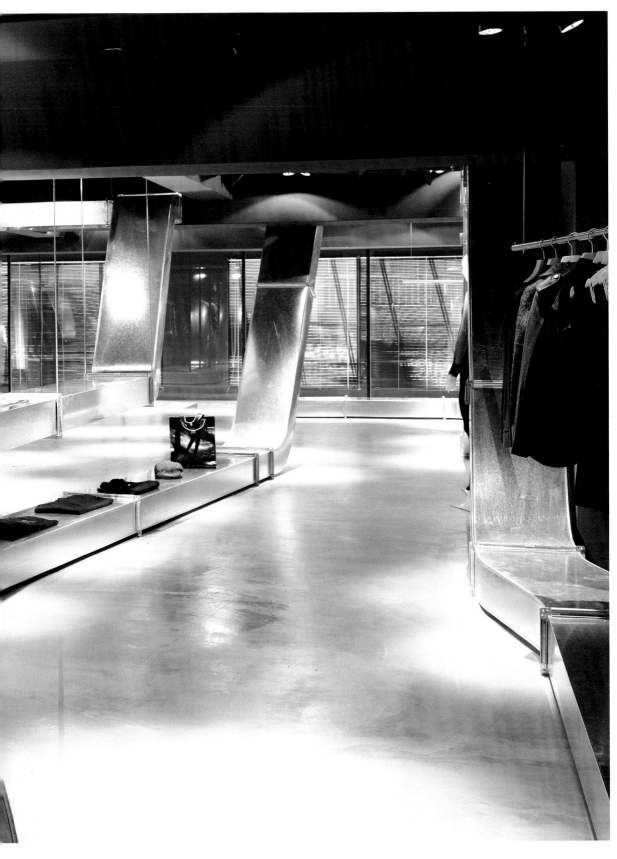

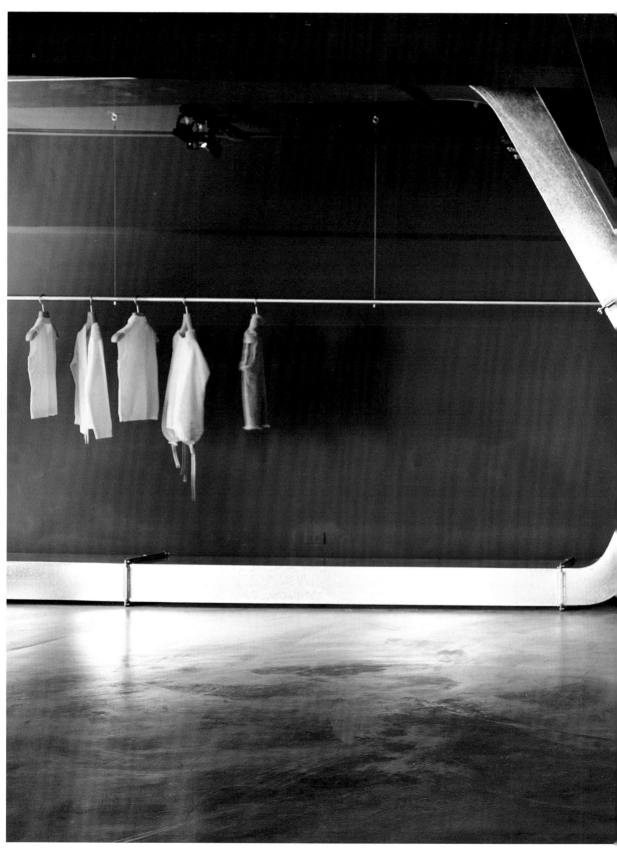

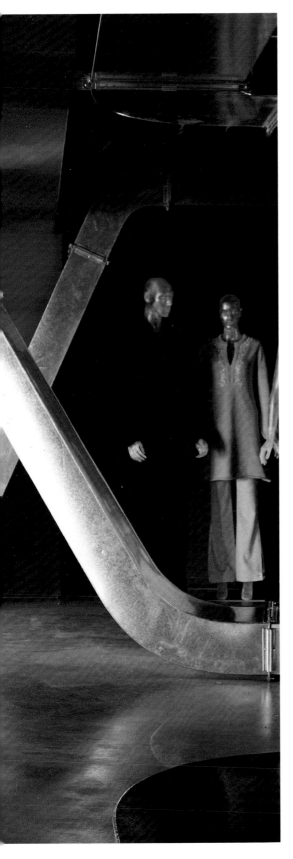

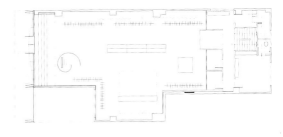

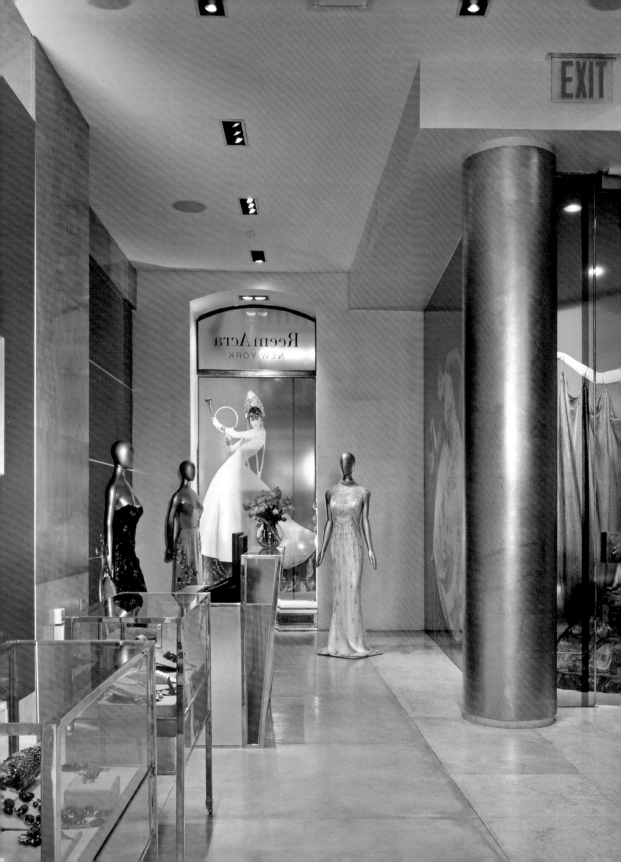

ReemAcra
NEW YORK

EXIT

CHELSEA ATELIER ARCHITECT, PC | NEW YORK

REEM ACRA
New York, USA | 2003

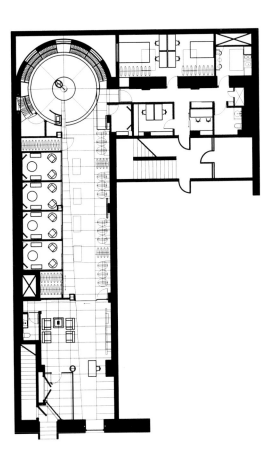

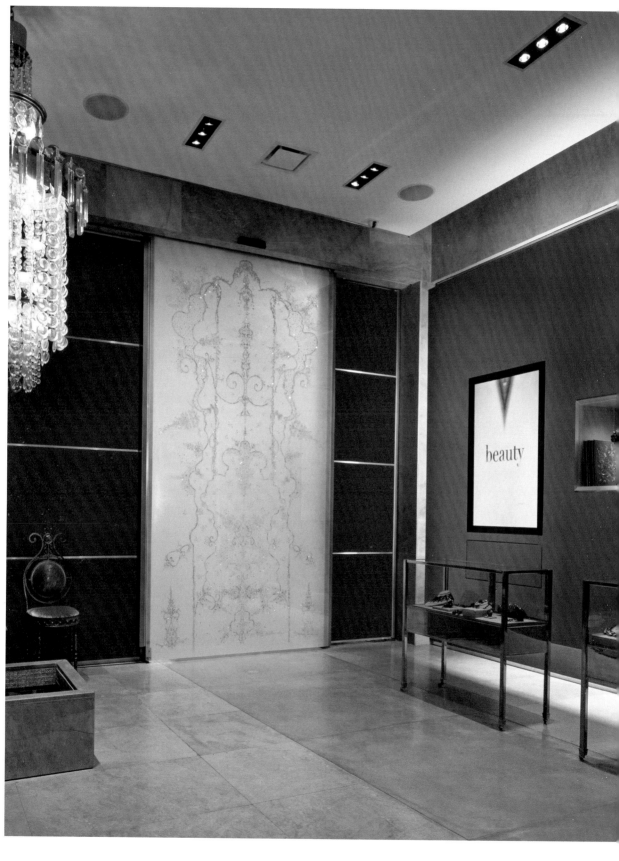

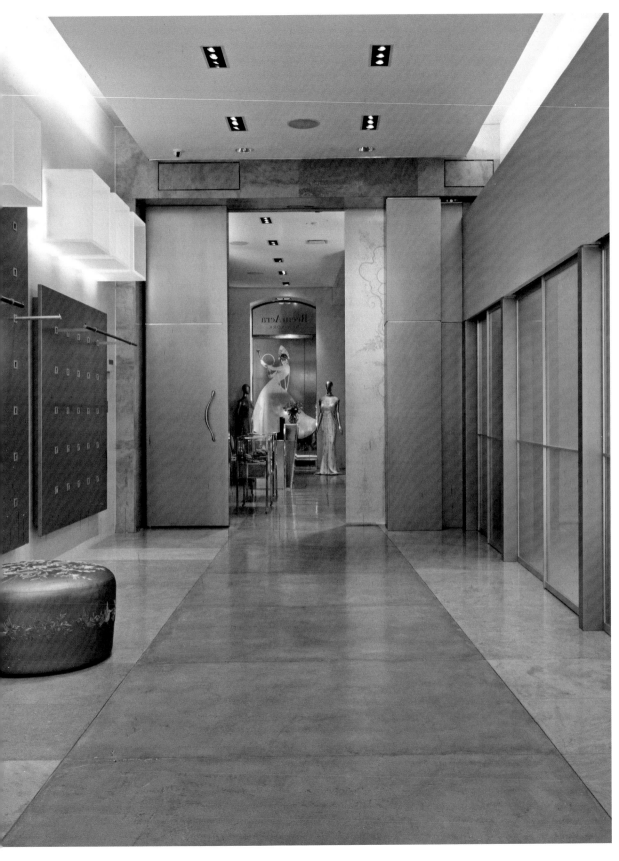

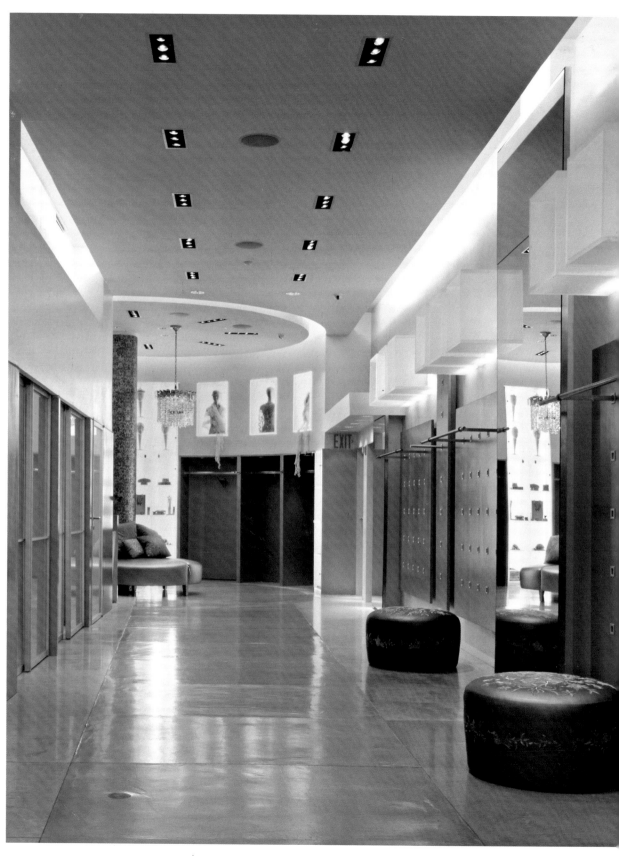

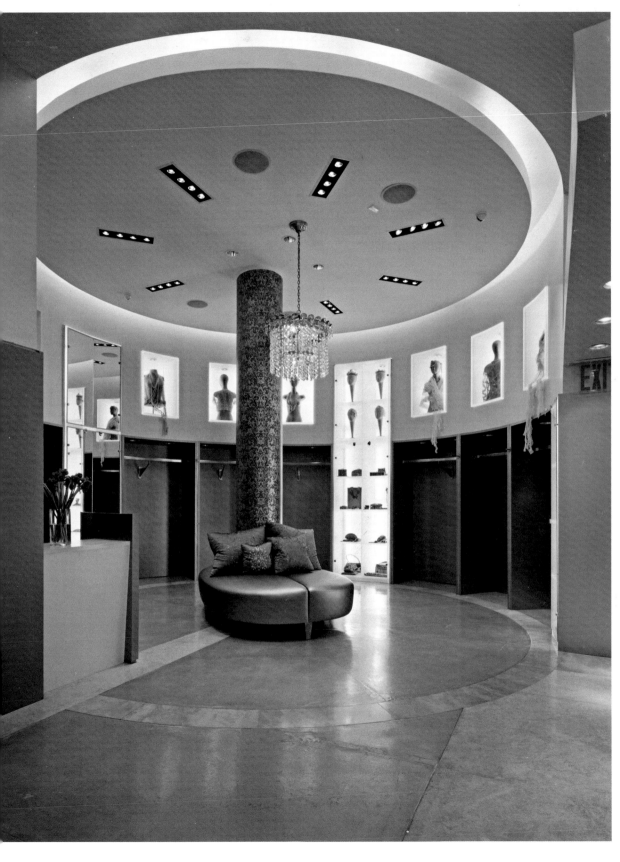

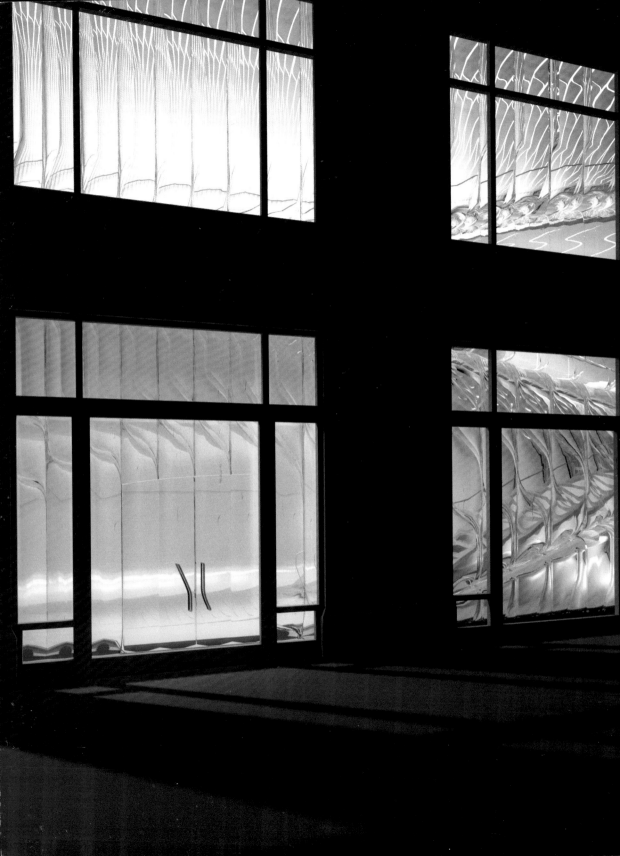

CONTEMPORARY ARCHITECTURE PRACTICE | NEW YORK
REEBOK
Shanghai, China | 2005

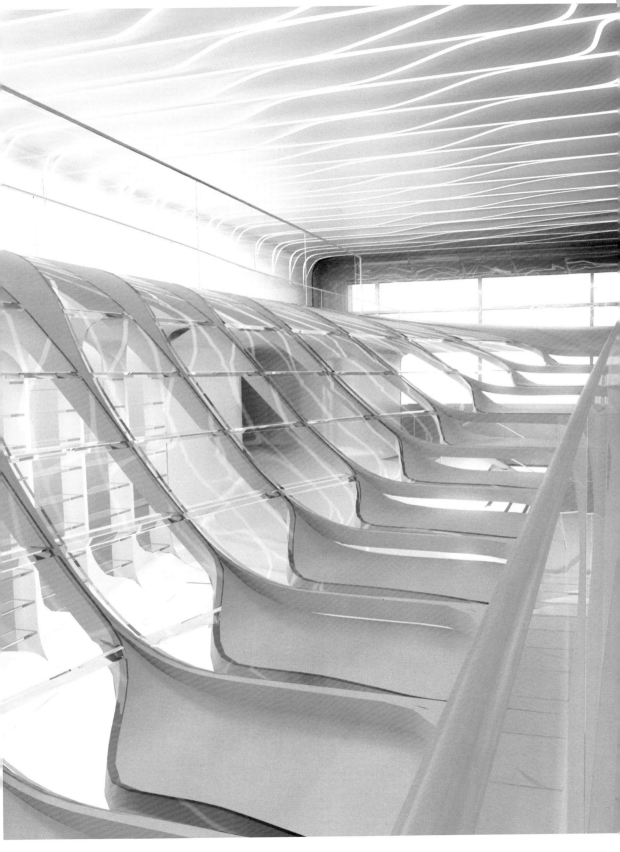

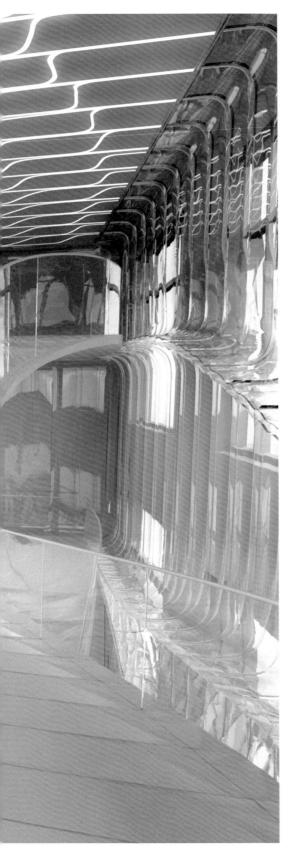

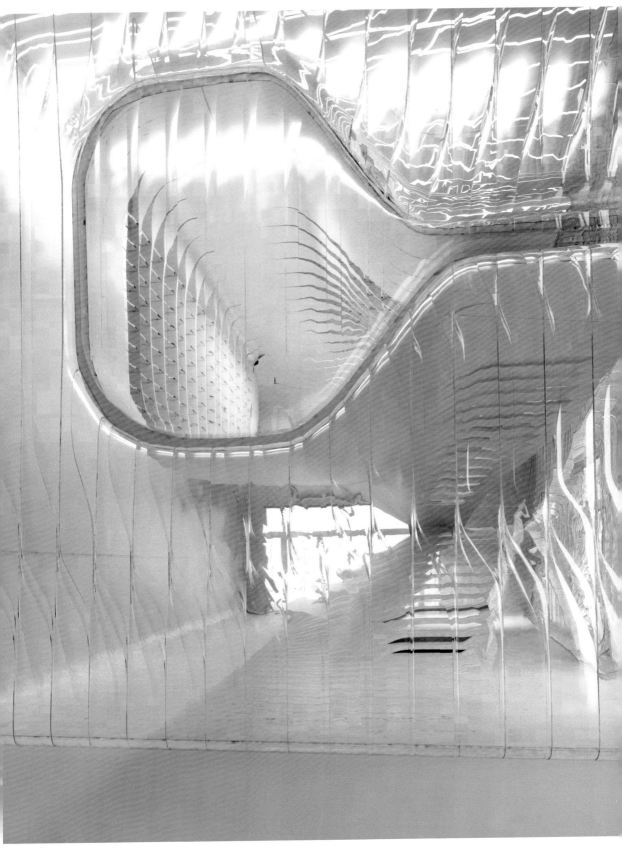

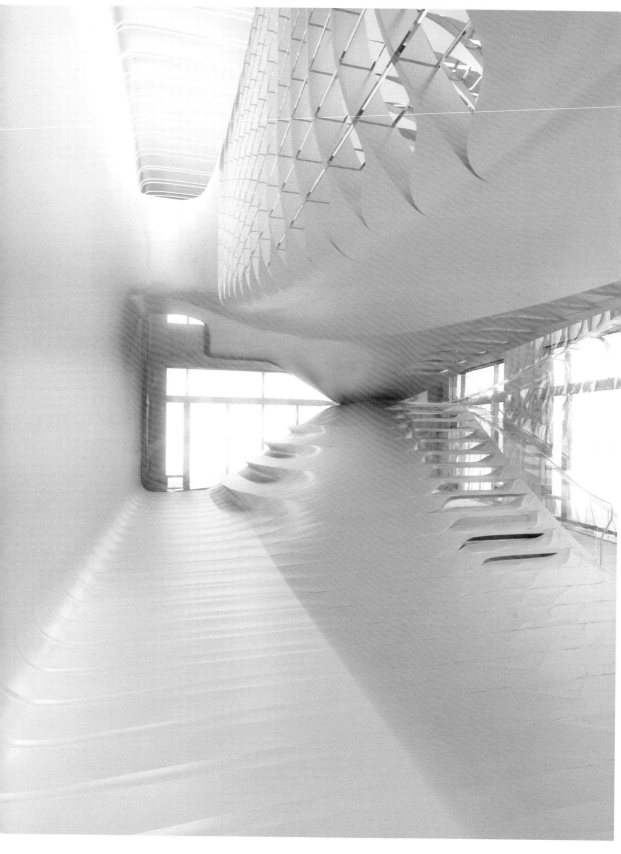

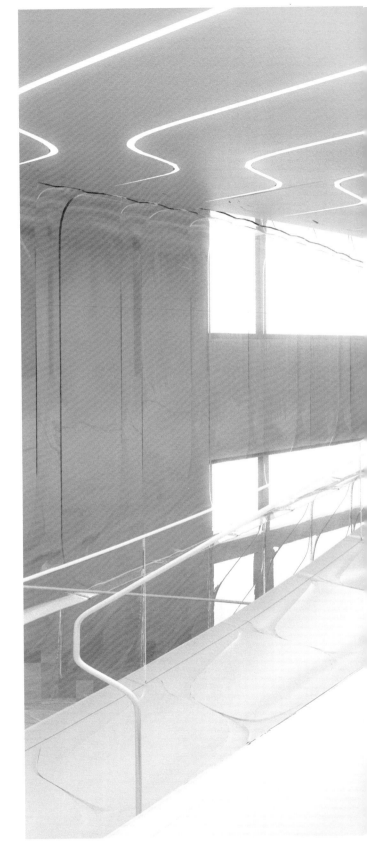

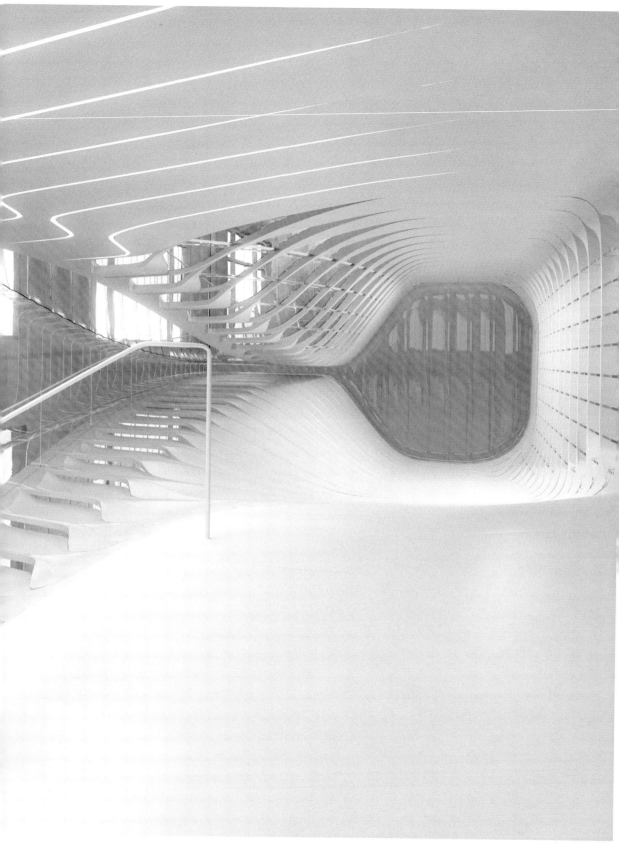

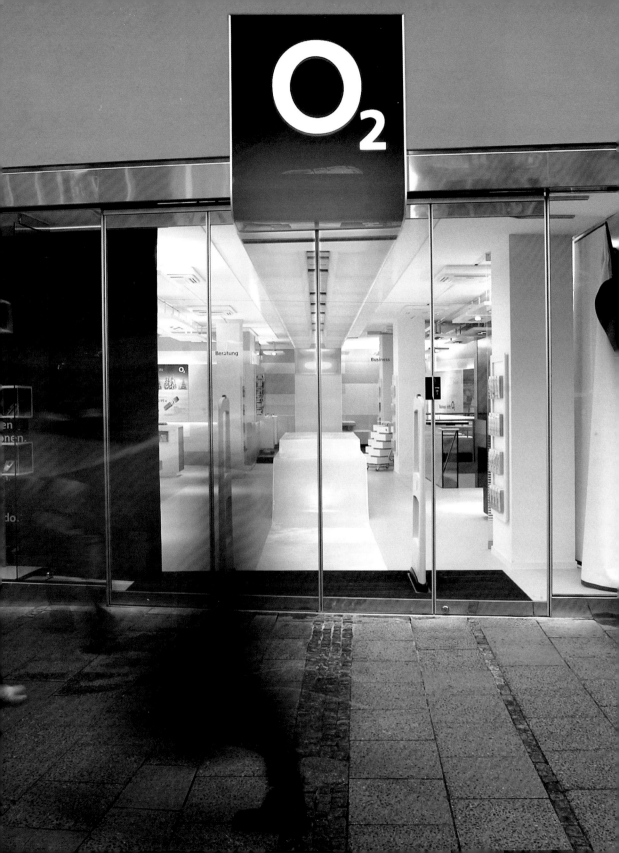

DAN PEARLMAN | BERLIN
O₂ FLAGSHIP STORE
Munich, Germany | 2004

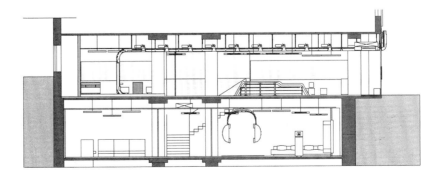

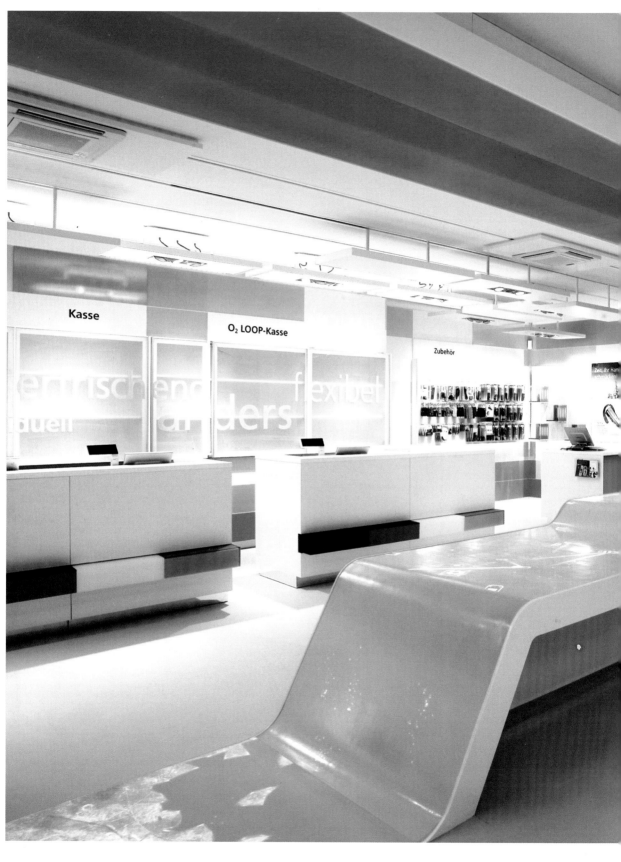

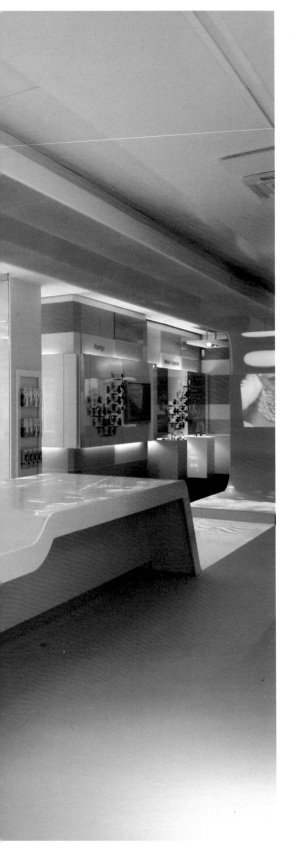

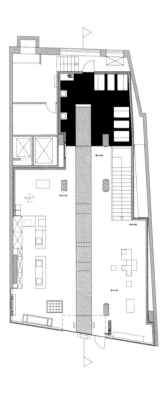

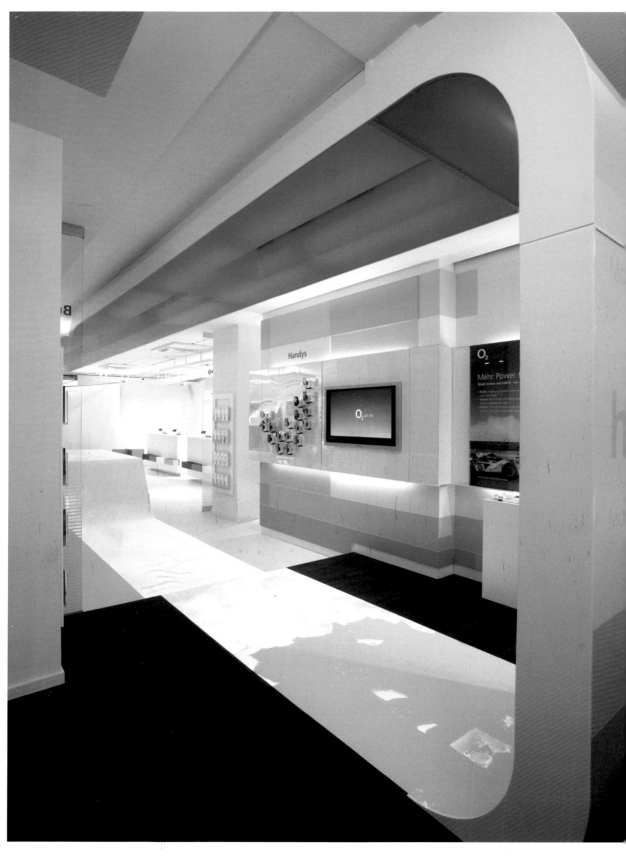

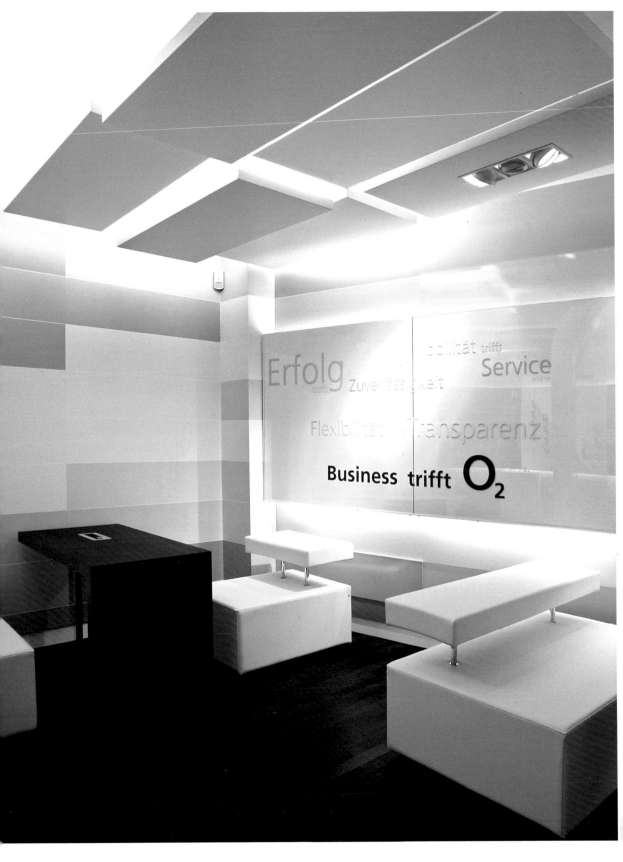

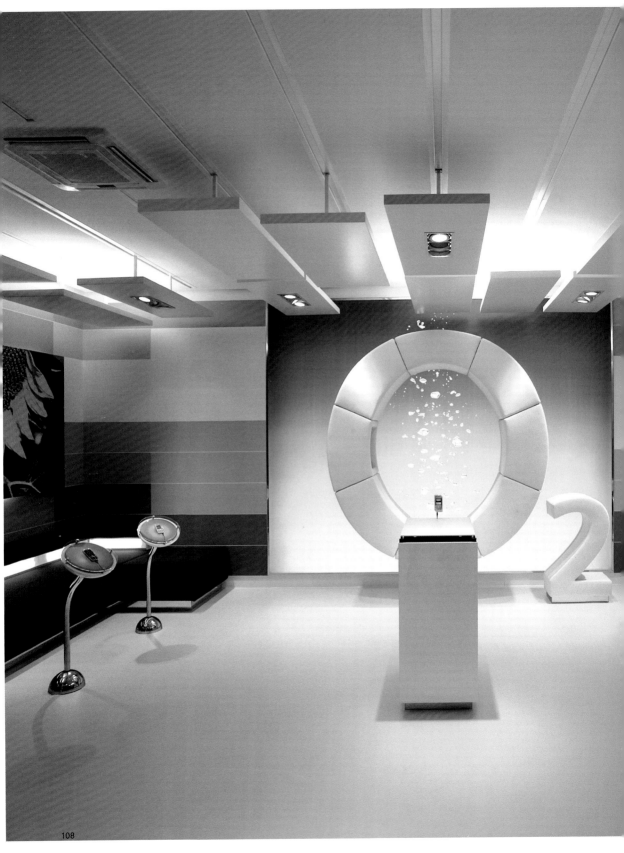

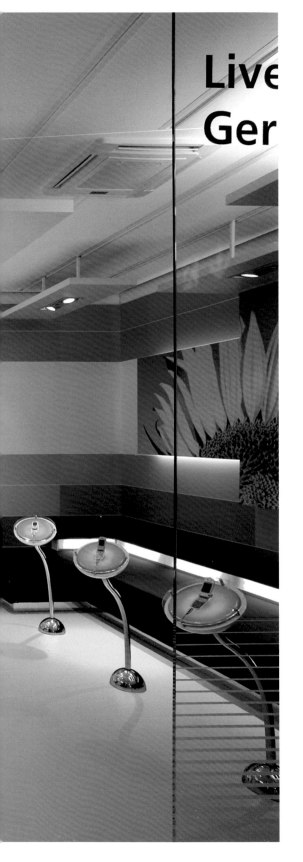

Live
Ger

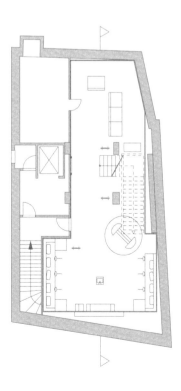

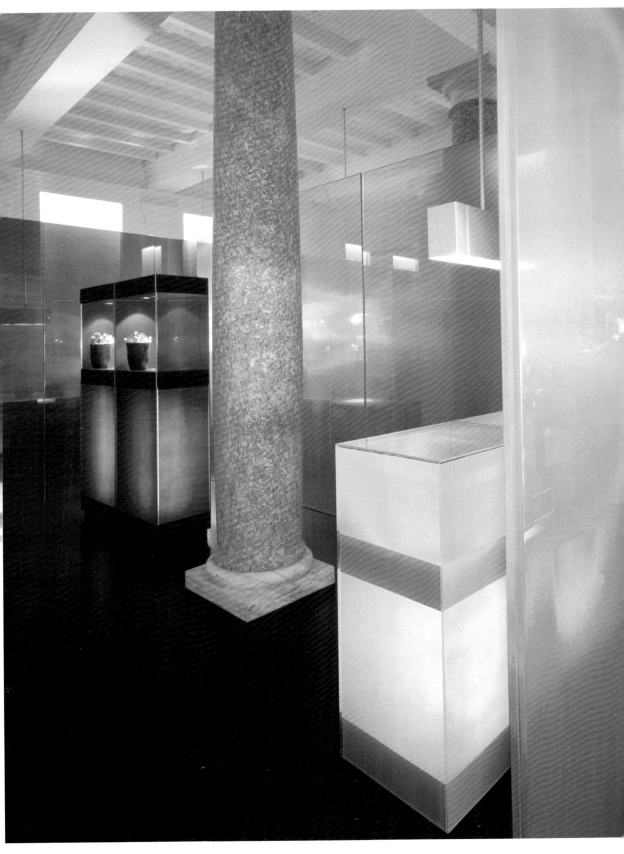

DAVID CHIPPERFIELD ARCHITECTS | LONDON
PASQUALE BRUNI SHOWROOM
Milan, Italy | 2001

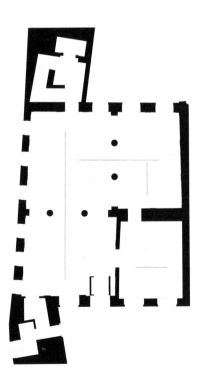

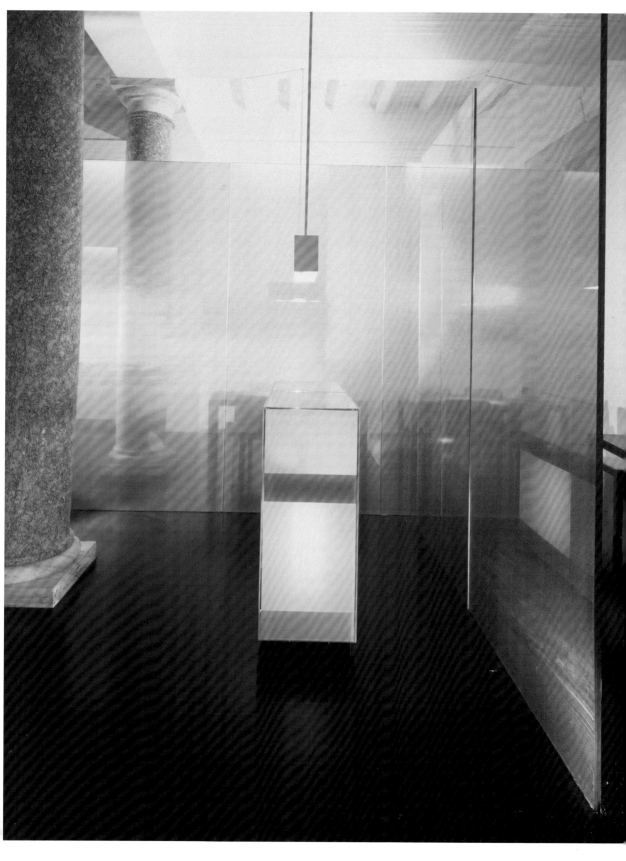

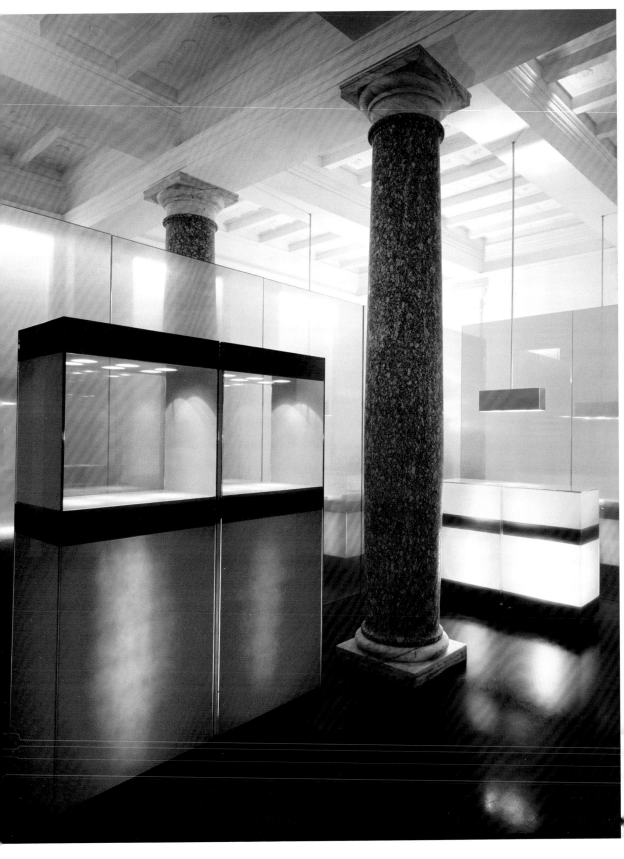

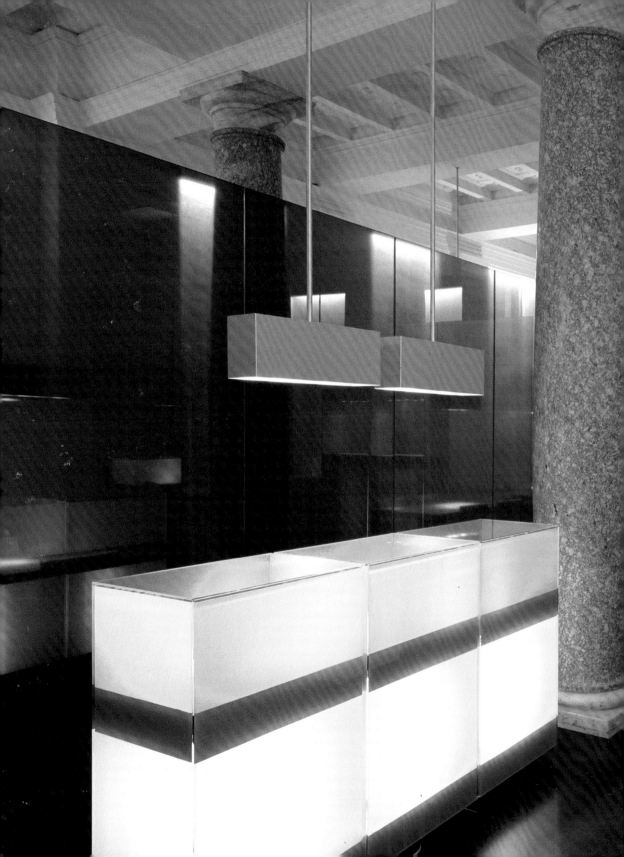

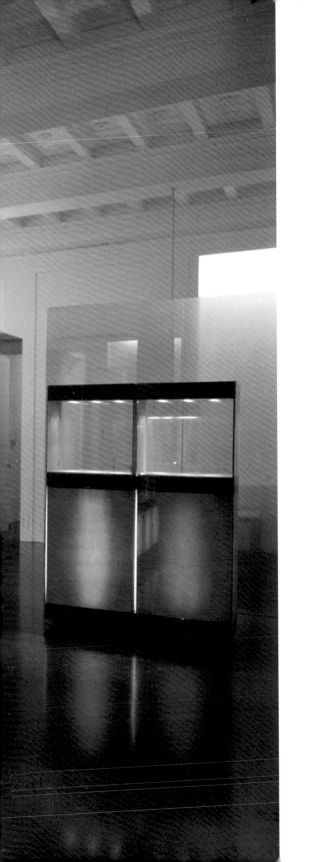

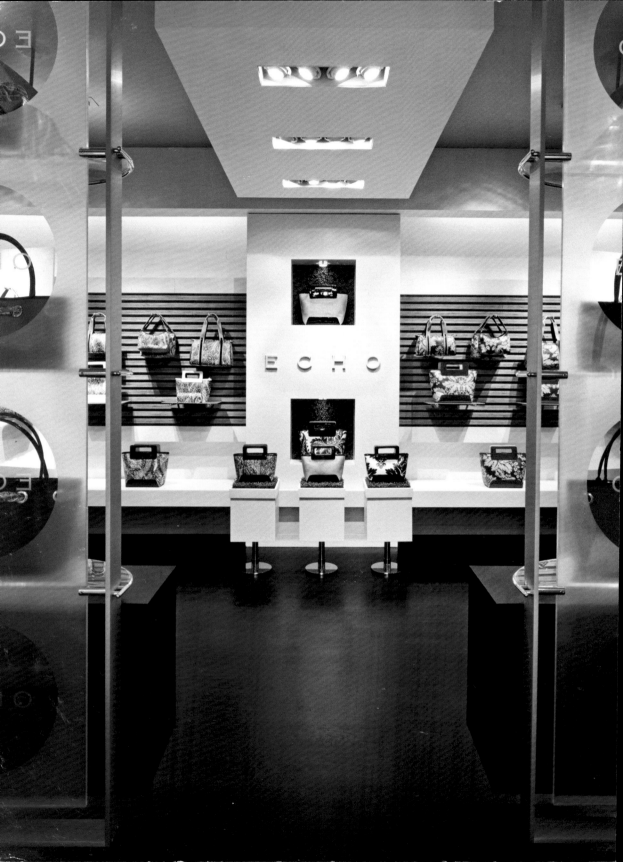

DUAL OFFICE | SAN FRANCISCO
ECHO HANDBAG SHOWROOM
New York, USA | 2004

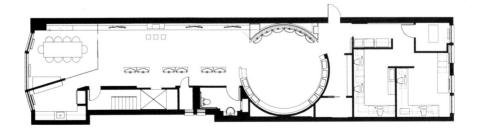

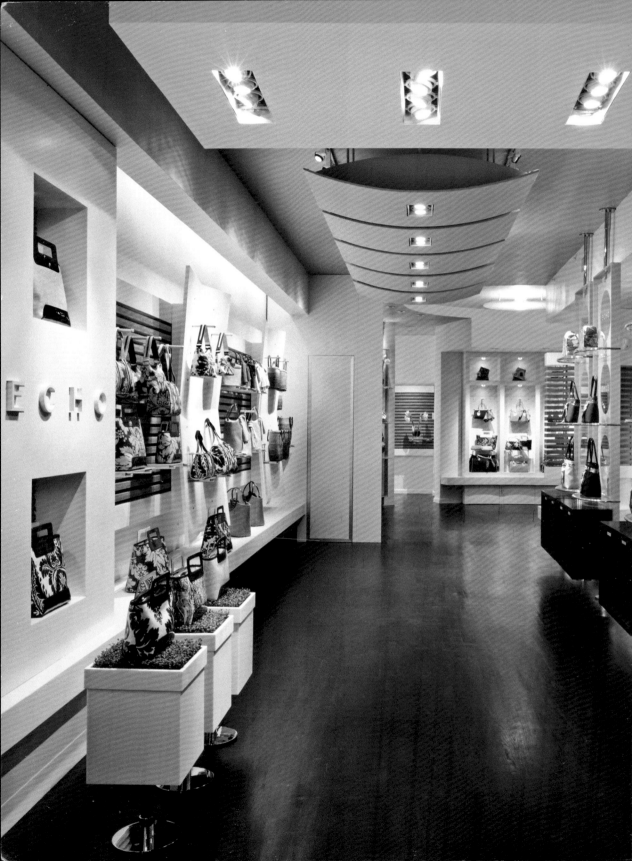

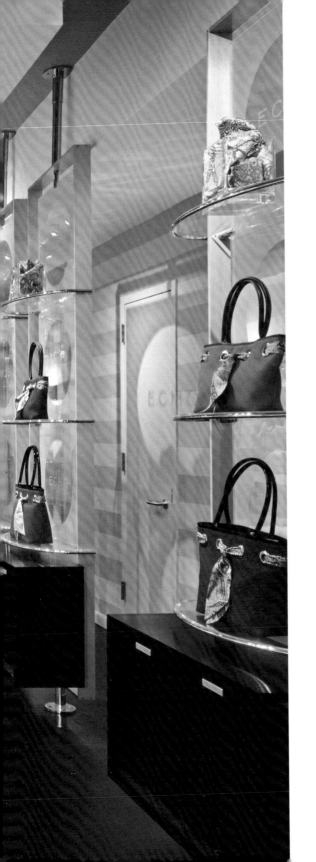

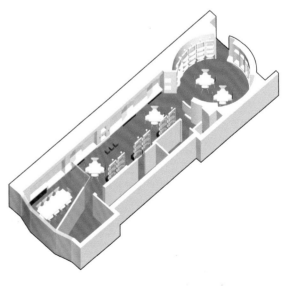

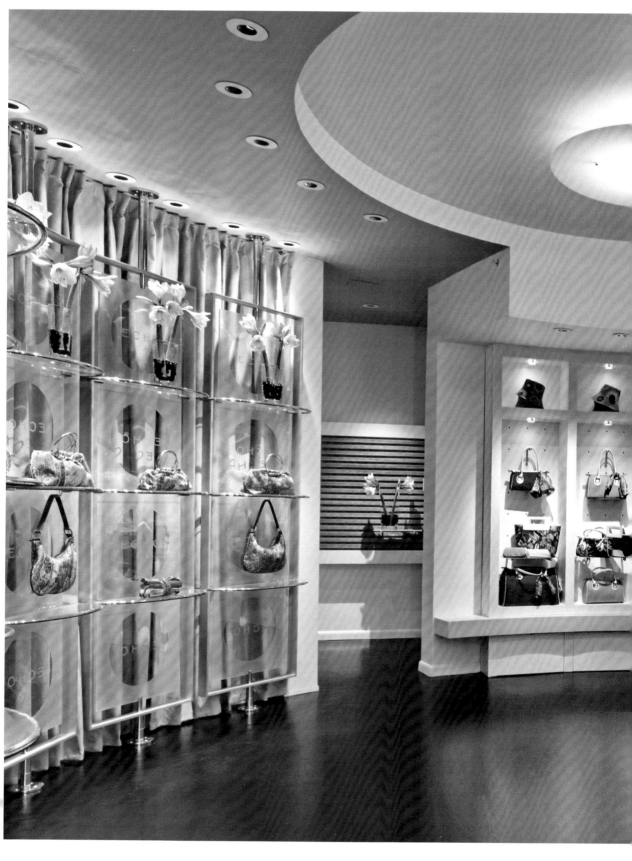

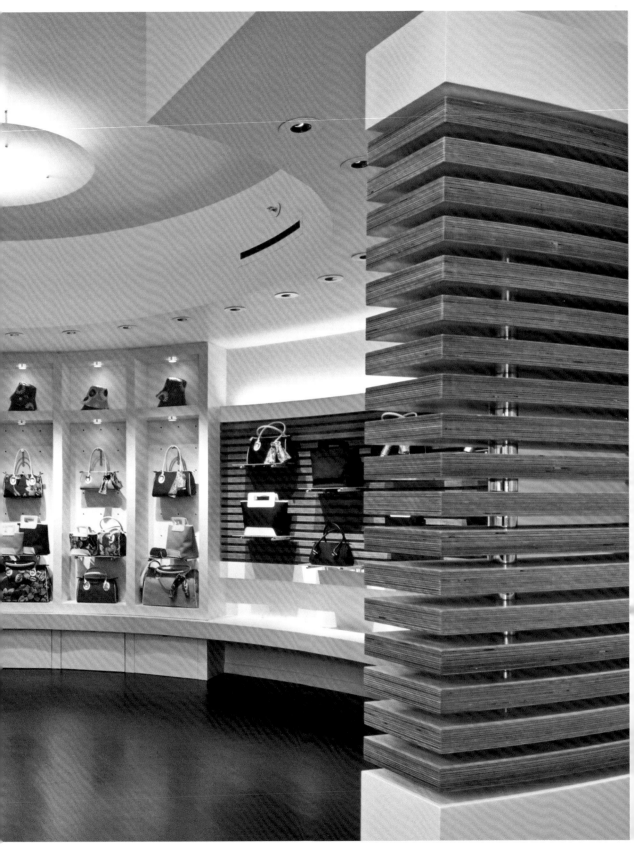

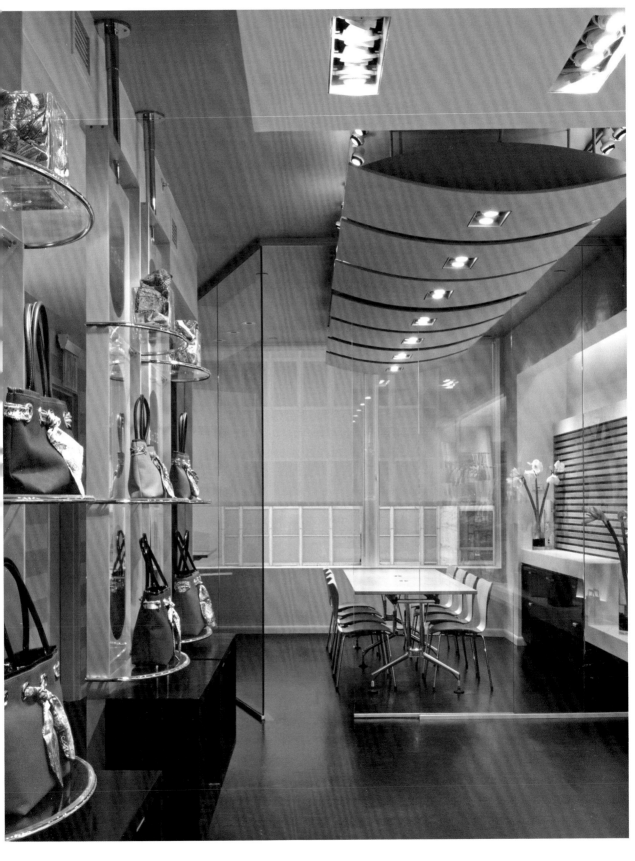

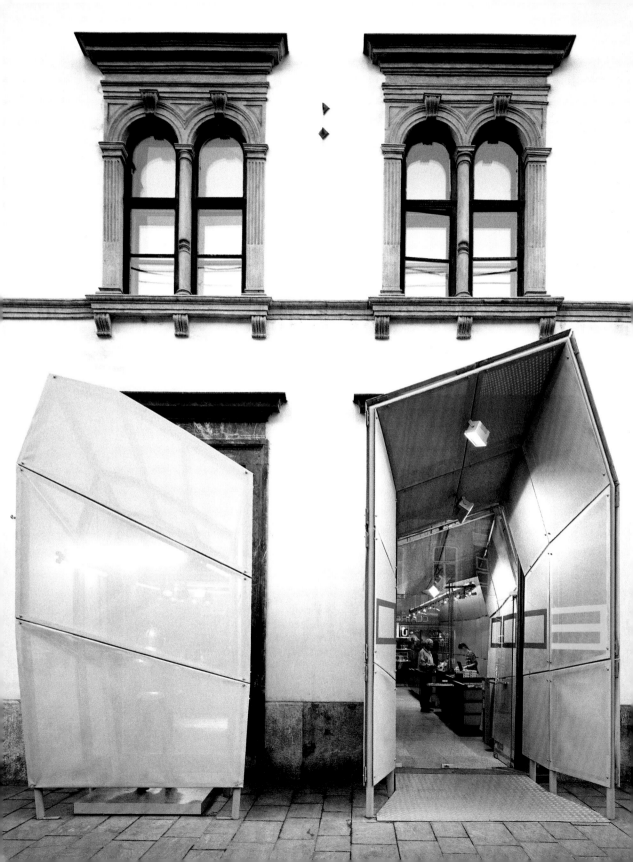

EOK – EICHINGER ODER KNECHTL | VIENNA
SHOP GRAZ
Vienna, Austria | 2003

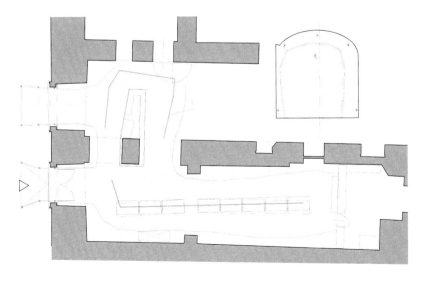

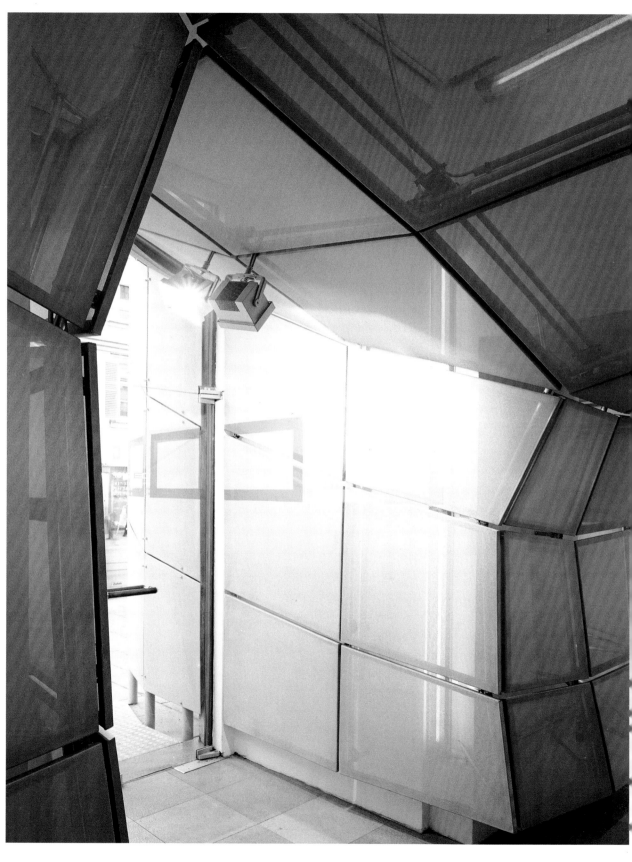

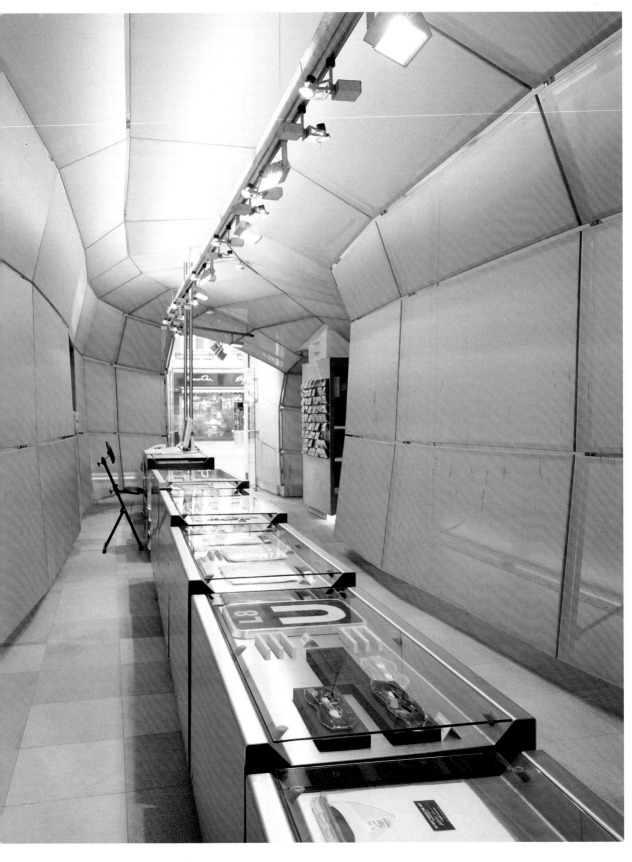

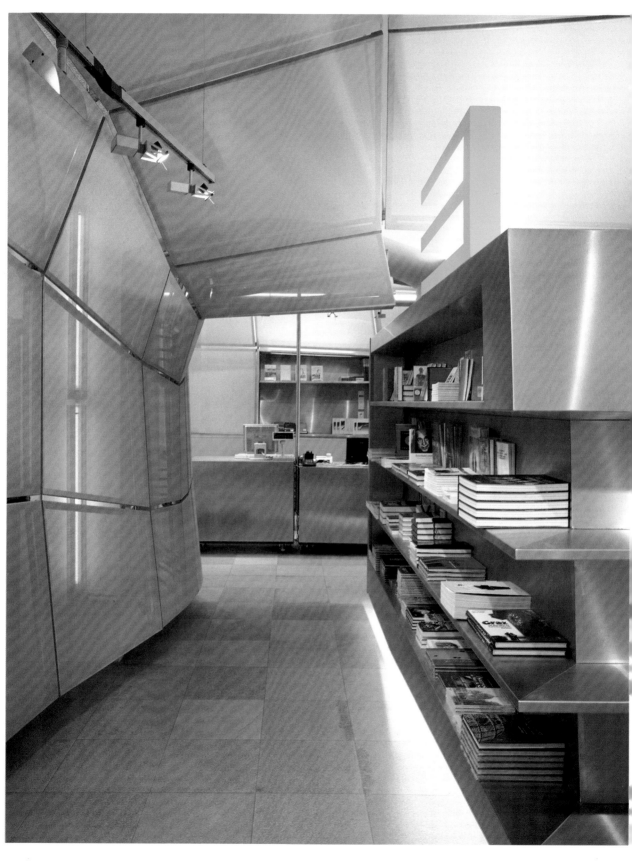

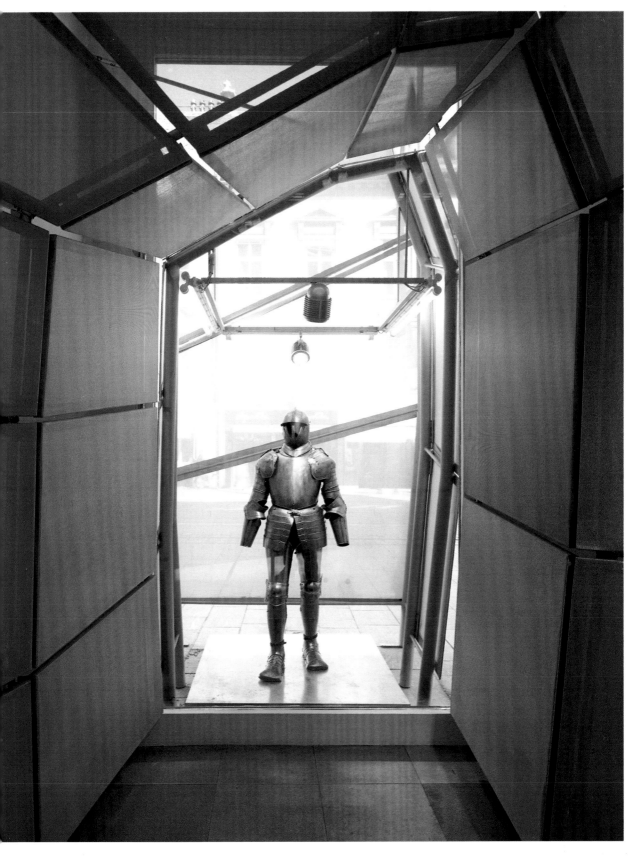

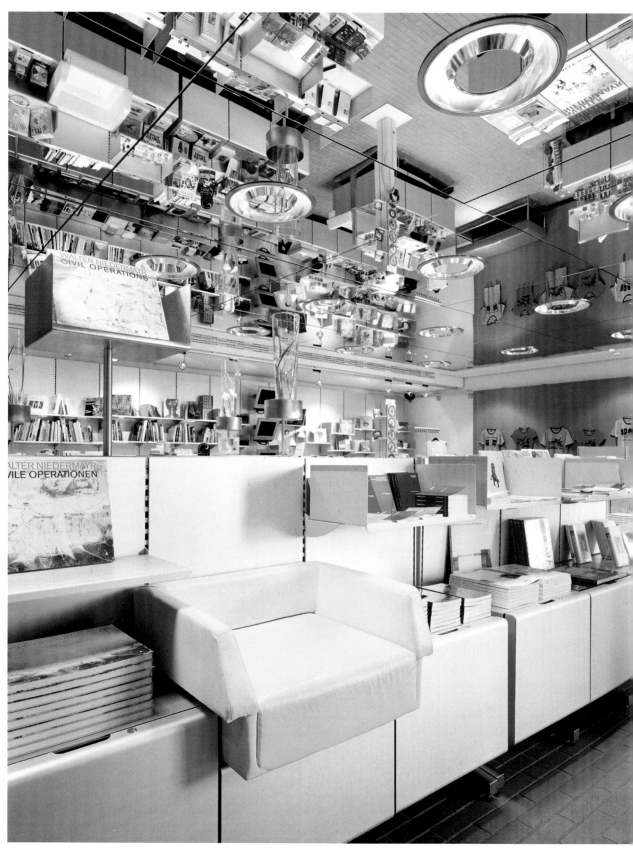

EOK – EICHINGER ODER KNECHTL | VIENNA
SHOP MQ
Vienna, Austria | 2004

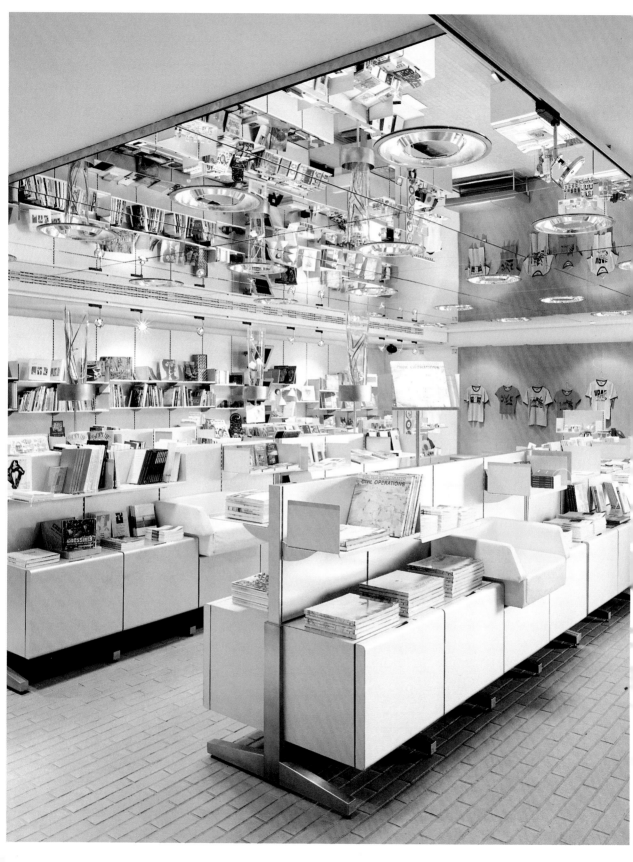

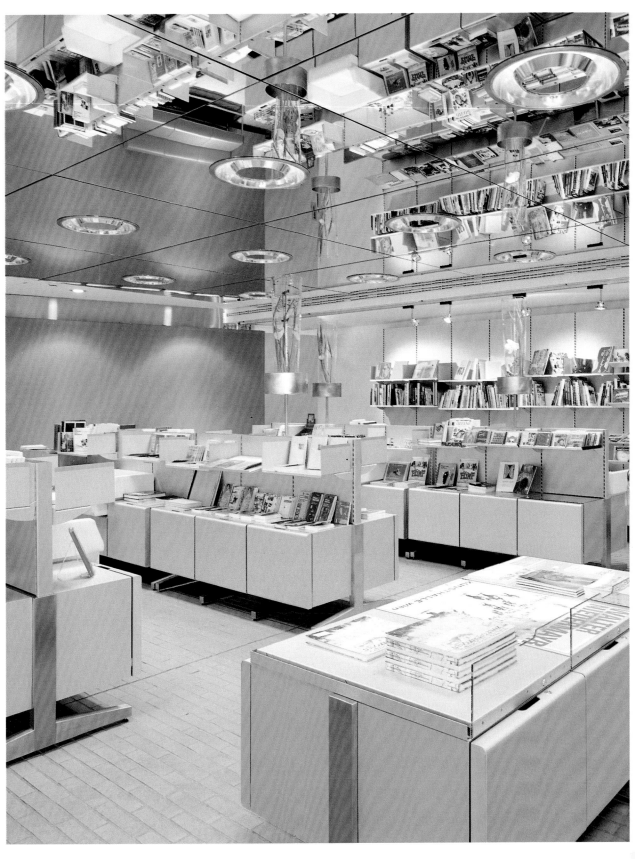

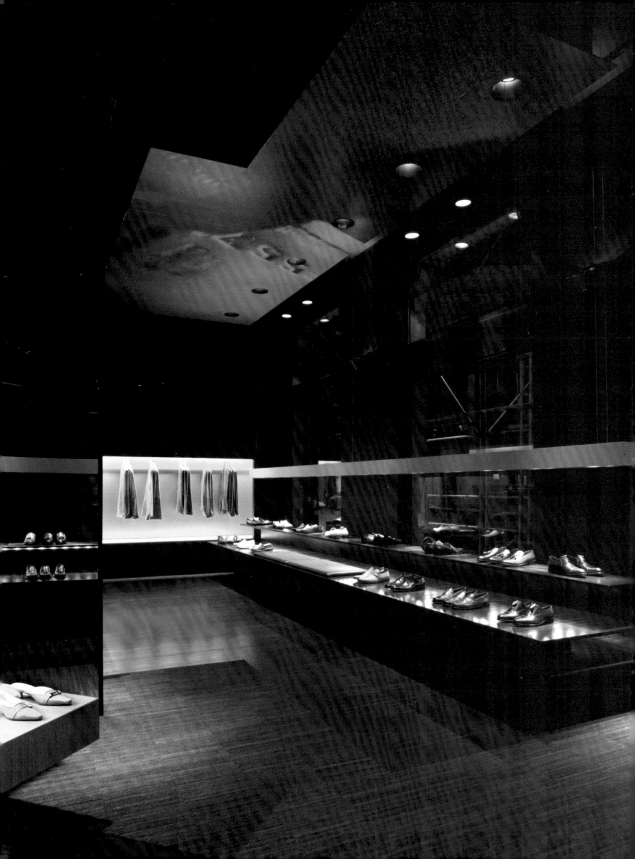

FORTEZA CARBONELL ASSOCIATS | BARCELONA
LOTTUSSE
Barcelona, Spain | 2004

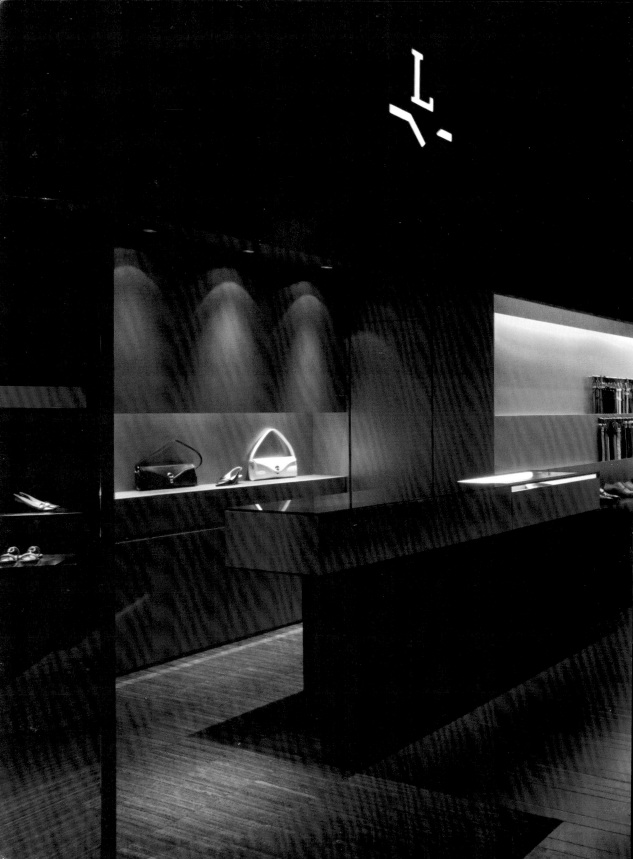

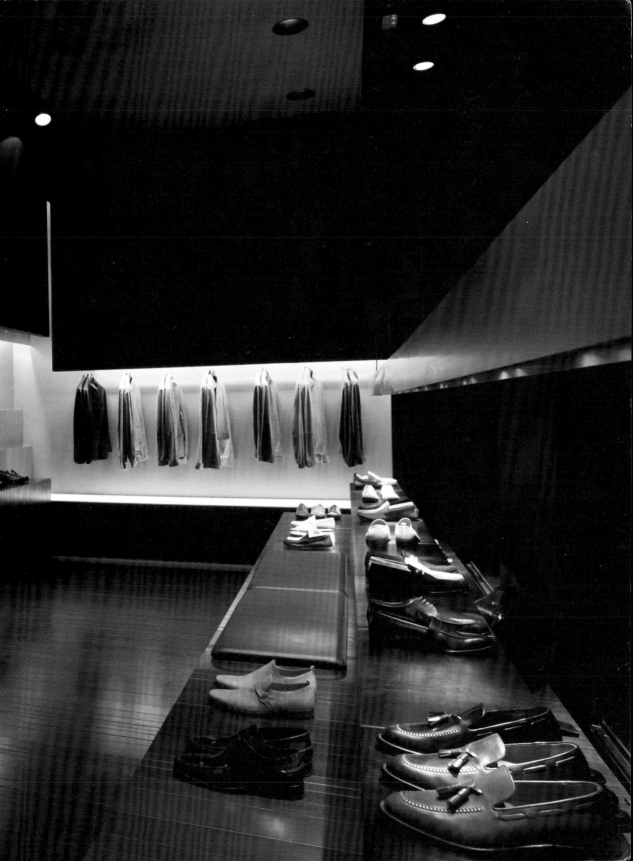

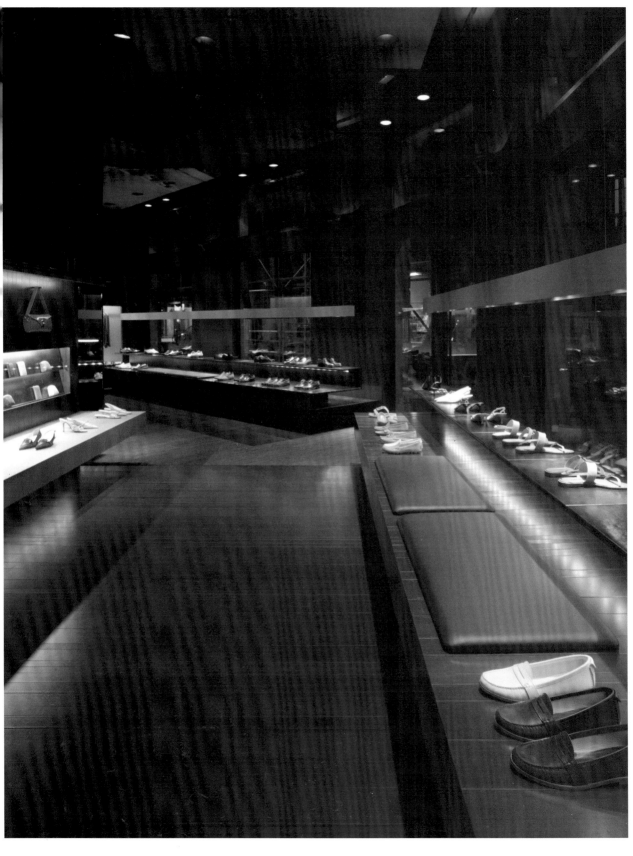

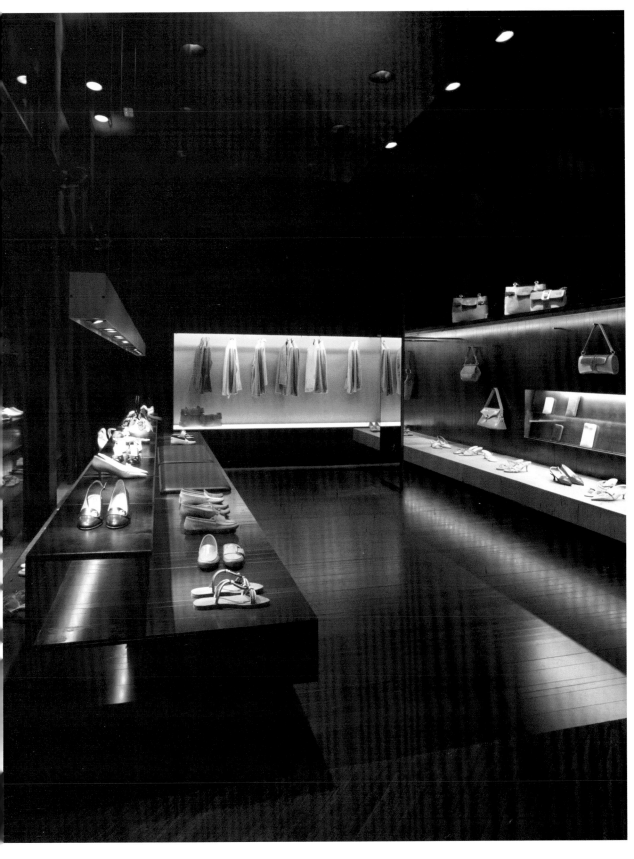

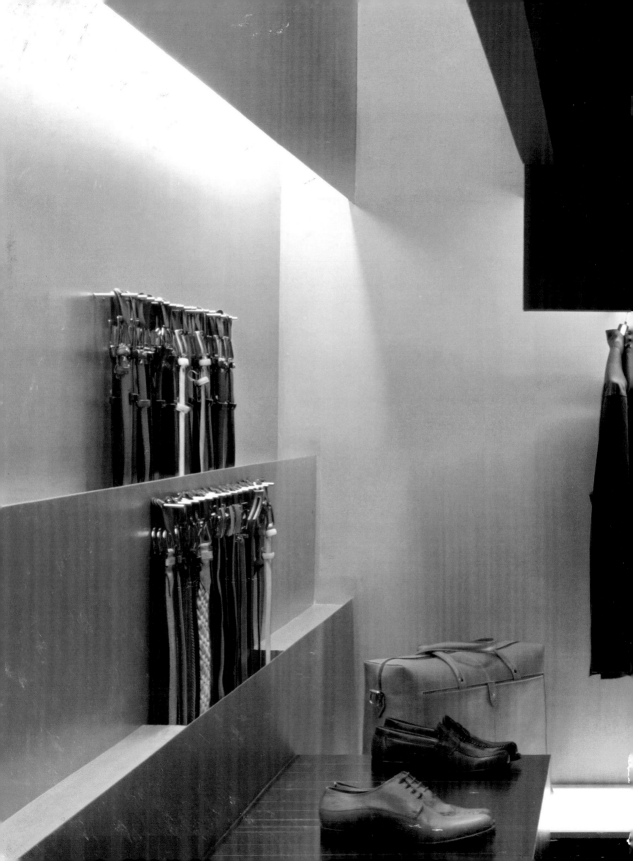

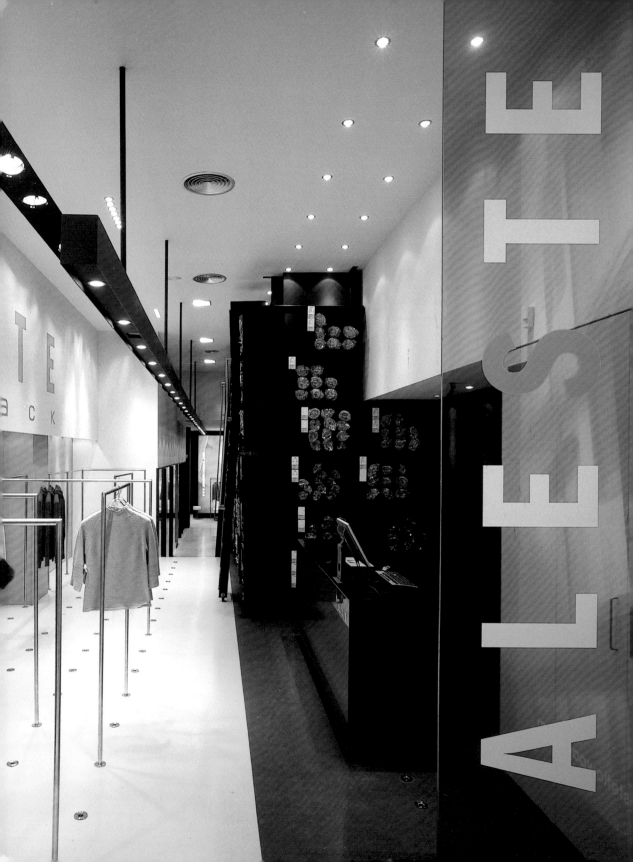

FRANCESC RIFÉ | BARCELONA

ALESTE FLOWPACK
Barcelona, Spain | 2003

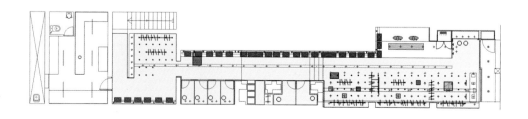

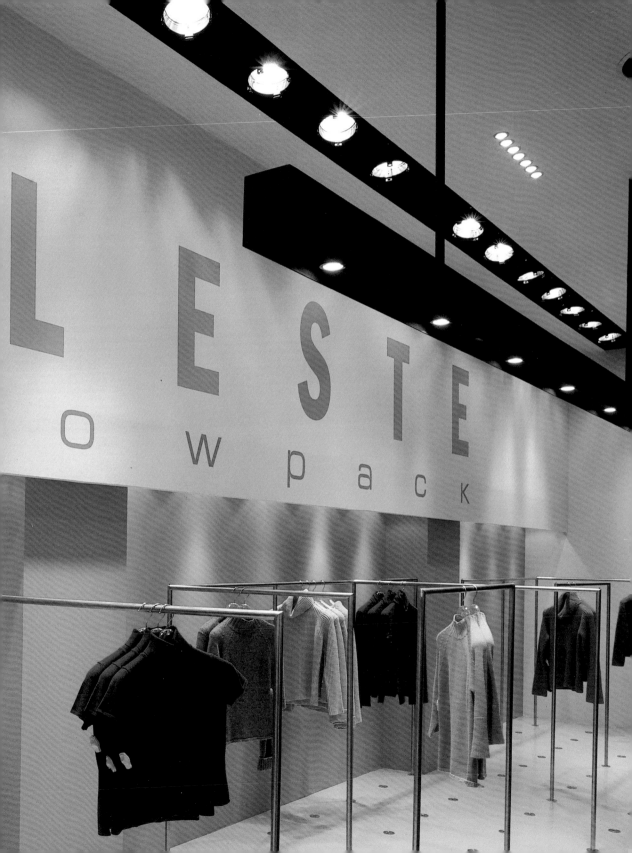

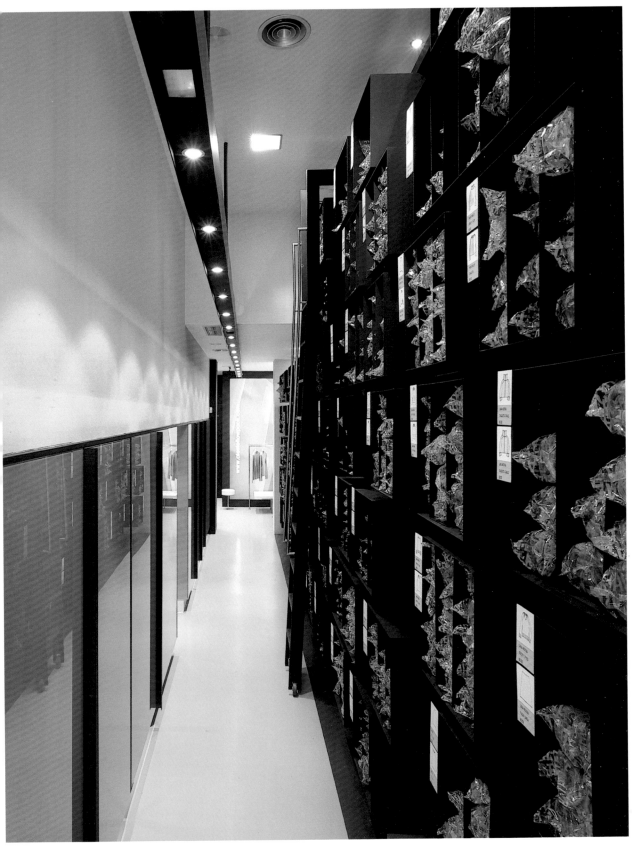

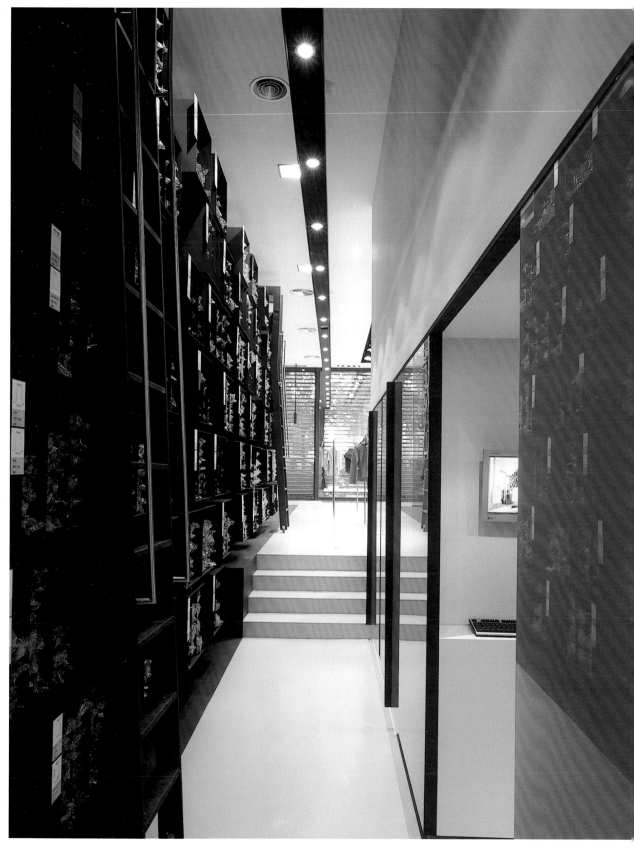

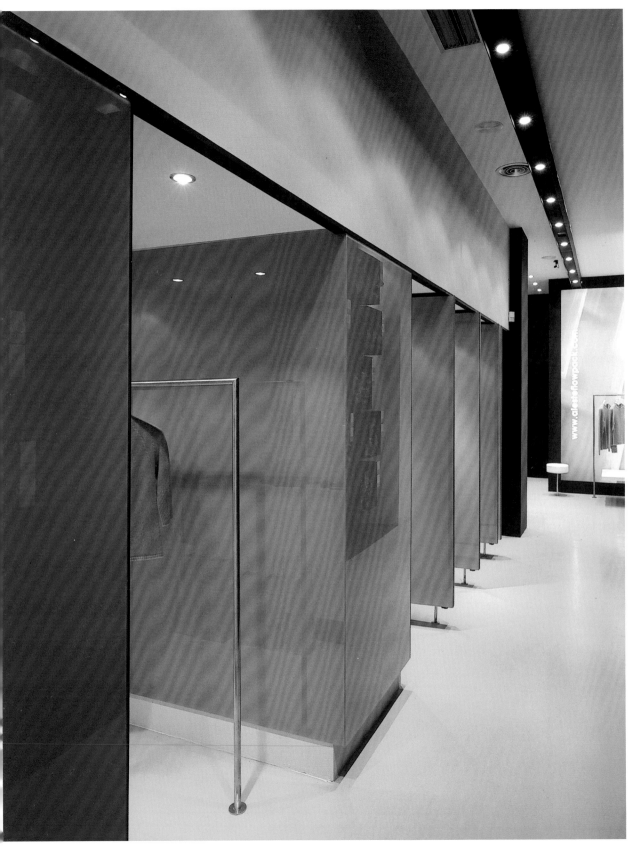

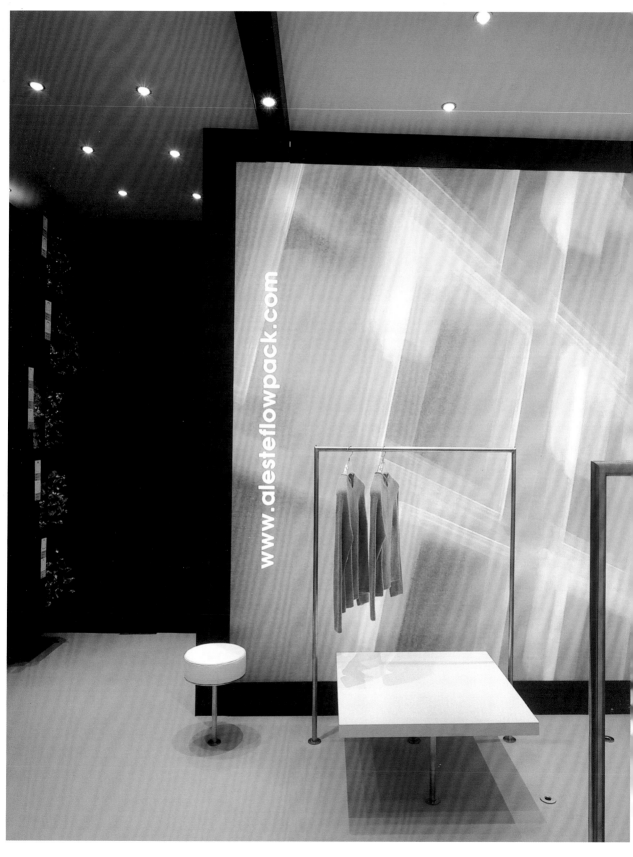

www.alesteflowpack.com

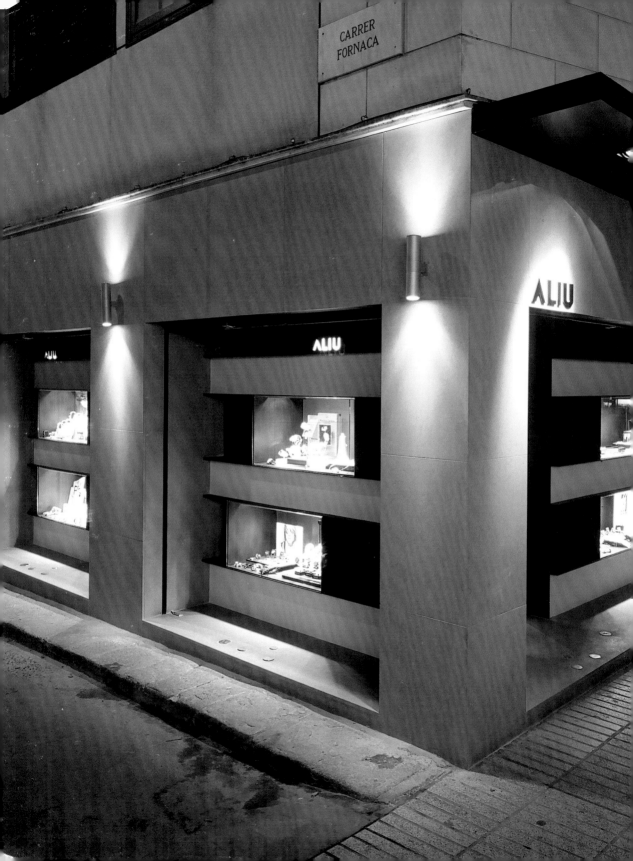

FRANCESC RIFÉ | BARCELONA
ALIU
Barcelona, Spain | 2003

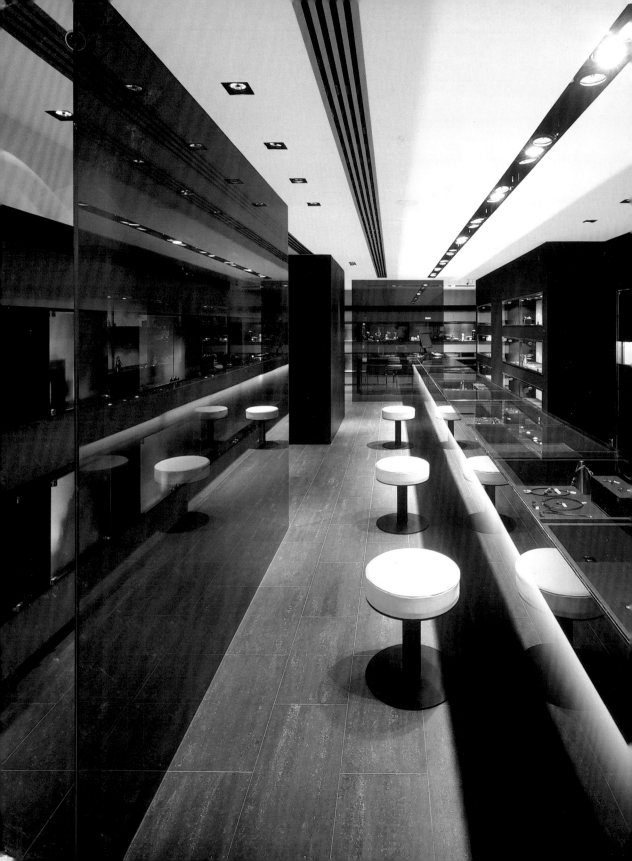

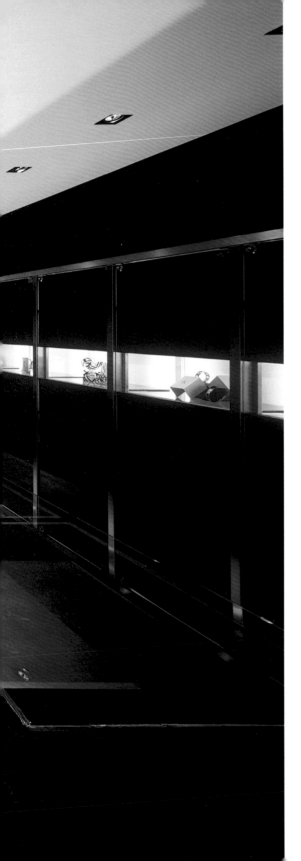

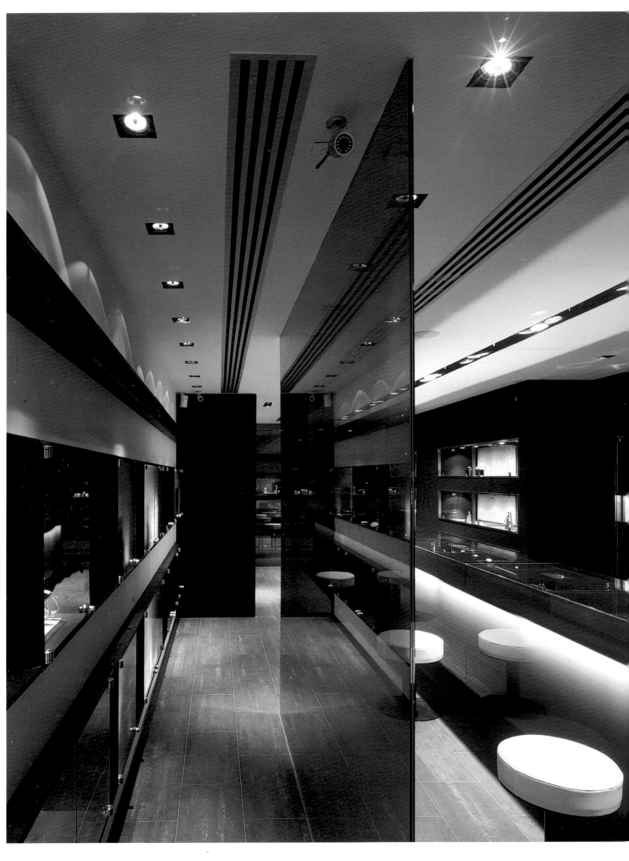

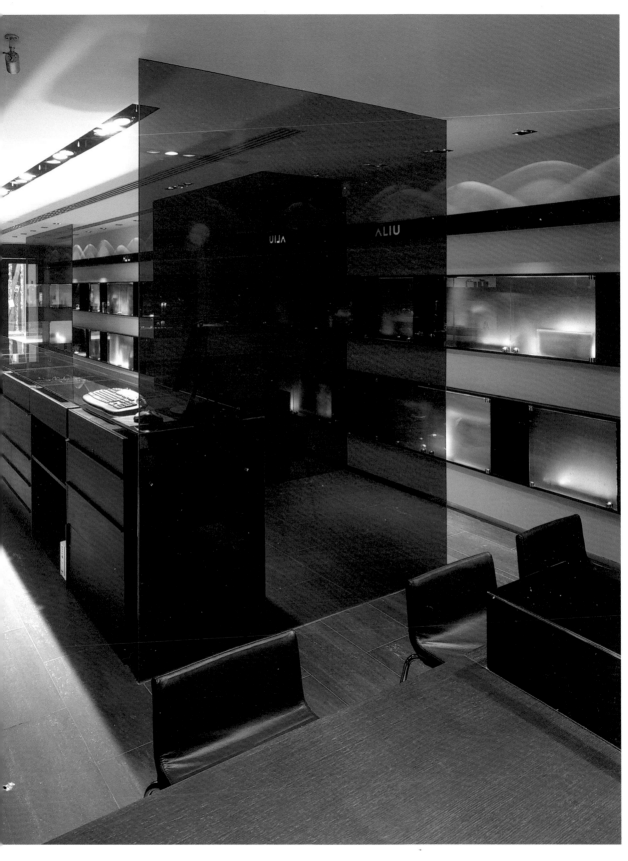

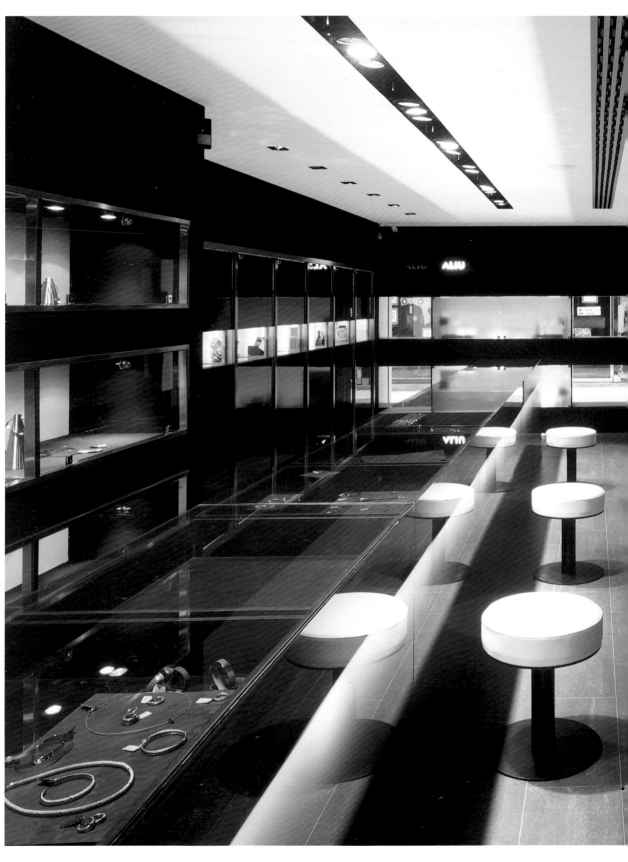

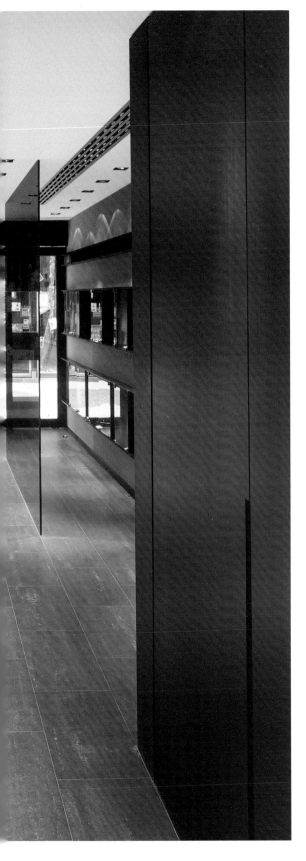

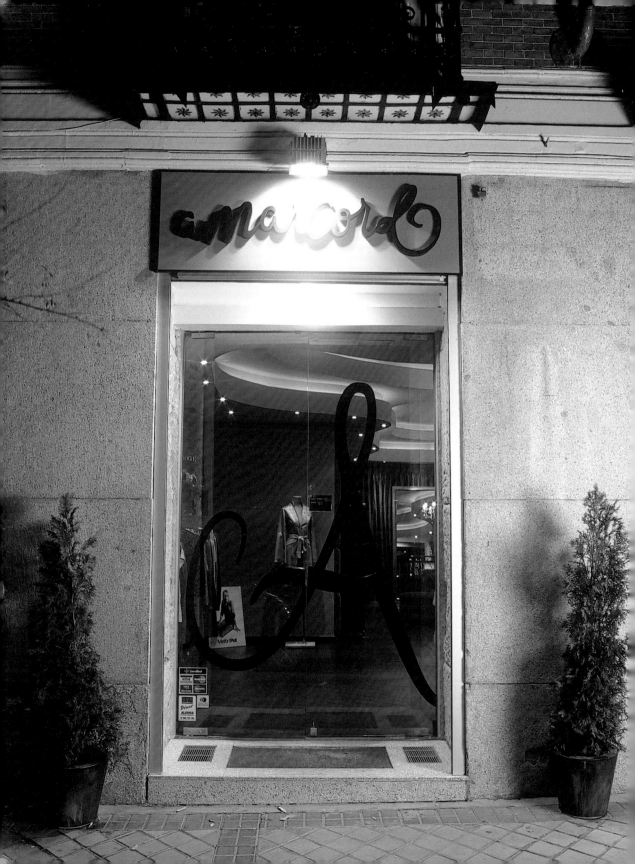

GUILLERMO BLANCO | MADRID

AMARCORD
Madrid, Spain | 2004

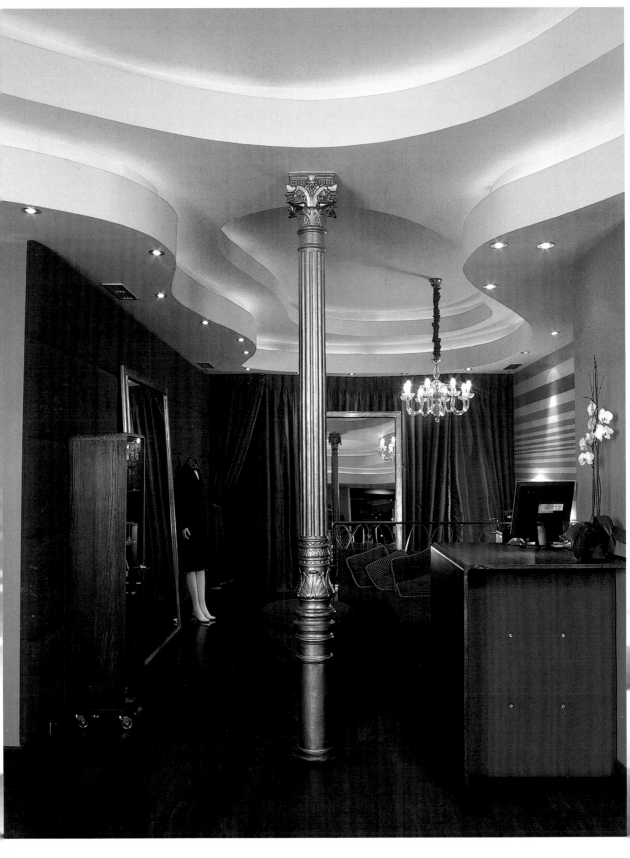

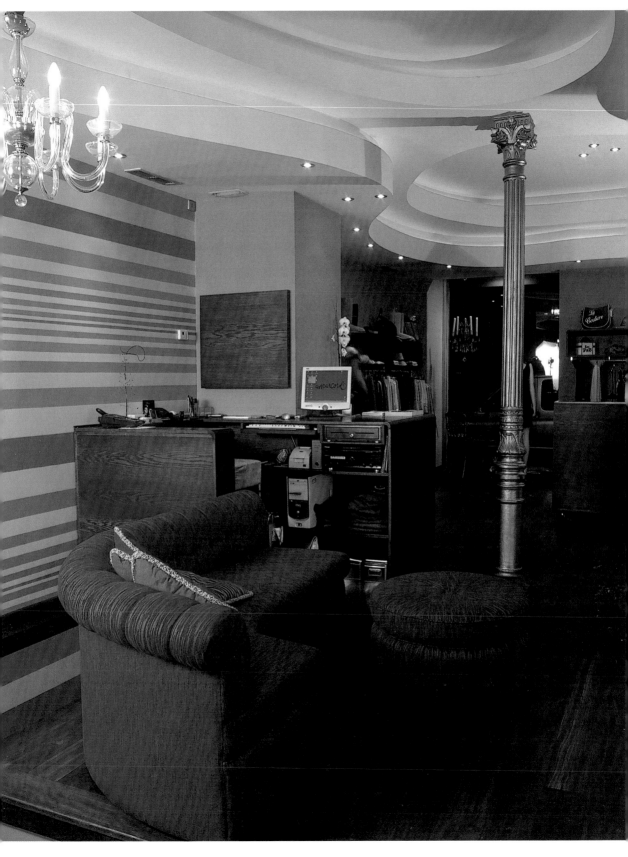

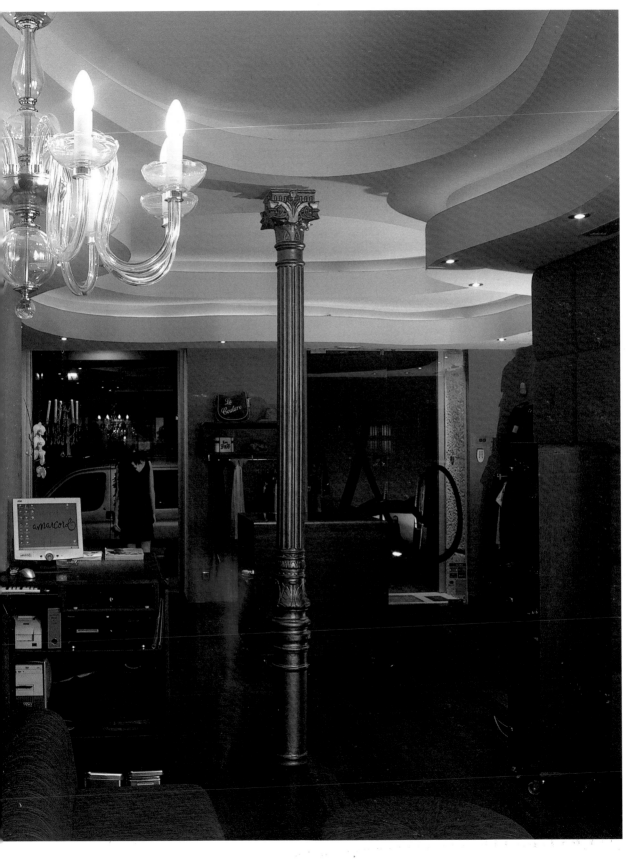

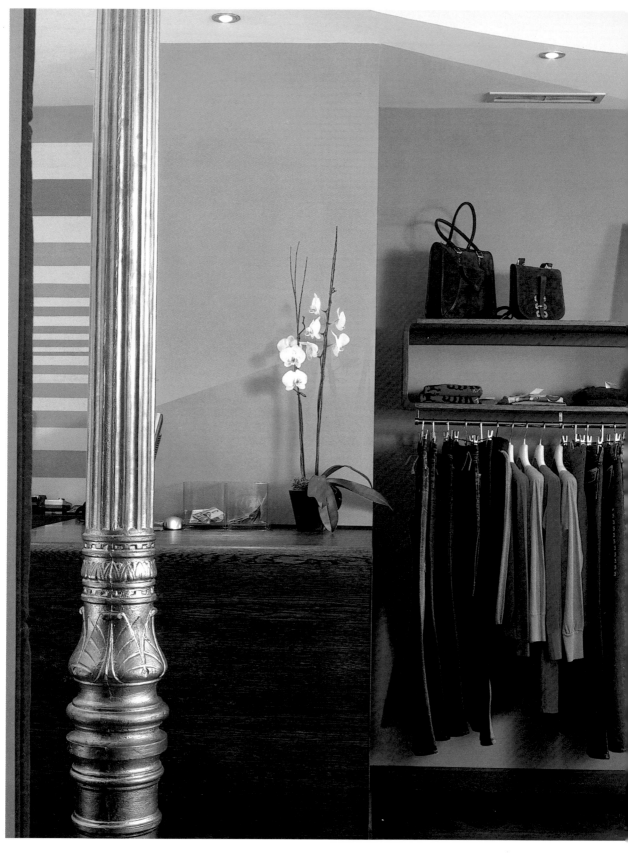

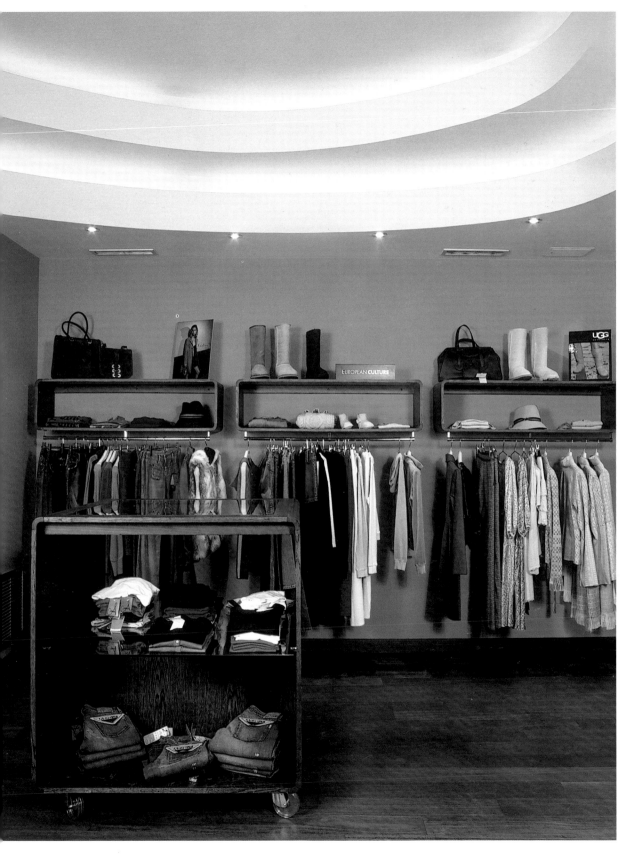

sigrun woehr

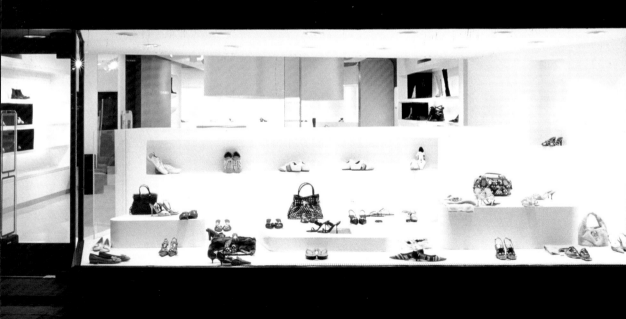

IPPOLITO FLEITZ GROUP | STUTTGART

SIGRUN WOEHR

Stuttgart, Germany | 2004

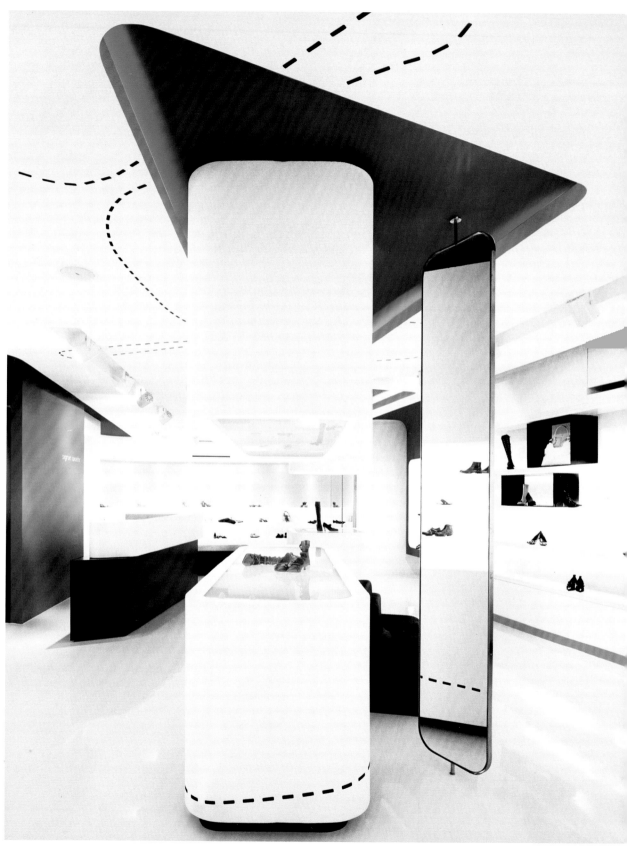

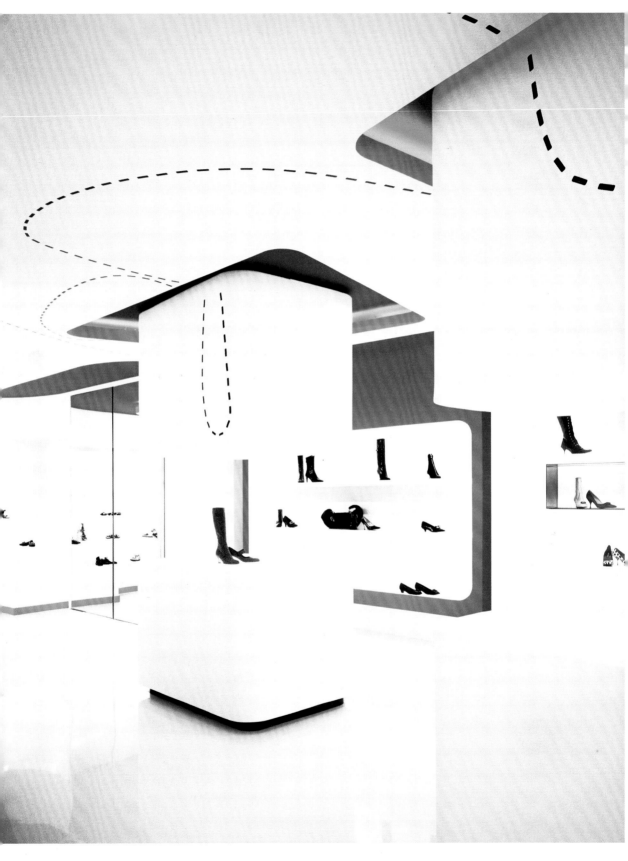

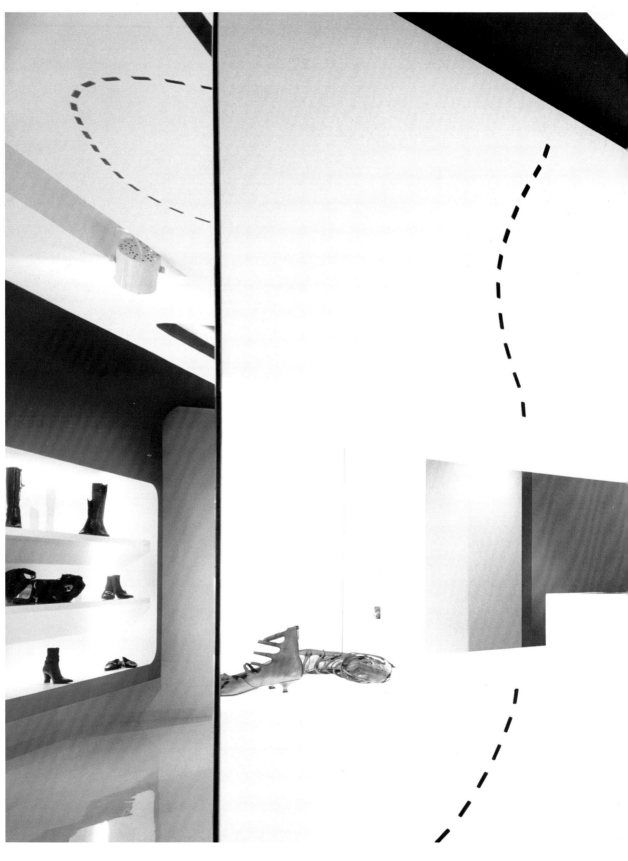

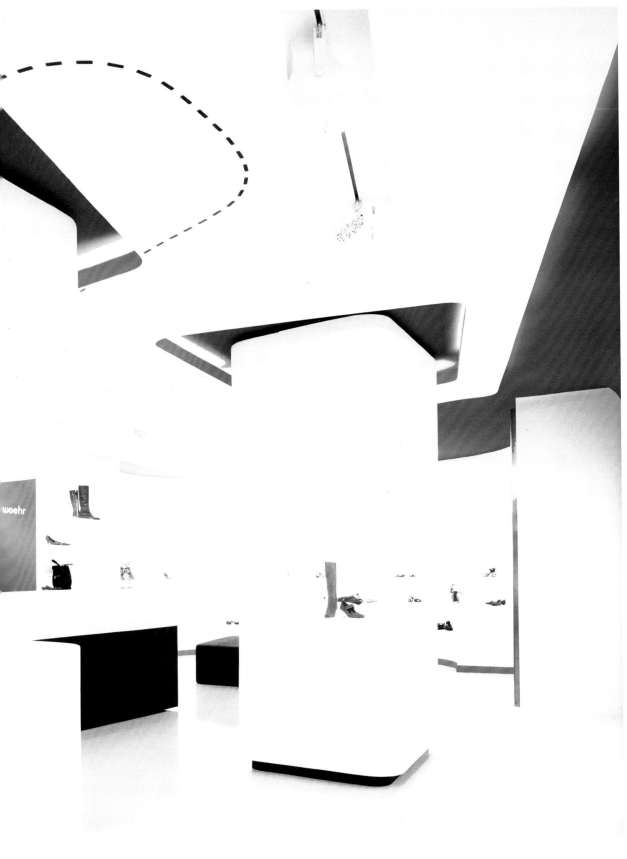

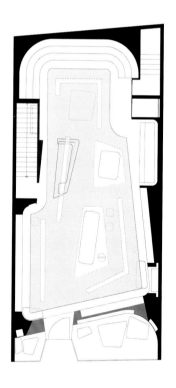

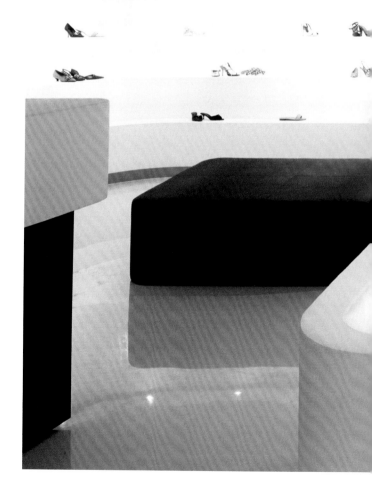

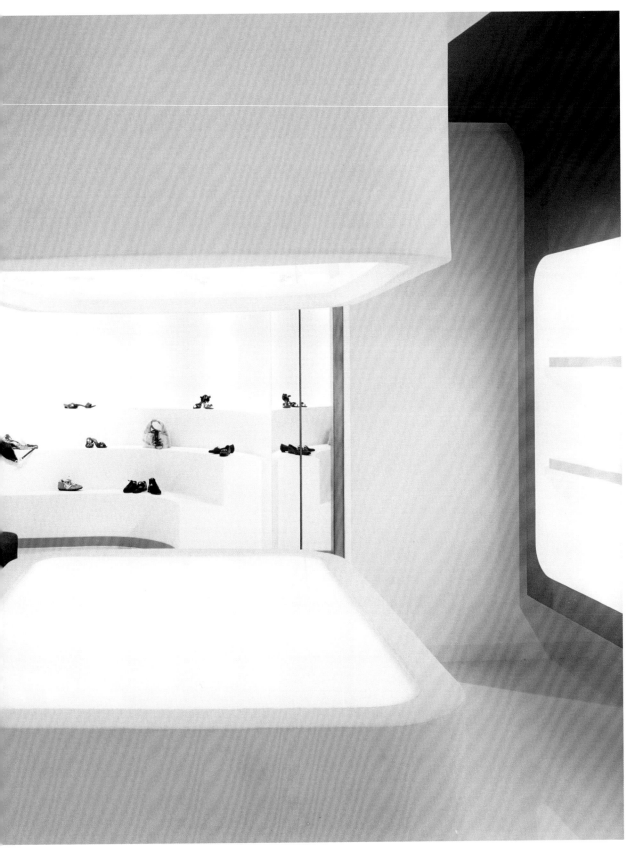

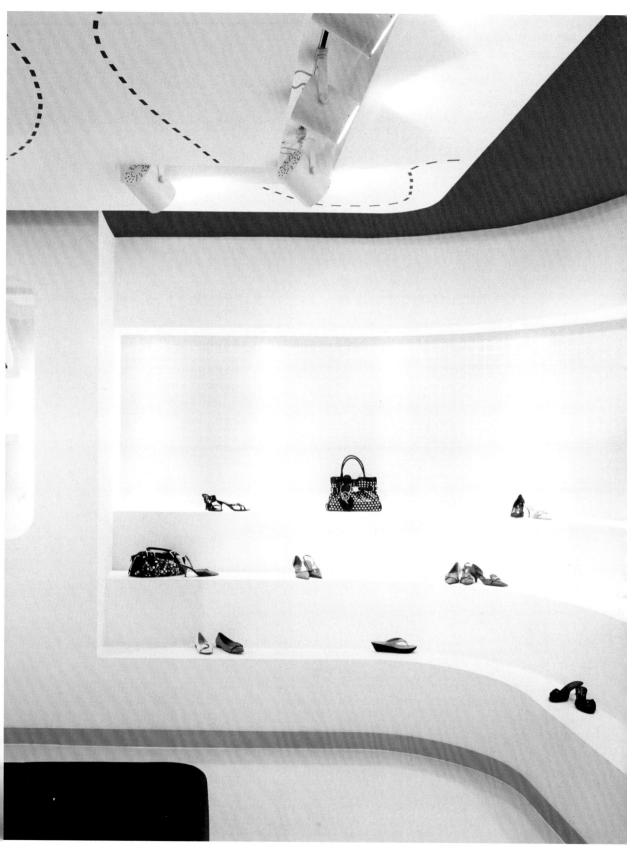

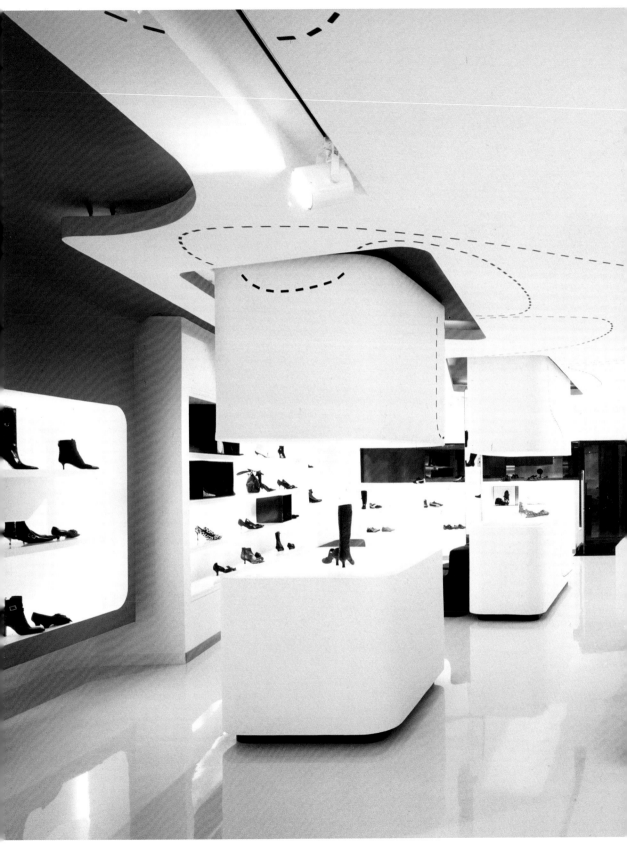

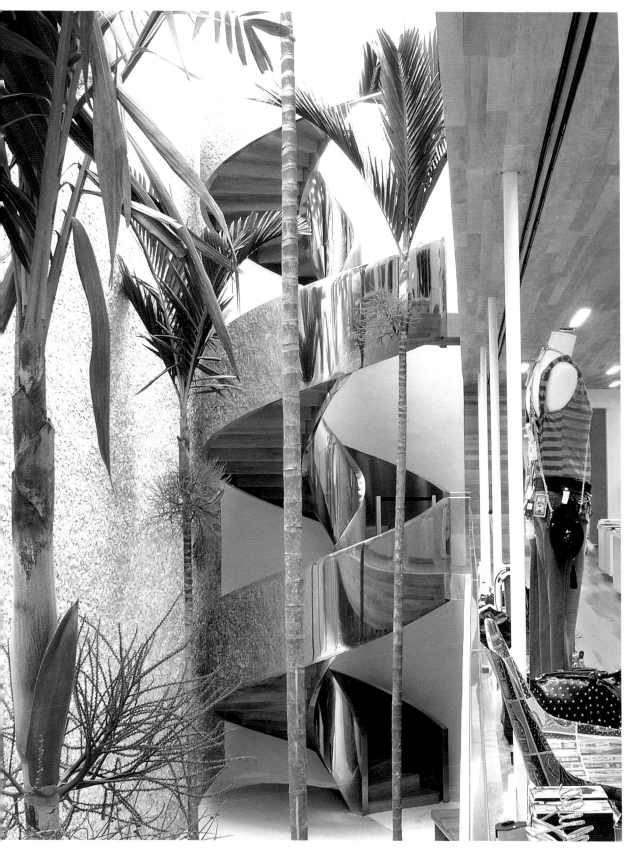

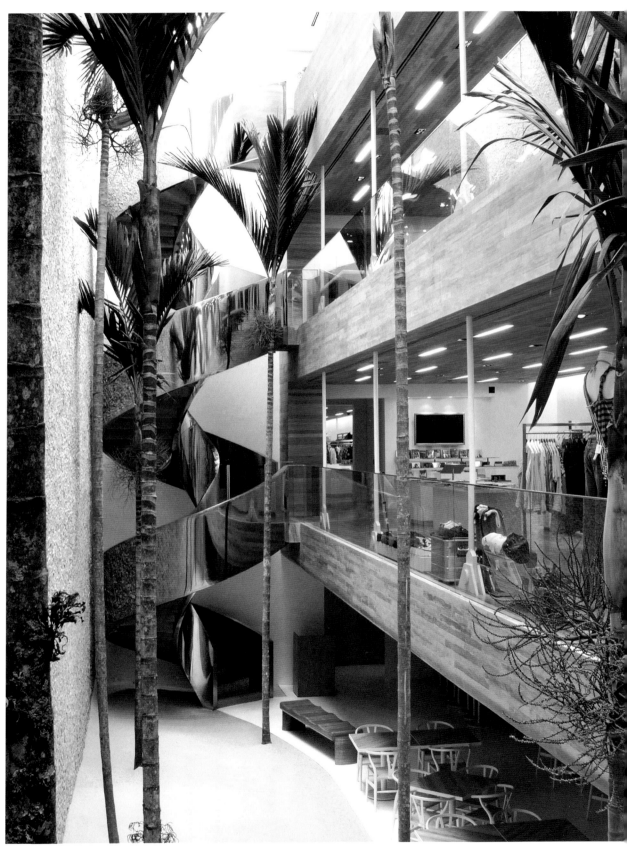

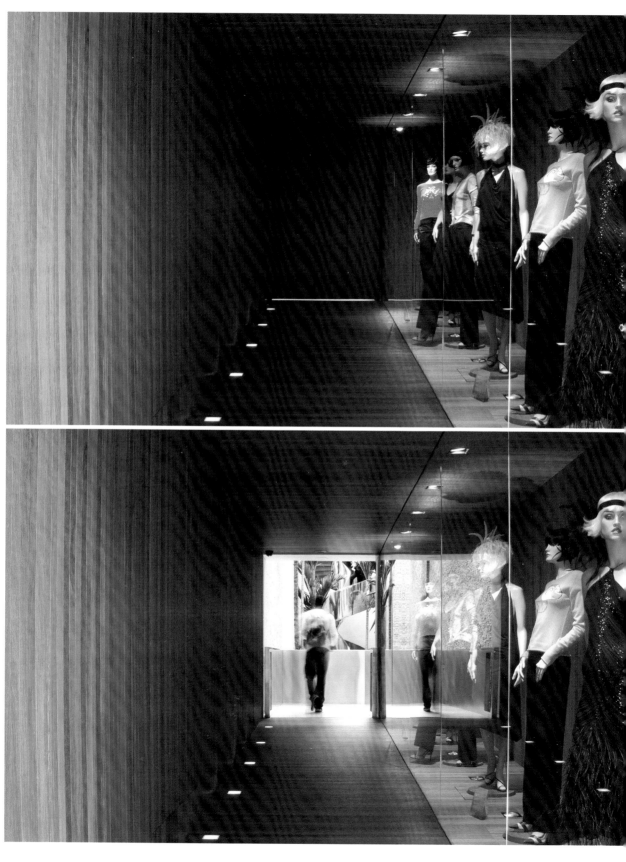

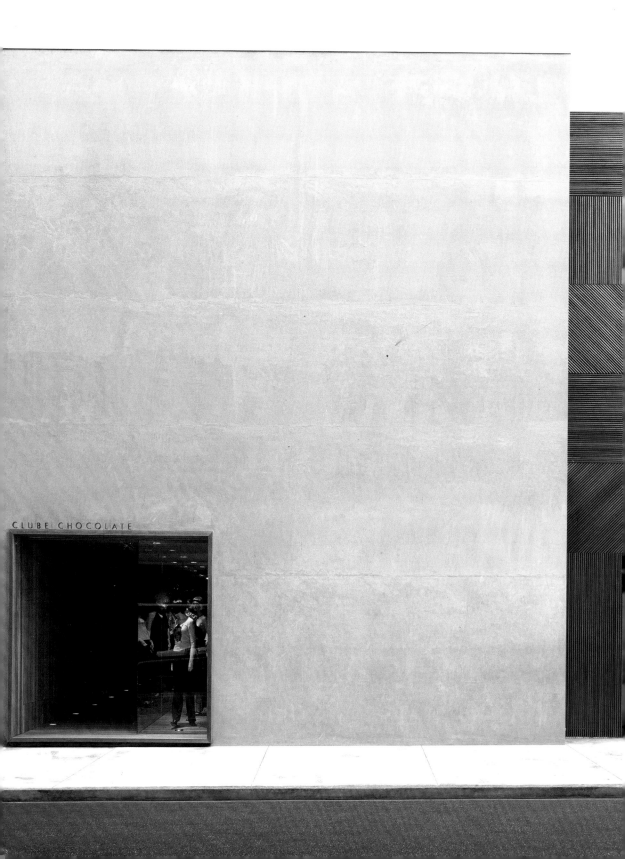

CLUBE CHOCOLATE

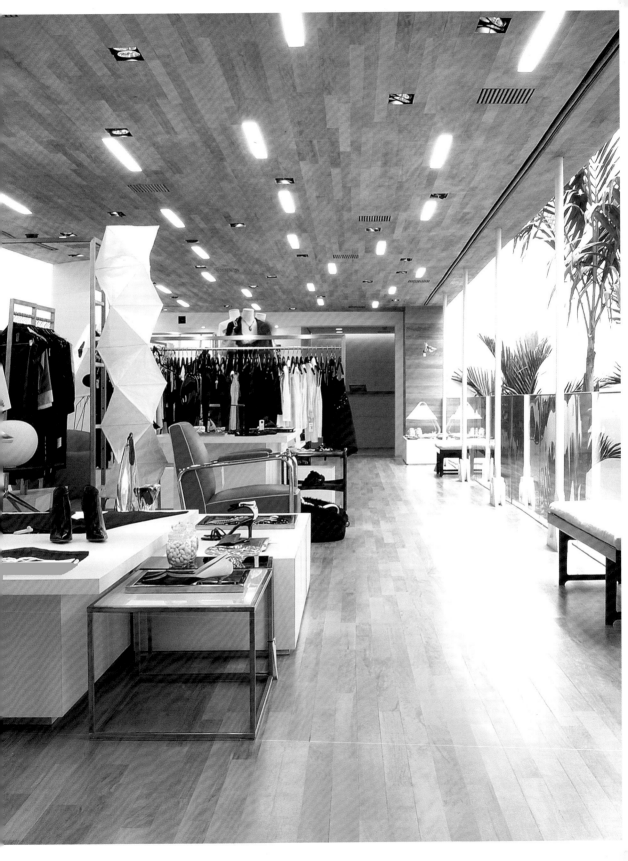

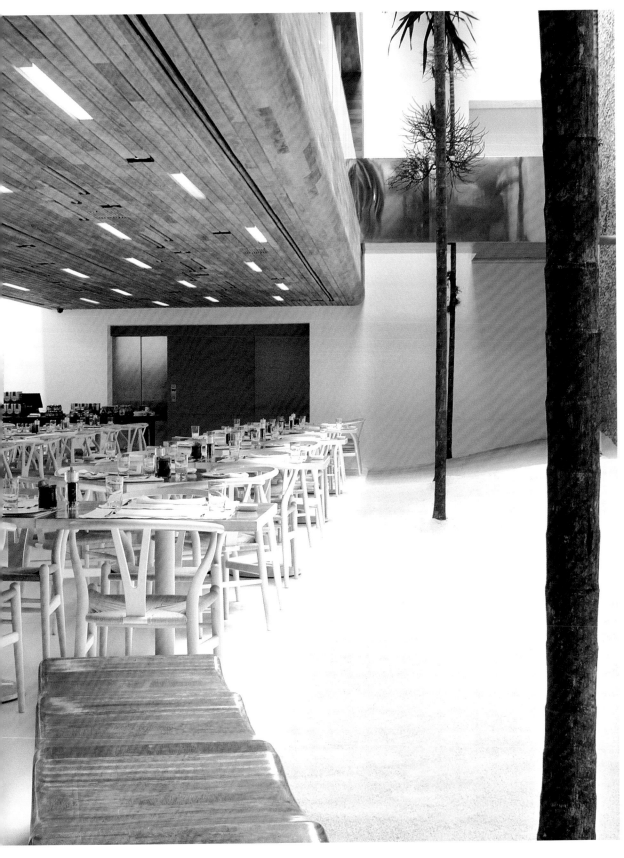

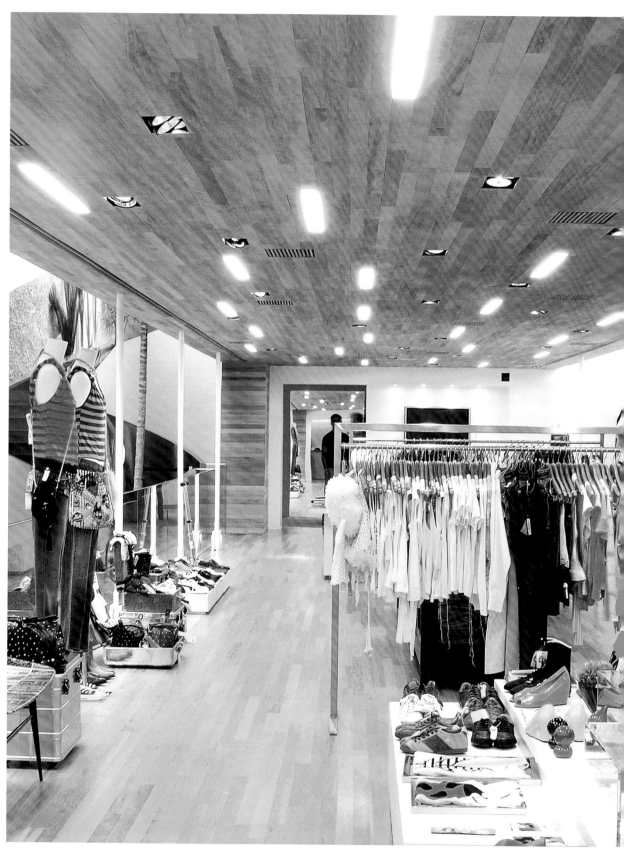

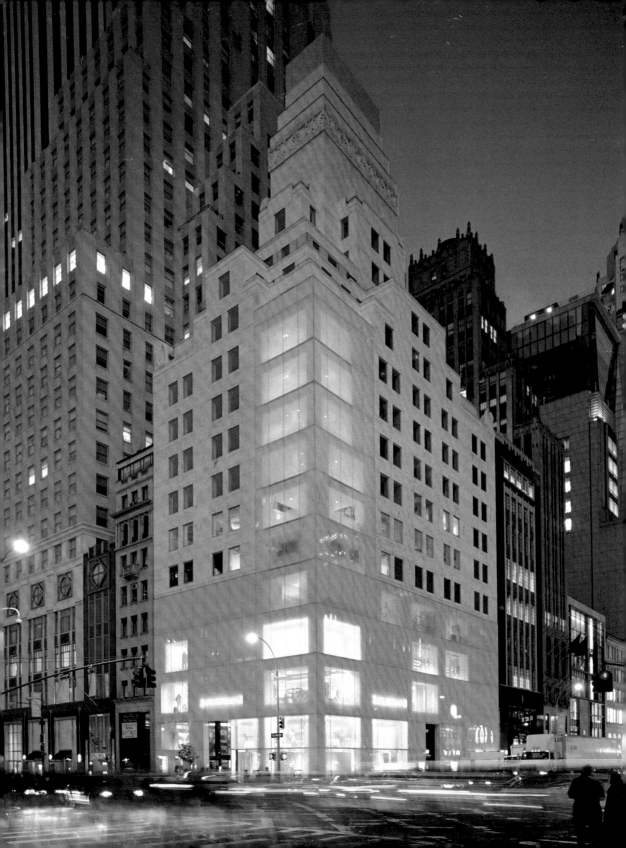

JUN AOKI | TOKYO
PETER MARINO | NEW YORK
LOUIS VUITTON
New York, USA | 2004

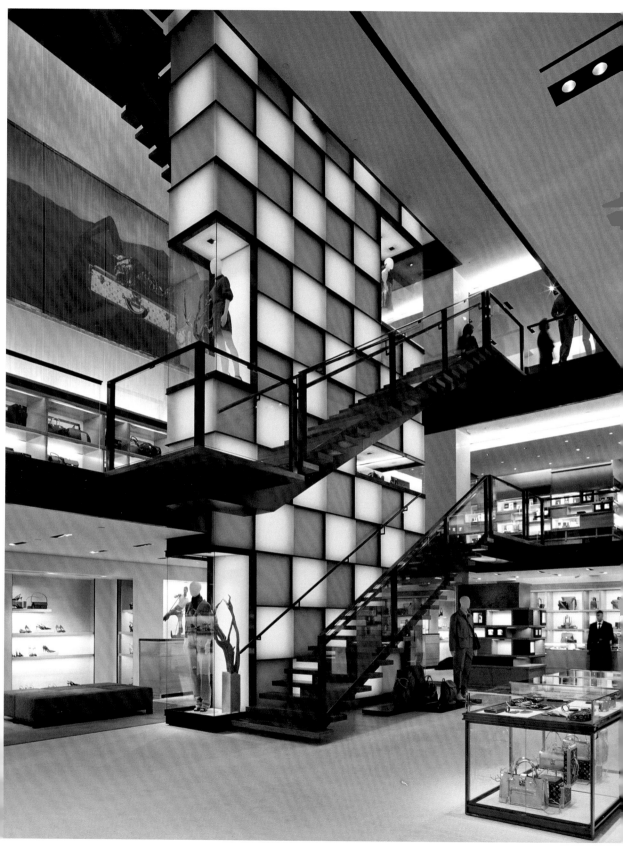

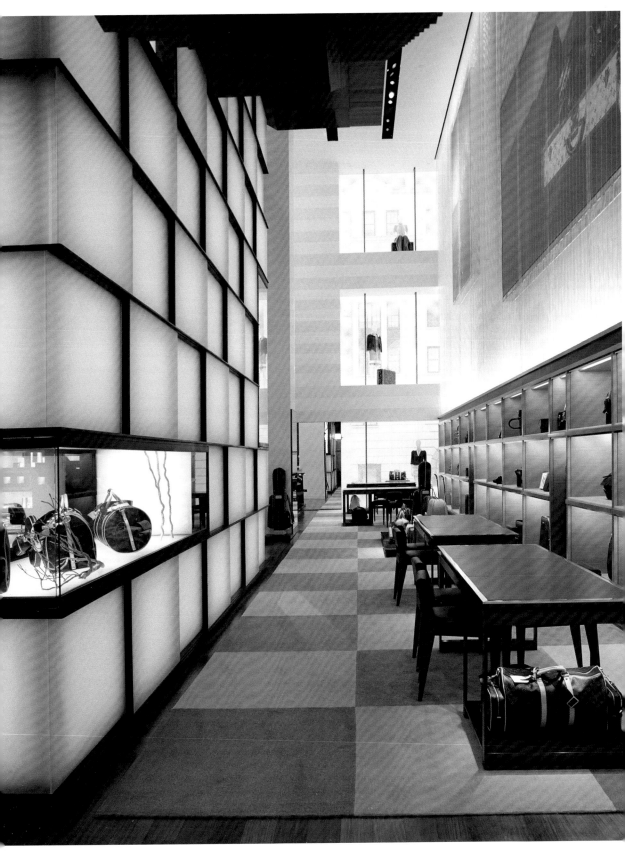

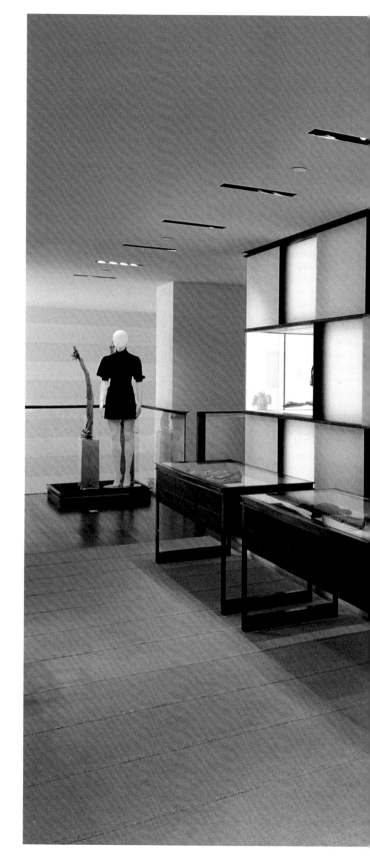

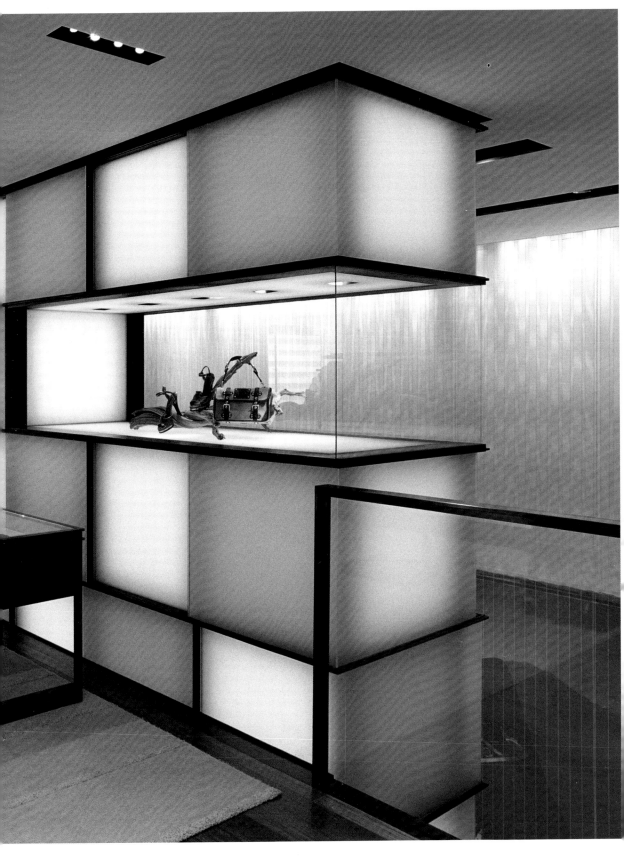

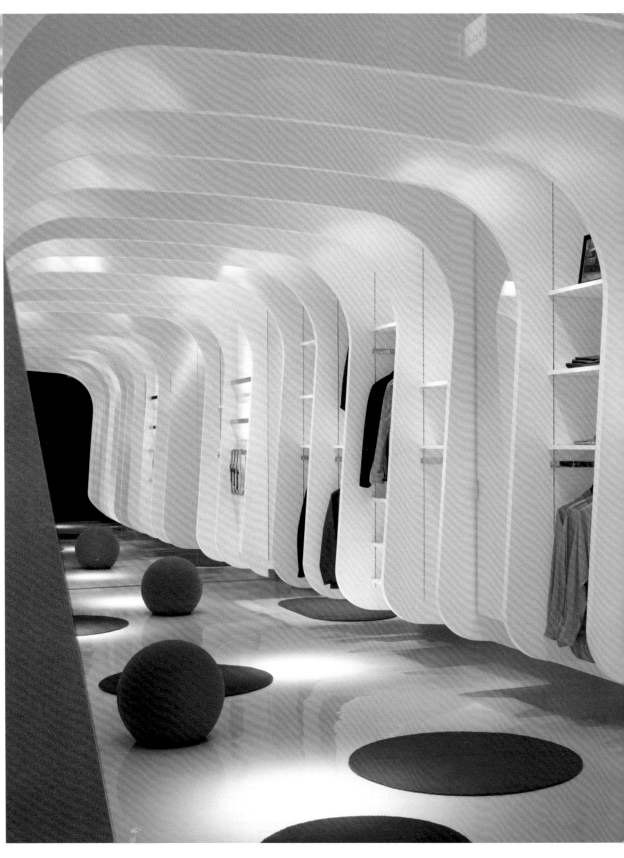

ORIHICA
Tokyo, Japan | 2003

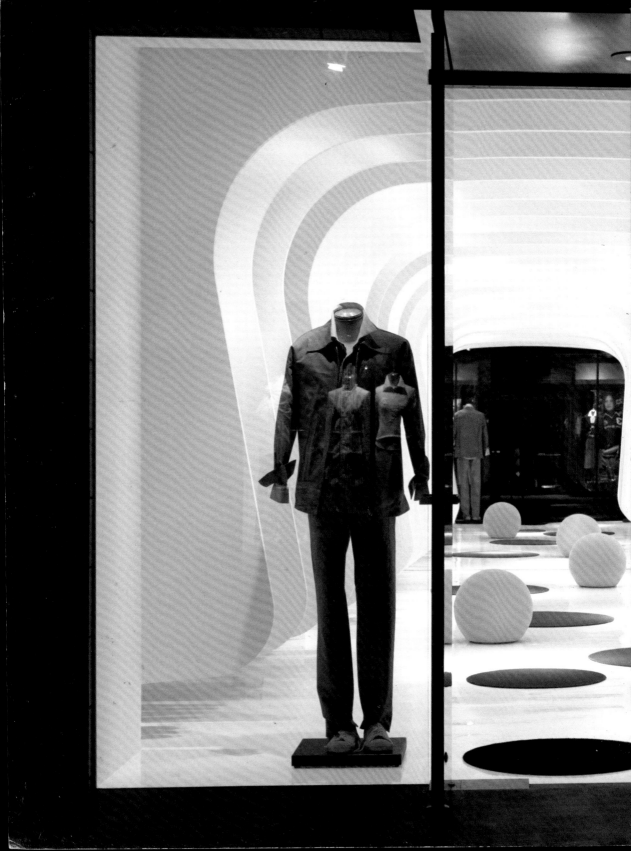

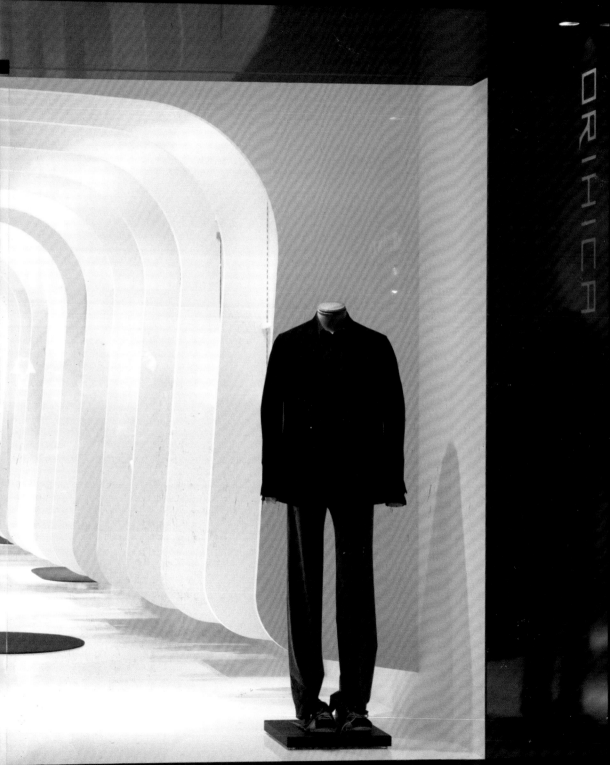

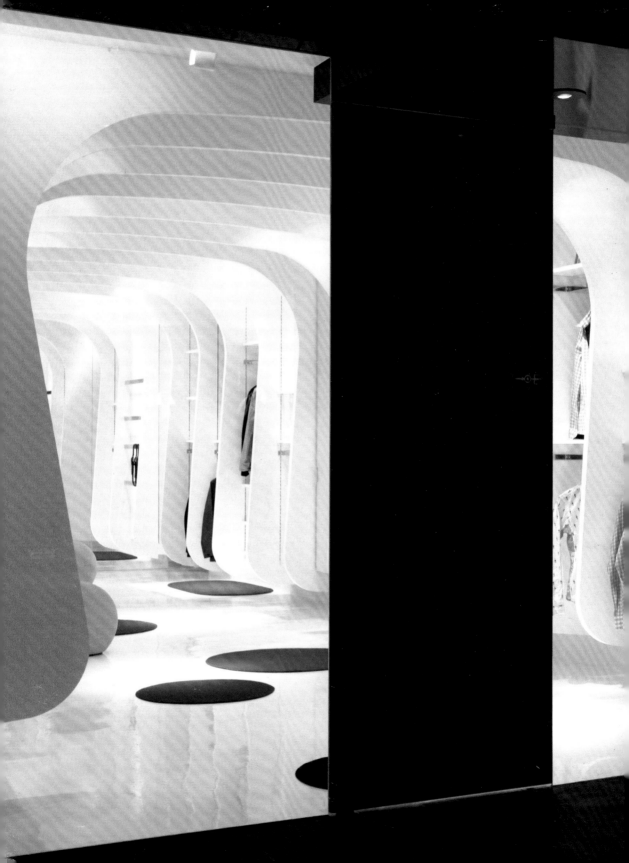

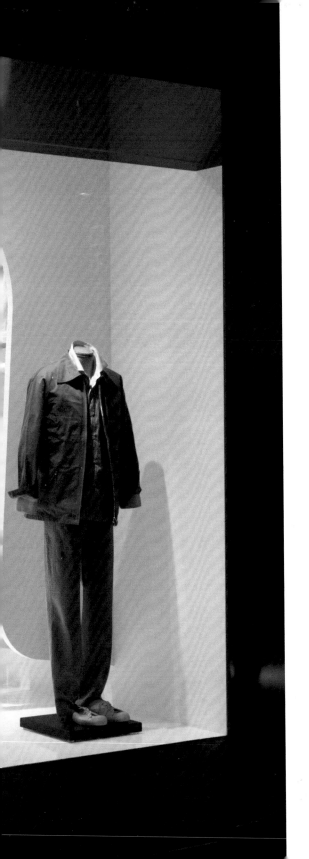

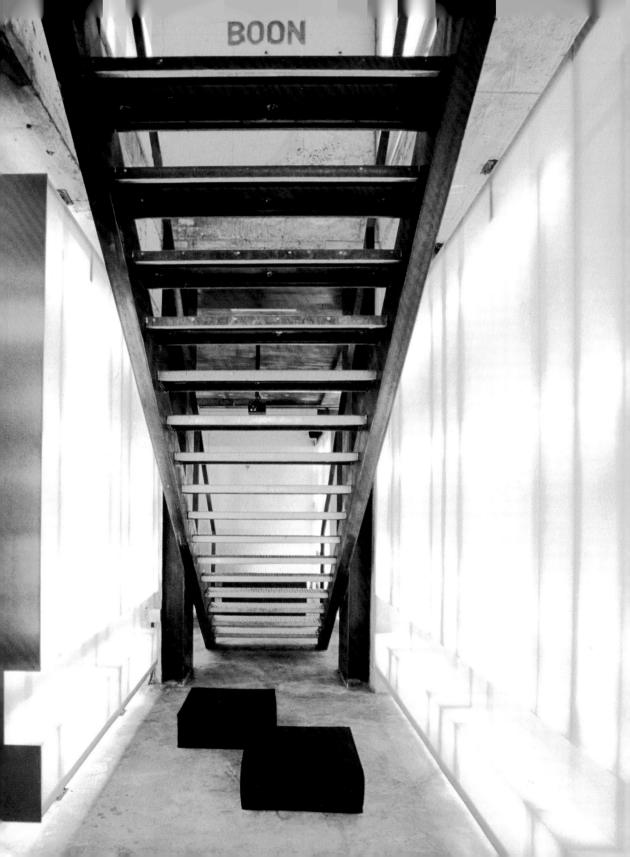

LOT-EK | NEW YORK

BOON
Seoul, Korea | 2003

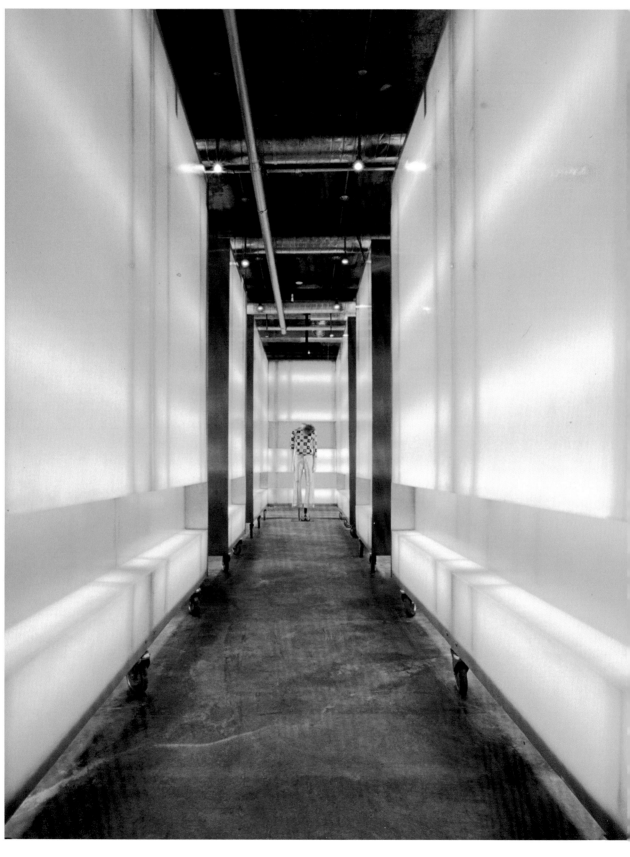

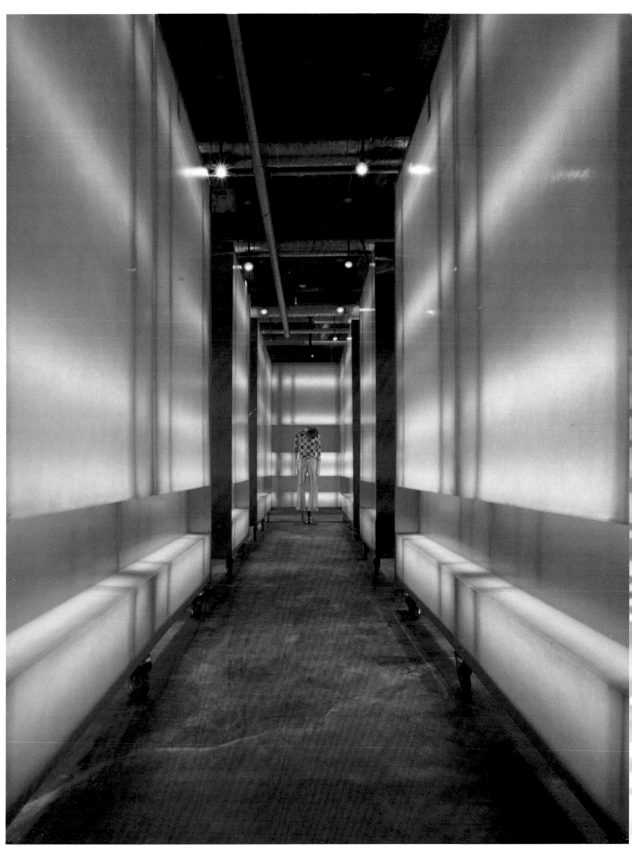

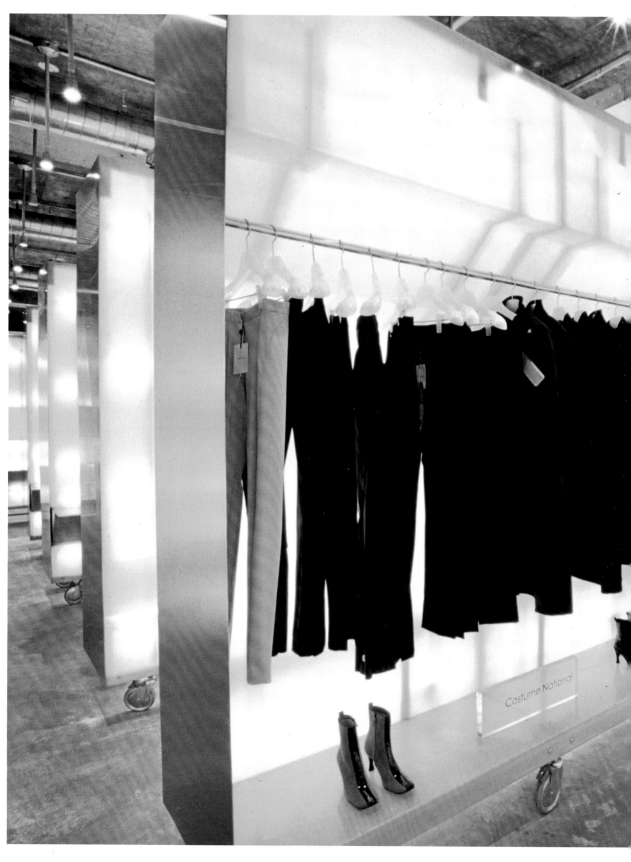

Costume National

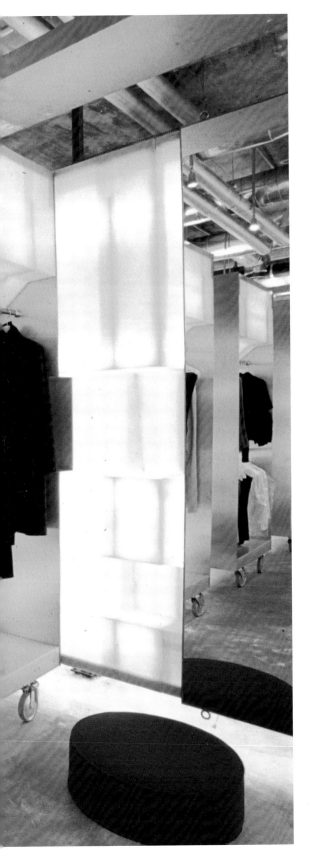

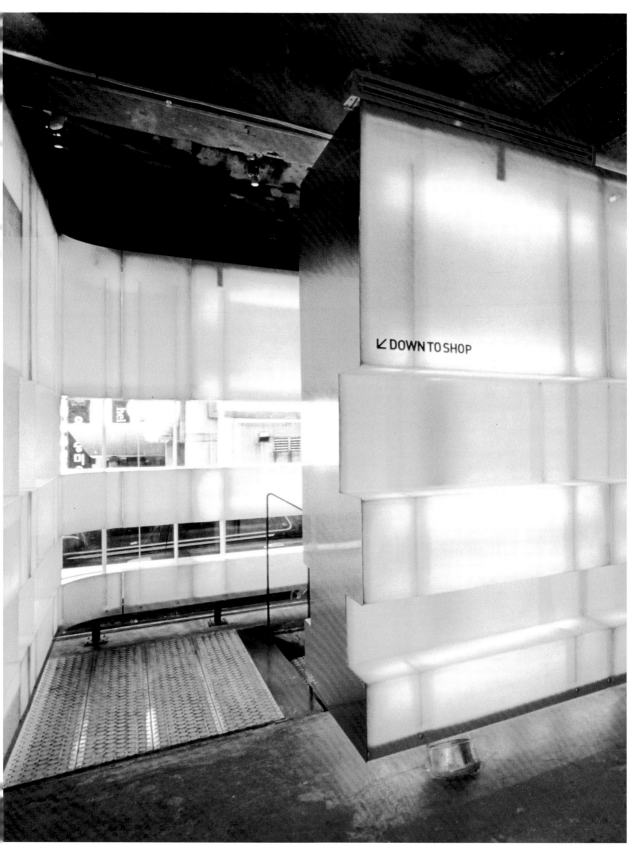

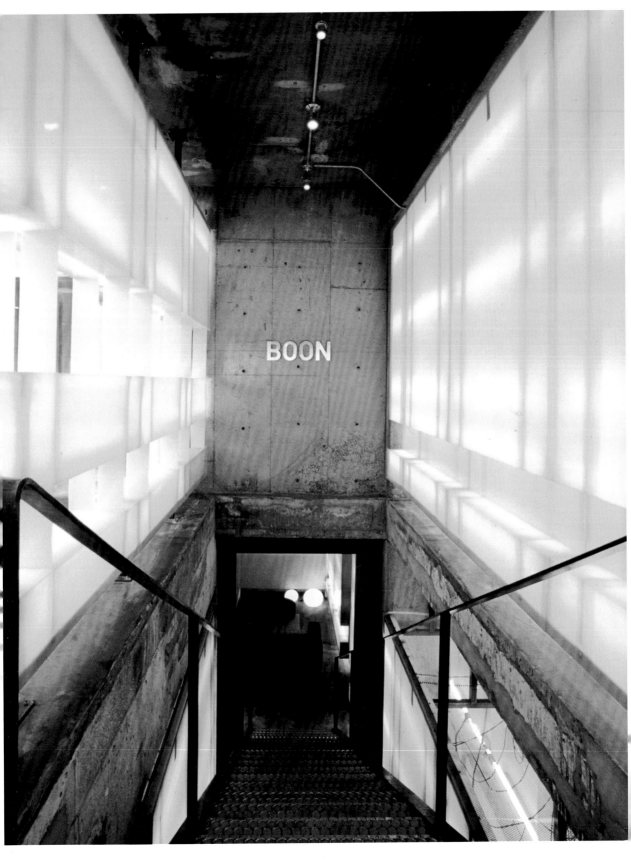

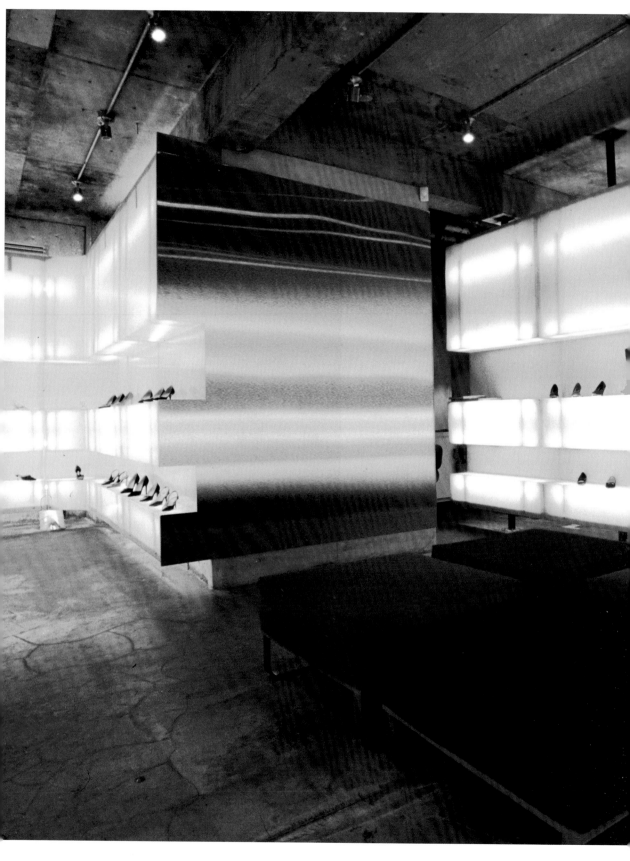

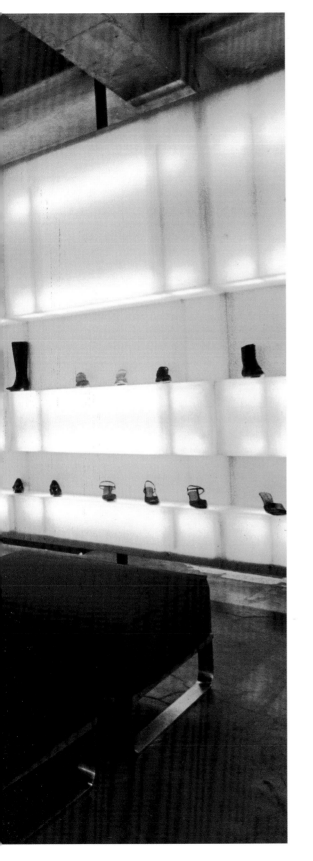

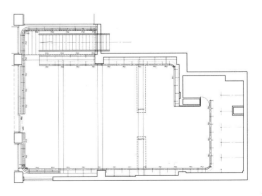

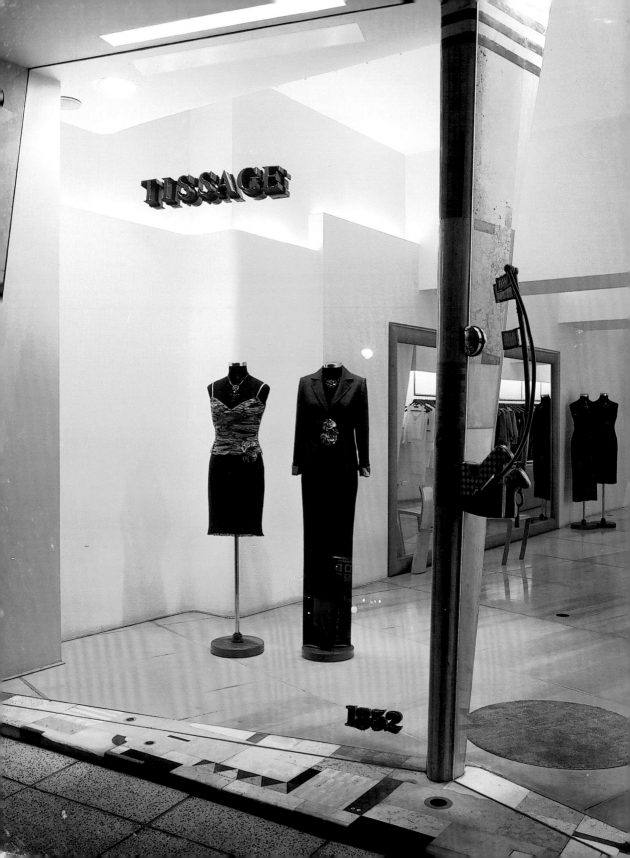

LUCIANO PÉREZ, JULIO PÉREZ | BUENOS AIRES
TISSAGE
Buenos Aires, Argentina | 2004

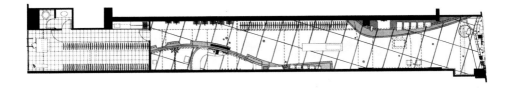

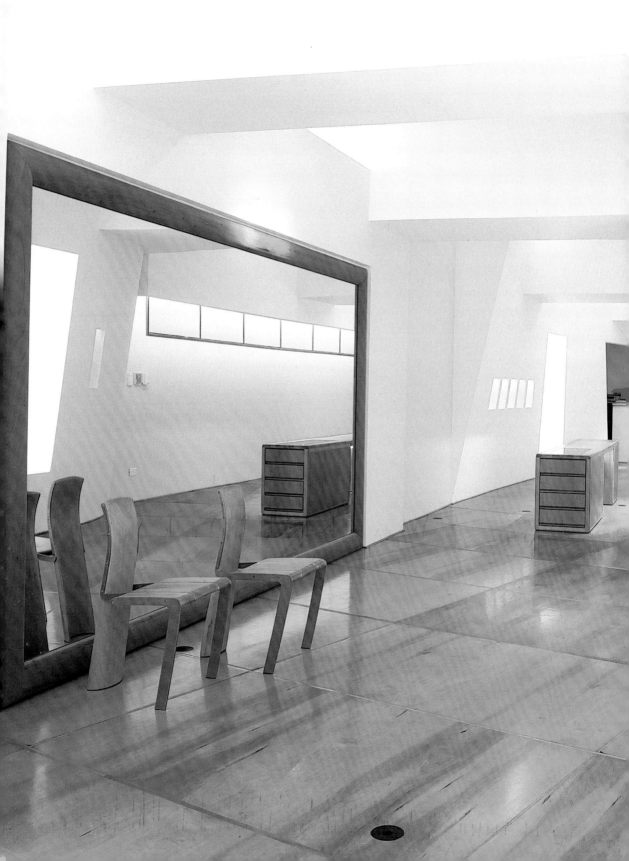

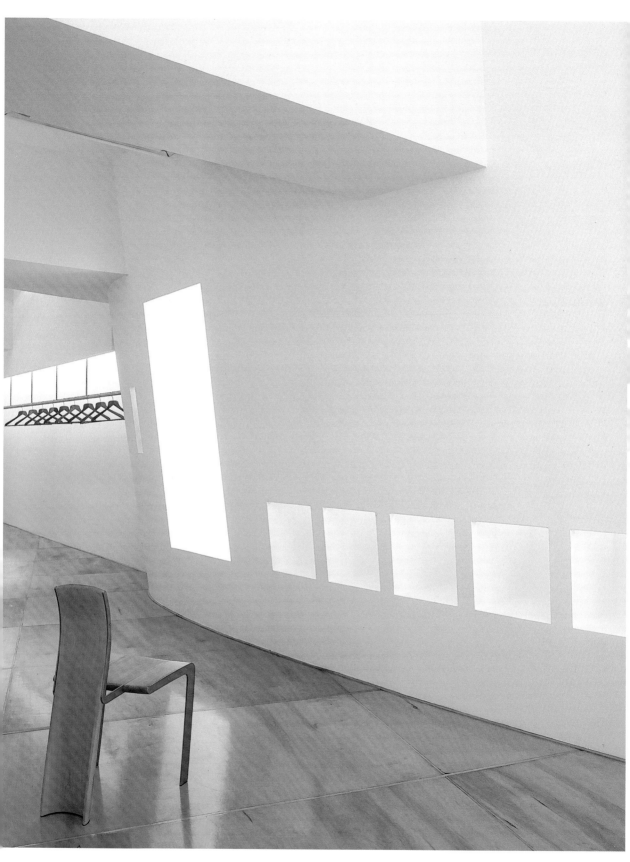

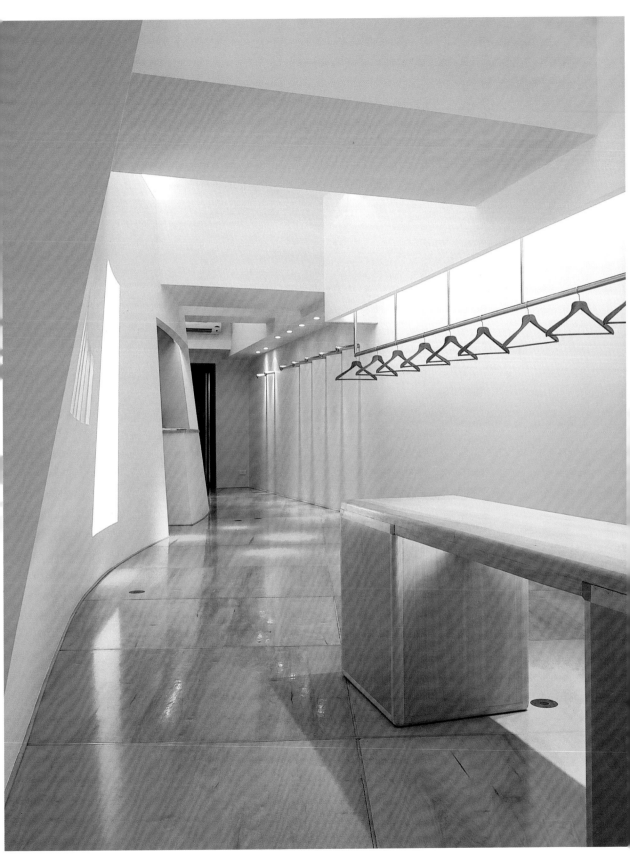

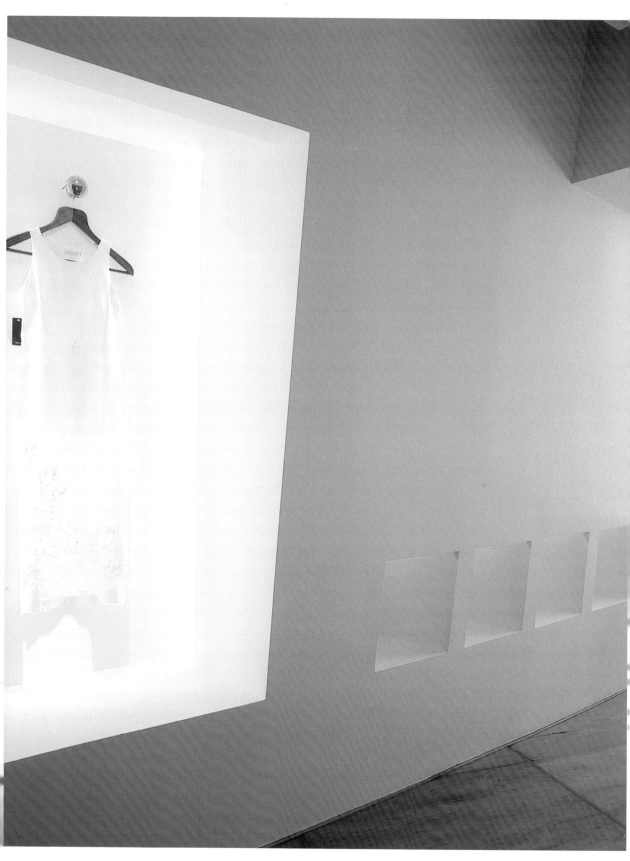

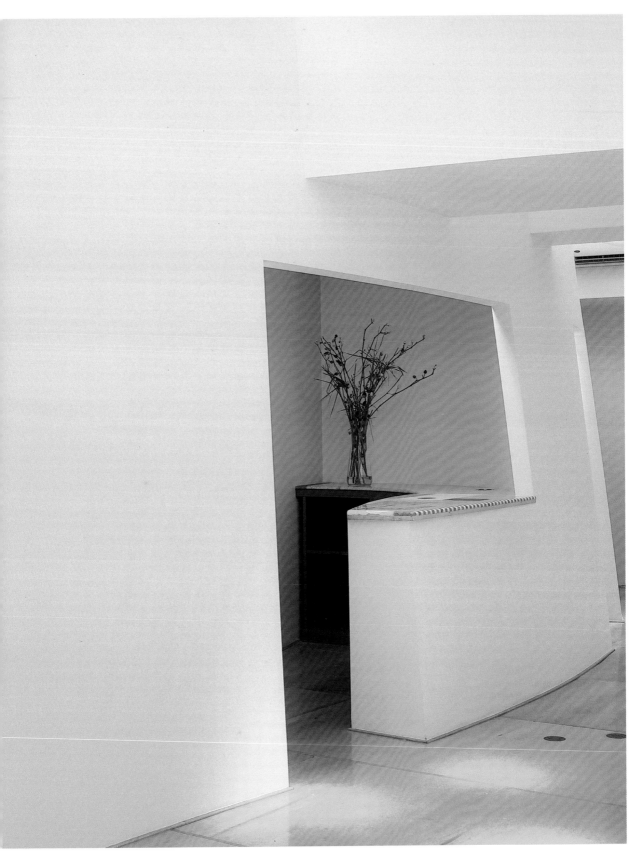

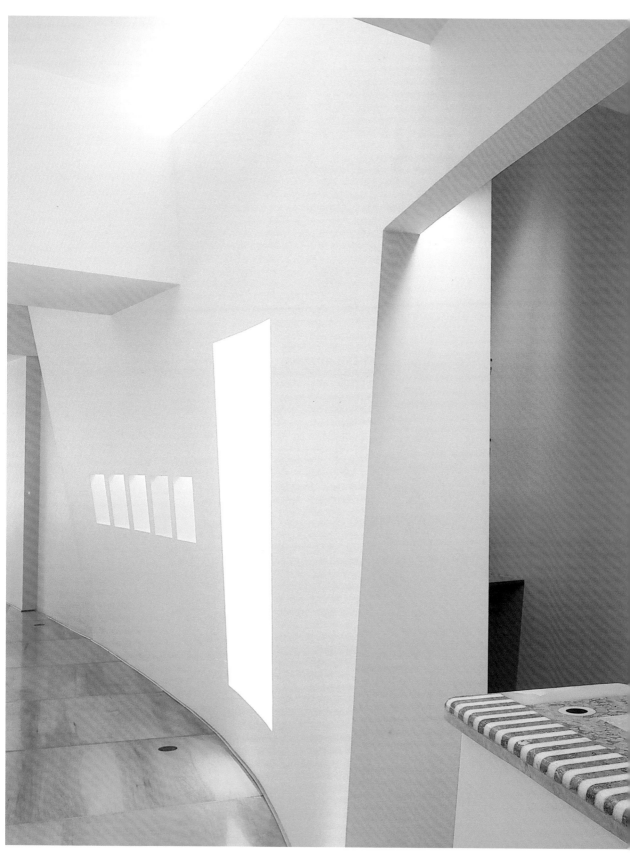

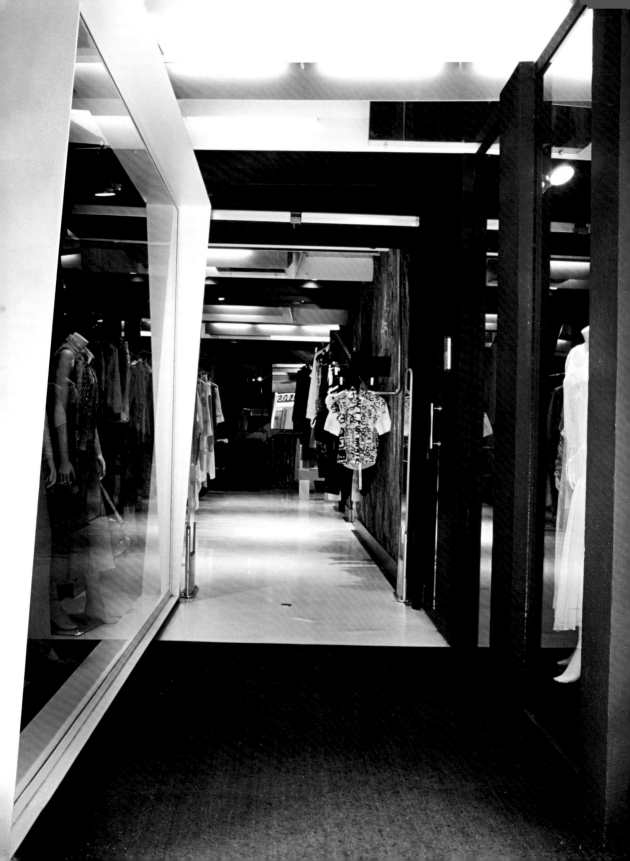

MANUEL BAILÓ & ROSA RULL | **BARCELONA**
SITA MURT
Reus, Spain | 2003

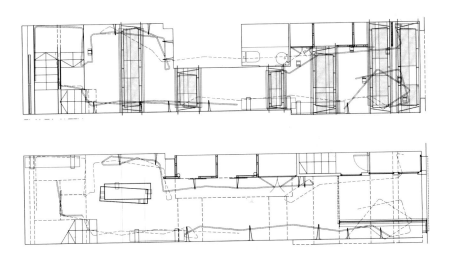

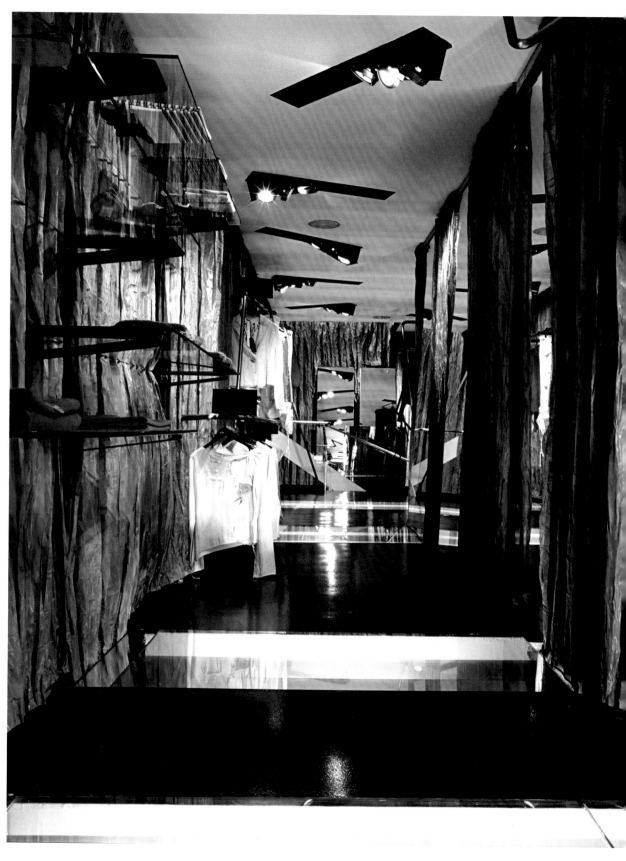

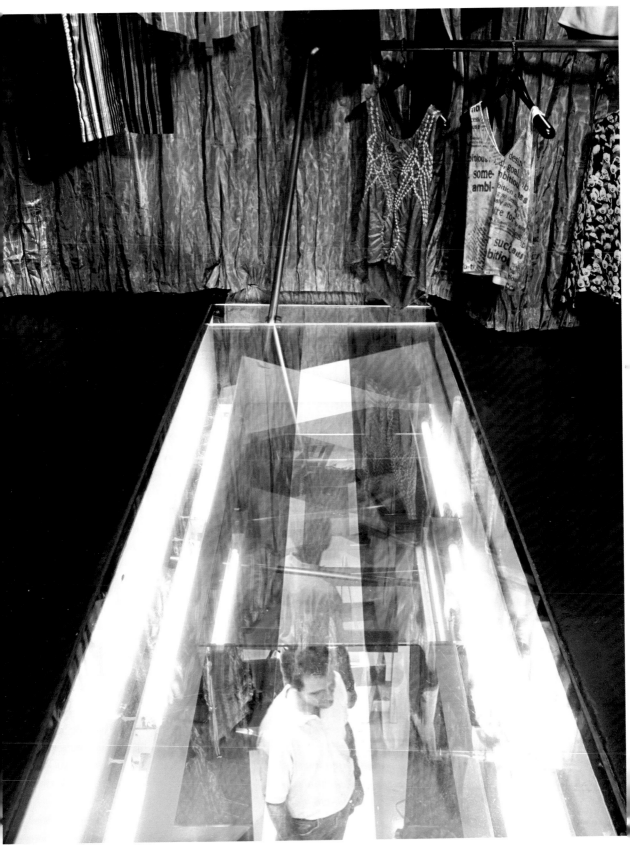

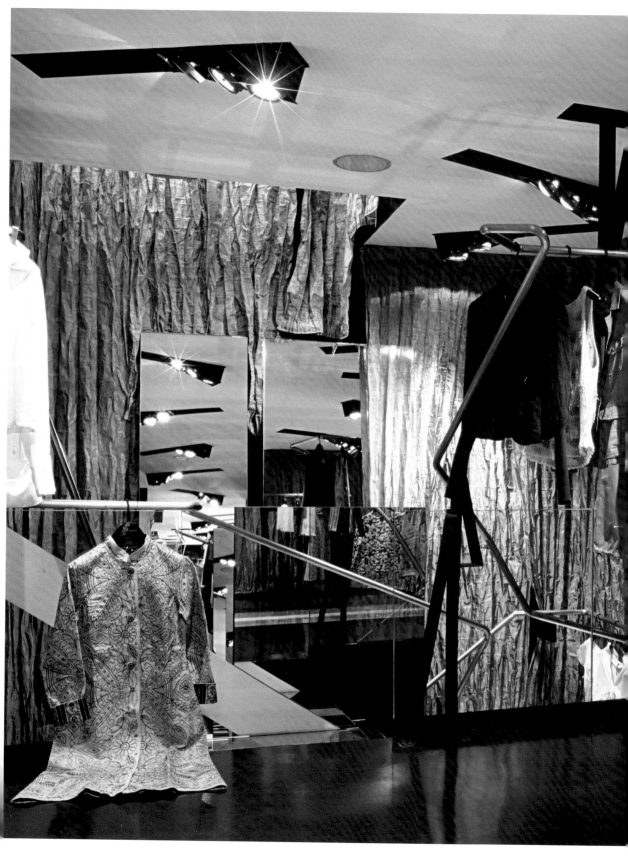

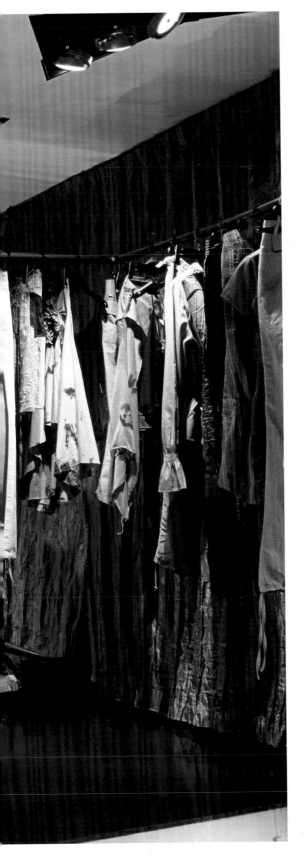

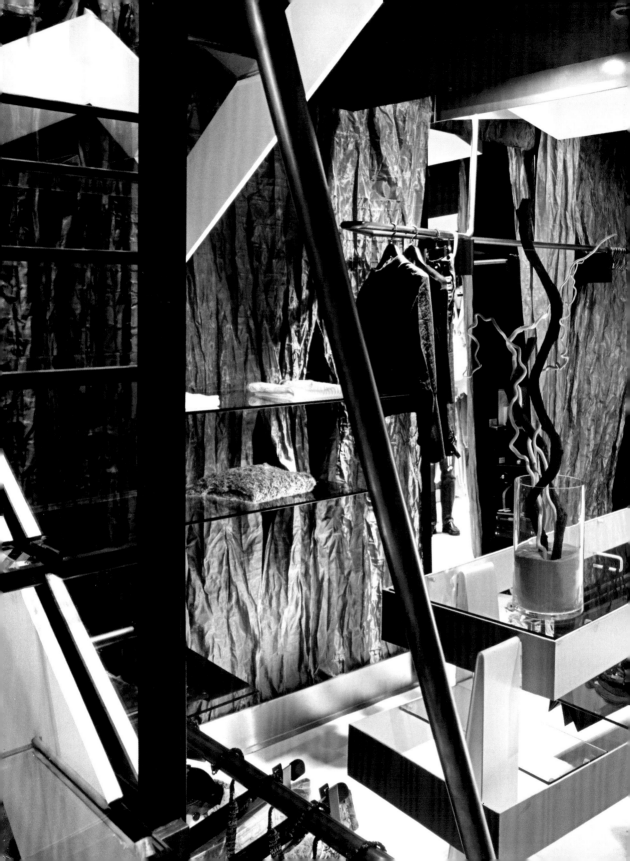

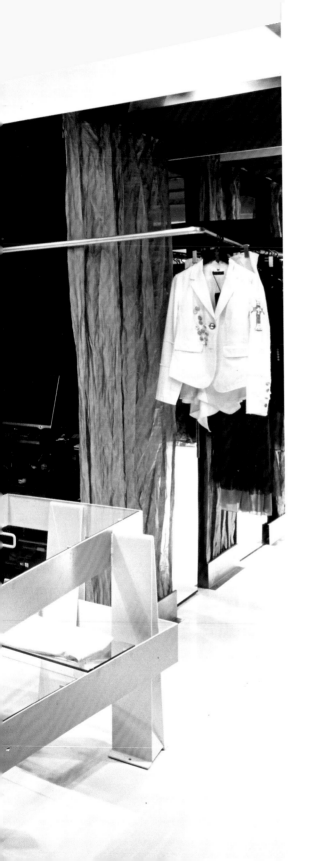

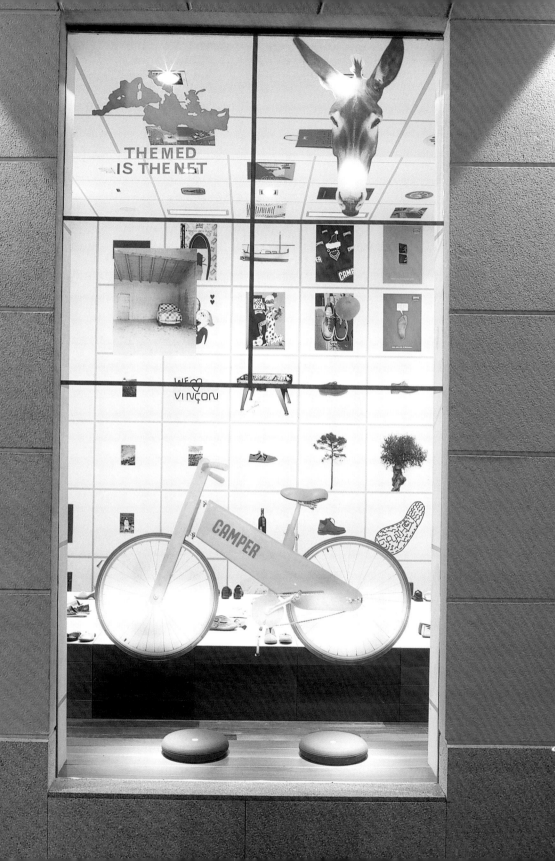

MARTÍ GUIXÉ | BARCELONA
CAMPER INFOSHOP
Madrid, Spain | 2004

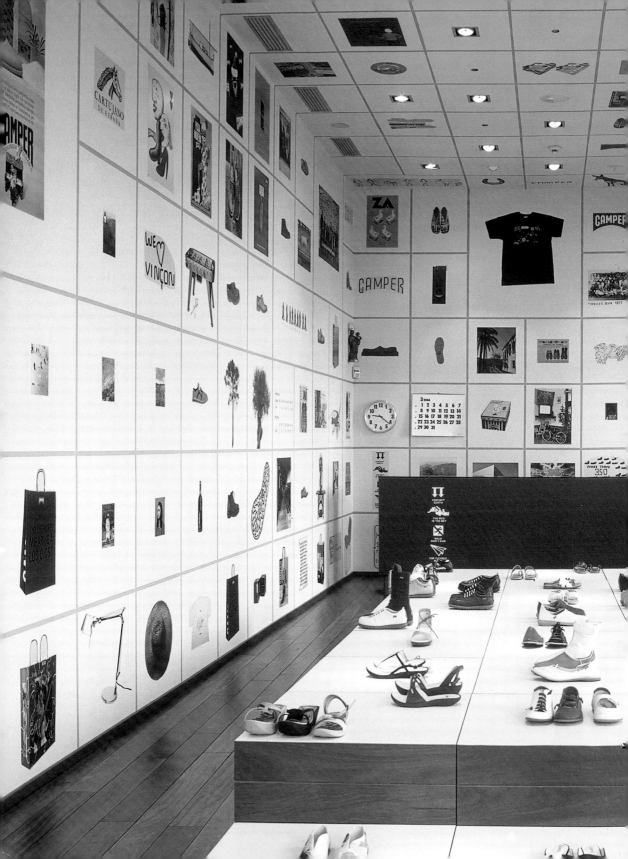

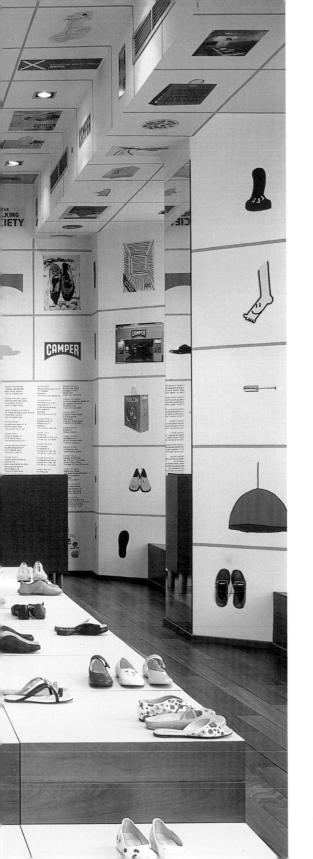

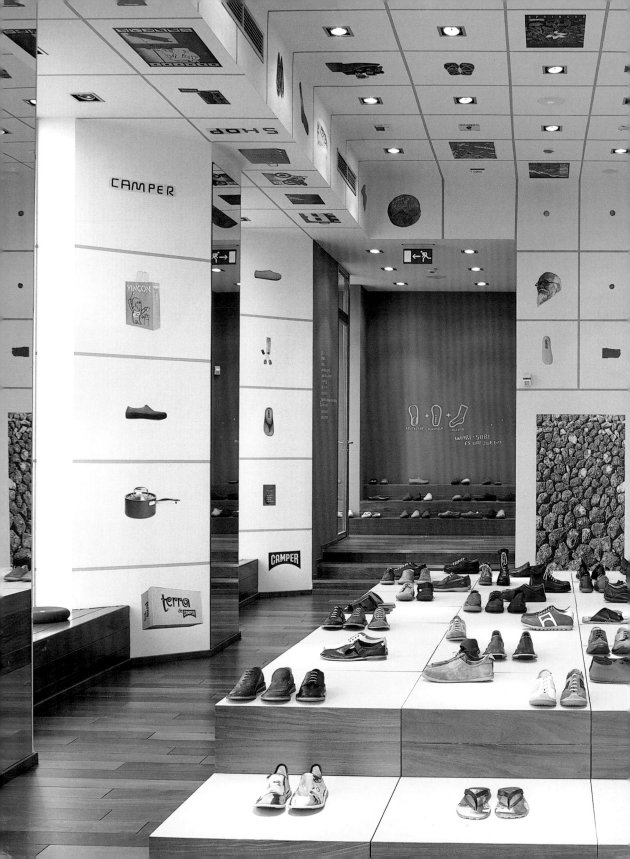

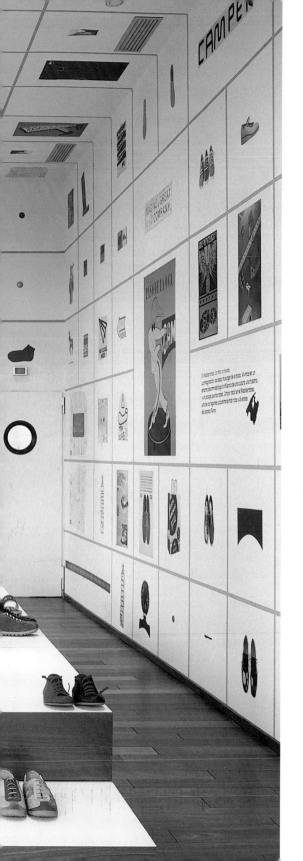

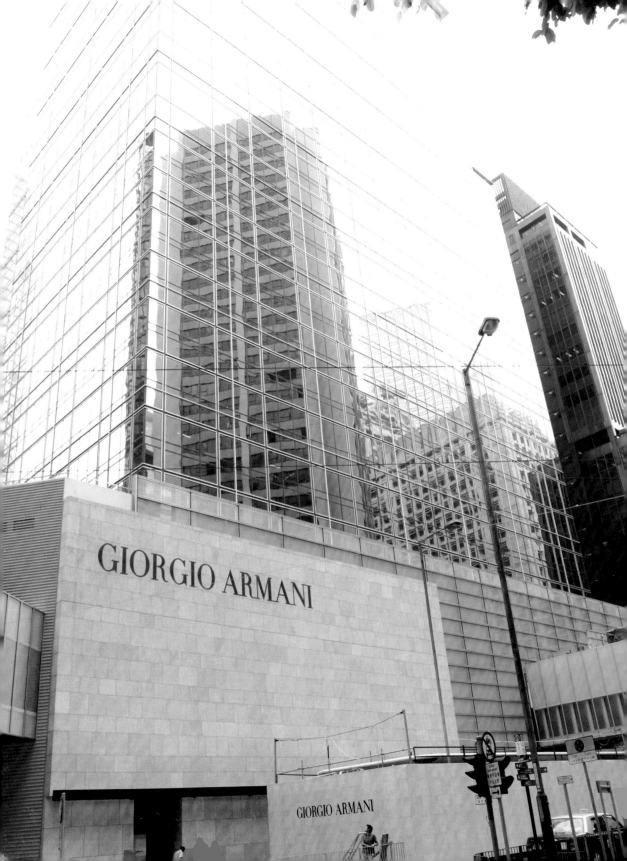

MASSIMILIANO FUKSAS | MILAN

GIORGIO ARMANI
Hong Kong, Japan | 2004

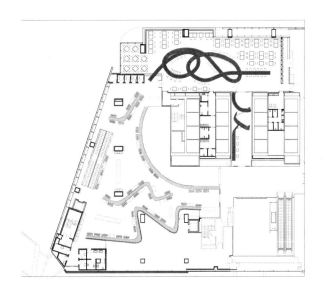

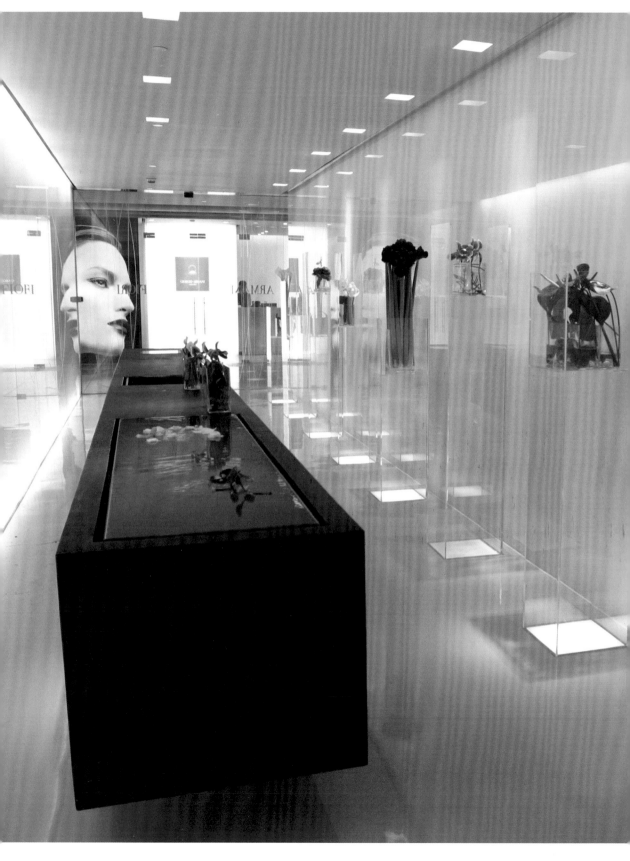

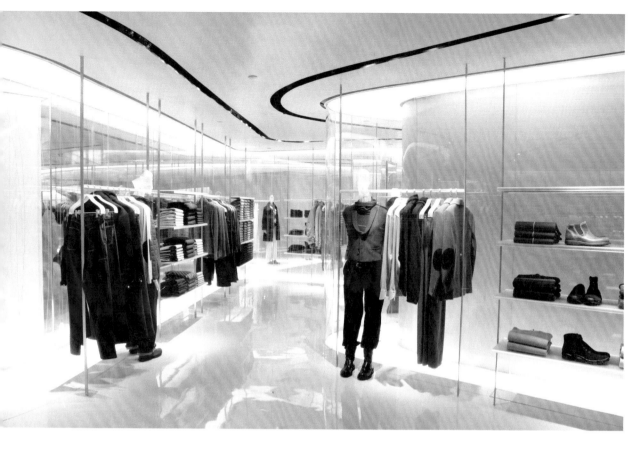

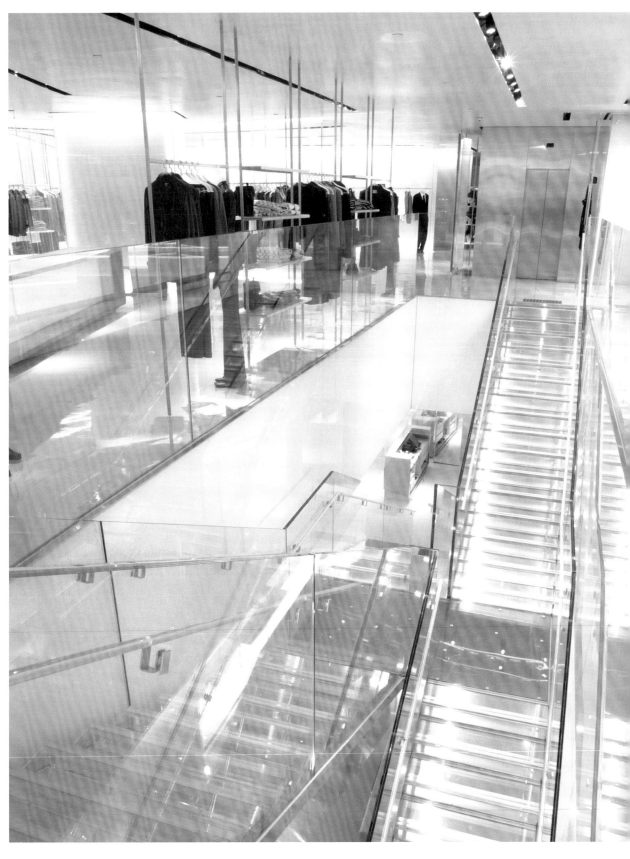

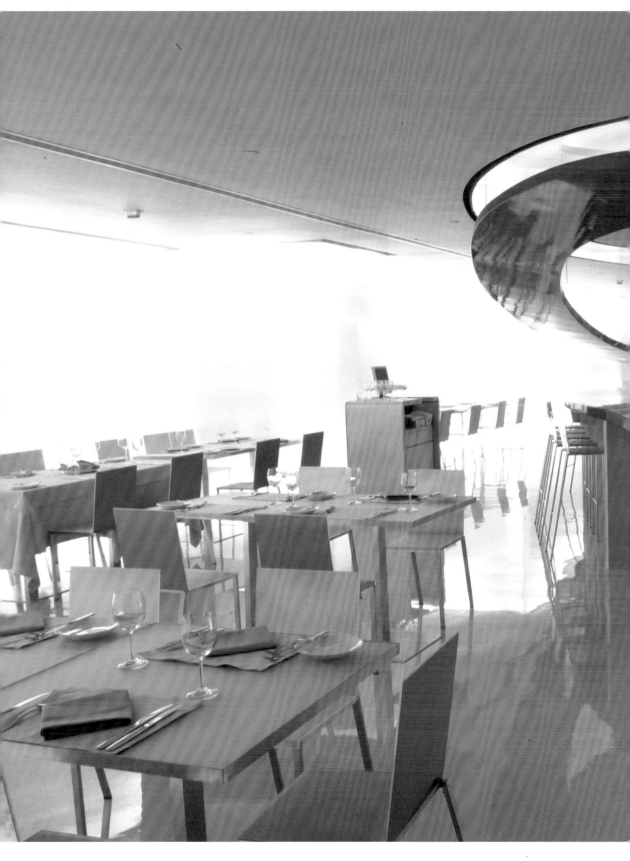

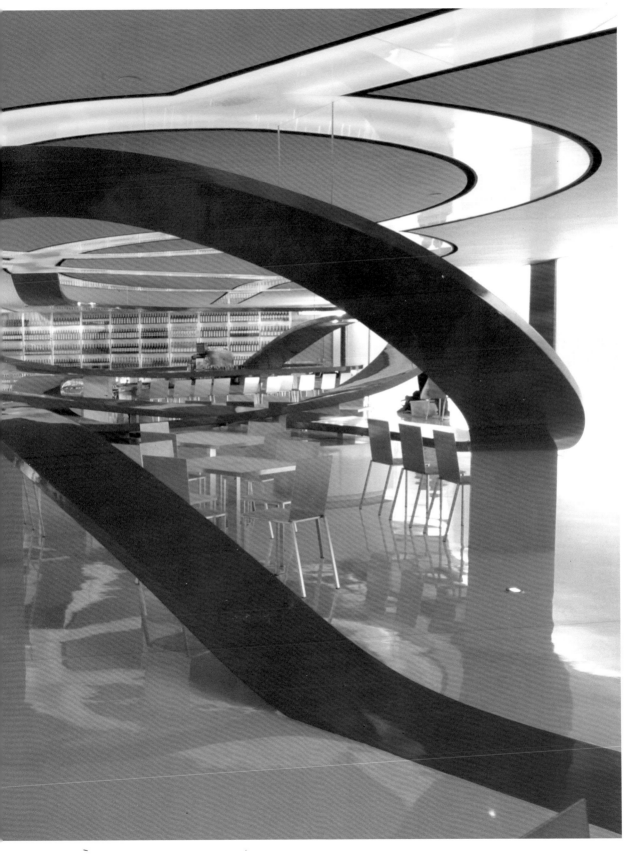

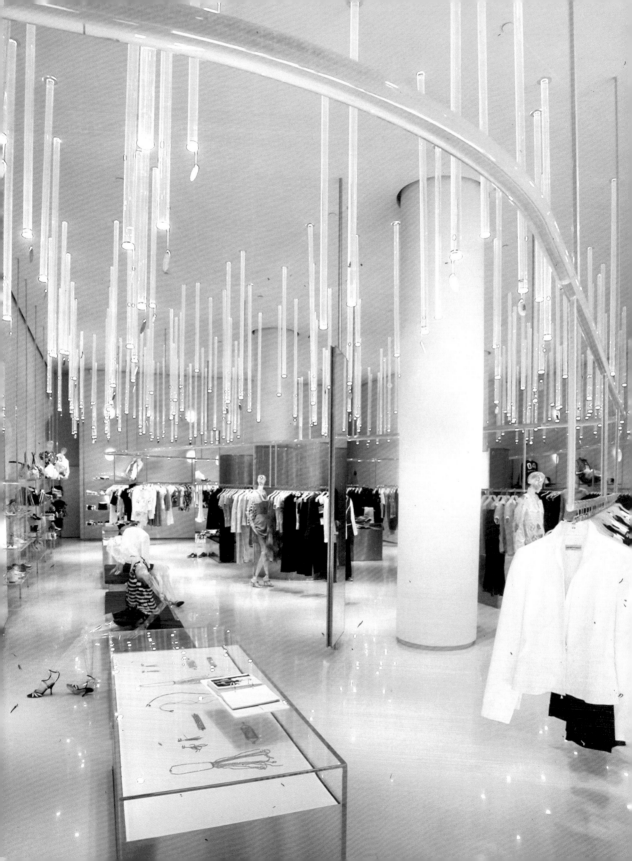

MASSIMILIANO FUKSAS | MILAN

GIORGIO ARMANI
Milan, Italy | 2004

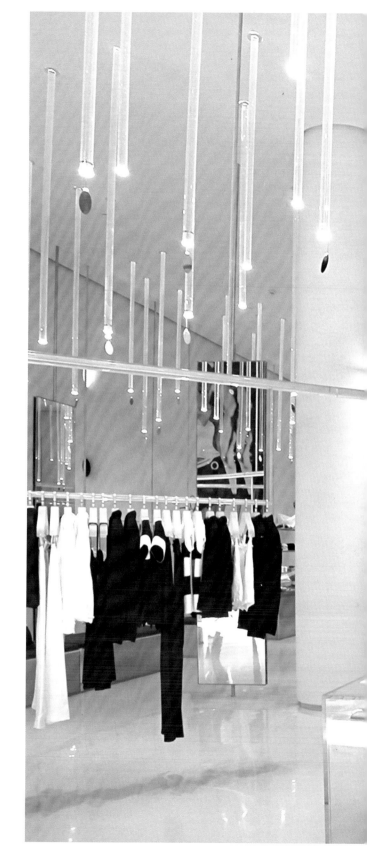

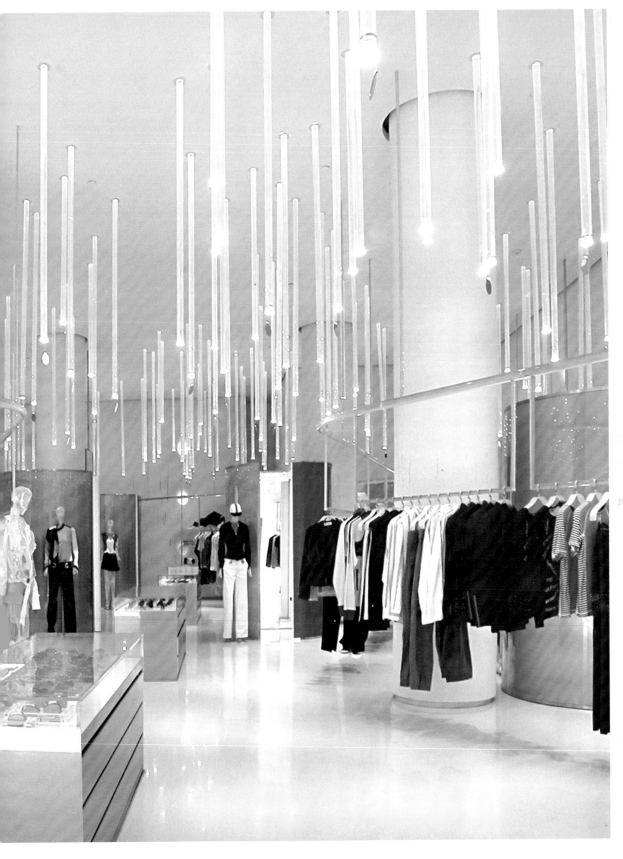

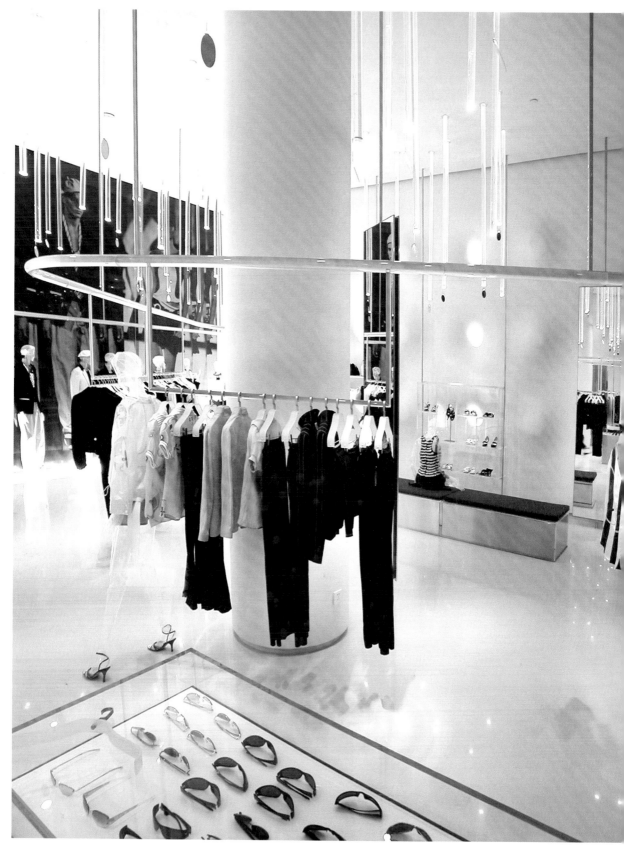

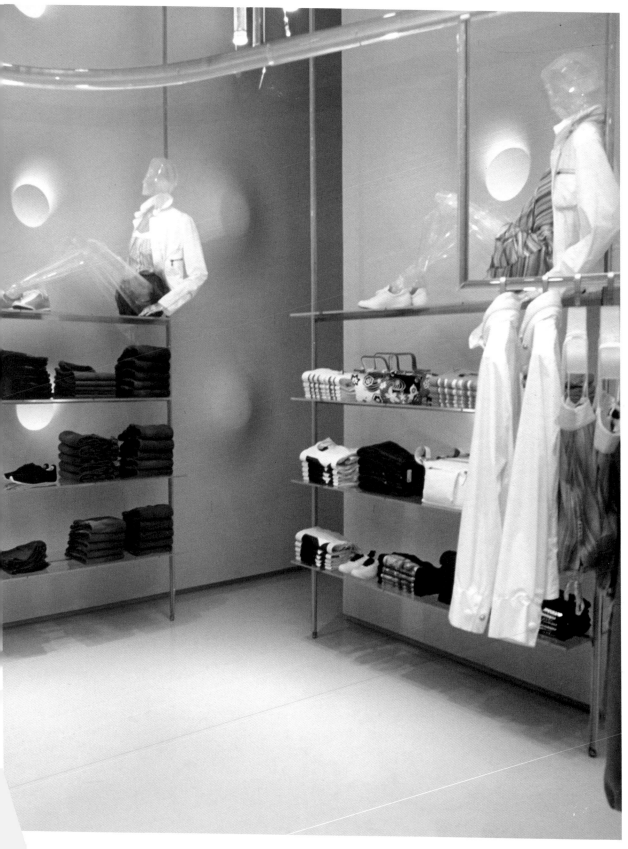

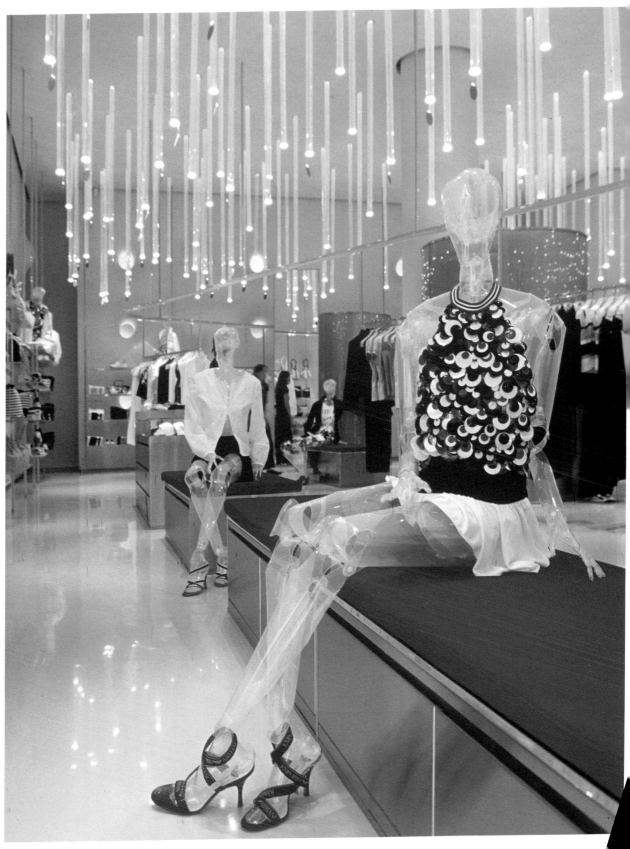

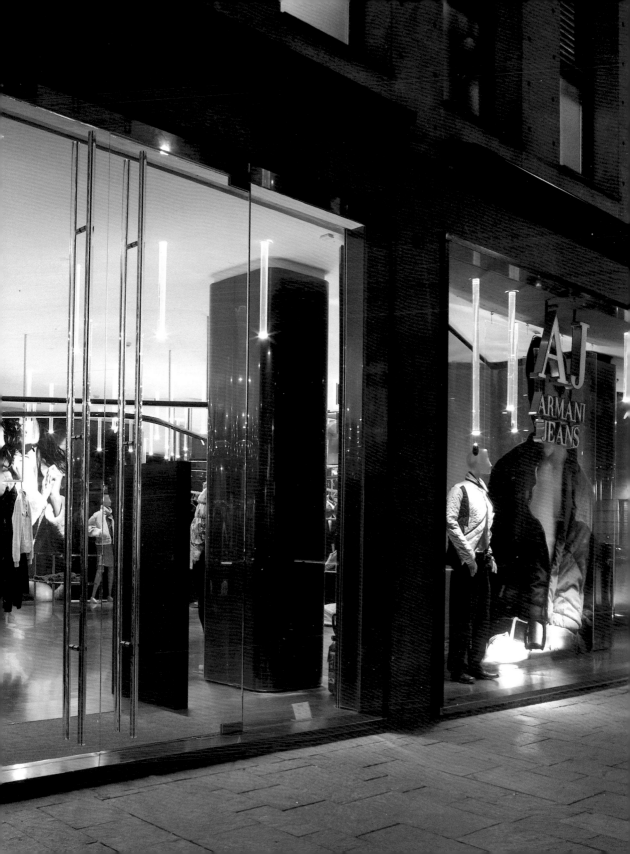

MASSIMILIANO FUKSAS | MILAN
GIORGIO ARMANI JEANS
Shanghai, China | 2004

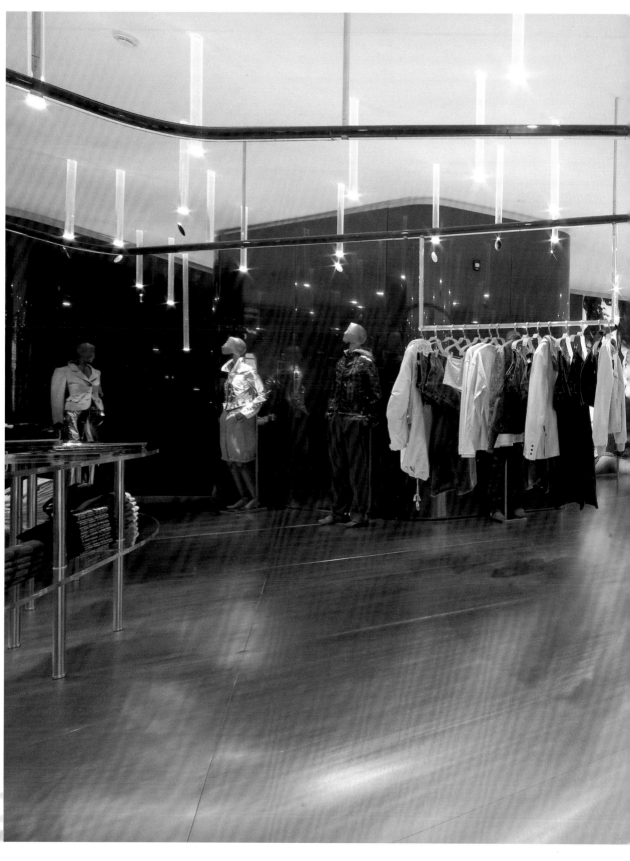

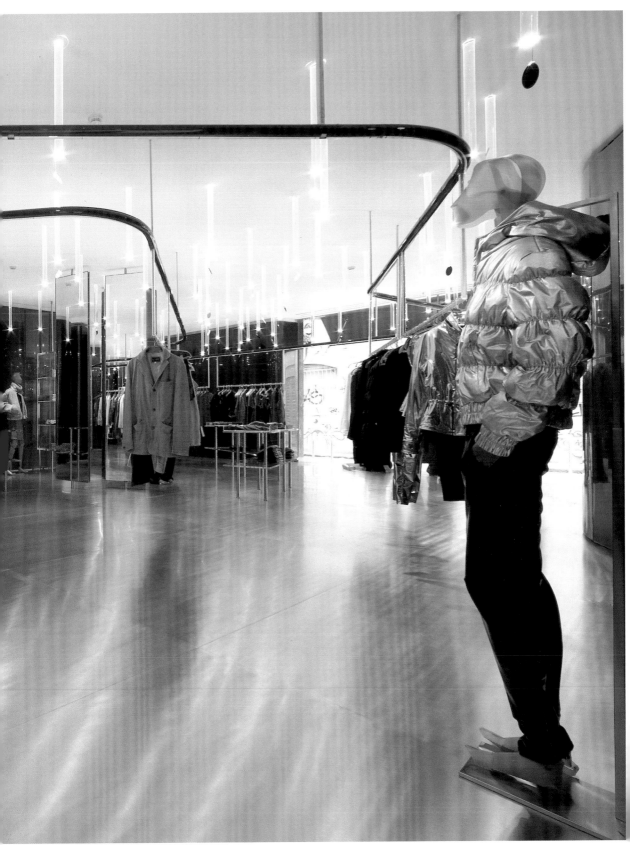

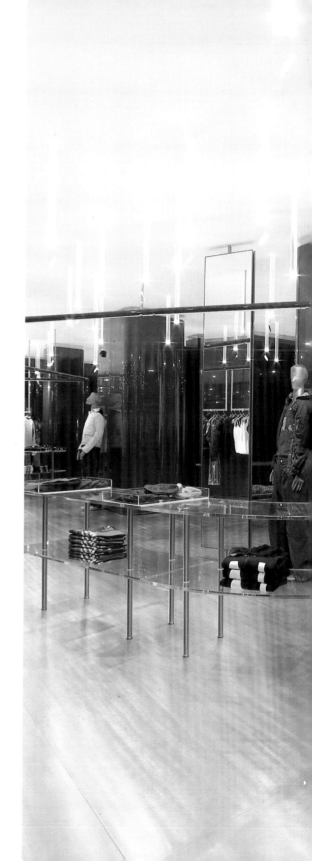

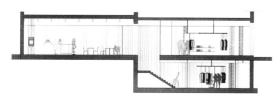

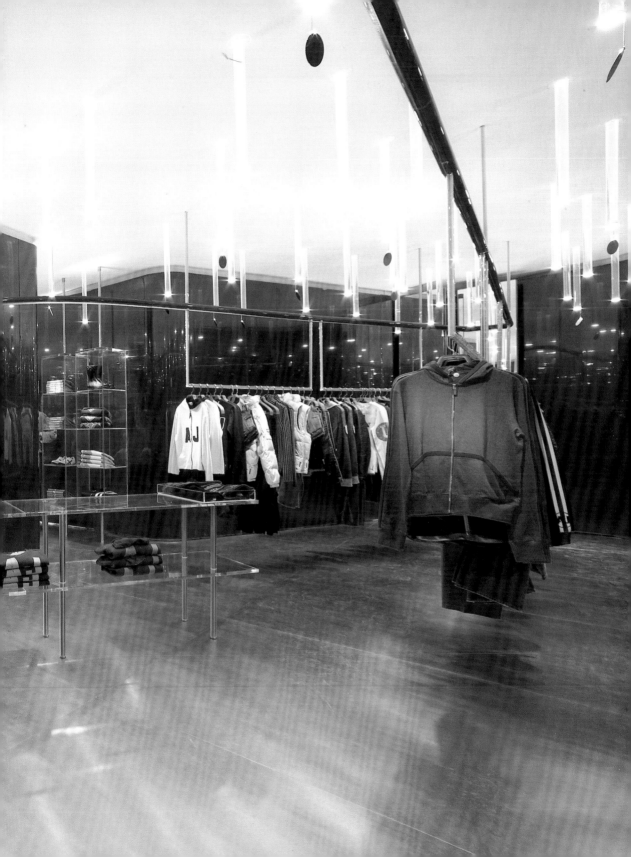

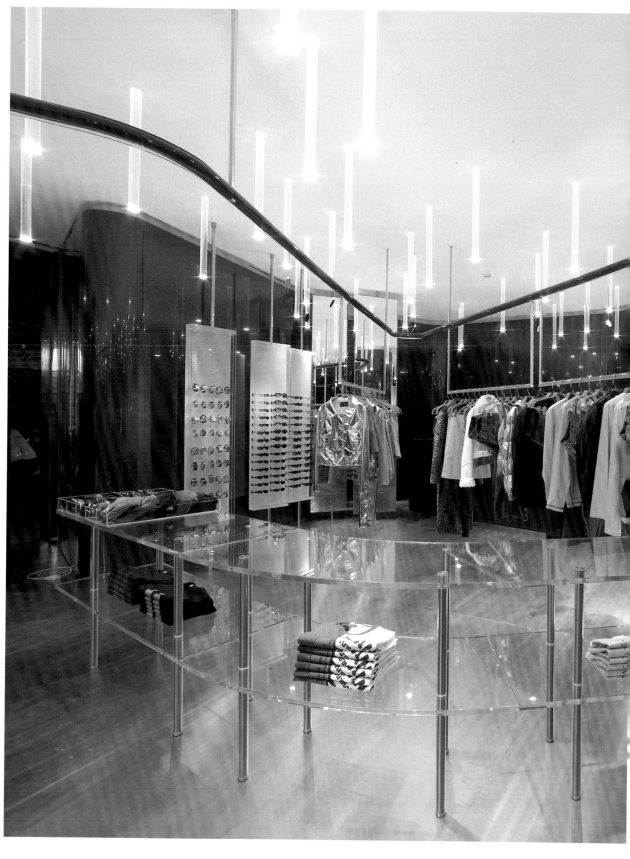

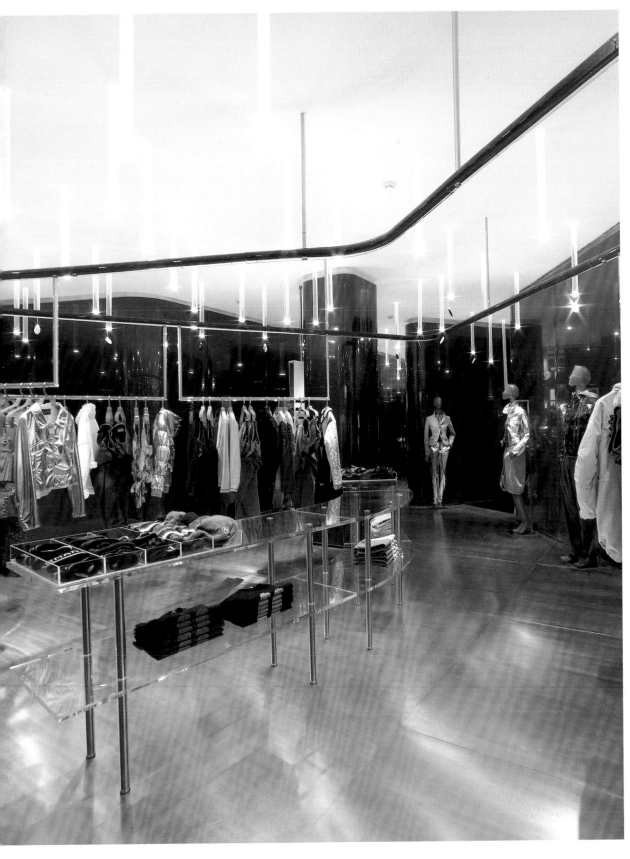

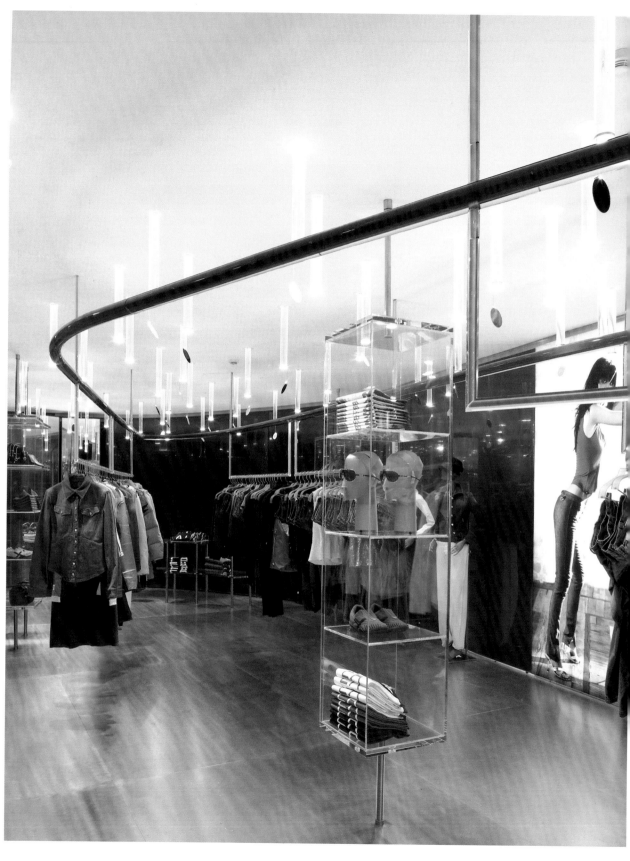

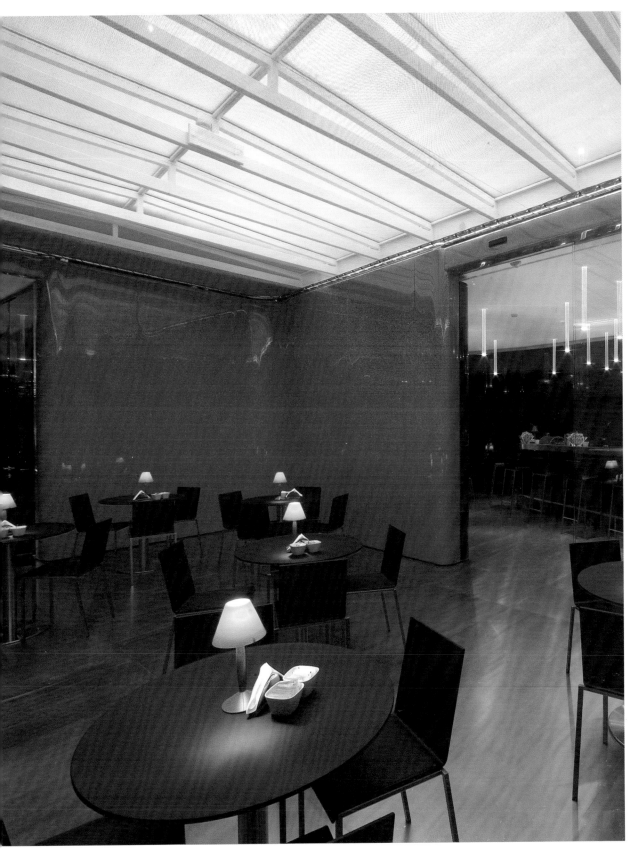

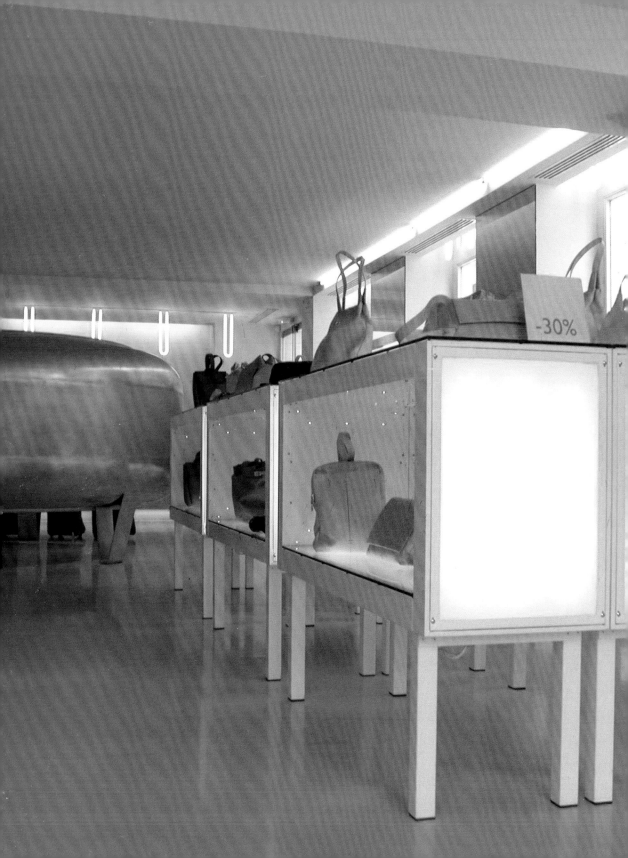

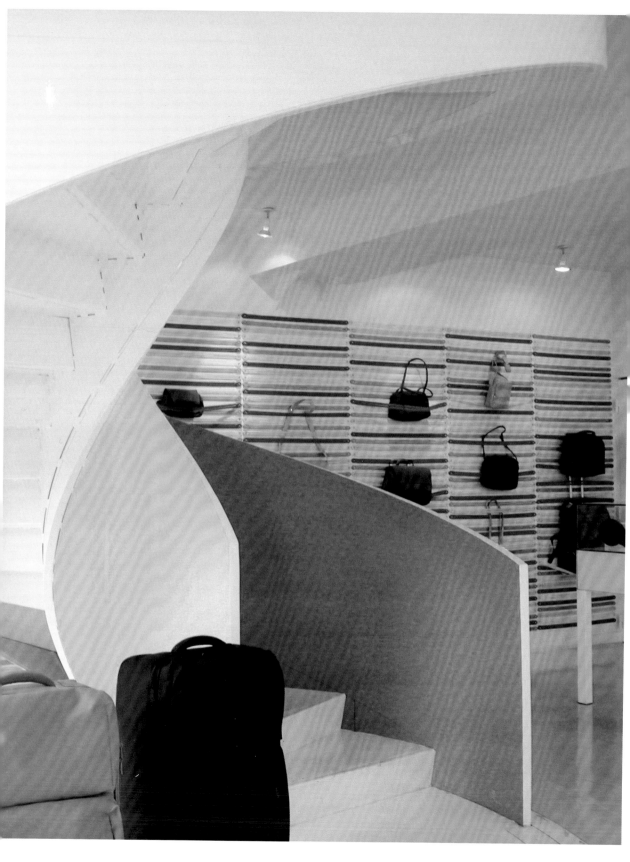

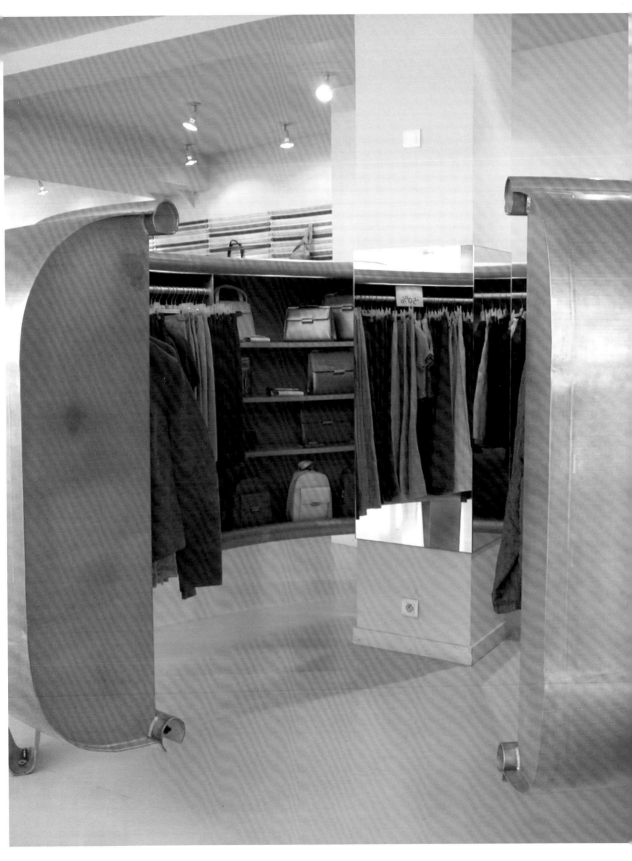

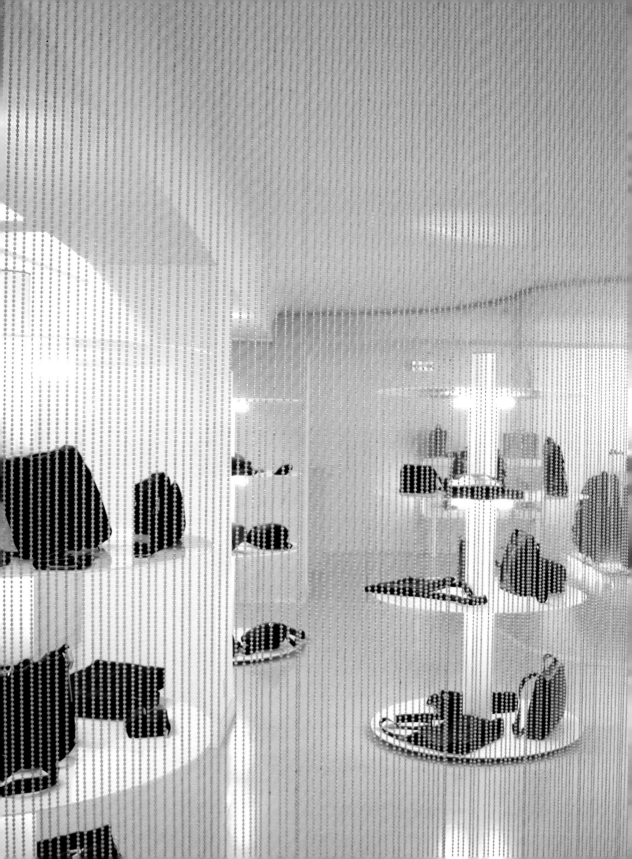

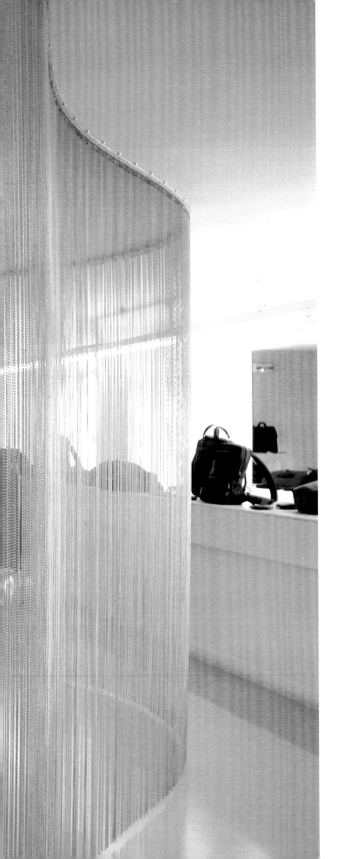

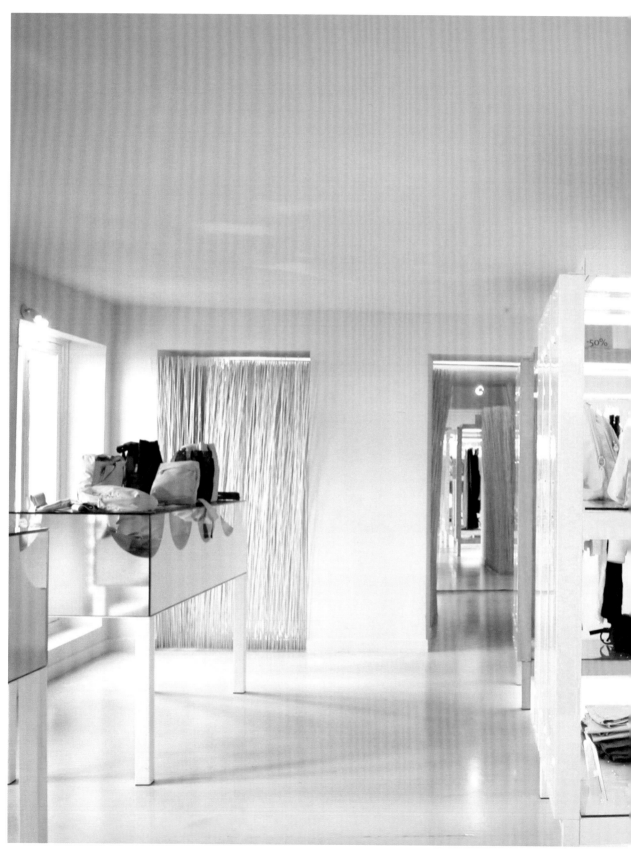

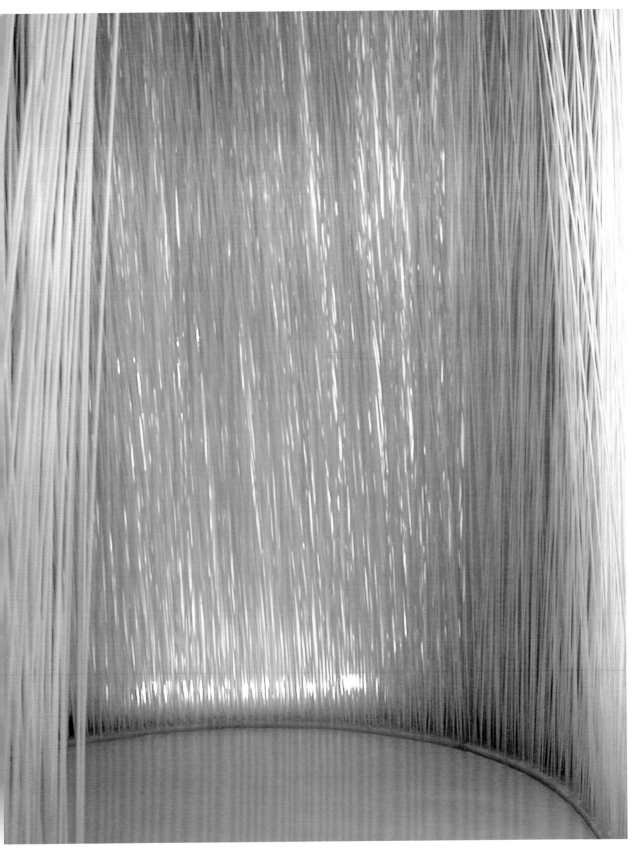

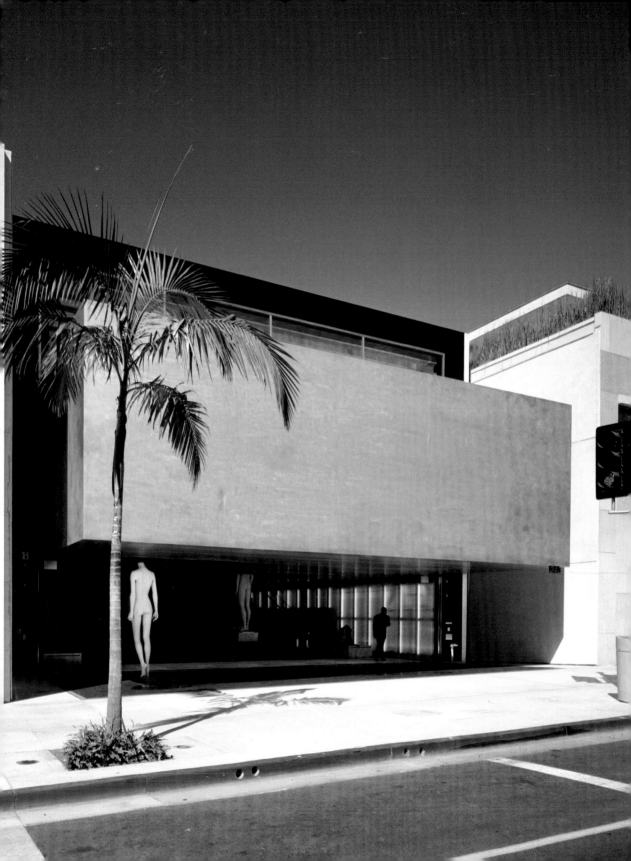

OFFICE FOR METROPOLITAN ARCHITECTURE | **ROTTERDAM**
PRADA
Los Angeles, USA | 2004

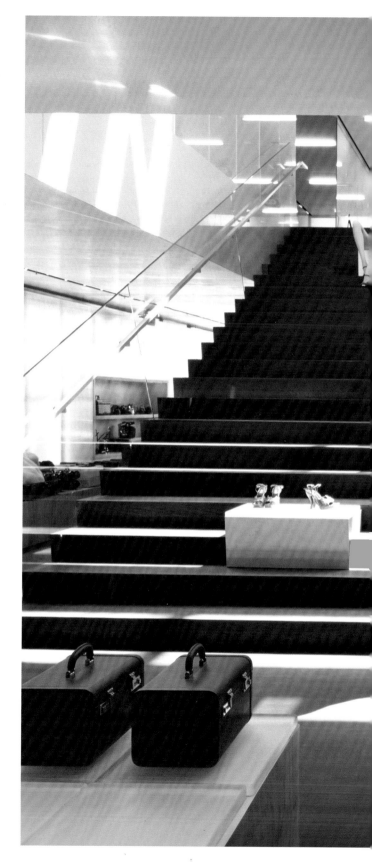

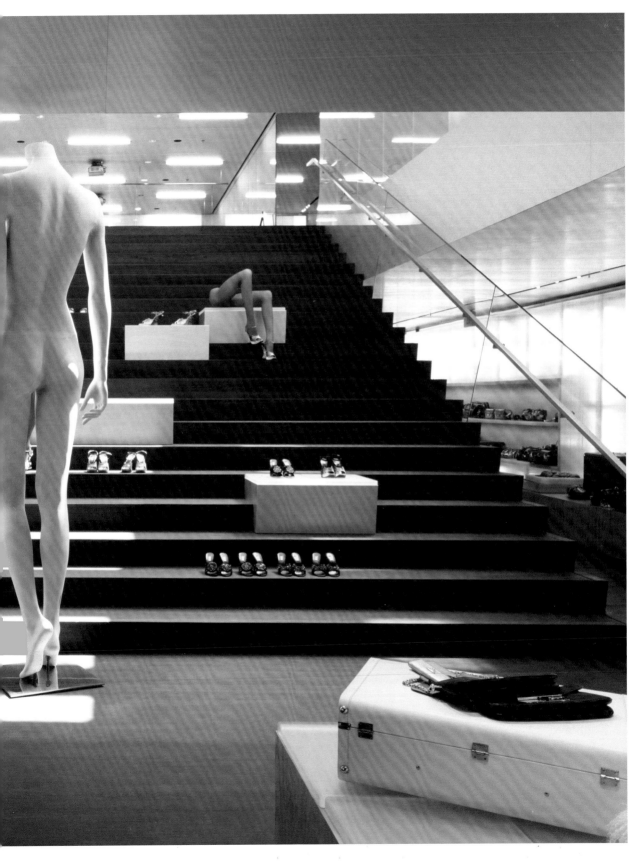

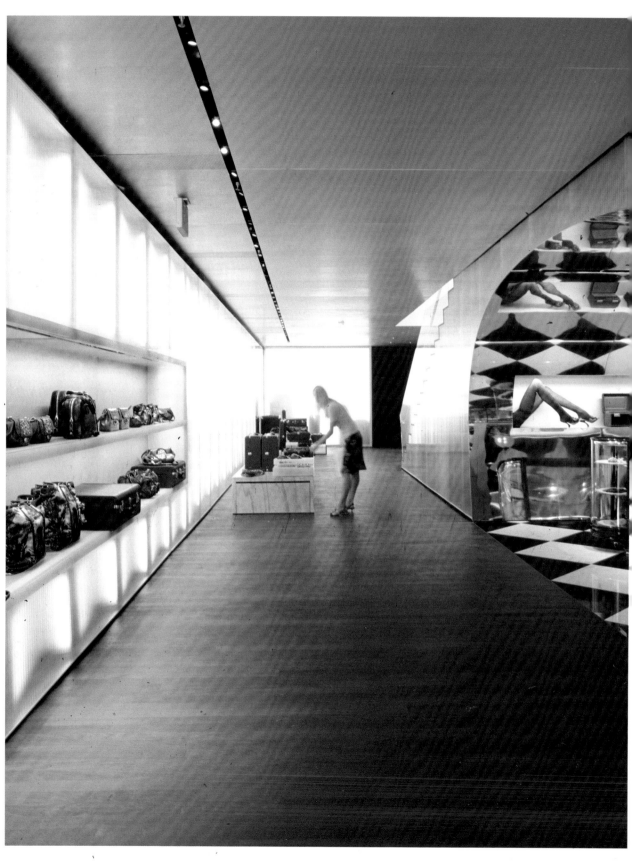

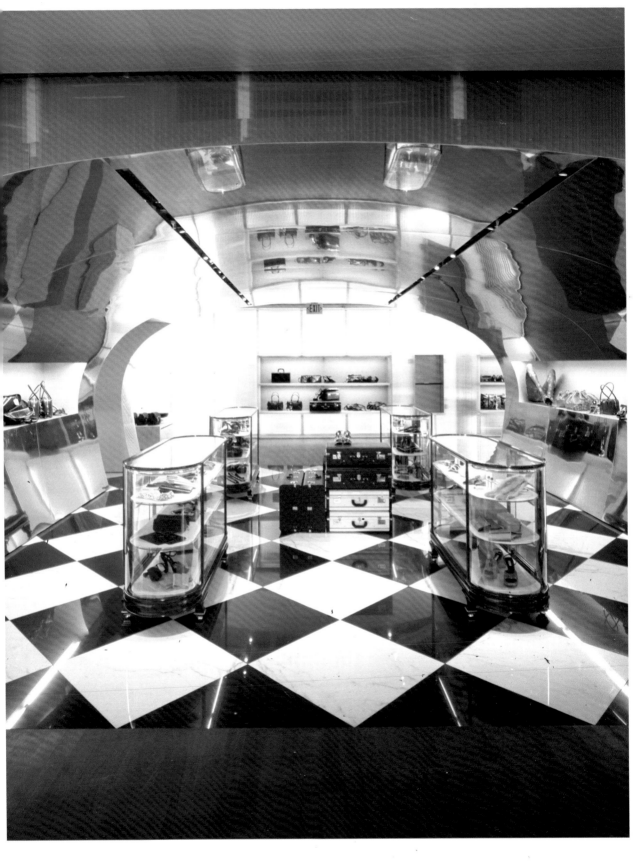

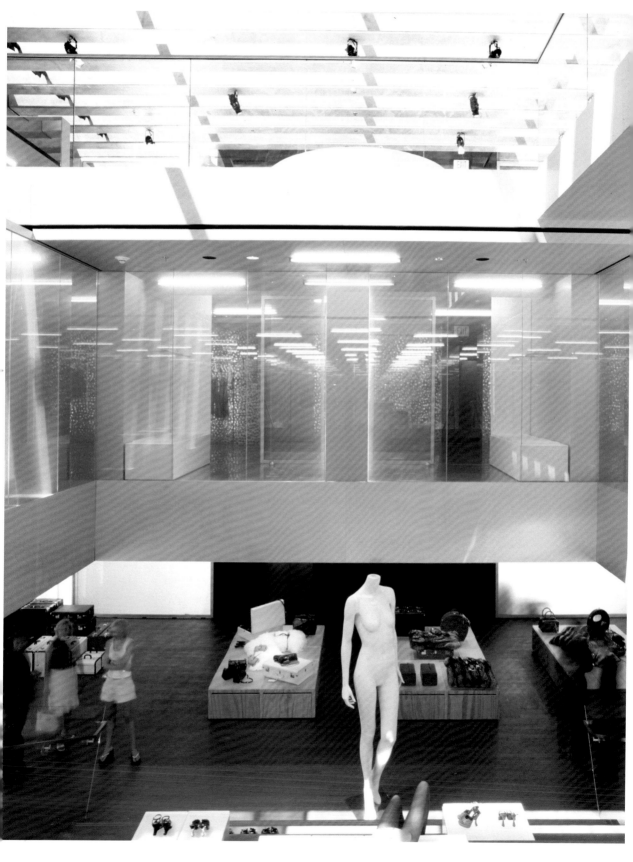

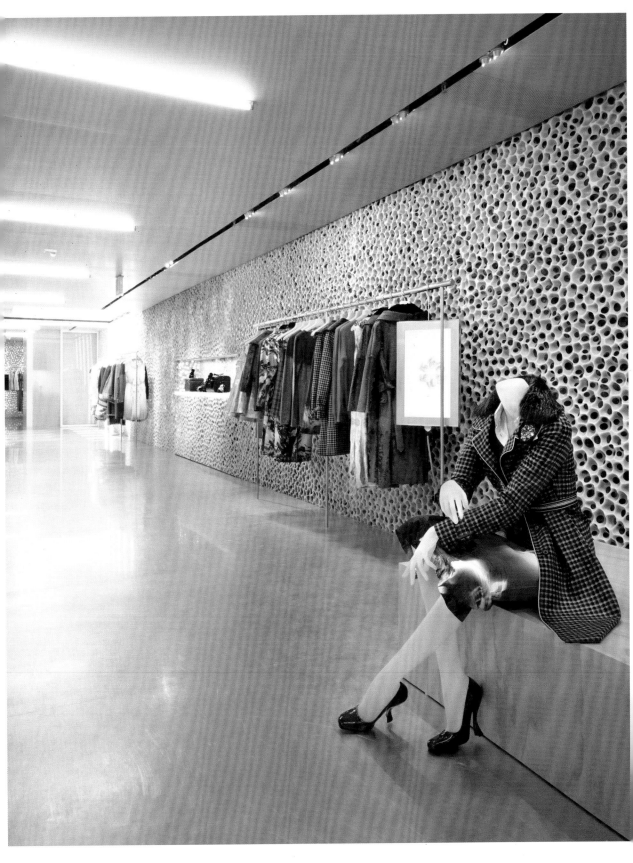

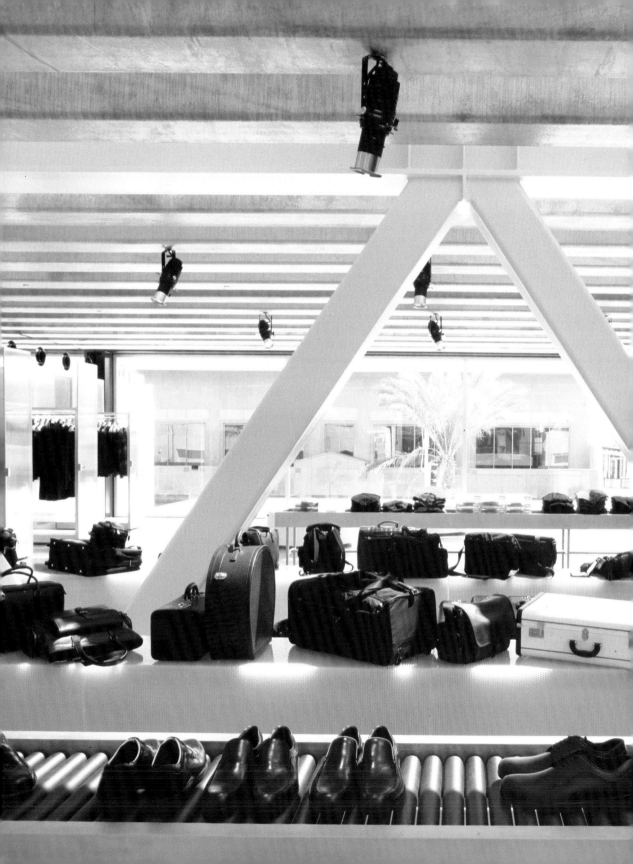

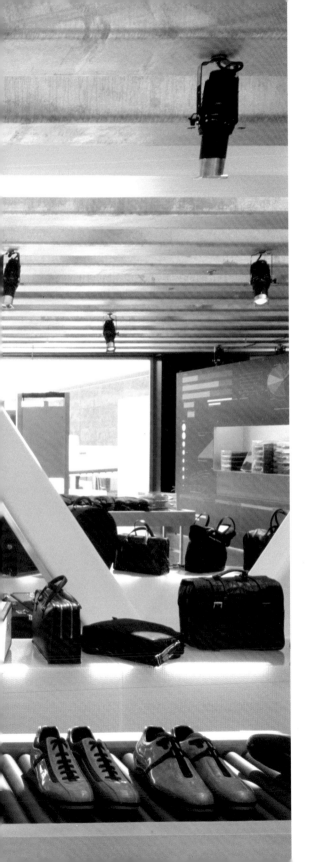

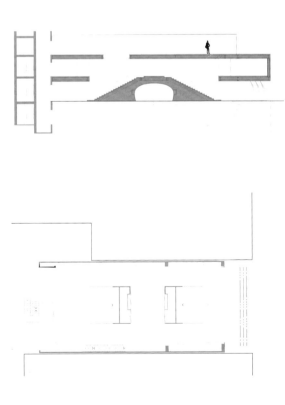

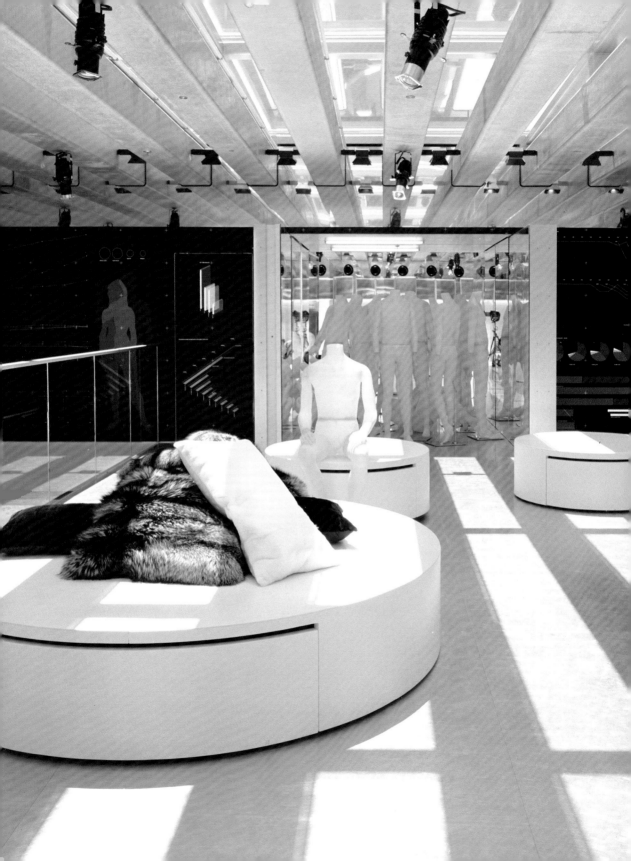

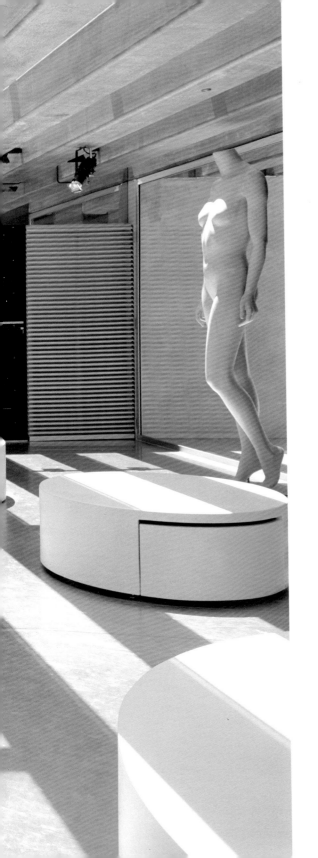

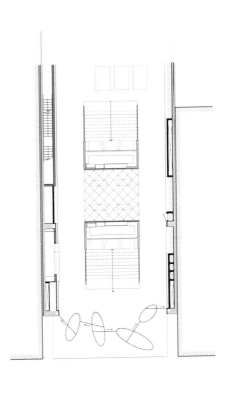

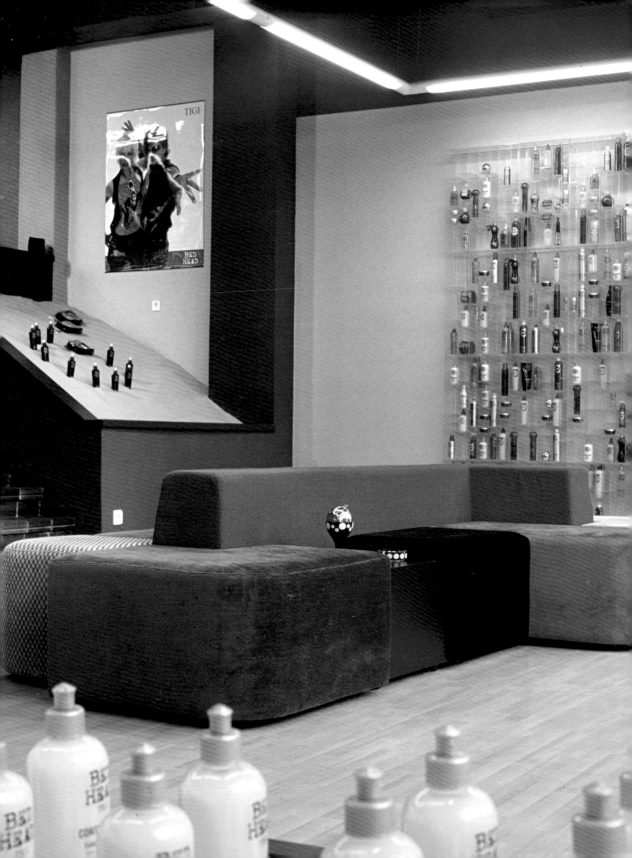

PICHIGLASS | BARCELONA
ADUHO
Barcelona, Spain | 2004

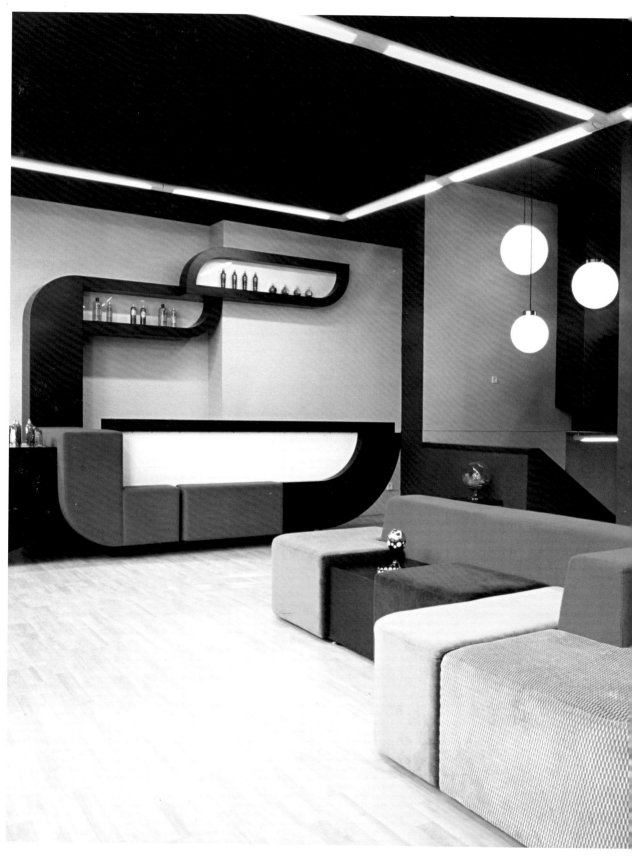

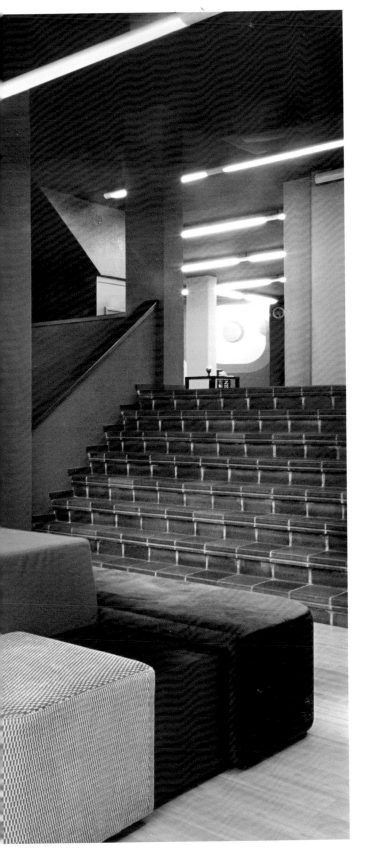

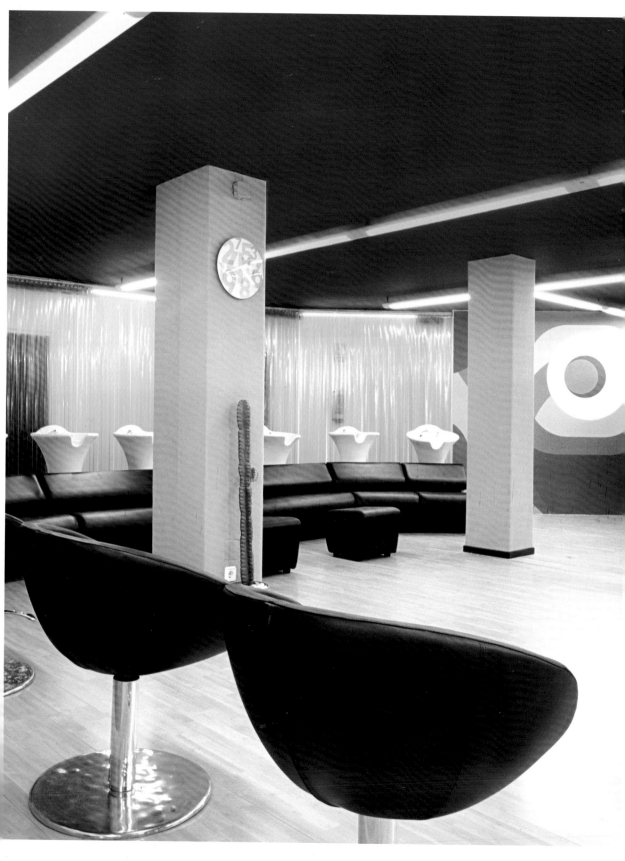

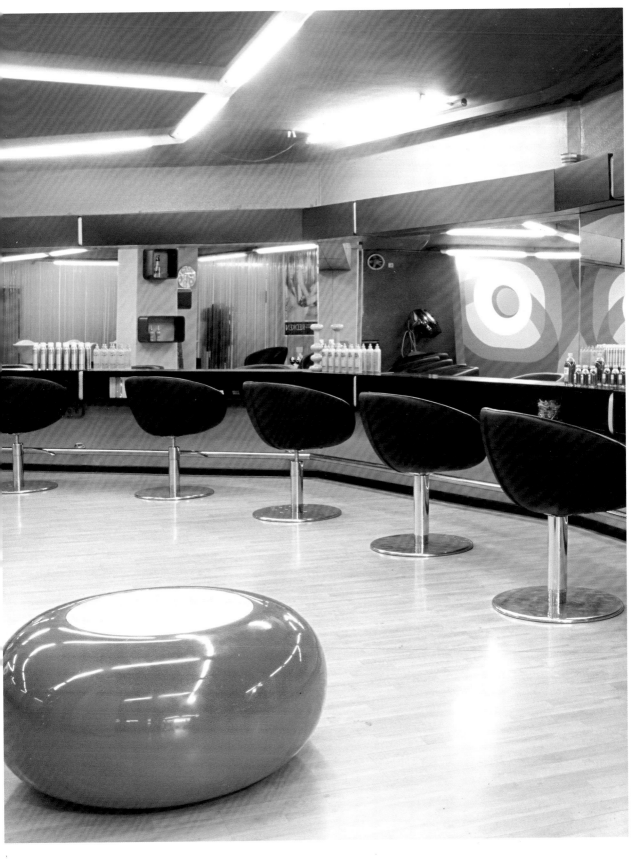

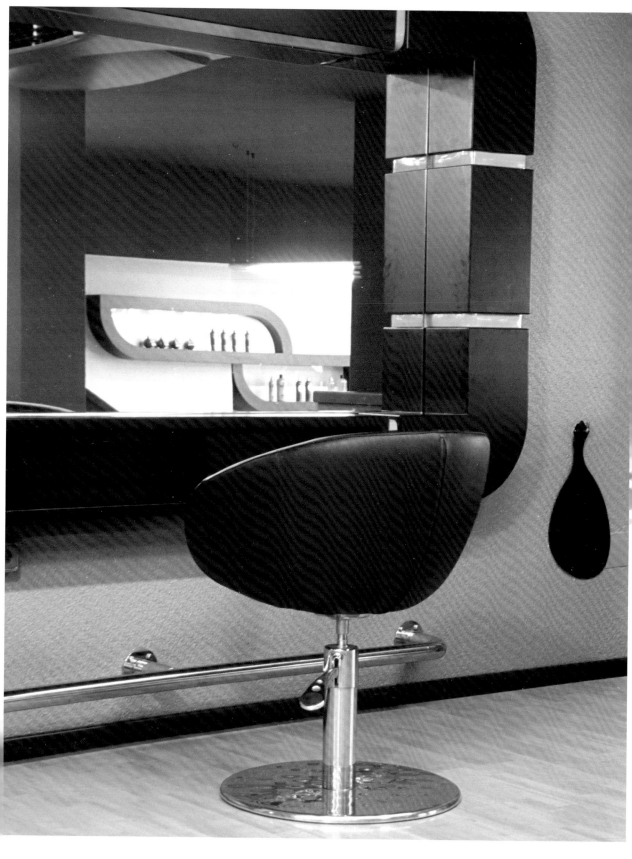

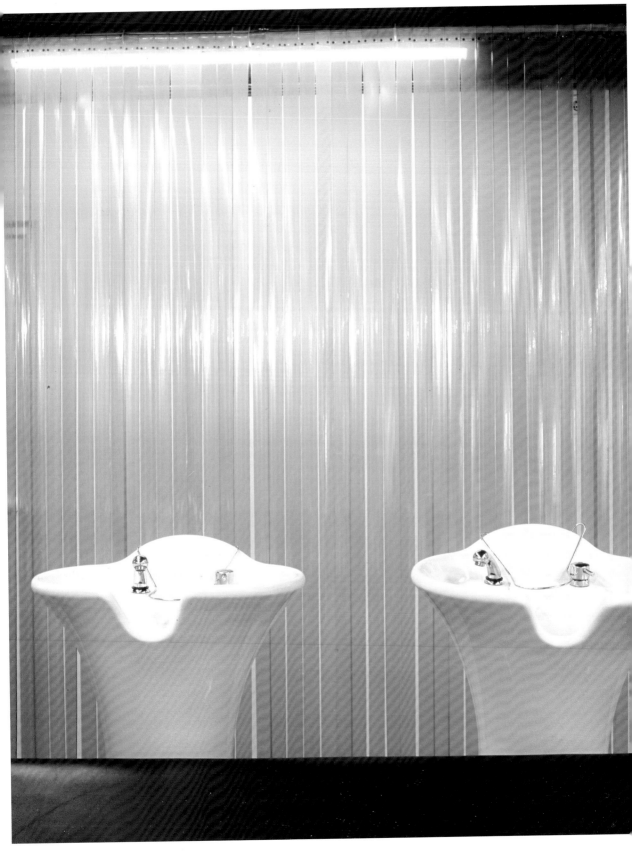

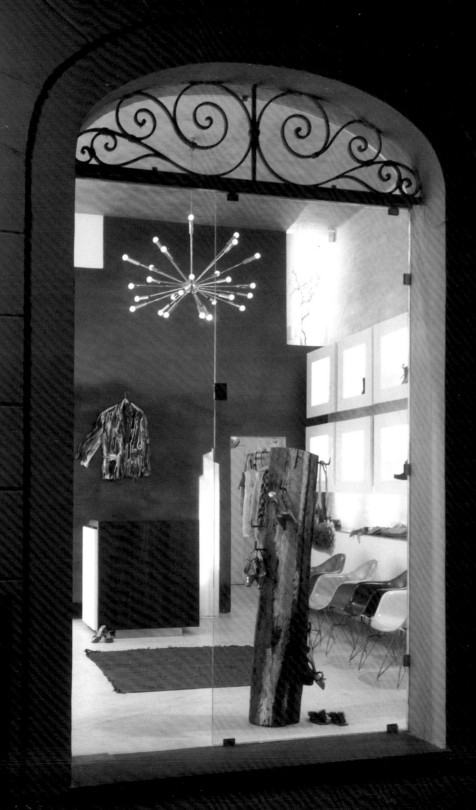

PIETRO GIORGIERI | FLORENCE
DAHL
Massa, Italy | 2001

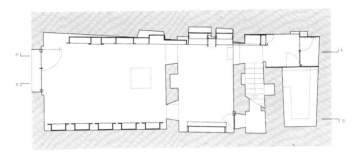

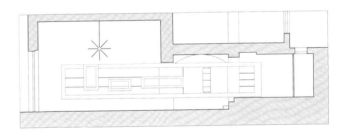

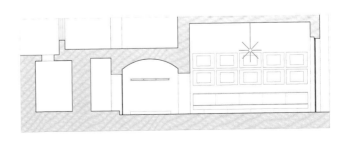

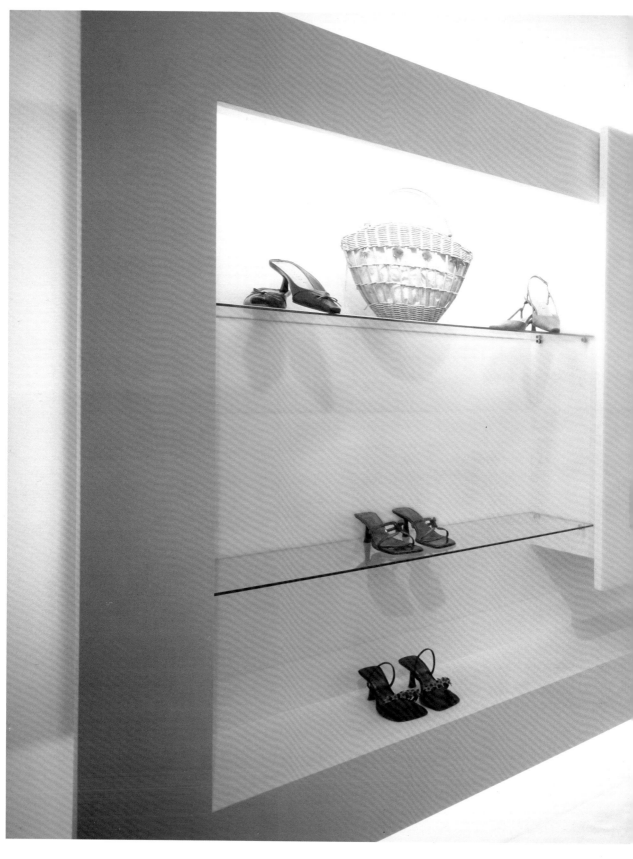

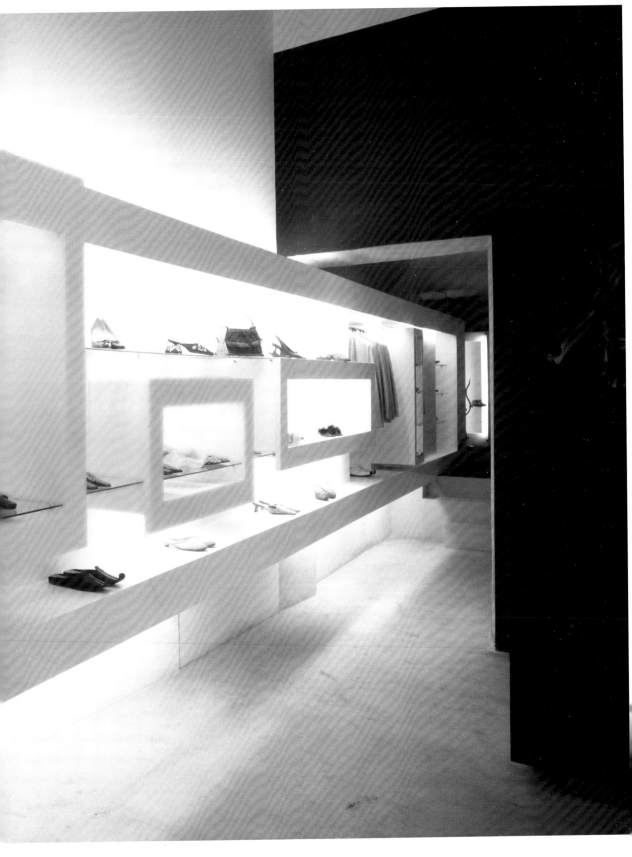

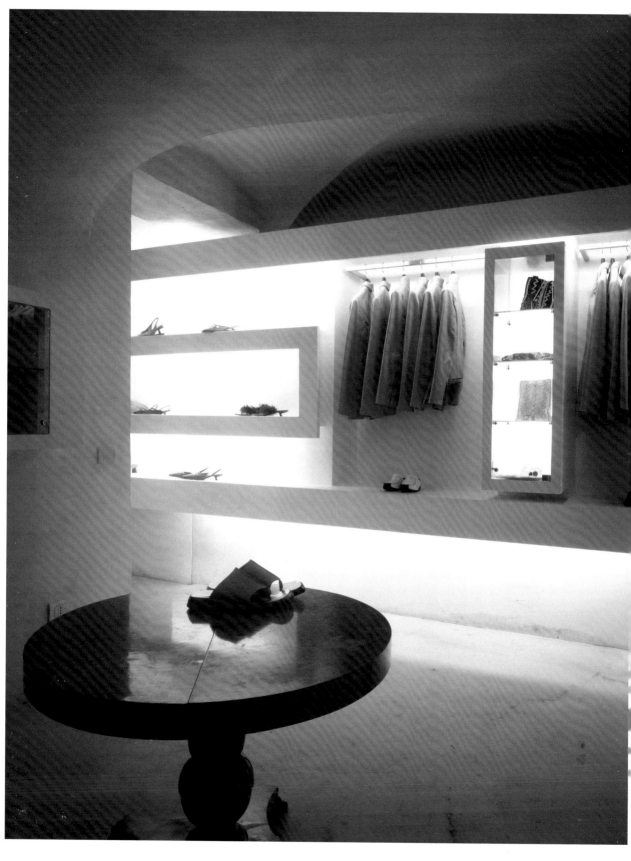

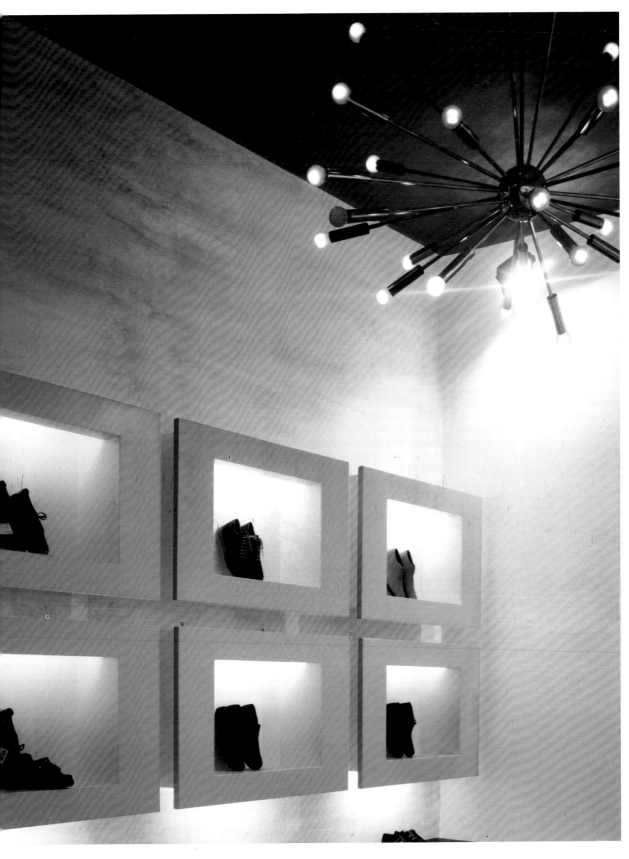

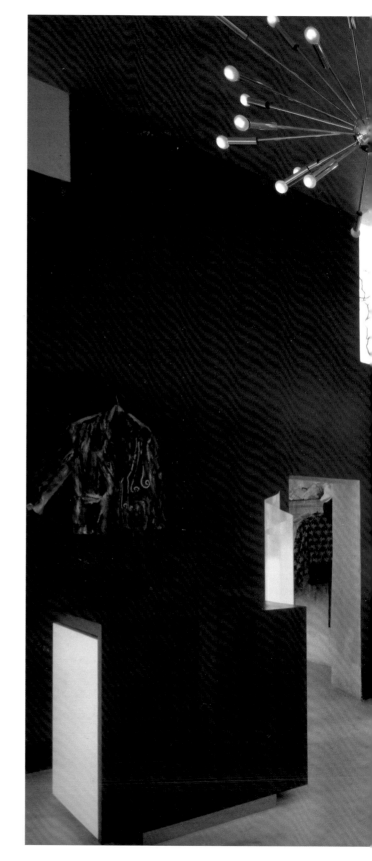

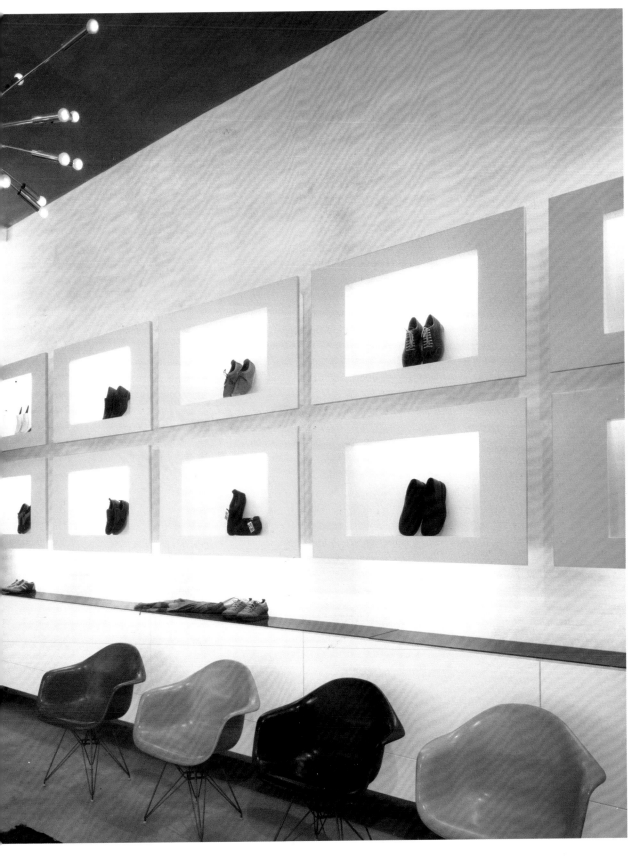

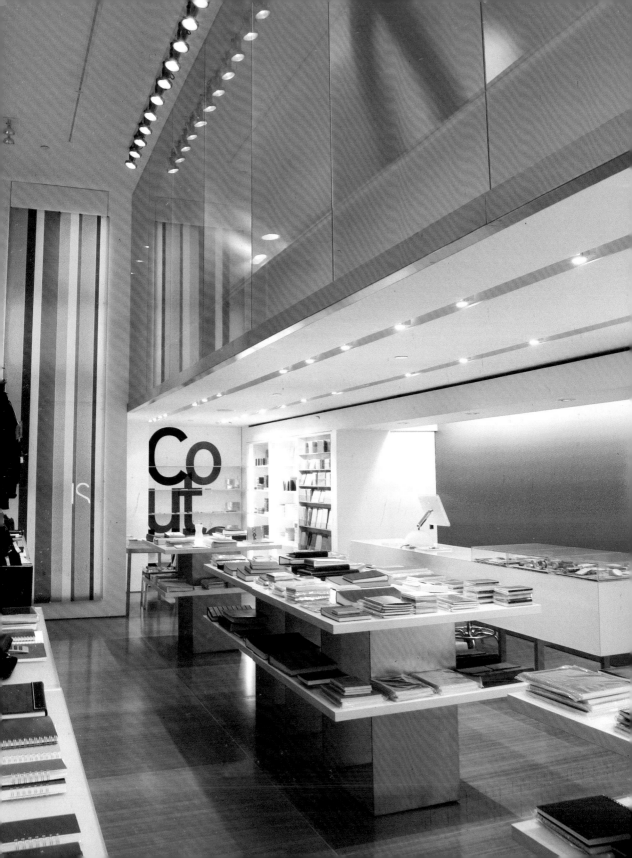

ROGER HIRSCH, MYRIAM CORTI | NEW YORK

IS/INDUSTRIES STATIONERY FLAGSHIP STORE
New York, USA | 2004

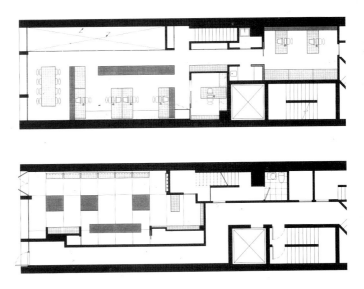

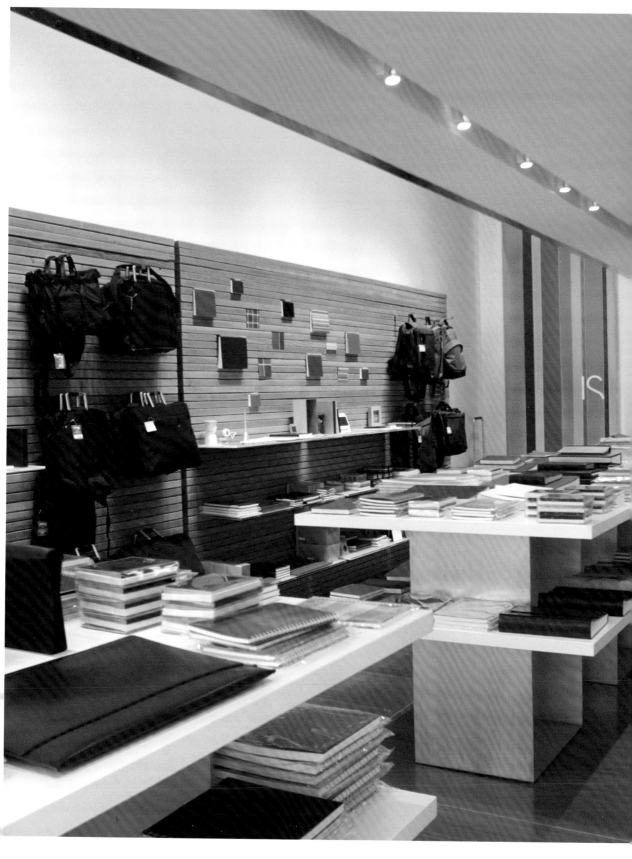

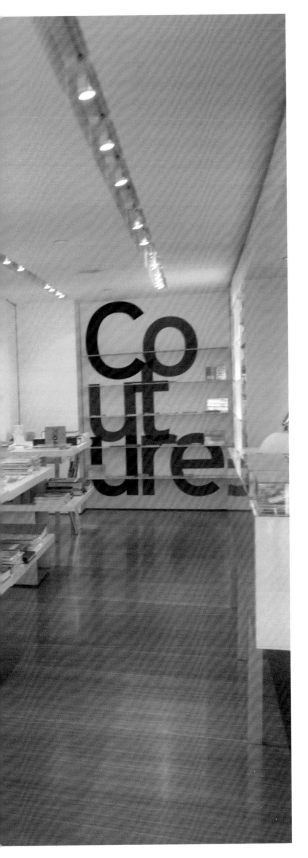

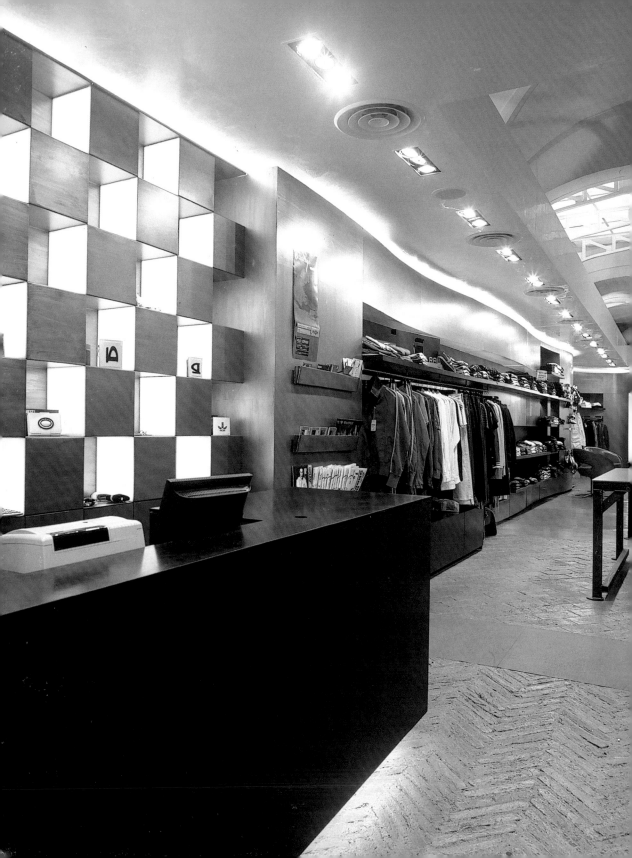

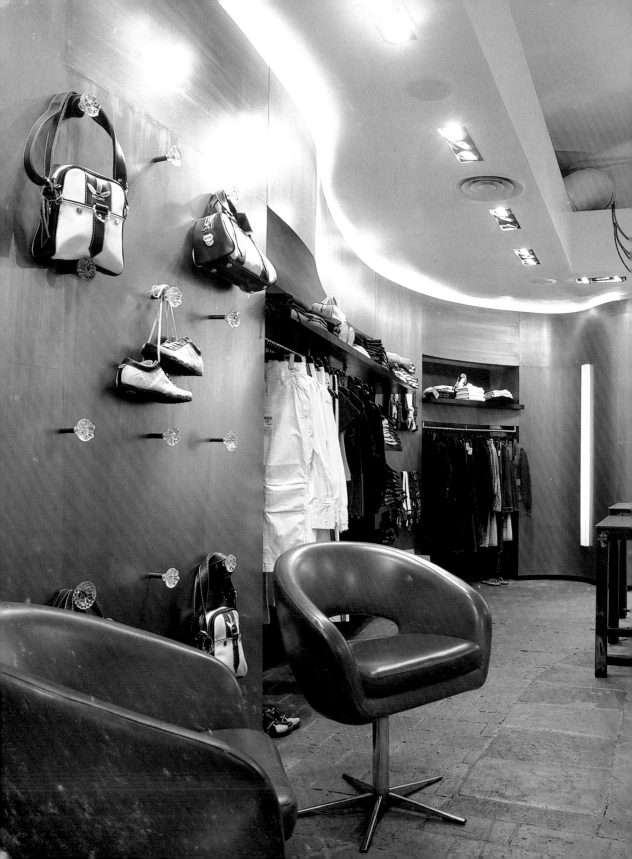

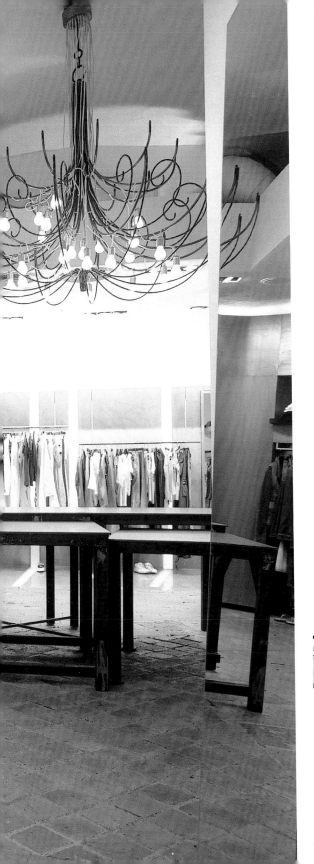

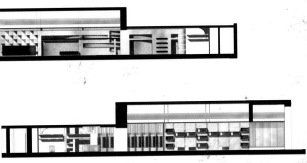

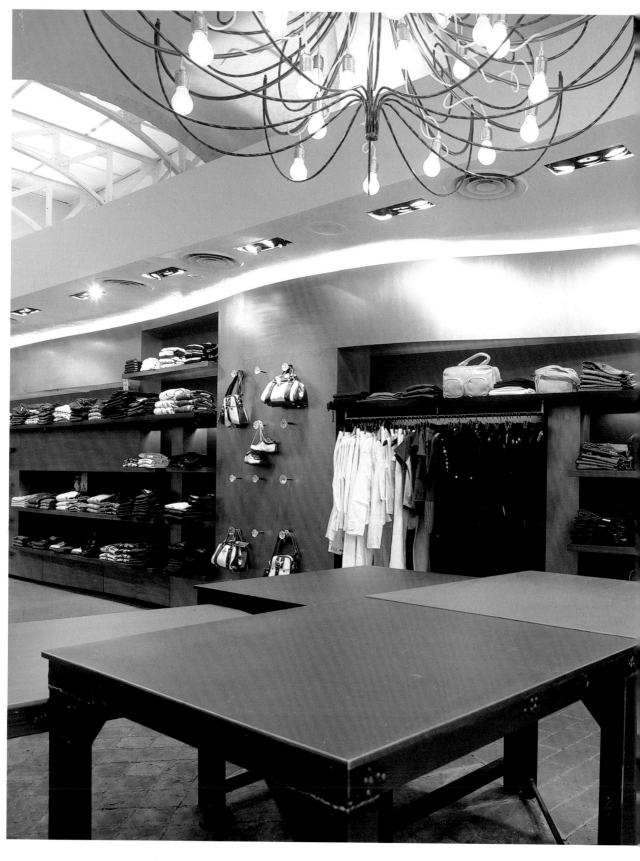

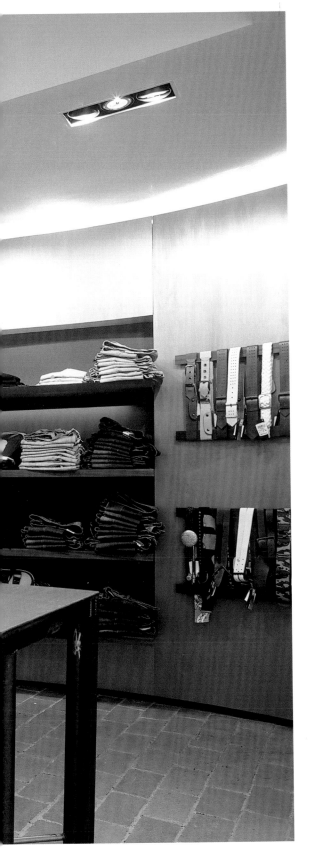

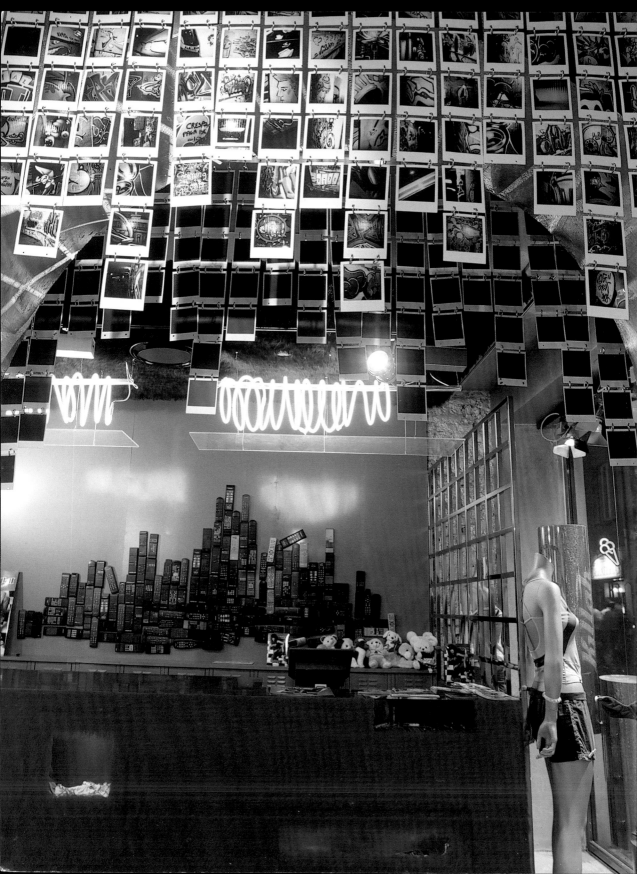

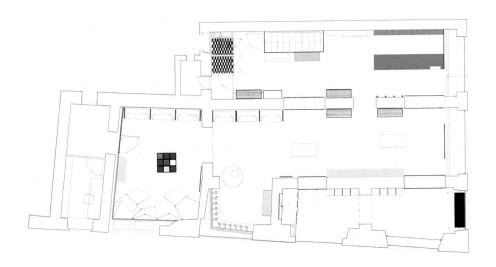

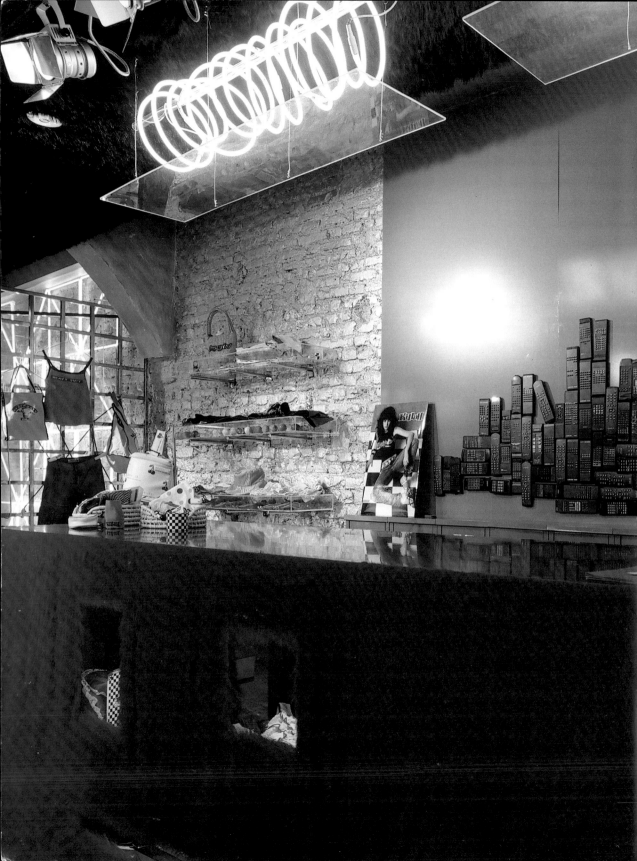

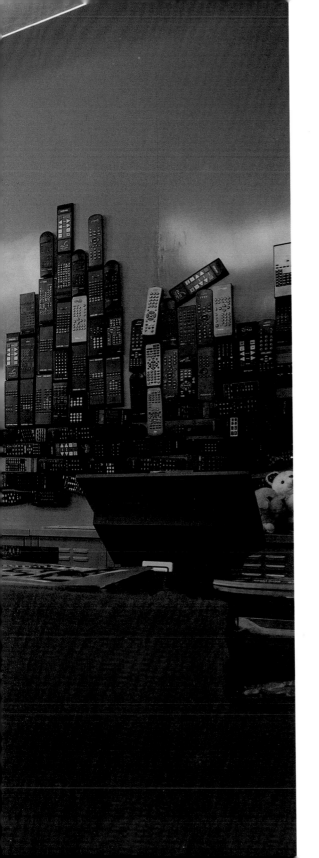

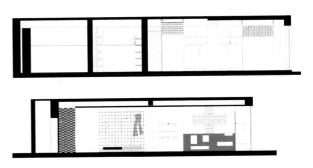

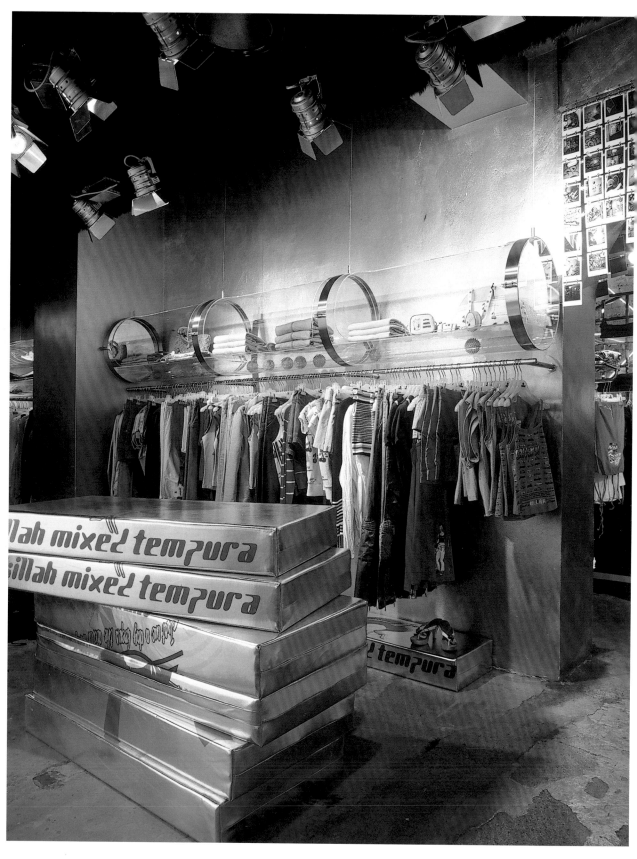

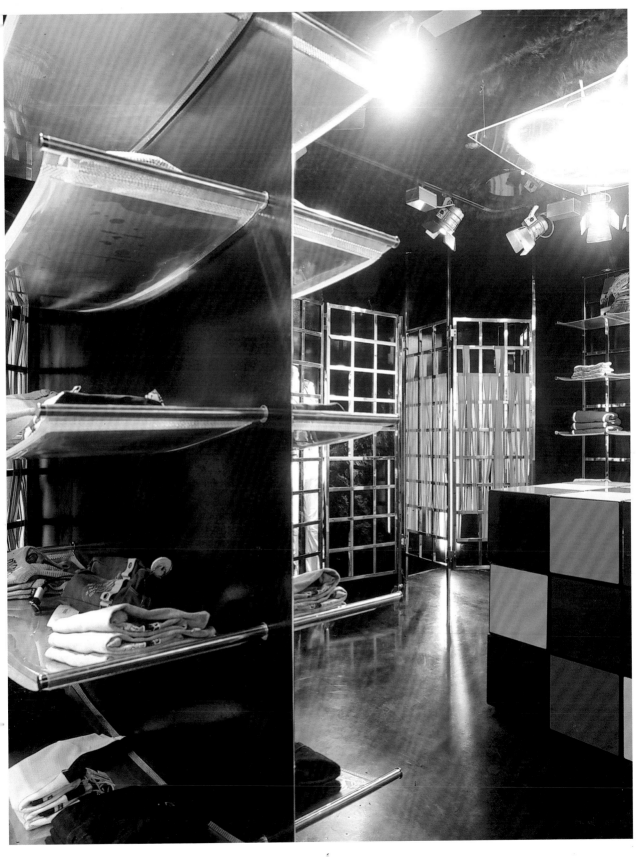

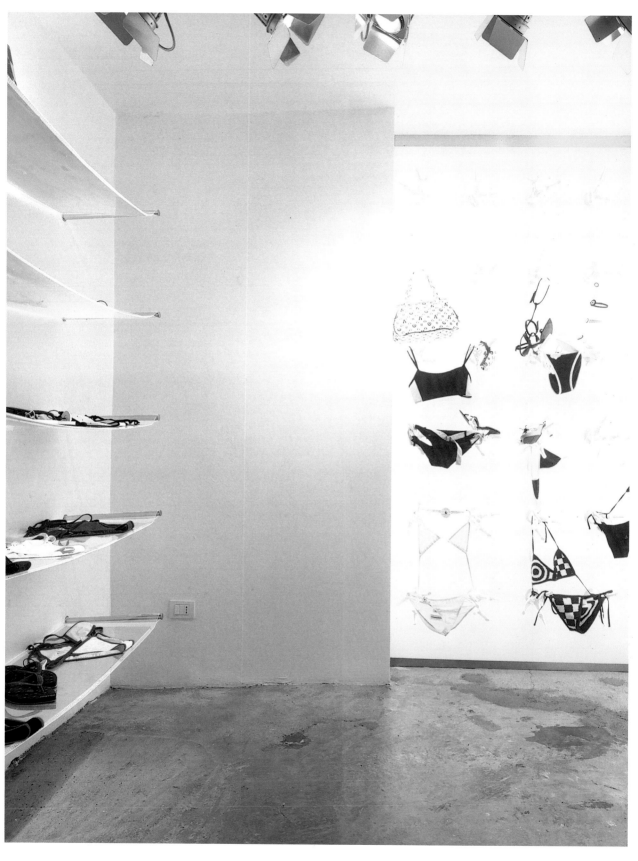

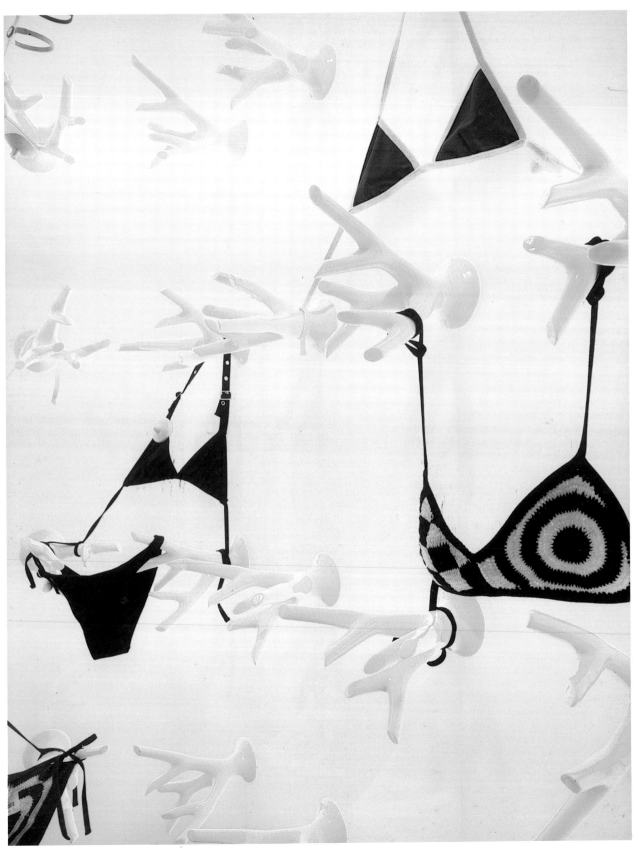

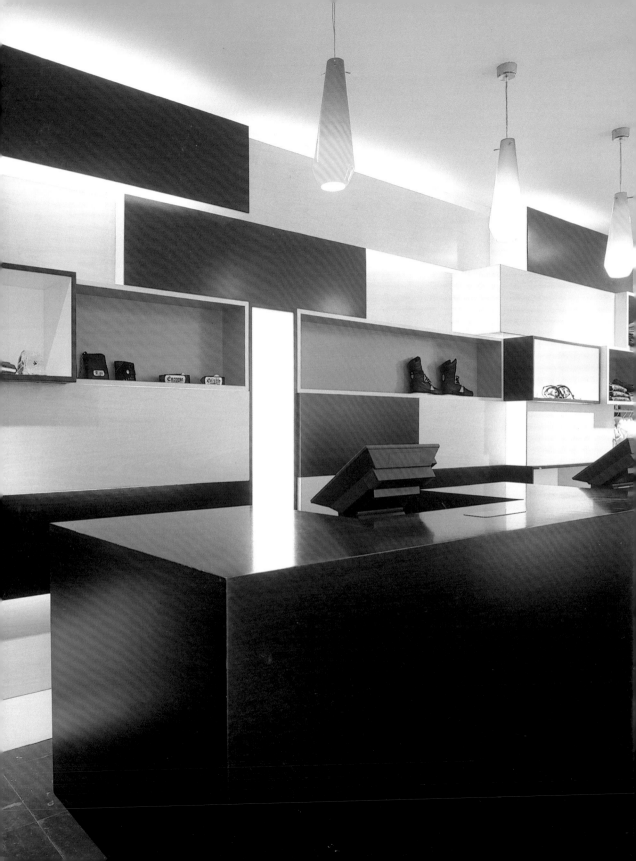

STUDIO 63 | FLORENCE
MISS SIXTY
Palermo, Italy | 2003

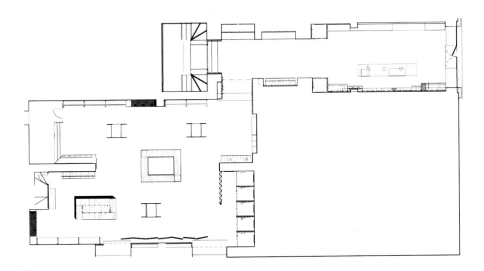

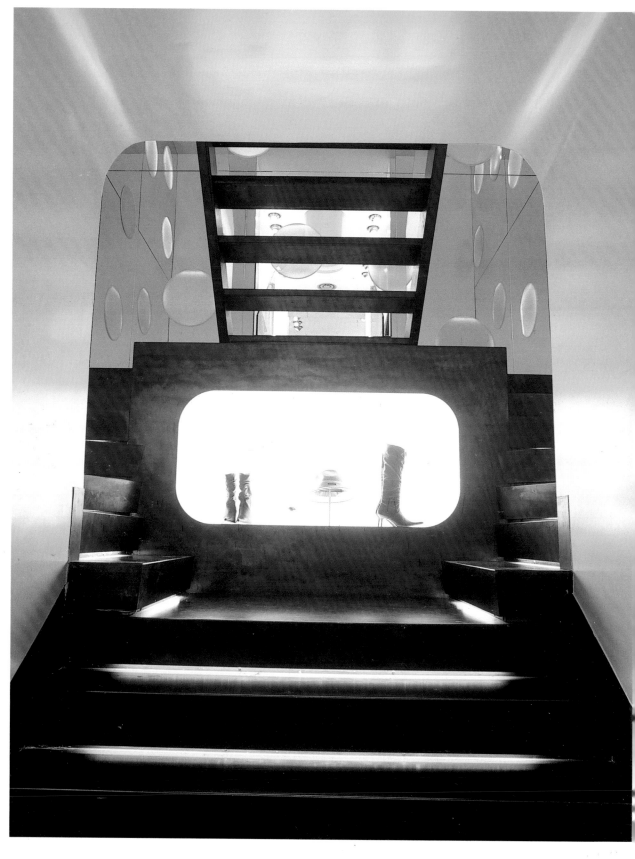

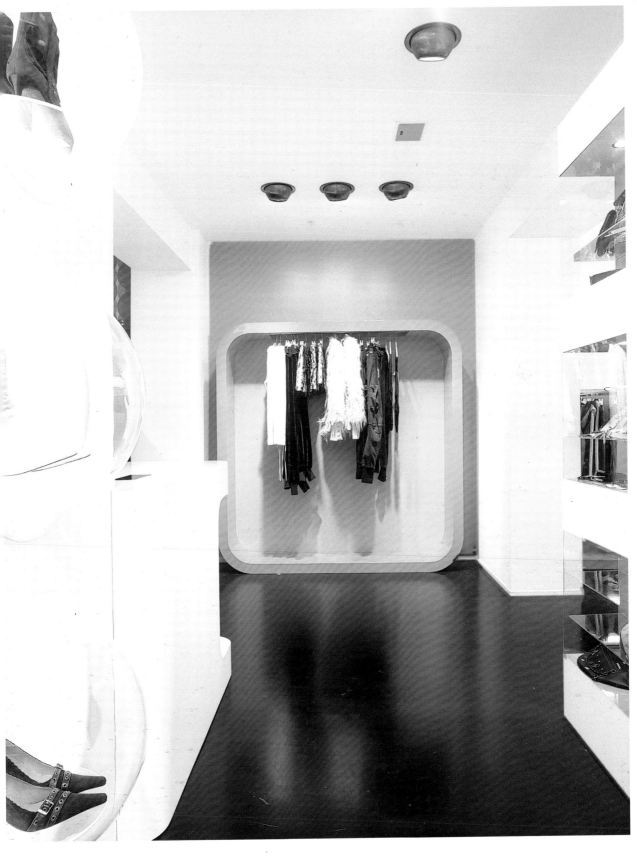

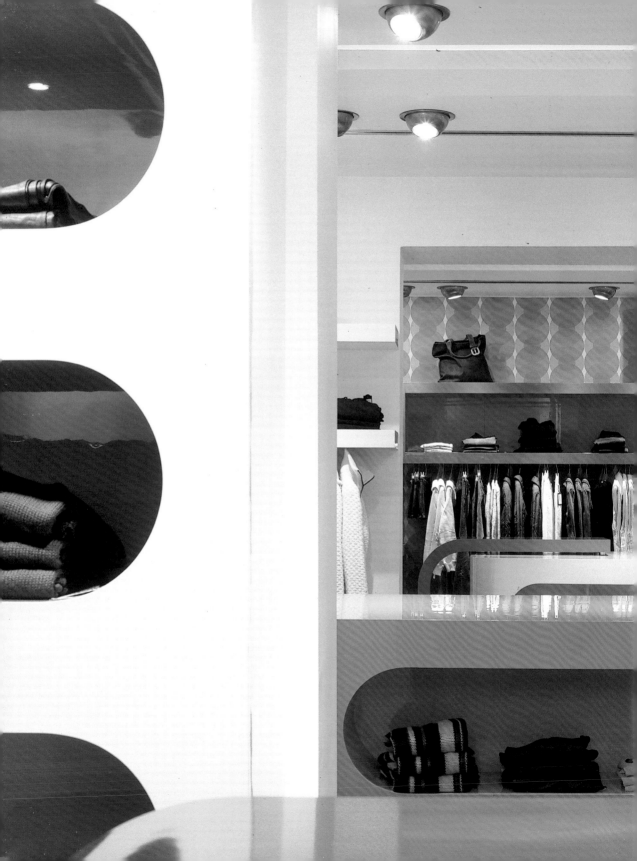

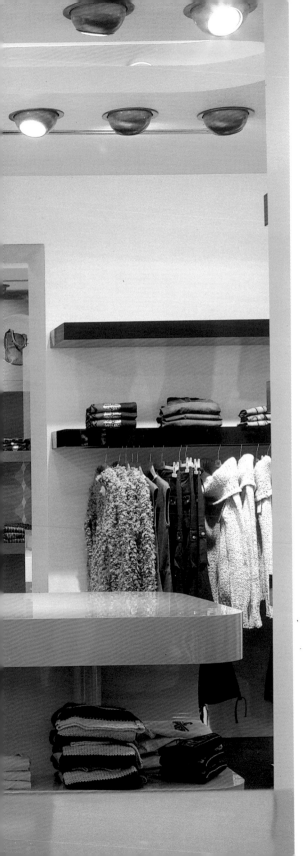

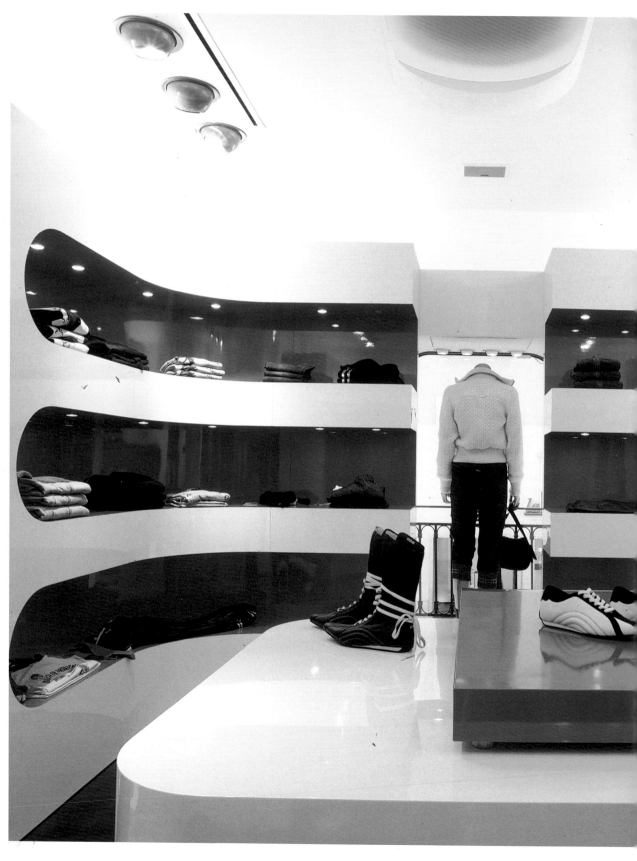

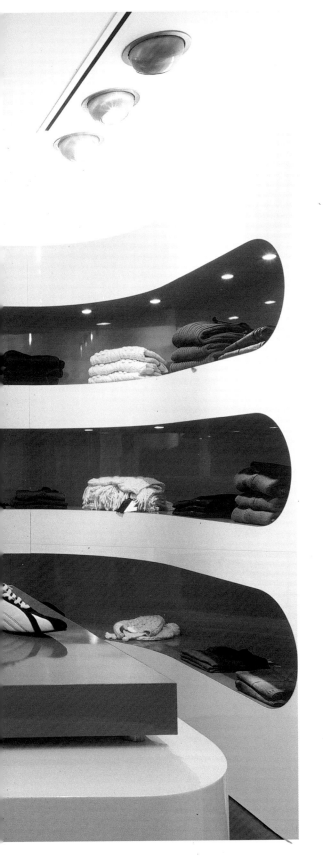

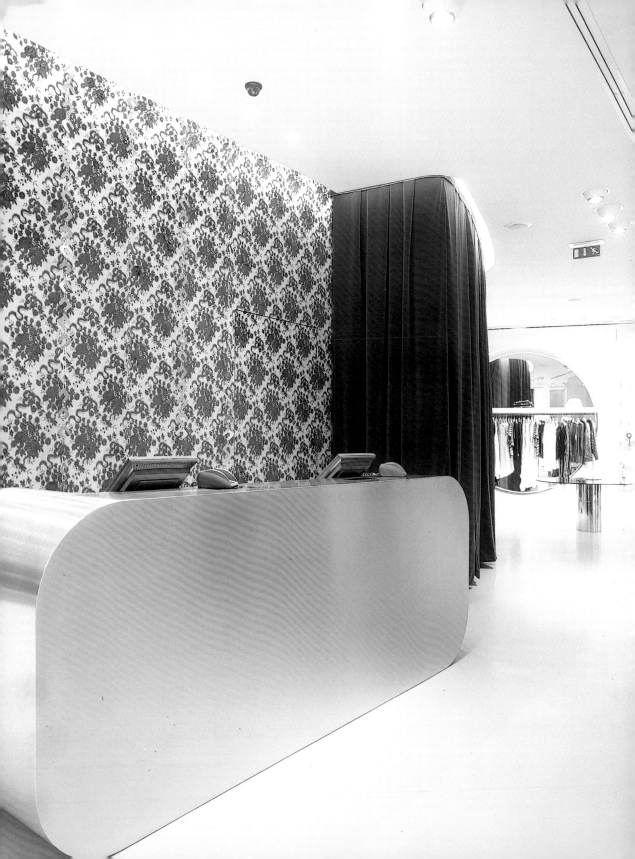

STUDIO 63 | FLORENCE

MISS SIXTY
Paris, France | 2003

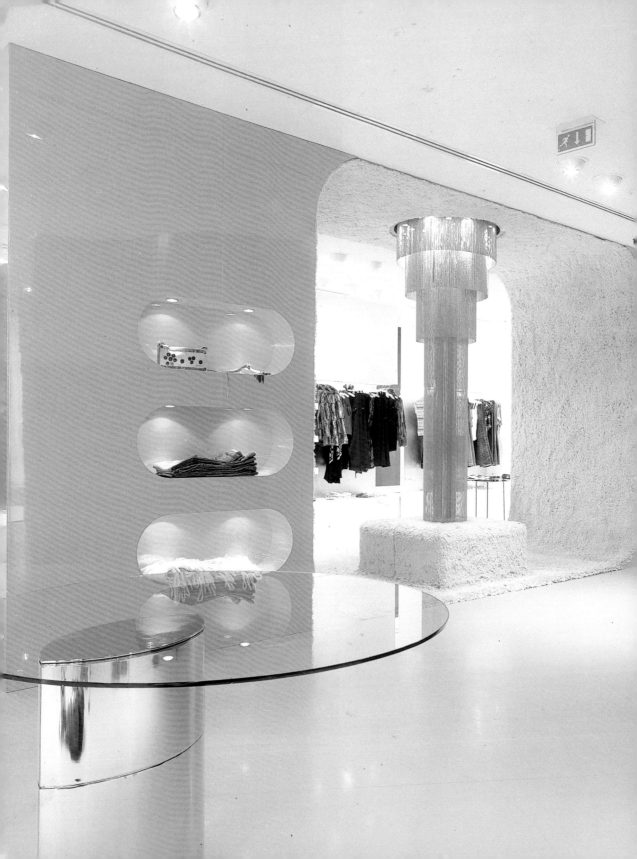

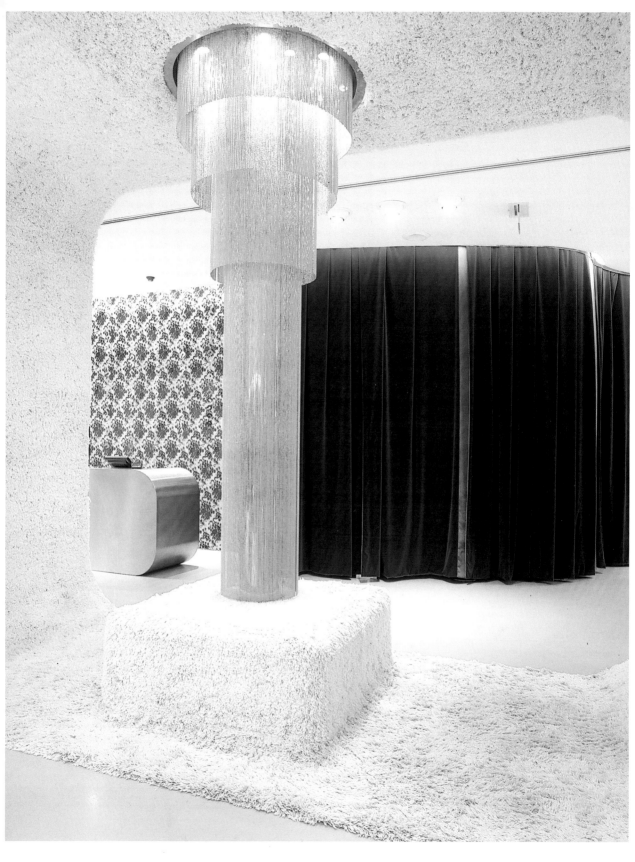

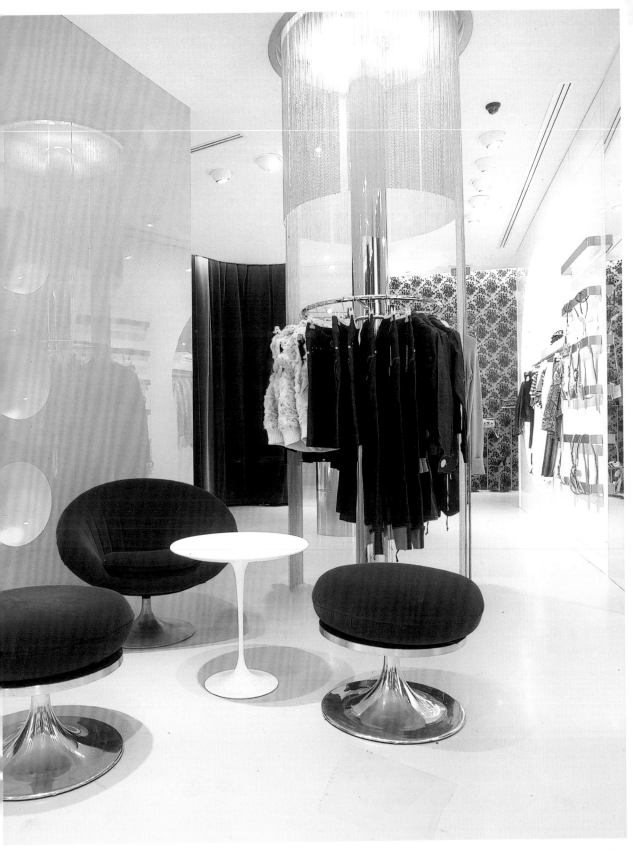

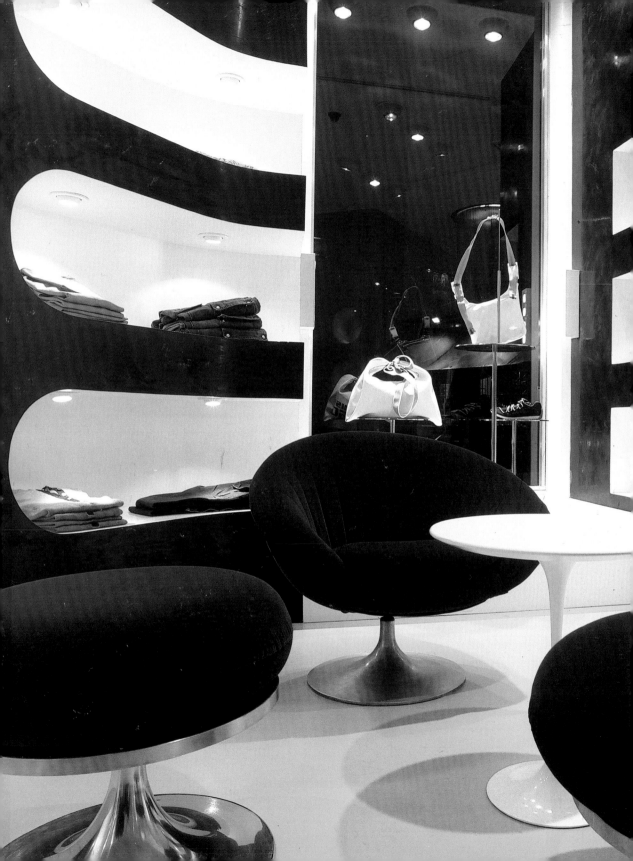

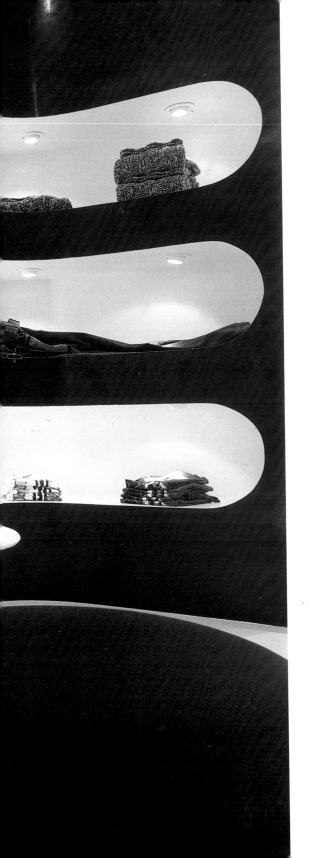

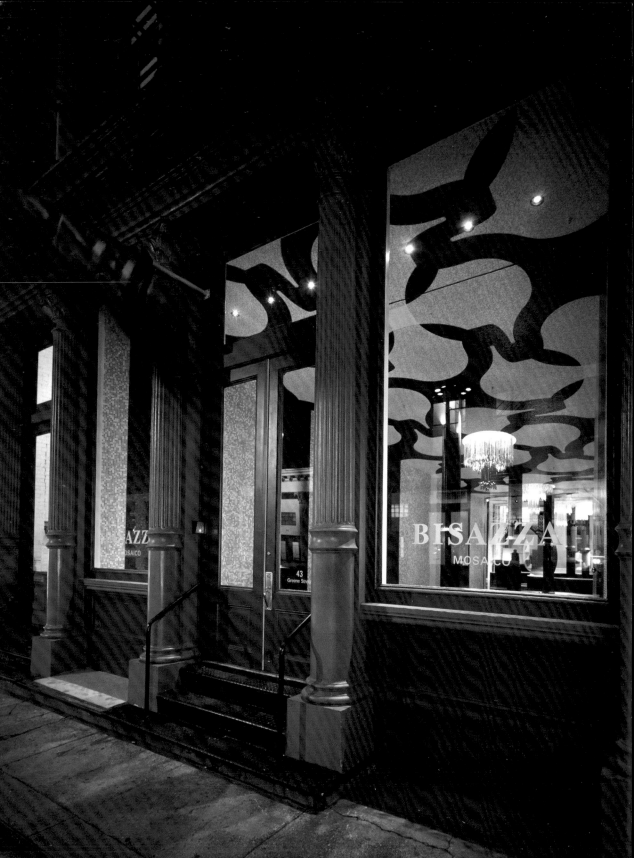

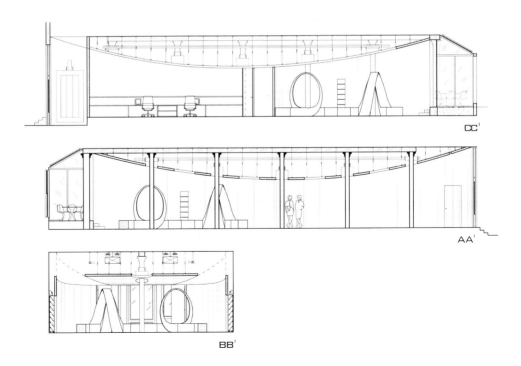

CC'

AA'

BB'

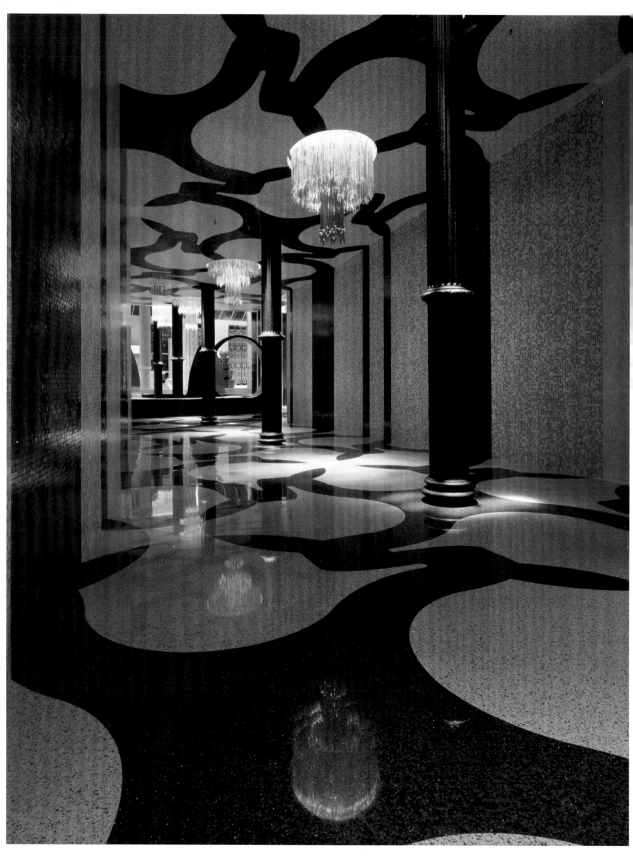

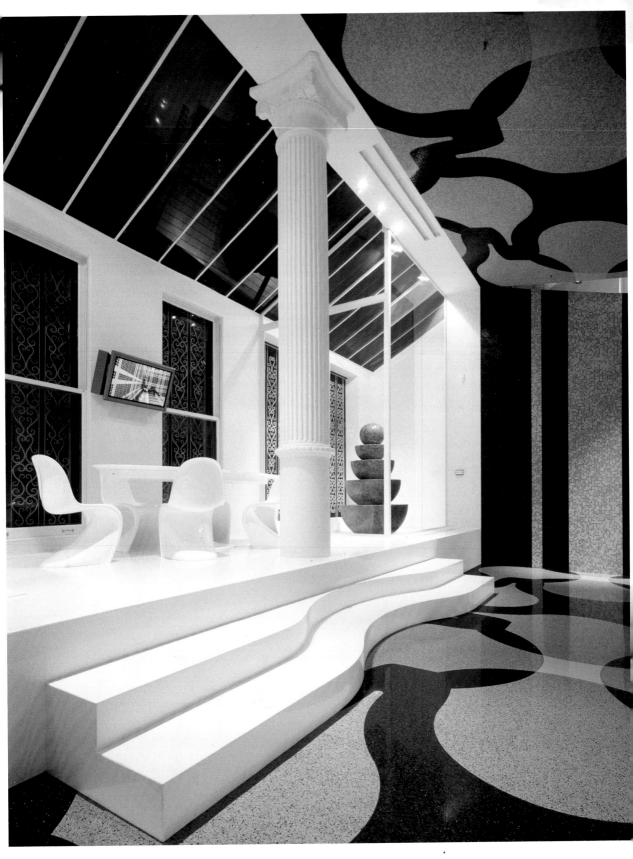

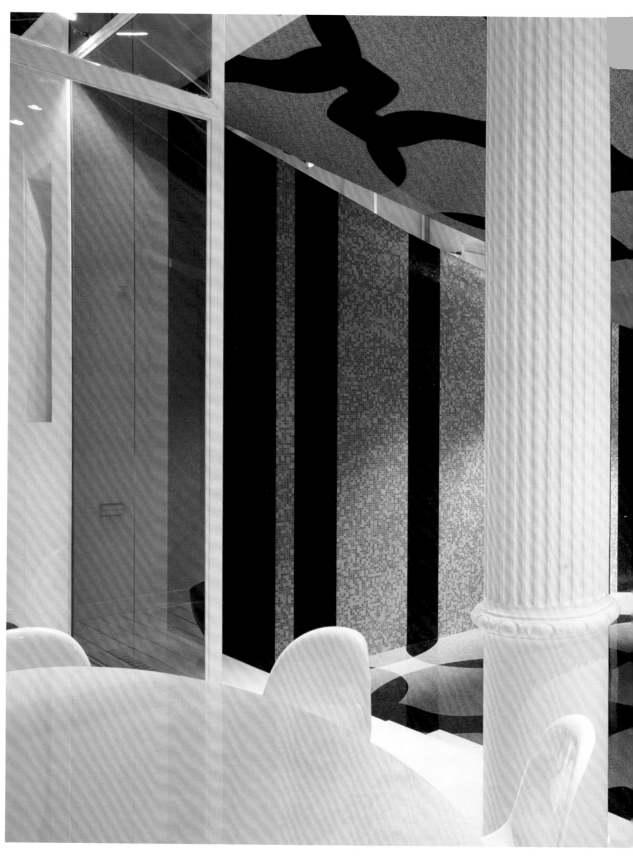

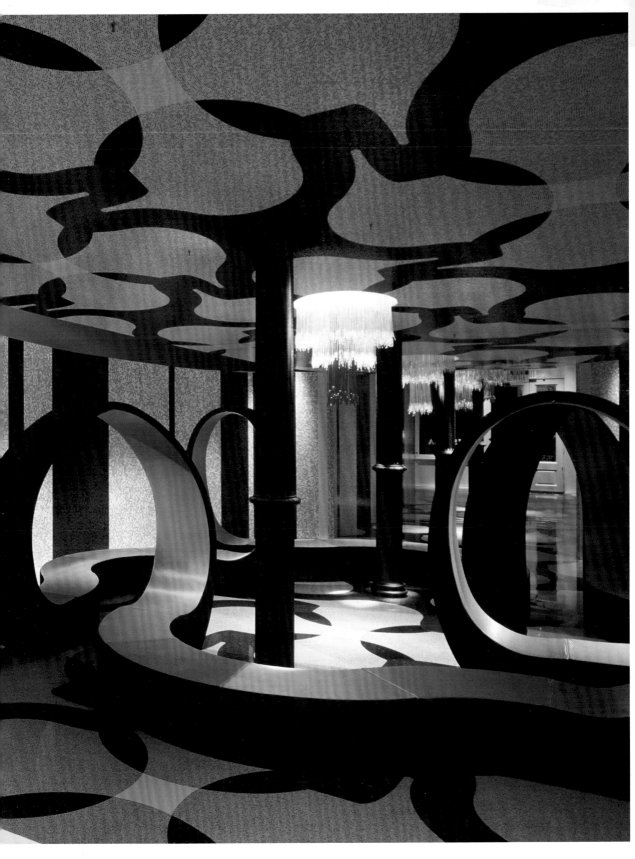

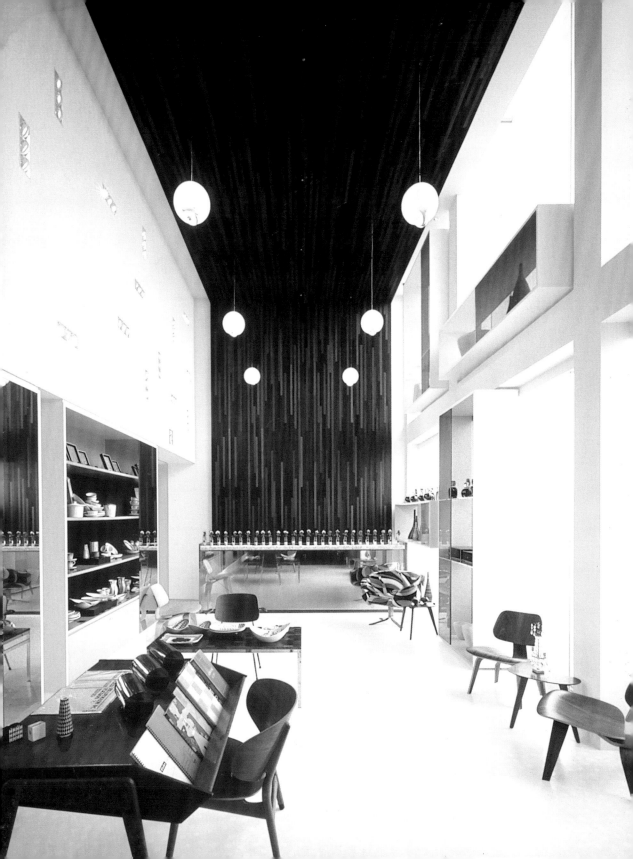

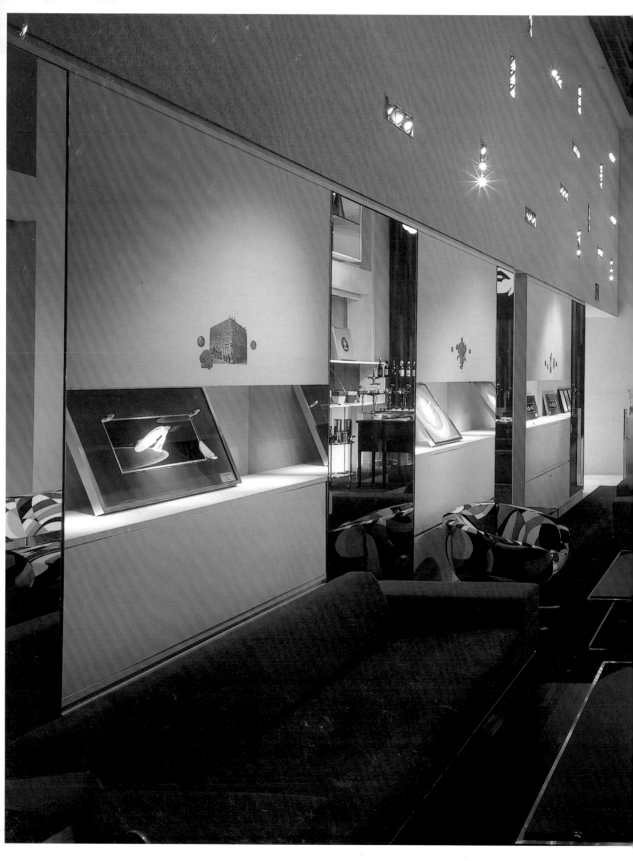

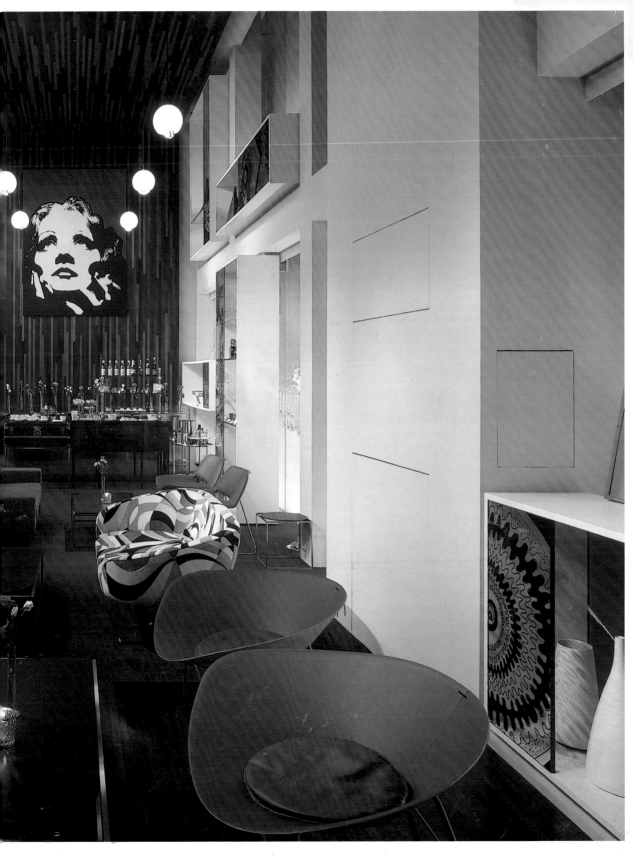

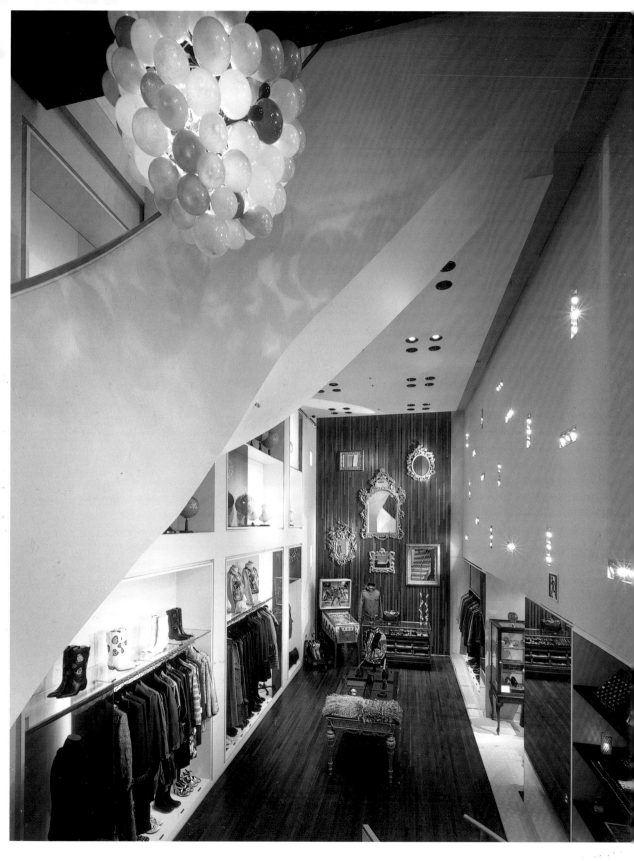

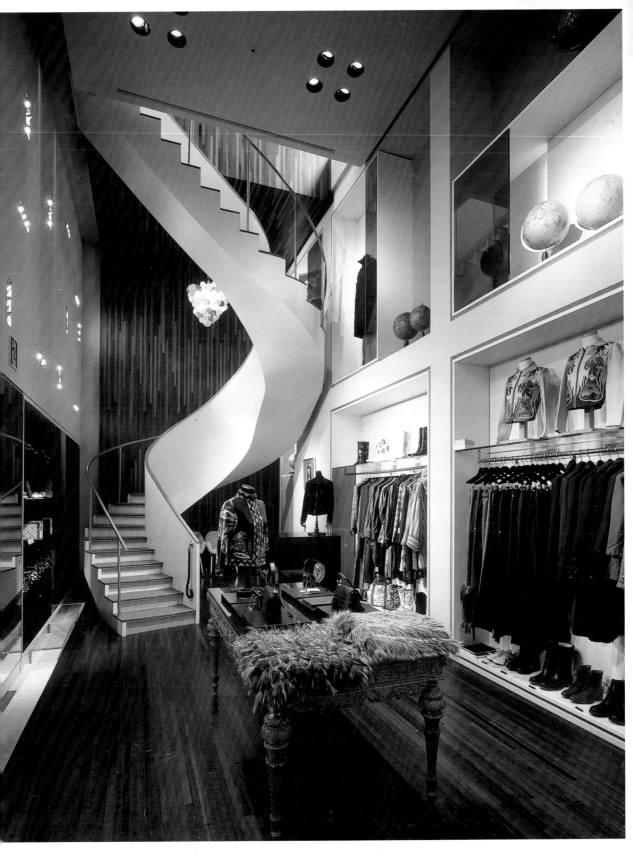

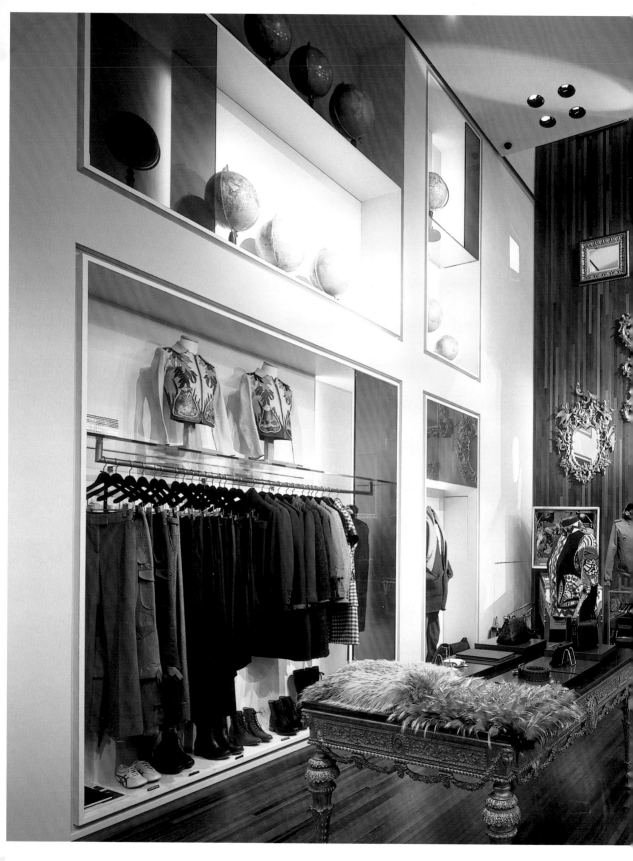

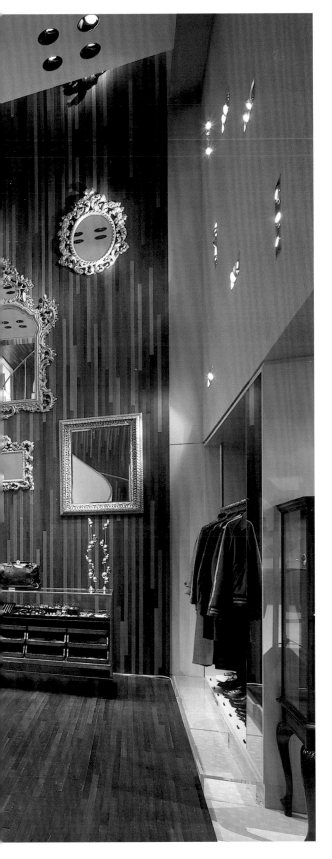

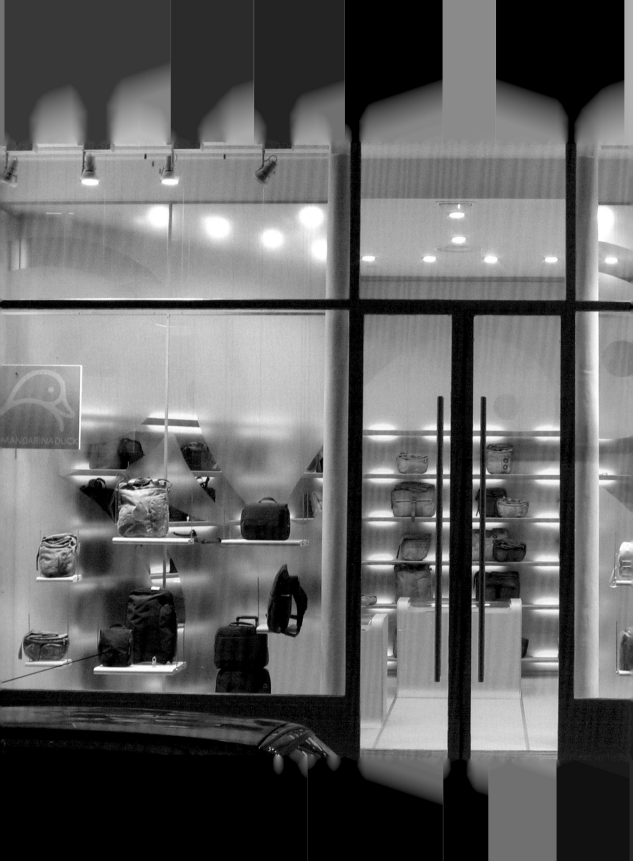

STUDIO X DESIGN GROUP | MILAN
MANDARINA DUCK
Paris, France | 2004

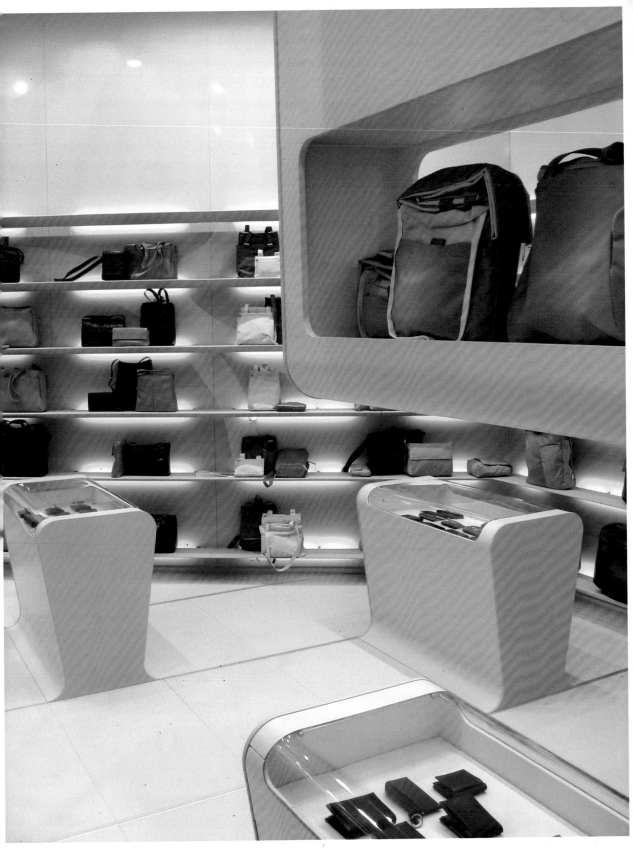

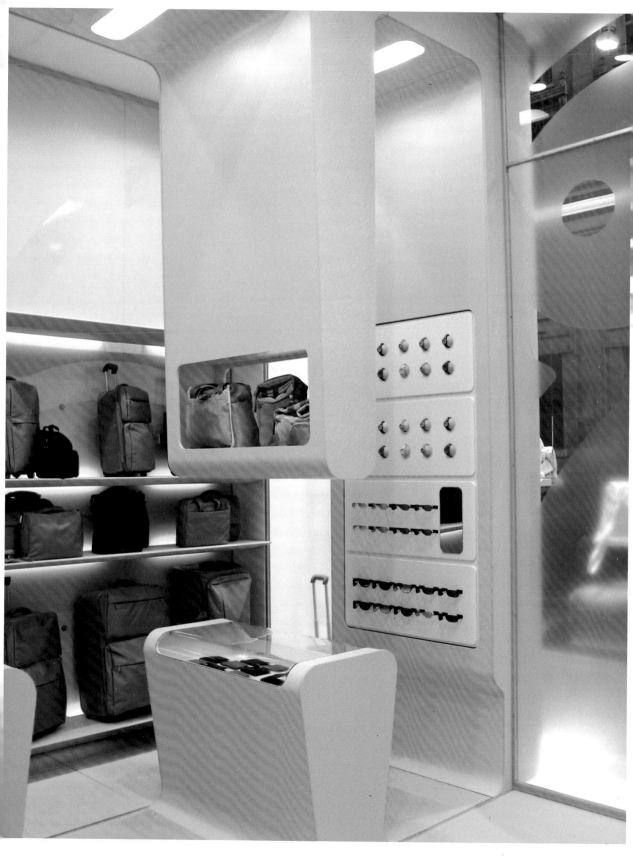

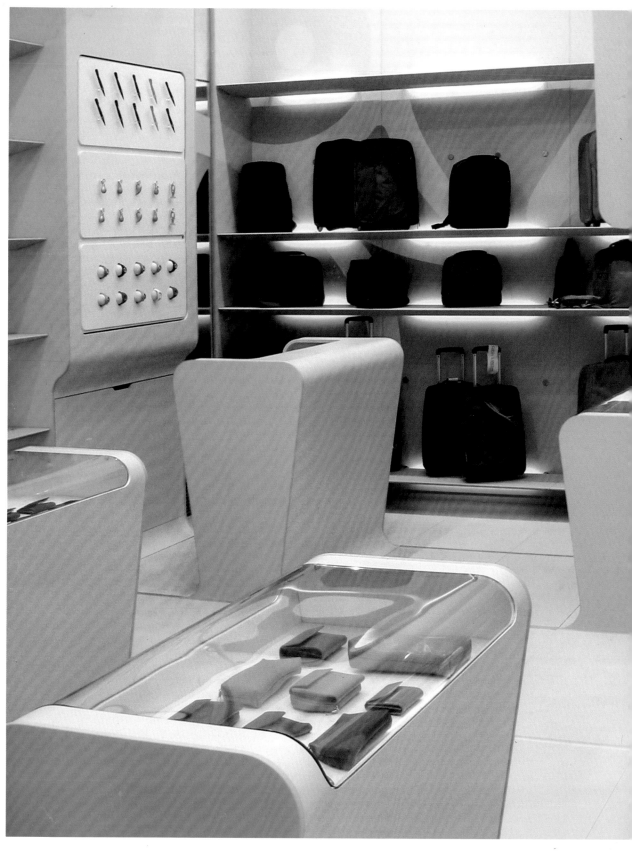

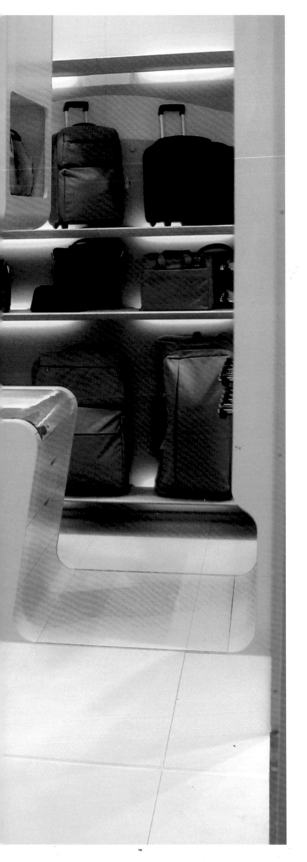

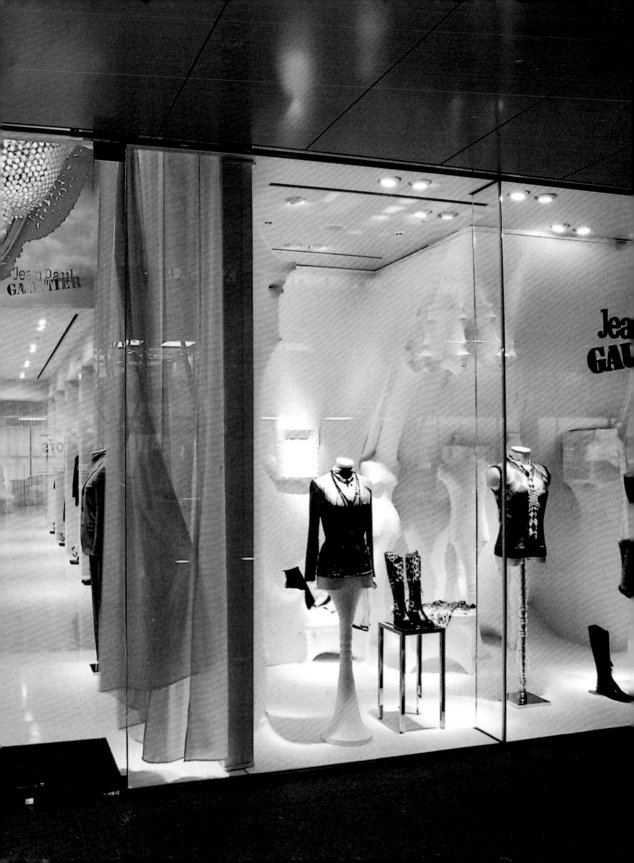

TAISHO DESIGN ENGINEERING | TOKYO
JEAN PAUL GAULTIER
Tokyo, Japan | 2004

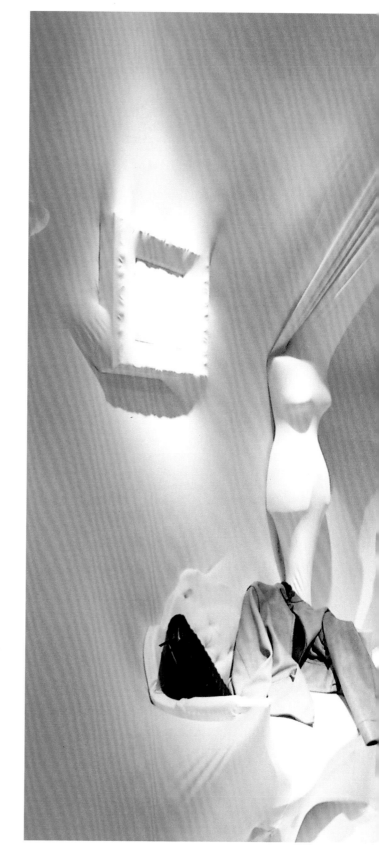

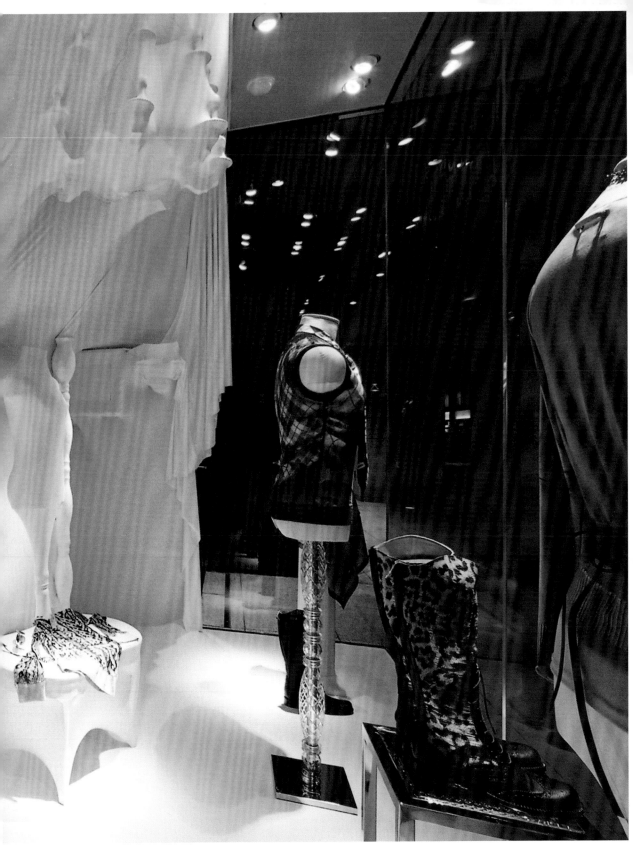

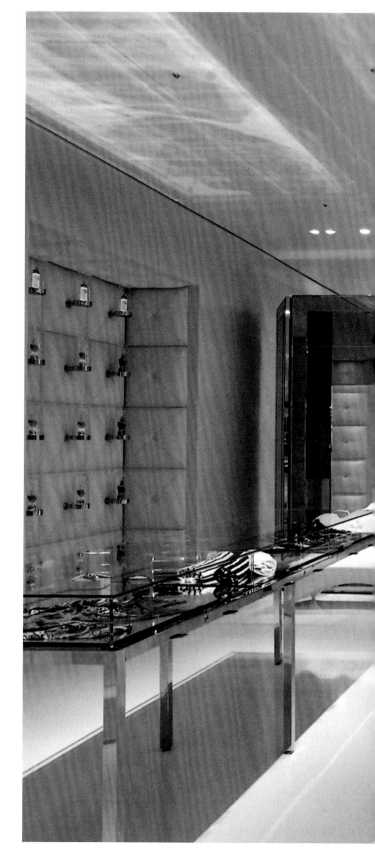

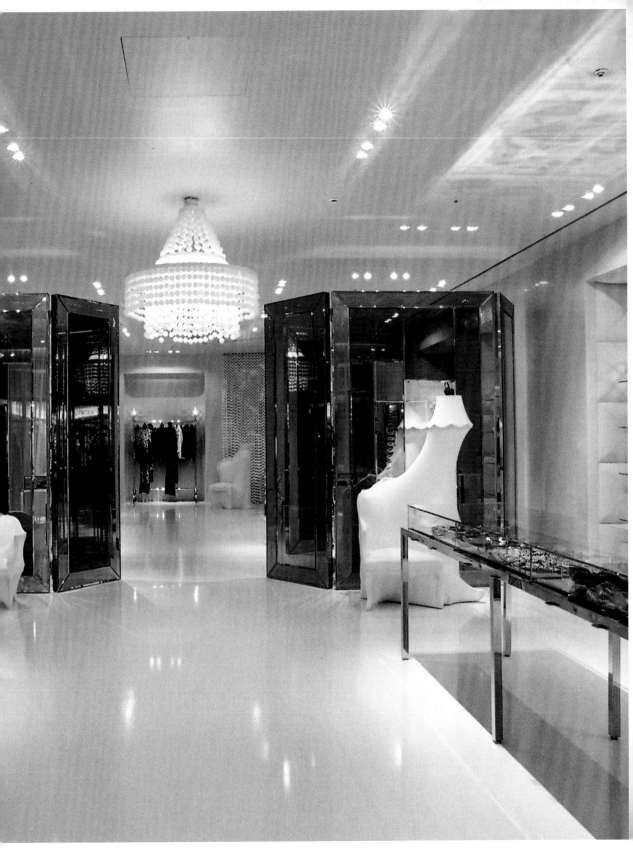

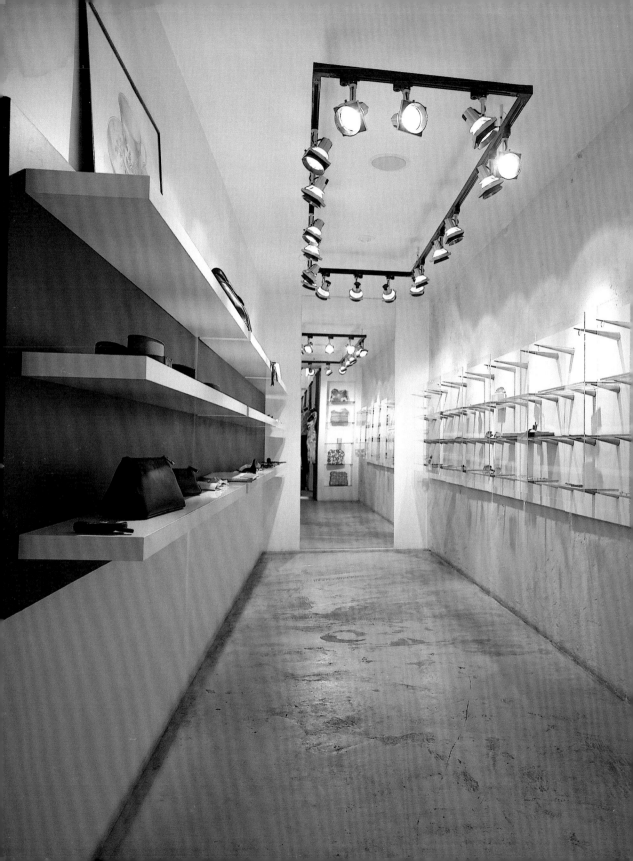

+VISION INTERIOR DESIGN, ARIADNA SHMANDUROVA | AMSTERDAM
BOUTIQUE UK-STYLE
Moscow, Russia | 2004

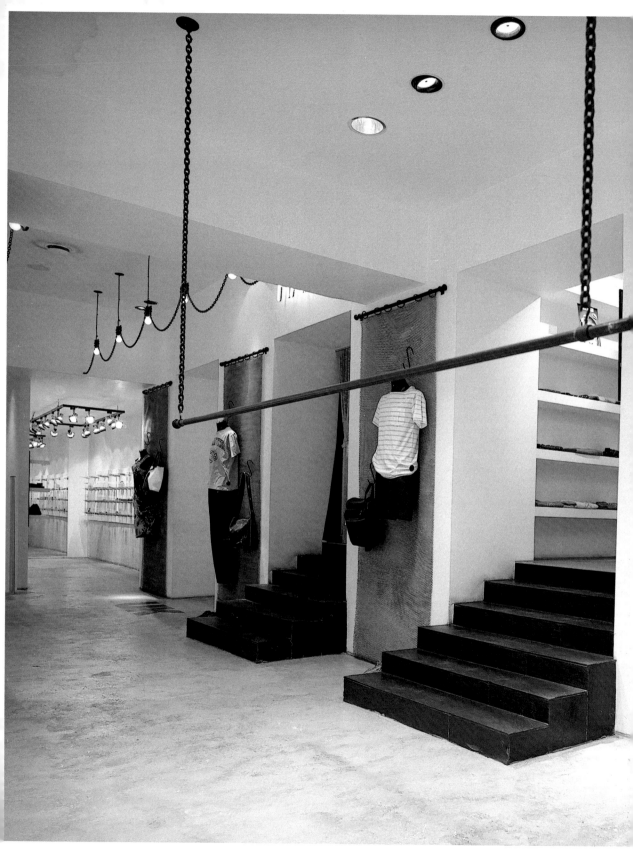

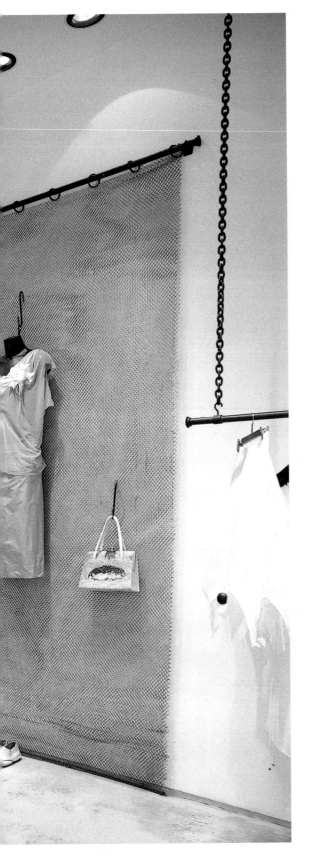

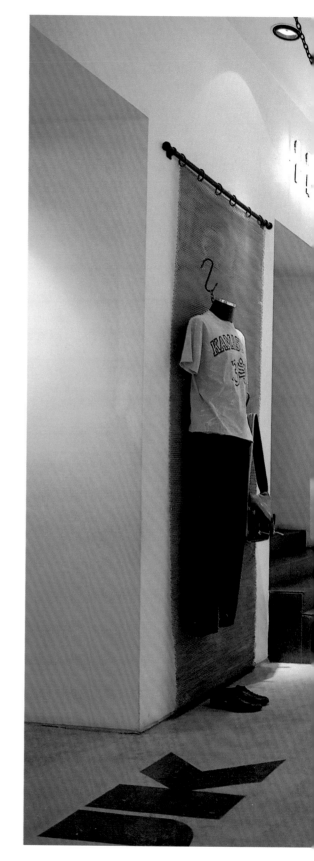

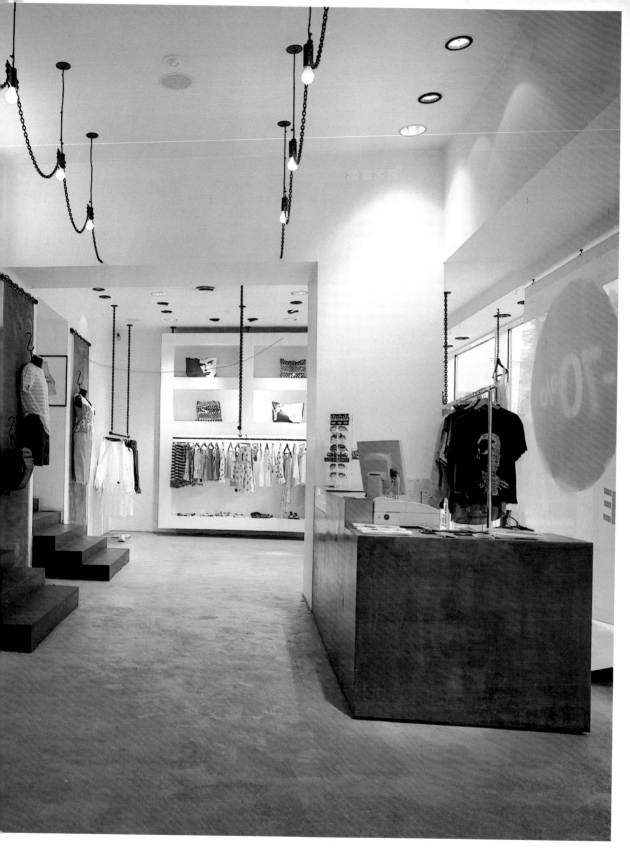

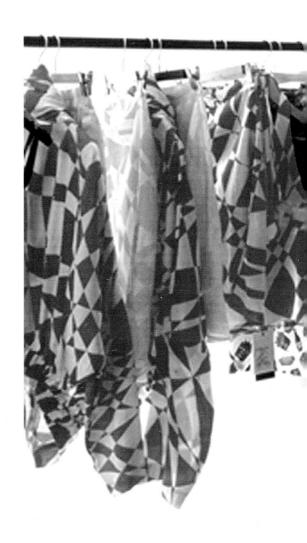

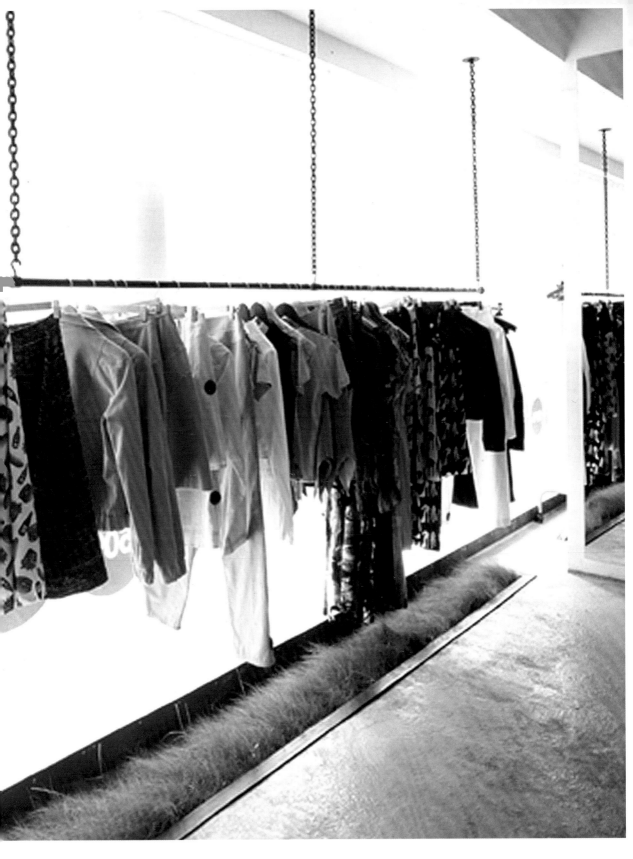

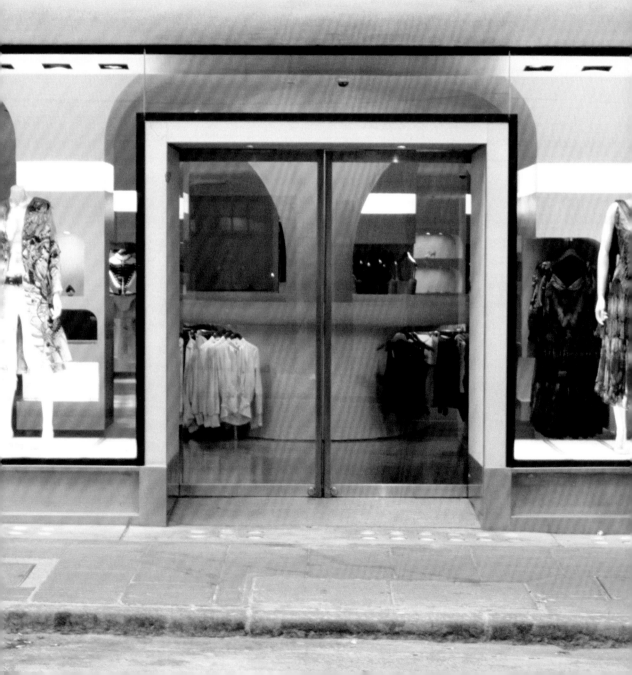

WILLIAM RUSSEL ARCHITECTURE AND DESIGN | LONDON
ALEXANDER McQUEEN
London, UK | 2003

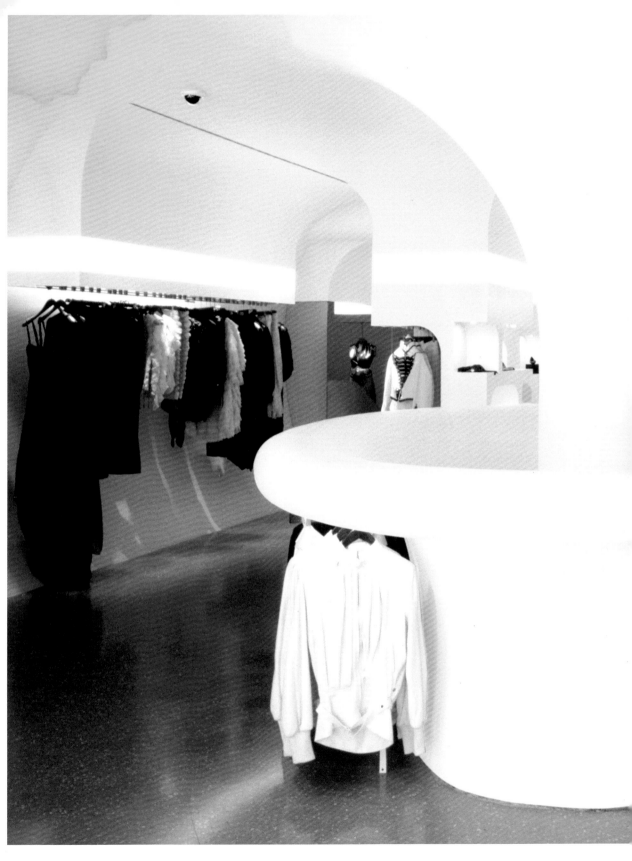

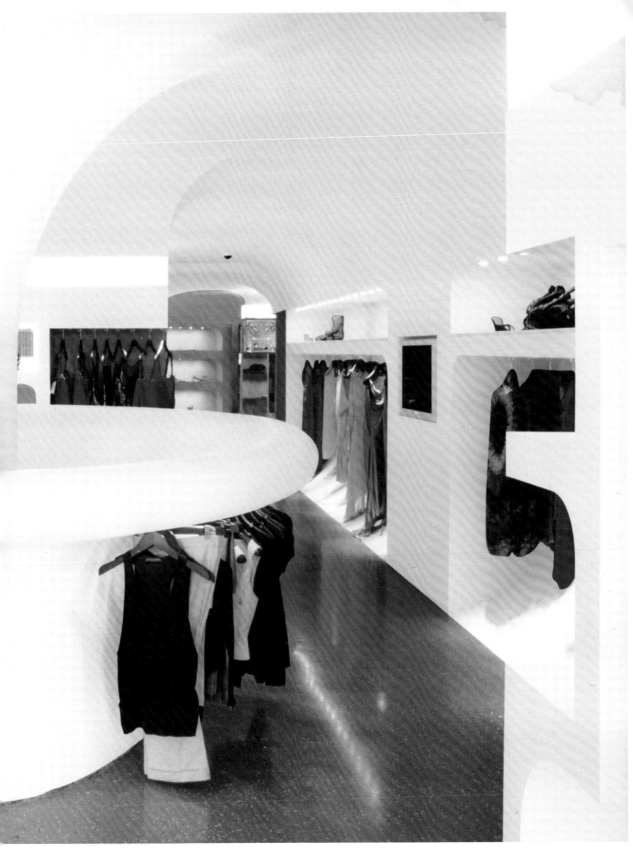

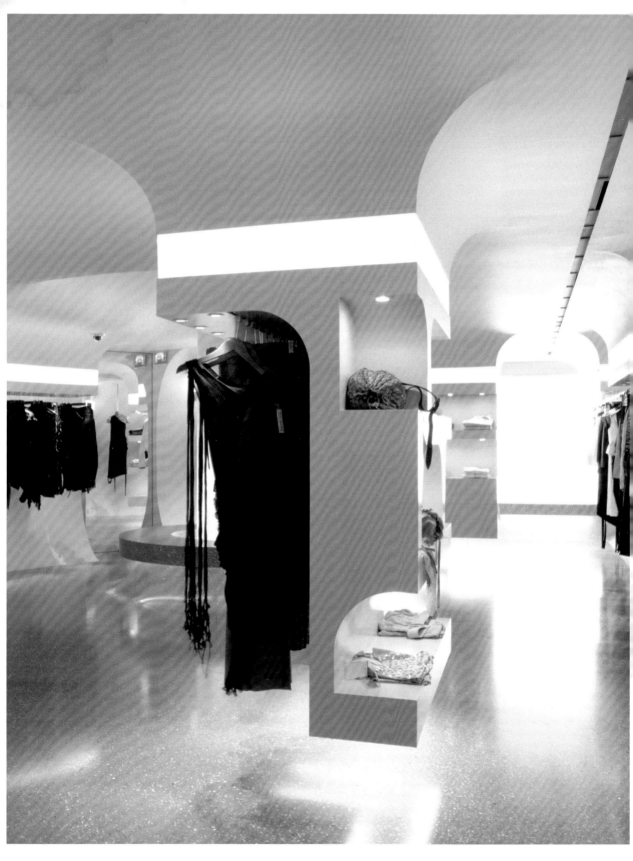

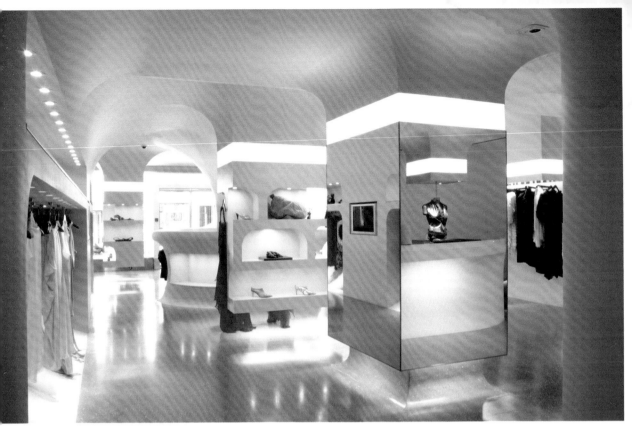

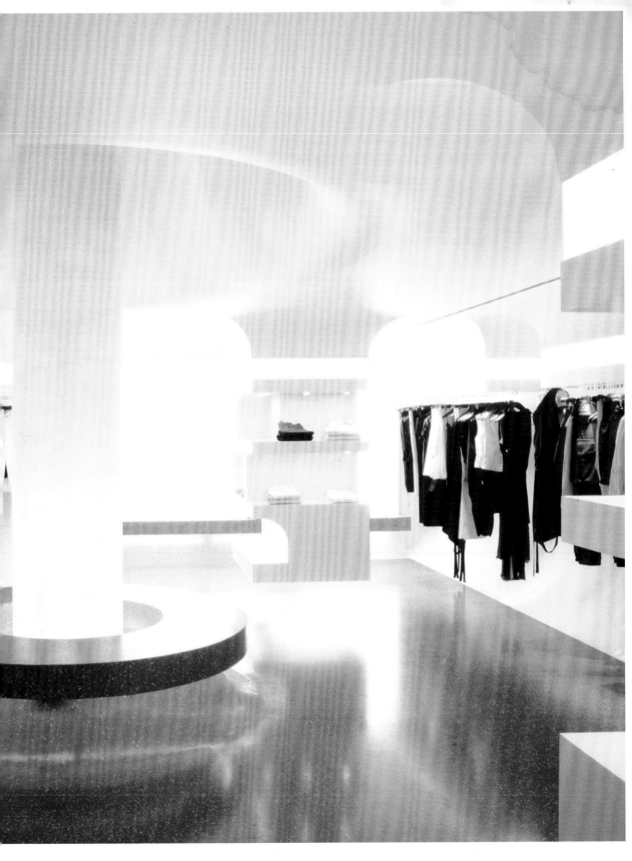

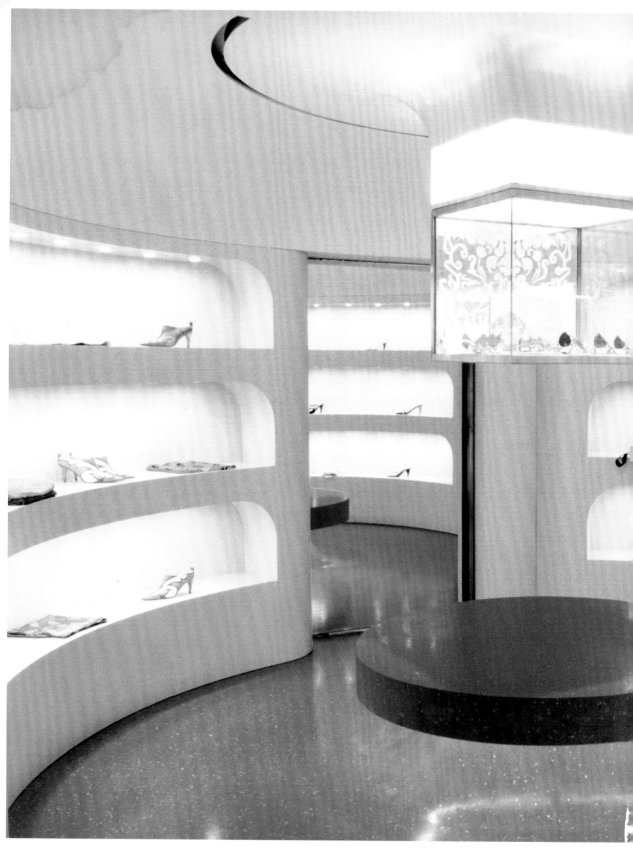

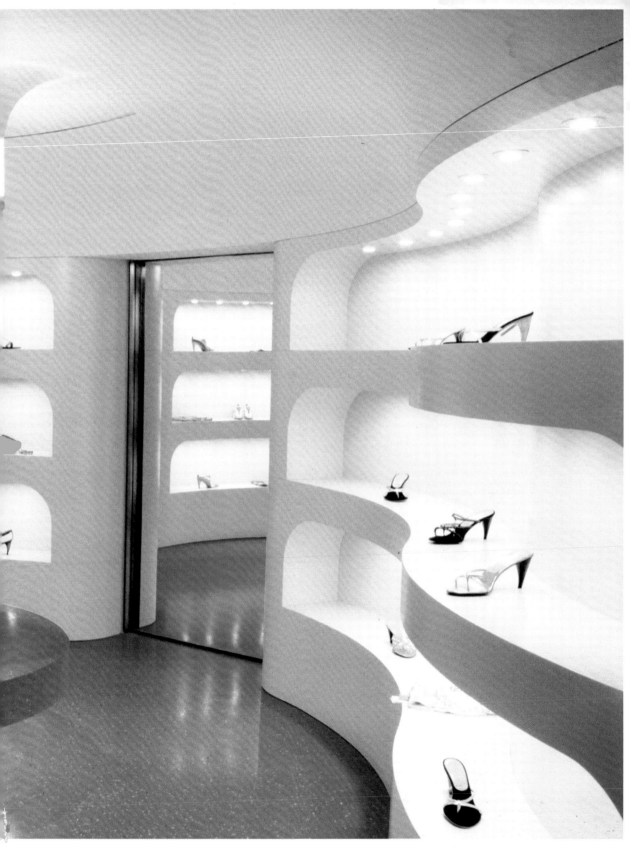

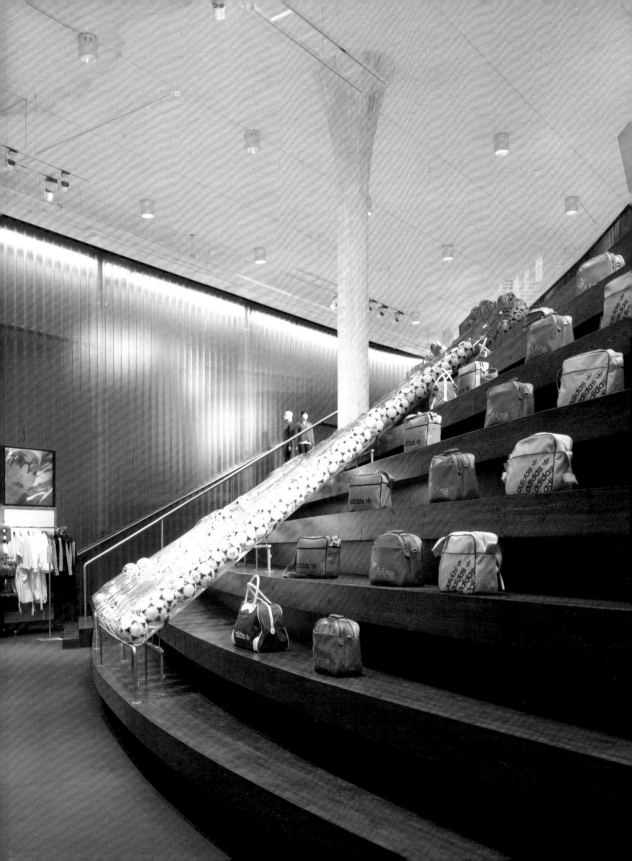

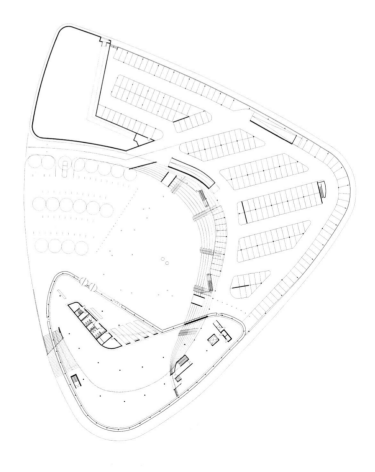

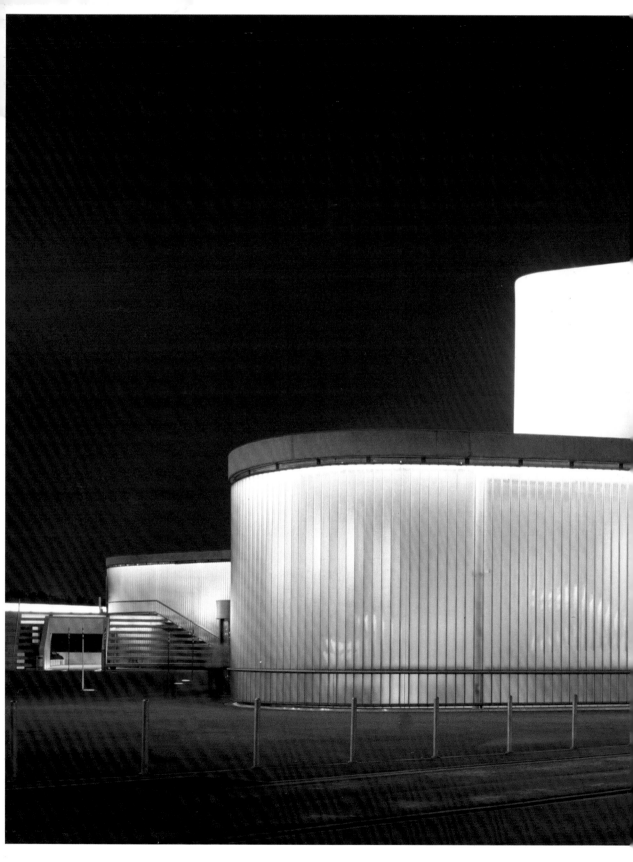

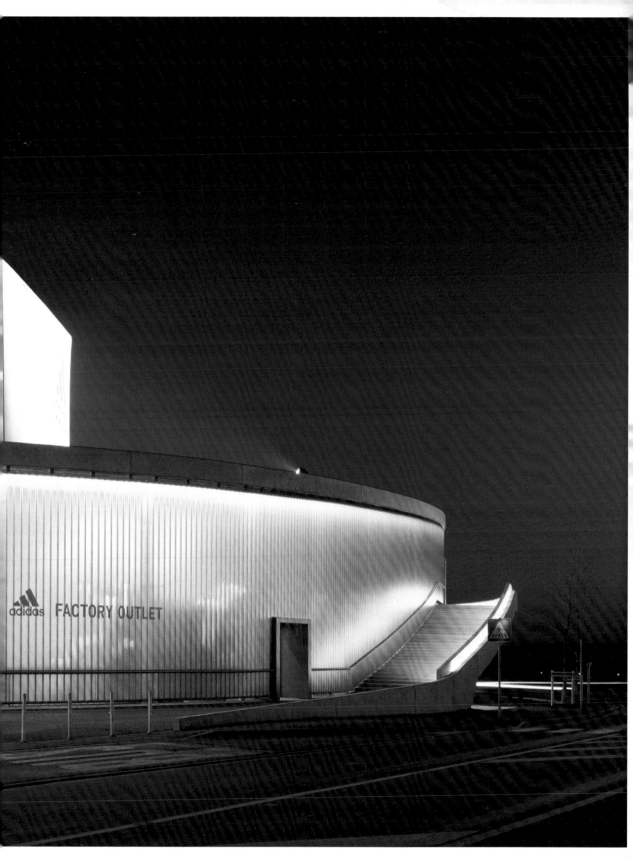

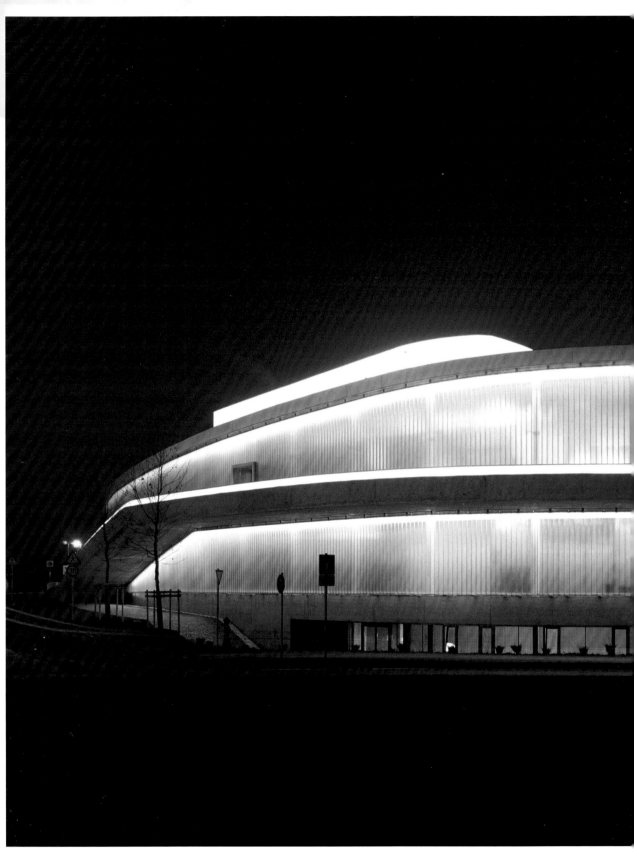

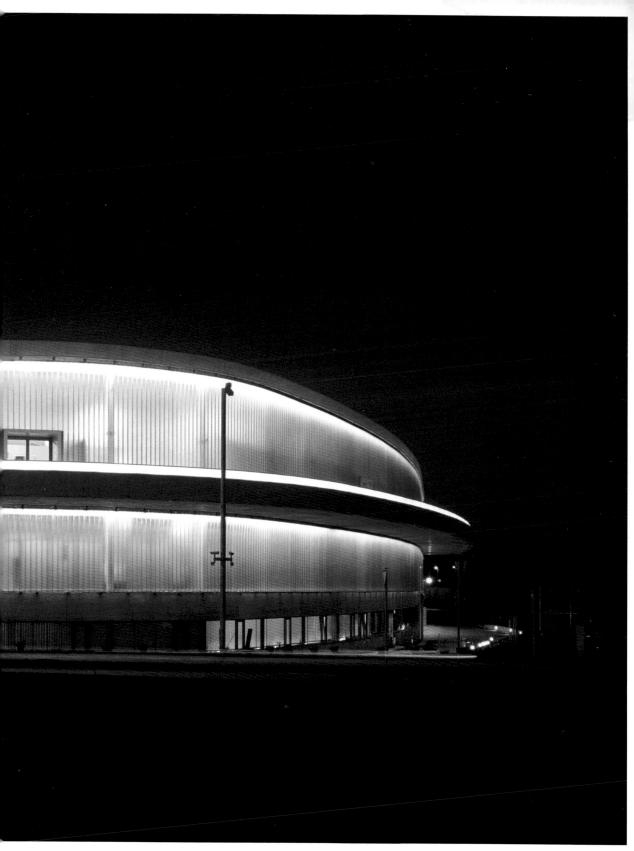

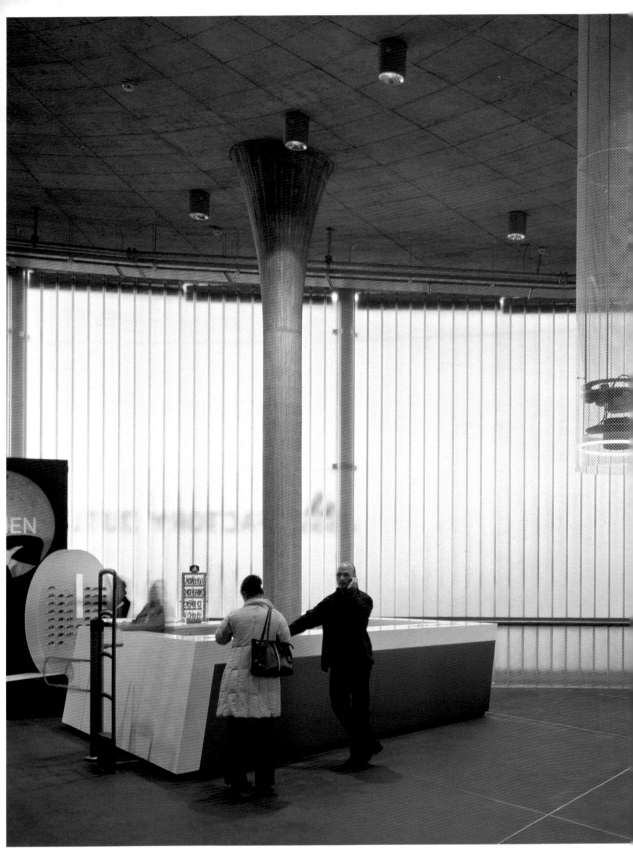

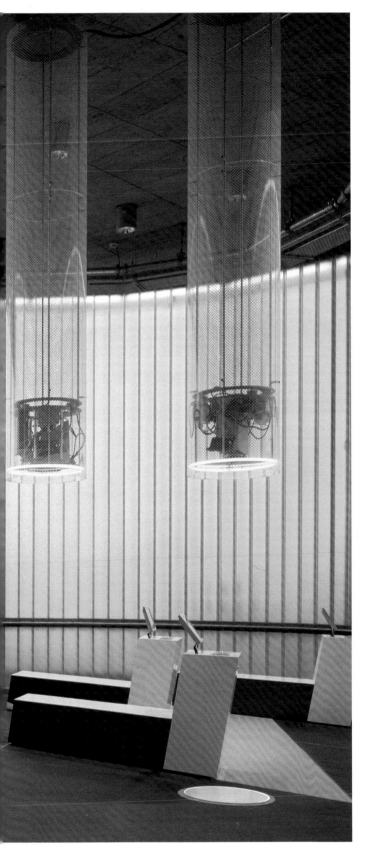

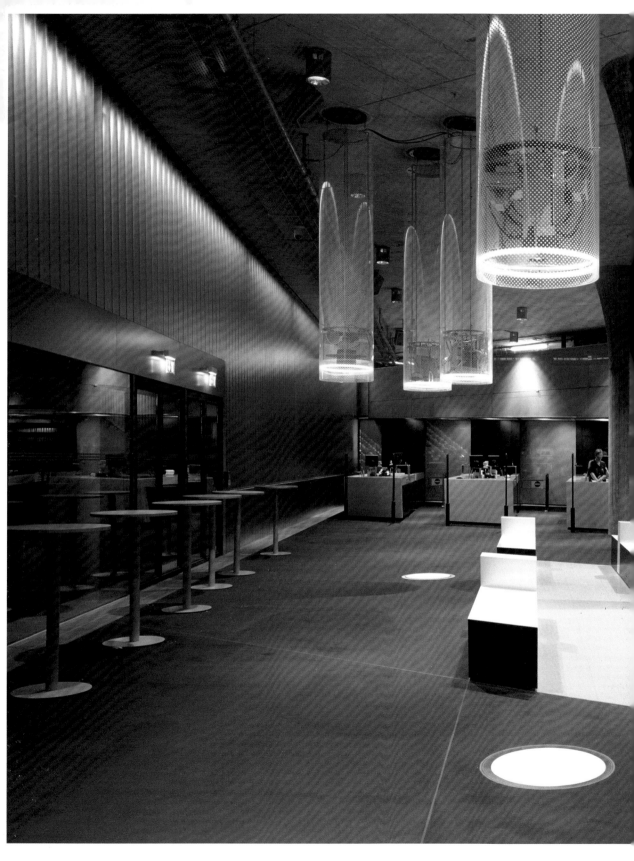

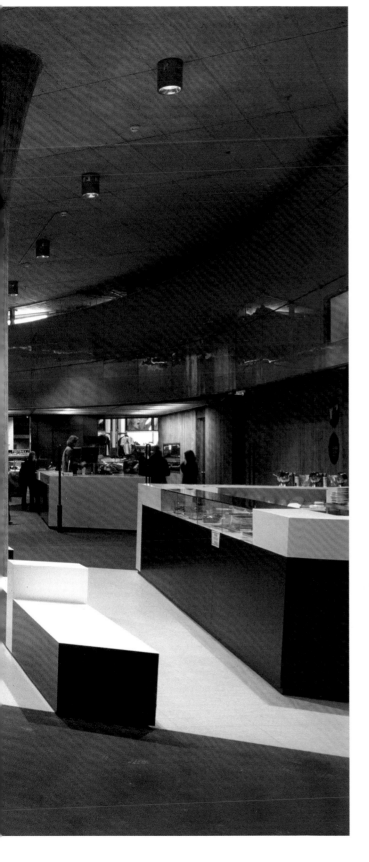

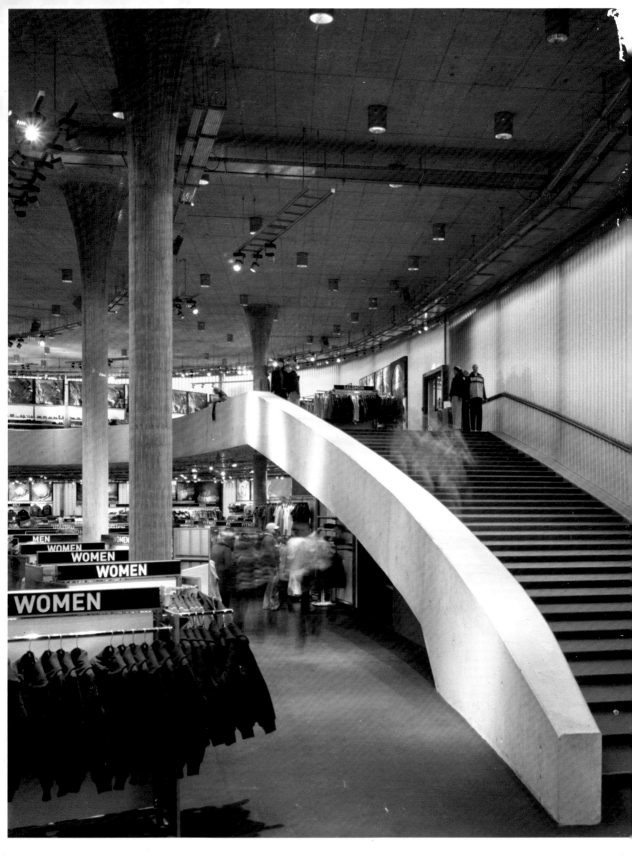

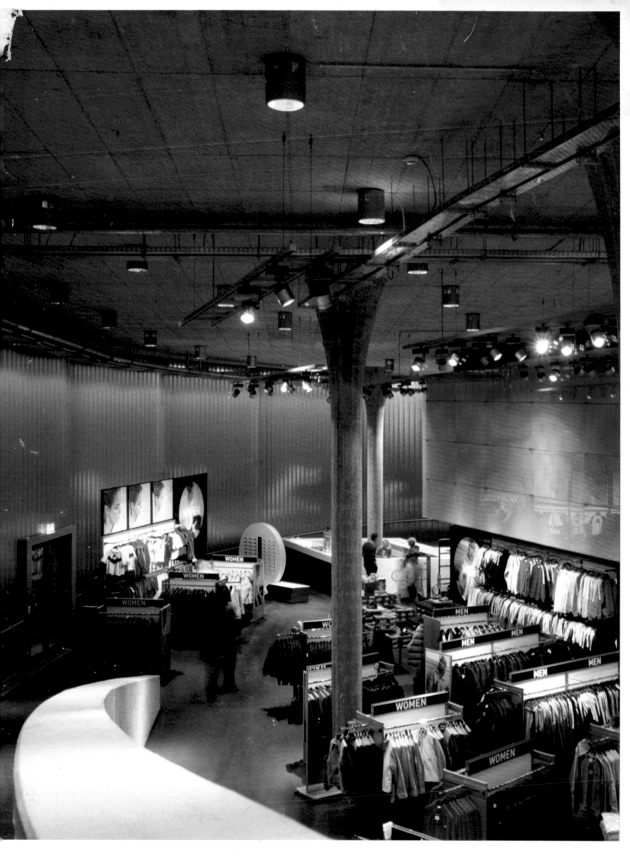

Architecture Studio
10, rue Lacuée, 75012 Paris, France
P +33 1 43 45 18 00
F +33 1 43 43 81 43
www.architecture-studio.fr
Bali Barret
Photos: © D-Studio-Franklin Azzi

Antonio Virga
1 bis Cité Paradis, 75010 Paris, France
P +33 01 48 00 01 25
F +33 01 48 00 81 26
Josep Font Paris
Photos: © Josep Font

Archea Associati
Lugarno Benvenuto Cellini 13, 50125 Florence, Italy
P +39 05 568 5202
F +39 05 568 10850
www.archea.it
Graniti Fiandre
Photos: © Alessandro Ciampi

A. Universal Design Studio
Second Floor, 181 Cannon Street Road
London E12LX, UK
P +44 (0) 207 033 3881
F +44 (0) 207 033 3882
www.universaldesignstudio.com
Stella McCartney
Photos: © Ed Reeve-Red Cover

Arthur Casas Arquitetura e Design
192 Lexington Avenue 17th Floor, New York
NY 10016, USA
P +1 212 686 4576
F +1 212 481 5590
casas@arthurcasas.com.br
Sacada Barra
Photos: © Arthur Casas

Baselli Vannucci Architetti
P +39 05 732 3992
Barghini Fashion
Photos: © Alessandro Ciampi

BEHF – Bernhard Ebner Hasenauer Ferenczy
Ziviltechniker GmbH, Kaiserstraße 41
A 1070 Vienna, Austria
P +43 152 417 50 12
F +43 152 417 50 20
www.behf.at
Manner
Photos: © Rupert Steiner

Buratti & Battiston Architects
Via Grigna 22, 20020 Busto Garolfo, Milan, Italy
P +39 033 156 9575
F +39 033 156 9063
www.burattibattiston.it
La Perla
Photos: © Matteo Piazza

Chelsea Atelier Architect, PC
245 7th Avenue, Suite 6A, New York
NY 10001, USA
P +1 212 255 3494
F +1 212 255 3495
www.chelseaatelier.com
Reem Acra
Photos: © Bjorg Magnea

CJ Studio
Floor 6, 54, Lane 260 Kwang Fu South Road,
Taipei, Taiwan
P +886 (02)2 773 8366
F +886 (02)2 773 8365
www.shi-chieh-lu.com
Wum-Showroom
Photos: © Kuomin Lee

Contemporary Architecture Practice
155 Avenue of the Americas (@Spring St.)
15th Floor, New York, NY 10013, USA
P + 1 212 366 9333
F + 1 212 366 9356
www.c-a-p.net
Reebok Shangai
Photos: © Contemporary Architecture Practice

Dan Pearlman Markenarchitektur gmbh
Kiefholzstrasse 1, 12435 Berlin, Germany
P +49 (0)30 53 000 567
F +49 (0)30 53 000 588
www.danpearlman.com
O2 Flagship Store
Photos: © Dan Pearlman

David Chipperfield Architects
Cobham Mews, Agar Grove, Camden
London NW1 9SB, UK
P +44 (0) 207 267 9422
F +44 (0) 207 267 9347
www.davidchipperfield.co.uk
Pasquale Bruni Showroom
Photos: © Ornela Sancassani

Dual Office
345 Vermont Street, San Francisco, CA 94103, USA
P +1 415 864 9900
F +1 415 864 9922
www.dualoffice.com
Echo Handbag Showroom
Photos: © Bjorg Magnea

EOK – Eichinger oder Knechtl
Franz Josefs Kai 29, A 1010 Vienna, Germany
P +43 153 55 424
F +43 153 54 039
www.eok.at
Shop Graz
Shop MQ
Photos: © Rupert Steiner

Forteza Carbonell Associats
Maria Aguilo 1-3, 08005 Barcelona, Spain
P/F: +34 933 076 501
www.fortalezacarbonell.com
Lottusse
Photos: © Santiago Garcés

Francesc Rifé
Escoles Pies 25
08017 Barcelona, Spain
P +34 934 141 288
F +34 932 412 814
www.rife-design.com
Aleste Flowpack
Aliu
Photos: © Eugeni Pons

Guillermo Blanco
Amarcord
Photos: © Rodrigo Pérez

Ippolito Fleitz Group
Bismarckstrasse 67B, 70197 Stuttgart, Germany
P +49 711 99 33 92 330
F +49 711 99 33 92 333
www.ifgroup.org
Sigrun Woehr
Photos: © Roland Halbe-Artur

Isay Weinfeld Architect
Rua Andre Fernandes 175, 04536 020 Sao Paulo SP
Brasil
P +55 11 3079 7581
F +55 11 3079 5656
www.isayweinfeld.com
Clube Chocolate
Photos: © Pedro D'Orey

Jun Aoki, Peter Marino
Louis Vuitton
Photos: © Floto + Warner

Klein Dytham Architecture
AD Bldg 2nd Floor,1-15-7 Hiro, Shibuya-ku
Tokyo 150-0012, Japan
P +81 03 5795 2277
F +81 03 5795 2276
www.klein-dytham.com
Orihica
Photos: © Tomoki Imai

Lot-ek
Ada Tolla & Giuseppe Lignano partners
55 Little West 12th Street
New York, NY 10014-1304, USA
P +1 212 255-9326
F +1 212 255-2988
www.lot-ek.com
Boon
Photos: © Lot-ek

Luciano Pérez, Julio Pérez
Tissage
Photos: © Virginia del Giudice

Manuel Bailó & Rosa Rull
ADD+ Arquitectura Bailó Rull
P +34 933 034 660
F +34 933 034 665
add.bar@coac.net
Sita Murt
Photos: © Jordi Miralles

Martí Guixé
www.guixe.com
Camper Infoshop
Photos: © Inga Knölke-Imagecontainer

Massimiliano Fuksas
Piazza del Monte di Pietà 30, 00186 Rome, Italy
P +39 066 880 7871
www.fuksas.it
Armani Hong Kong
Armani Milan
Armani Jeans Shanghai
Photos: © Giacomo Giannini

NL Architects
Van Hallstraat 294, NL 1051 HM Amsterdam
the Netherlands
P +31 (0)20 620 7323
F +31 (0)20 638 6192
office@nlarchitects.nl
Mandarina Duck
Photos: © Ralph Kämena

OMA – Office for Metropolitan Architecture
Heer Bokelweg 149
3032 AD Rotterdam, the Netherlands
www.oma.nl
P +31 10 243 8200
F +31 10 243 8202
Prada
Photos: © Floto & Warner

Pichiglass
Aduho
Photos: © Jordi Miralles

Studio Giorgieri
Via S. Reparata 42, 50129 Florence, Italy
P +39 055 496 389
F +39 055 486 399
www.studiogiorgieri.it
Dahl
Photos: © Alessandro Ciampi

Roger Hirsch
91 Crosby St., New York, NY 10012, USA
P +1 212 219 2609
F +1 212 219 2767
www.rogerhirsch.com
Is/Industries Stationery Flagship Store
Photos: © Patrik Rytikangas

Studio 63
Piazza Santa Maria Sopr'Arno 1, Florence 50124, Italy
www.studio63.it
P +39 055 200 1448
F +39 055 200 1433
14 Once Florence
Killah Milan
Miss Sixty Palermo
Miss Sixty Paris
Photos: © Yael Pincus

Studio Novembre
Via Mecenate 76/3, 20138 Milan, Italy
P +39 02 504104
F +39 02 502375
www.novembre.it
Bisazza Showroom
Photos: © Alberto Ferrero

Studio Power
Via Canonica 67, 20154 Milan, Italy
P +39 023 361 9063
F +39 023 493 4502
www.timpower.com
Celux Tokyo
Photos: © Daico Ano

Studio X Design Group
Via Risorgimento 11, 331100 Treviso, Italy
P/F: +39 042 254 5309
www.stxdesign.com
Mandarina Duck
Photos: © StudioXdesigngroup

Taisho Design Engineering
Jean Paul Gaultier
Photos: © Shinya Sudo-Omnia

+ Vision Interior Design
Da costakade 83 A,1053 WJ Amsterdam, the Netherlands
P +31 (0)20 470 6927
F +31 (0)61 554 5594
www.plusvision.biz
Boutique UK-Style
Photos: © + Vision Interior Design

WRAD LTD − William Russell Architecture and Design
First Floor, 101 Redchurch Street, London E27DL, UK
P +44 (20)7 729 3133
F +44 (20)7 729 1013
www.wrad.co.uk
Alexander McQueen
Photos: © Ed Reeve-Red Cover

Wulf & Partner
Charlottenstr. 29/31, 70182 Stuttgart , Germany
P +49 711 248 9170
www.wulf-partner.de
Adidas Factory Outlet
Photos: © Roland Halbe-Artur

© 2005 daab
cologne london new york

published and distributed worldwide by
daab gmbh
friesenstr. 50
d - 50935 köln

p + 49 - 221 - 94 10 740
f + 49 - 221 - 94 10 741

mail@daab-online.de
www.daab-online.de

publisher ralf daab
rdaab@daab-online.de

art director feyyaz
mail@feyyaz.com

editorial project by loft publications
© 2005 loft publications

editor and text Eva Dallo

layout Ignasi Gracia Blanco
english translation Ana G. Cañizares
french translation Marion Westerhoff
italian translation Maurizio Siliato
german translation Constantin Nagel
copy editing Cristina Doncel

printed in spain
Anman Gràfiques del Vallès, Spain
www.anman.com

isbn 3 - 937718 - 37 - 0
d.l.: B - 43099-05